AMERICAN WOMEN

images and realities

AMERICAN WOMEN
Images and Realities

Advisory Editors
ANNETTE K. BAXTER
LEON STEIN

A Note About This Volume

This book by William Forrest Sprague pictures the hardships and accomplishments of women pioneers in the trans-Allegheny region. It analyzes those economic and social aspects of western life which assisted women in their fight for greater legal and political rights. Scholarly and incisive as social history, it details the journey westward and the nature of life in the frontier settlements.

WOMEN AND THE WEST:

A Short Social History

BY

WILLIAM FORREST SPRAGUE.

ARNO PRESS,
A New York Times Company
New York • 1972, c1940.

Reprint Edition 1972 by Arno Press Inc.

Reprinted from a copy in The State Historical
Society of Wisconsin Library

American Women: Images and Realities
ISBN for complete set: 0-405-04445-3
See last pages of this volume for titles.

Manufactured in the United States of America

- - - - - - - - - - - -

Library of Congress Cataloging in Publication Data

Sprague, William Forrest.
 Women and the West.

 (American women: images and realities)
 Bibliography: p.
 1. Frontier and pioneer life--The West. 2. Women in
the West. I. Title. II. Series.
F591.S77 1972 917.8'03 72-2624
ISBN 0-405-04480-1

WOMEN AND THE WEST

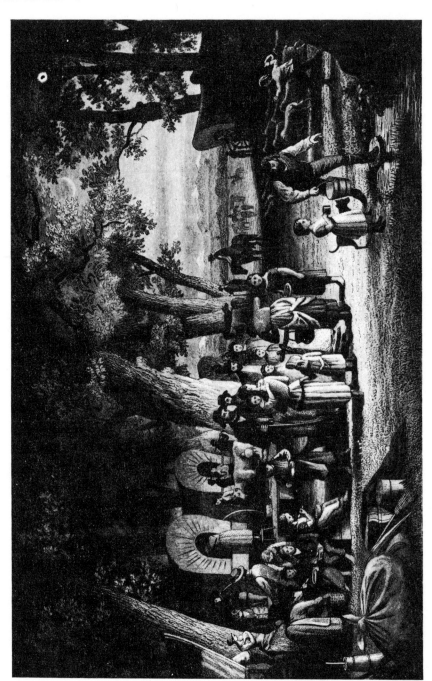

AN EMIGRANT CAMP

(From L. P. Brockett. *Our Western Empire*)

WOMEN AND THE WEST

A Short Social History

BY

WILLIAM FORREST SPRAGUE, Ph. D.

"But truce with kings and truce with constitutions,
With bloody armaments and revolutions,
Let Majesty your first attention summon,
Ah! *ca ira!* THE MAJESTY OF WOMAN!"
—*Robert Burns.*

The Christopher Publishing House
Boston, U. S. A.

TO MY LATE PARENTS,
NELLIE WOODWARD SPRAGUE
AND
PAUL ROGER SPRAGUE

PREFACE

The realization that women have played a very important rôle in American history is of course not new. But most of the previous studies which emphasize this fact have been biographical in character. This category includes not only the works which concern themselves directly with the lives of prominent females, but those of men, the authors of which have stressed the influence of women in shaping the important decisions of their careers.

In this study the biographical approach has been avoided as far as possible. The chief purposes of the work are to portray the hardships and accomplishments of the female pioneers in the trans-Alleghany region, and to mention somewhat more sketchily the important effects of the westward movement upon the lives of women in the older sections of the nation. Moreover the survey is confined to women of European descent. Hence women of American Indian tribes, and those of Oriental ancestry are not included. Nor does it attempt to estimate the services of ladies who were affiliated with religious orders or missionary societies which attempted to be of service in the West. The writer believes that all such considerations represent separate studies.

In selecting material for the appendix, an attempt was made to procure source excerpts which would prove both readable and significant. It was attempted also to show women in as many frontier rôles as possible, and to include writings which present clearly both the humor and pathos engendered by unique circumstances resulting from the westward migrations.

It probably will be evident to the reader that two of the general subjects which are treated in the pages which follow

are the hardships of the pioneer women in the regions west of the Alleghanies, and the economic and social aspects of western life which assisted that sex in its struggle for greater legal and political rights. For suggesting the possibilities of a treatment of the first-named category, the writer feels indebted to Dr. Raymond C. Werner of the University of Illinois. Nearly a decade ago, when the writer was an undergraduate at the latter institution, Dr. Werner mentioned in one of his lectures that historians had failed to appreciate adequately the sufferings and services of the pioneer mothers.

Dr. Walter P. Webb of the University of Texas must be thanked for pointing out in his work, *The Great Plains,* the fact that reasons why the very masculine Far West was the first section of the country to accord women the ballot, had yet to be studied. Encouraging also during the final phases of the preparation of the manuscript, was a statement in the work of Dr. Howard E. Wilson, *Education for Citizenship* (McGraw-Hill, 1938). In reporting the findings of the New York Regents Inquiry (initiated late in 1935), Dr. Wilson stated that history manuals in the past have contained too little data that is of vital interest to girls.

For their encouragement and suggestions thanks are extended to Dr. Howard E. Egan, Dean of the Downtown College of Liberal Arts of De Paul University, and to Dr. Albert J. Huggett, of the Department of Education of Chicago Teachers College. For kind and hospitable assistance in obtaining manuscript data in West Texas, Mr. Giles E. Bradford, M. A. of Sweetwater, Texas, is thanked. Appreciated also was the use of the manuscripts owned by Mr. William J. Donaldson of Polo, Ill., and those from the collection of Mr. Charles E. Wickliffe of Chicago, Ill. Helpful also was the reading of the work by Mr. Frederick B. Hall, Jr., of Chicago, Ill.

Two members of the sex about which this study is chiefly concerned, rendered assistance, without which satisfactory

progress in the preparation of the manuscript could not have
been possible. Miss Winifred Vernooy of the University of
Chicago library staff, made available the research facilities of
the latter institution for a period of nearly three years, while
Miss Margaret Collins, B. S. of the faculty of the Chicago
Public High Schools, provided helpful and efficient assistance
in typing the several drafts of the manuscript.

The writer is also most grateful to Major General E. S.
Adams of the Department of War, for his kindness of sending
data regarding the enlistment of western women in the Union
armies during the Civil War. Most valuable in the location of
necessary source material, were the staffs of the following
libraries: The Illinois State Historical Library, the Library of
Congress, and the Henry E. Huntington Library and Art
Gallery of San Marino, California.

William Forrest Sprague.

Chicago, Illinois
June 28, 1940

CONTENTS

	PAGE
PREFACE	7
LIST OF ILLUSTRATIONS	13

CHAPTER I

INTRODUCTION	15
1. Women of the Colonial Frontier	15
2. Women of the French and Spanish Settlements	16
3. The Two Great Divisions of the Trans-Alleghany West	22
4. Some Factors Which Augmented the Westward Movement	23

CHAPTER II

HARDSHIPS OF WOMEN ON THE TIMBER-PRAIRIE FRONTIER	30
1. The Journey Westward	30
2. Their Tasks and Dangers on the Farms	37
3. The Ravages of Disease	51
4. The Unsatisfactory Social Environment	57

CHAPTER III

GAINS OF WOMEN ON THE TIMBER-PRAIRIE FRONTIER	66
1. Prestige Through Scarcity	66
2. Early Achievement of Educational Equality	76
3. Belated Recognition of Her Services	87
4. Their Improved Legal Status	91

CHAPTER IV

OPENING UP THE "LAST WEST"	100
1. The New Frontier Environment for Women	100
2. The Continued Scarcity of Women on the Frontier	118
3. Eastern Suffrage Leaders Face West	132
4. Women Politically Educating the Far West	143

CHAPTER V

THE LAST WEST GIVES EQUAL SUFFRAGE ITS FIRST CHANCE	150
1. The Wyoming Experiment	150
2. Mormonism and the Utah Suffrage Experiment	158
3. Suffrage in Washington Territory	171
4. Wyoming the First Suffrage State	174

CHAPTER VI

WESTERN FEMINISM IN THE NINETIES 178
1. Colorado Suffrage and the Populists 178
2. Mormonism and the Utah Constitution of 1895 181
3. Borah and the Idaho Suffrage Movement 187
4. Western Women as Political Reformers 191

CHAPTER VII

THE WEST AND THE FINAL SUFFRAGE VICTORY 199
1. Reasons for the "Fruitless Years" 199
2. Women as Alaska Pioneers 201
3. A Decade of Suffrage Success, 1910-1920 207
4. First Western Women in High Positions 211

CHAPTER VIII

SOCIAL AND CULTURAL RESIDUE 213
1. The Continued Shortage of Women in the West 213
2. Some Representative Women Writers of the West 216
3. Social Reverberations of Both Frontiers 219
4. The Adaptability of Western Women 228

APPENDIX .. 235
1. Mrs. Trollope's Description of a Camp Meeting Service...... 235
2. Extracts of a Diary Kept by Mrs. Narcissa Whitman on Her
 Trip to Oregon in 1836 239
3. A Woman's Description of an Illinois Prairie 242
4. Deathbed Statement of a Frontier Woman 244
5. The Experiences of Mrs. Sarah N. Worthington in Frontier
 Illinois ... 258
6. Campaigning for Woman Suffrage in Kansas as Told by Mrs.
 Elizabeth Cady Stanton 262
7. Women of a Hotel in a Colorado Mining Community, 1874.. 266
8. An Interview with a Mormon Mother 269

BIBLIOGRAPHY ... 273

INDEX .. 287

LIST OF ILLUSTRATIONS

PAGE

An Emigrant Camp*Frontispiece*

Sitting Room of a Beau at a One-Room Cabin Homestead **38**

Miss Anthony Addressing the Miners **147**

Plains-Mountain Indians Gambling for the Possession of a White
Female Captive **109**

13

Women and the West, a Short Social History

CHAPTER I

INTRODUCTION

1. WOMEN OF THE COLONIAL FRONTIER

It is well known that the sources for American colonial history contain numerous episodes which depict the bravery, industry, and self-reliance of the women of the frontier communities. Why then, does not this group merit precisely the same degree of esteem and veneration as the women who aided in the settlement of the vast trans-Alleghany area? Apparently, the most potent reason is that there were relatively few instances in the colonial epoch of American history where the frontier advanced any great distance inland. Said the traveler Latrobe, "The posts of the advancing column of civilization . . . were ordinarily pushed forward with caution, and seldom so far, as to be totally beyond the reach of co-operation and support." [1]

Perhaps the best single explanation why no great attempt was made to push the frontier far from tidewater in the colonial period was that the underlying motives of English officials and capitalists were commercial, rather than agrarian. The empire planners looked upon these North American possessions as a source of certain raw materials, including naval stores. For a long period, even a large part of those interested in agriculture

[1] C. J. Latrobe, *The Rambler in North America*, I, 83.

felt that the West Indies afforded greater crop producing potentialities than did British North America.

Nor did the colonial frontier women suffer as greatly from many long journeys to new localities as did the wives of many backwoodsmen and first settlers on the borders farther West. While it is true that a large number of the families who occupied the isolated valleys of the eastern slope of the Appalachian Mountains later migrated to western territories, still many others remained—their mode of life destined to be little altered by the political, economic, or cultural changes in the balance of the nation.

A third consideration is that this old frontier did not produce the enormous wealth in products and land values which was to come from the "New West." Its soil was not marked for fertility; relatively few fortunes were amassed from the occupation of the country between the mountains and the coastal plain. Hence there was, comparatively, but slight cause to appreciate the hardships of the women who went to this frontier.

But while the individualistic Anglo-American families were occupying the Piedmont and Appalachian valleys in the eighteenth century, certain French and Spanish settlements were being founded in areas which later were to become a part of the United States. Before undertaking the study of the rôle of women on the American frontier beyond the Alleghanies, therefore, it seems pertinent to analyze briefly the position of females in those colonies.

2. WOMEN OF THE FRENCH AND SPANISH SETTLEMENTS

Although many of the North American communities of French and Spanish origin were isolated, they were usually not in great danger of Indian attack, since both powers were successful in maintaining far more satisfactory relations with the

tribes near their borders than was the government of the United States during the frontier epoch. Moreover, the homes were less scattered; thus ample military protection was easier to provide. Traveling through the western sections of the country in 1796, Volney had an opportunity to compare the American mode of settlement with that of the French. After discussing the methods and aims of the pioneers from the older states, he declared: "They will remain sometimes six months without seeing the face of a stranger."

Yet in regard to the habits and character of the French families, he said:

Neighbors pay and return visits: for visiting and talking are so indispensably necessary to a Frenchman from habit, that throughout the whole frontier of Canada and Louisiana there is not one settler of that nation to be found, whose house is not within the reach or within sight of some other.[2]

It seems evident also that the males of these French and Spanish settlements were not continually seeking new sites for homes; hence episodes depicting the murder of women and children who were unprotected either by their husbands or the soldiers of their homelands, were extremely rare. Since there were no large and unrestricted movements of listless farmers to the frontiers of either nation, instances where wives and mothers were obliged to do most of the work on the farmsteads in addition to their numerous household duties, certainly must have been uncommon. Other feminine immigrants to these regions included the wives of officials and merchants. For this group of females, the separation from home associations was probably very often depressing, but mere subsistence could hardly have been of great concern.

[2] C. F. Volney, *View of the Climate and Soil of the United States of America,* 385-386.

The isolated position of the average Anglo-American pioneer family is discussed in greater detail in Chapter II, Section 2, of this work.

It should not be implied, however, that these French and Spanish women possessed no traits worthy of note. While a thorough study of this group is not within the scope of this work, some impressions of writers and travelers concerning their capabilities might be cited. Two early governors of Illinois were among those who praised the French women which the first Anglo-American pioneers found in Kaskaskia and circumjacent villages. Ford declared that they were "remarkable for the sprightliness of their conversation and the elegance of their manners." He added that although they lived rather far from any urban area, they were quick to take up the Paris fashions of which they were informed by the dressmakers of New Orleans. While the application of new styles was usually modified by the use of homespun materials, still the finished garments must have been impressive. Reynolds declared that they "always had something neat and tasty for Church and the Ballroom." [3]

Brackenridge, who lived with a French family in Ste. Genevieve (in modern Missouri) for three years, 1791-1794, not only praised the virtue and industry of these frontier women, but the foods which they prepared as well. In place of the few foods and the attitude of frustration on the part of the women, which so many travelers noted in the Anglo-American pioneer homes of this period, he found at Ste. Genevieve contentment and plenty. The wide variety of tempting dishes which he discovered on the tables of these French families, deeply impressed this traveler, since he wrote: "With the poorest French peasant, cookery is an art well understood. They make great use of vegetables, and prepared in a manner to be wholesome and palatable." [4]

Many other writers commented upon the high moral tone

[3] Thomas Ford, *History of Illinois*, 36-37; John Reynolds, *My Own Times*, 71.
[4] H. M. Brackenridge, *Recollections of Persons and Places in the West*, Second Edition, 21.

of the French communities, but unfortunately the social situation in the Spanish settlements was less ideal. It was not the policy of the officials at Madrid or Cádiz to allow unmarried women to migrate to the "Indies," and hence marriageable girls of pure Spanish descent were very scarce in virtually all of the Hispanic colonies. Many of the Spaniards who settled down in America married Indian women, and it is not surprising that the court records of colonial California contain the notations of many punishments for sexual offenses against the wives of other Spaniards and Indian women.

Nevertheless the young women of Spanish ancestry made a deep impression upon the first Americans who entered New Mexico and California. Traders from the states began to journey overland to Santa Fe in 1822, and their impressions of life in this New Mexican town were rather widely printed in newspapers. It appears that for the first time, many of these travelers realized that a girl could deliberately attempt to make herself attractive to members of the other sex, not wear a superabundance of clothing, and at the same time possess respectability and high character. Said Gregg, probably the most famous of those who wrote concerning life in this portion of northern Mexico:

> The ordinary apparel of the female peasantry and the *rancheras* is the *enaguas* or petticoat of home-made flannel; or, when they are able to procure it, of coarse blue or scarlet cloth, connected to a wide list of some contrasting-colored stuff—bound around the waist over a loose white chemise, which is the only covering for the body except the rebozo [shawl]. Uncouth as this costume may appear at first, it constitutes, nevertheless, a very graceful sort of undress—in which capacity it is used even by ladies of rank.[5]

[5] Josiah Gregg, *Commerce of the Prairies, or the Journal of a Santa Fe Trader*, Second Edition, I, 216.
By the term *rancheras* Gregg probably meant the wives of owners of small farms.

In a like manner, many of the Anglo-Americans who arrived in California in the late eighteen-forties were impressed with the personalities of many of the native white women. Colton remarked that "specimens of beauty" were rare among them, but he noted the dancing ability of the señoritas, and the great fecundity of most of the married women.[6] The historian Hittell was less restrained in his praise when he declared that "the daughters of the old California families were in refinement and accomplishments the peers of any of their sex, some were considered great beauties, all who married good men made good wives."[7]

But most interesting are the statements in praise of these California females by two other observers early in the American period. A member of the armed forces of the United States wrote to a friend in the East:

> Have you ever seen a *California belle*? A real genuine, out-and-out, live native belle, I mean, indigenous to the soil. I can assure you I have nearly lost my heart with one of them the daughter of a "Ranchero," who lives about fifty miles in the interior; and should my application for a leave of absence prove unsuccessful, I don't know but I shall really become a "Ranchero" myself. The girl is beautiful,— her complexion is of a dark, rudy hue, tinged with red, like the leaves of autumn, with raven tresses, eyes intensely black and intensely sparkling, teeth as white as pearls, but not like them, for no string of pearls was ever so regular; a faultless form embodying a soul as pure and guileless as the angels. In addition to all these natural charms, she can "pay her mess bill," sings most sweetly, touches her guitar with exquisite skill, dances divinely, and laughs right merrily! She rides wild horses, throws the lasso adroitly, and never misses her aim with a rifle; she carries a hunting knife in her garter, and understands the anatomy of either stag or buffalo;

[6] Walter Colton, *Three Years in California*, 27.
[7] T. H. Hittell, *History of California*, III, 190-191.

she has never sat upon a chair in all her life, knows nothing about corsets, capes, furbelows, flounces, never wears bonnets, and speaks no English!

While the reader may consider the above to be an indication of infatuation and not an impartial observation, still the description of California women by the traveler Mrs. Bates is virtually as complimentary. For example, she wrote:

> . . . There are few things more beautiful than their manner of salutation.
> Among themselves, they never meet without embracing; but to men and strangers on the street they lift the right hand to near the lips, gently incline the head toward it, and gracefully fluttering their fingers, send forth their recognition with an arch beaming of the eye that is *almost* as bewitching as a kiss.[8]

In short, it is evident that the majority of the French and Spanish women of remote settlements succeeded in retaining the vivacity and charm of the females of their homelands. Moreover, it appears likely that their ability to adapt themselves to the border environment provided a certain encouragement to the Anglo-American women who followed them. It can hardly be said, however, that as a whole they were obliged to endure sufferings comparable to those experienced by the women of the frontier of the United States, nor did their labors result in the formation of immense economic wealth or new political concepts. Such were to be the accomplishments of the pioneer women as the American frontier pushed rapidly westward.

[8] "W" to the Editor of *The Home Journal*, Monterey, California, n. d. [evidently the winter of 1847-1848], in *The Home Journal* (New York, N. Y.), March 4, 1848; Mrs. D. B. Bates, *Incidents on Land and Water*, 135-136.

3. THE TWO GREAT DIVISIONS OF THE TRANS-ALLEGHANY WEST

The first of these areas, one which extended approximately to the ninety-eighth meridian, possessed the same general climatic and topographic features as the Atlantic coastal plain. With the exception of the prairies of Illinois and Iowa, it was a timbered region. The prairies differed from the plains farther west in that the grass was taller and more luxuriant, and in that many varieties of wild flowers flourished upon them. Since trees grew without difficulty on the prairies following the Anglo-American settlement, the question is often raised as to why they were previously absent. Early travelers and geographers failed to agree upon the cause. Several held that the Indian practice of burning the tall grass each autumn to facilitate their winter hunting, resulted in the saplings being destroyed, while others believed that the extremely heavy sod precluded their germination.

But at least this absence of trees was not traceable to scanty rainfall; in both timber and prairie portions of this first trans-Alleghany West, precipitation was normally adequate for the growth of the traditional plants, fruits, and vegetables, and many navigable streams permitted the wide use of steamboats. It would be extremely desirable and convenient to call this entire territory the "Old West." But since an older school of American historians has already assigned this term to the colonial frontier, other names are needed. In this work, therefore, the section of the "New West" which has been described will be known as the "timber-prairie" frontier, while the appellation "plains-mountain" will be assigned to the vast section of the nation between the ninety-eighth meridian and the Pacific Ocean.

The last-named was characterized by physical features of a drastically different nature, and was to become the home of immigrants who, in general, possessed an outlook upon life

which was far more optimistic than that of the majority of the timber-prairie pioneers. The absence of such an attitude would very probably have rendered the permanent settlement and development of this area impossible, since the sparse vegetation, high evaporation, almost incessant winds, and the frequency of dry years had caused the geographers and map makers of the period before 1850 to call these plains and plateaus the "Great American Desert." There were few rivers suitable for navigation, and the first settlers were to experience great difficulty in obtaining sufficient quantities of timber and water.[9] Nevertheless, many factors were to combine for the rapid settlement of this vast region, and hence the American frontier had all but vanished by the year 1890. A brief survey of the causes for this rapid expansion of the borders of the Anglo-American civilization will conclude the introduction to this study.

4. SOME FACTORS WHICH AUGMENTED THE WESTERN MOVEMENT

After the close of the Revolutionary War, the citizens of the seaboard states gradually ceased to be "marine minded," and turned their attention to the many possibilities which the vacant lands west of the Alleghanies seemed to offer. There appears to be ample justification for the assertion that the chief cause for the decline and extinction of the federalist party was the inability of its leaders to realize that the United States was becoming more and more interested in the potentialities of the frontier, and less concerned over the several phases of navigation upon the high seas. Miss Martineau, an English traveler of the second decade of the nineteenth century, observed this

[9] For a discussion of the difference between the "plains-mountain" environment and the "timbered area", see F. J. Rowbotham, *A Trip to Prairie-Land* (London, 1885), 166-185 and 205-210; also W. P. Webb, *The Great Plains* (Ginn and Co., 19.1), 17-26.

new attitude and wrote, "The possession of land is the aim of all action, generally speaking, and the cure for all social evils among men of the United States." [10]

With the growth of this hunger for land came the efforts of the national government to make more territory available for settlement. There were the well-known treaties with foreign nations providing for extension of the national domain, beginning with the Louisiana Purchase treaty with France, and ending with the Gadsden Purchase agreement with Mexico in 1853. Furthermore, after 1783 there was a long series of Indian cessions of trans-Alleghany territory, the first being concluded at Fort Stanwix in 1784, while the last of great importance was the treaty with the Creeks and Seminoles which opened the "Unassigned Lands" of Oklahoma for settlement in 1889. In short, to meet the growing demand for land, there was a series of pacts with other powers covering half a century, and a long list of Indian cessions for a period of slightly more than a century.

The average western immigrant demanded, however, not simply land, but cheap land, even free land. Efforts to force the minimum government price per acre below two dollars were unsuccessful until 1820, but the smallest unit which would be sold declined from 640 acres as provided by the land law of 1796, to 160 acres, as prescribed in the act of 1804. These earlier congressional enactments also included a scheme for partial payments. The very important land legislation of the years 1820-1821, cut the minimum unit sold to eighty acres, and reduced the minimum price to $1.25 an acre, but required that payments be on as cash basis.[11] Thus a family could hope to procure the land for their farm home with the proceeds of the sale of a portion of their chattels. Finally, four decades

[10] Harriet Martineau, *Society in America*, Fourth Edition, I, 292.
[11] For further details on the public land policy of the United States in this period, see B. H. Hibbard, *A History of the Public Land Policies*, 65-92.

later, or in 1862, Congress passed the famous "Homestead Act," thereby offering to the immigrant 160 acres of land, free, save for certain small fees incidental to "entry." At last the demand of the frontier for two generations, "free land for actual settlers," was satisfied. Nevertheless, after the Indians had been removed, and the settler had obtained his land, he was faced by another perplexing problem, that of obtaining the materials needed to start life in the wilderness.

One commodity which was virtually indispensable to the homesteader and needed in rather large volume, was salt. It was required as a part of the diet of farm animals, and as a preservative for meats, both those sold and those used in the home. The settlement of the timber-prairie region might have been retarted for many years, had not many salt wells and mines been discovered in Kentucky, Indiana and Illinois in the period between the Revolutionary War and the War of 1812. Prior to the finding of these saline resources, salt for the frontier had to be sent westward on the backs of horses and mules. This practice made the price of salt in the settlements beyond the Alleghanies as high as eight dollars a bushel, while following the discovery of supplies in the West, the cost to the farmer dropped to as low as fifty cents per bushel by the year 1817.[12]

On the timber-prairie frontier, wood was usually available for houses and other buildings, although in some parts of the prairie region there seems to have been some difficulty in procuring sufficient timber for rail fencing. After the line of settlement crossed the ninety-eighth meridian, the need for water and fencing materials might have checked its growth, had not efficient wind mills and barbed wire fencing been perfected during the years 1873 and 1874.[13]

The level prairies and plains of the Middle West tempted

[12] *Manufactures of the United States in 1860, Compiled from the Original Returns of the Eighth Census*, pp. ccii-cciii.

[13] For a discussion of the influence of the windmill and the barbed wire fence upon the settlement of the Great Plains, see Webb, *The Great Plains*, 295-339.

farmers to operate on a larger scale than was feasible in the older and more hilly sections; this demand also was met after 1847, when Cyrus Hall McCormick established his reaper factory in Chicago. Travelers in Illinois during the early eighteen-fifties noted the use of farm machinery on the prairies.[14]

By the middle of the nineteenth century, there were many manufacturing plants in the Middle West, rather close to the frontier settlements, but no doubt sound money would have been rather scarce in the territories and new states had it not been for the discovery of gold in California in 1848, and silver in Colorado and Nevada about ten years later. While the irksome shortage of "hard money" during the colonial period and in the new states of the timber-prairie region led to experiments in the issuance of paper money with slight security, the comparative abundance of silver in the more recently developed areas of the plains-mountain region, resulted in a rather persistent demand for a "silver standard" during the last quarter of the nineteenth century. At least silver money was more sound than unsecured notes.

Although the rather fortunate availability of needed supplies furnished another reason why the West became an attractive place for settlement, these had to be transported, and the products of the farm, factory and mine had to be sent to market. The problem of transportation, therefore, also remained to be solved.

For the Anglo-American settlements west of the Appalachian Mountains, the Ohio and Mississippi Rivers long afforded virtually the only means of sending products to market; hence, until the fourth decade of the nineteenth century, New Orleans was the chief place of deposit for the Mississippi Valley. The steamboat appeared on western rivers in 1811, and its use was more or less general by 1817.[15] The Cumberland road had been

[14] William Hancock, *An Emigrant's Five Years in the Free States of America,* 283.
[15] *New York Advertiser* (New York, N. Y.), June 17, 1817.

built across the mountains by 1818. These developments, however, afforded but slight encouragement to send products eastward, rather than southward. It was not until the opening of the Erie Canal in 1825, and the subsequent growth of traffic on the Great Lakes that the position of New Orleans was threatened. It has been estimated that the canal enabled the cost of transporting a ton of freight between Buffalo and New York City to be reduced from one hundred dollars to ten dollars, and the time from about twenty days to eight.[16]

Shortly before the coming of the railroads to the Middle West, an attempt was made in some sections to create a satisfactory type of highway, namely, the plank road. But the high cost of building and maintaining such thoroughfares prevented their general acceptance, and areas remote from navigable rivers were required to await the building of railroads before they acquired anything resembling satisfactory transportation facilities.

The eighteen-fifties, however, saw most important areas east of the Mississippi River supplied with railroad connections, direct service being established from Chicago to New York in 1852 and from St. Louis three years later. By 1855 also, the building of the Illinois Central Railroad had made sufficiently attractive for settlement millions of acres of land in Illinois. Finally, the driving of the last spike of the Union Pacific-Central Pacific roadbed in 1869 was an indication that soon the important cattle and mining regions of the plains-mountain West would have tolerable railroad service.

Vast expanses of territory, which, on the whole, were hardly as desirable for permanent residence as the timber-prairie wilderness had been, were now available for settlement. But the desire for land with agricultural and mining potentialities, and the availability of supplies and markets by virtue of the

16 J. D. Hicks, *The Federal Union*, 388.

coming of the railroads, caused this "last West," the "plains-mountain West," to fascinate and attract men, even more markedly than the older frontier had done. Nevertheless, by 1860, when the line of settlement had reached the edge of the Great Plains, there was still another factor which seemed to insure the rapid settlement of all desirable land as quickly as it became available for entry, this was the increasing immigration from Northern and Central Europe.

As late as 1820, the number of immigrants arriving in America from Europe was almost insignificant, the rapid growth in population resulting very largely from the fact that the average family of the United States was large. The total number of arrivals for the three years, 1820-1822, was only 24,426, while statistics for a period of a similar length, or the years 1847-1849, inclusive, disclose a total immigration of 766,484.[17] This phenomenal increase appears to have been the result of three conditions: crop failures, such as the famous Irish potato famine of 1845, increasing dissatisfaction over political conditions, and the discouraging economic outlook caused either by the Industrial Revolution or ill-advised tariff policies. The importance of immigration in the development of the new Iowa communities of the eighteen-fifties is confirmed in a letter from the western correspondent of a Washington, D. C. newspaper. He declared that "the crout-loving German, and the potato-loving Irishman, settle down side by side."[18]

It appears, however, that fewer of the Irish immigrants had sufficient means to undertake farming operations than was true in the case of the German and Scandinavian arrivals: hence, in spite of their agricultural background, large numbers of the "Sons of Erin" were obliged to seek employment in the cities.

While the number of immigrants had been very small earlier

[17] *Illinois State Journal* (Springfield, Illinois), November 30, 1870; J. F. W. Johnson, *Notes on North America*, II, 460-461.
[18] *National Era*, November 1, 1855.

environment.[2] While such anguish was often concealed, the departure from the East continued to distress women even after the construction of railroads and the appearance of a more desirable moral tone in most of the western states. James Robertson, another English traveler, tells of meeting an emigrant family on a train at Niagara Falls, New York, in 1854. He asked the young wife if she did not regret leaving her home and friends and journeying to a new and unknown country. Smiling faintly and turning toward her husband, the young woman replied, "Wherever he goes, that is my home." [3] Perhaps it is unnecessary to add that it was this spirit that rendered the rapid development of the West possible.

Mrs. Christiana H. Tilson described her feelings regarding her impending trip to Illinois in 1822 as follows:

> Partings, the breaking up of families and home attachments, have always been to me particularly painful, and the sad forebodings I was constantly hearing at that time of the fearful journey, and the dismal backwoods life which awaited me, were not calculated to dispel the cloud which would sometimes come over me . . .[4]

When the journey to the new home started, the women experienced other hardships, the intensity of which few historians have fully appreciated. Since the average road was evidently far more unsatisfactory than the worst highways of the twentieth century, the discomforts of travel for women, especially those unwell, can readily be realized. As late as 1850, an English traveler, Mr. J. R. Beste, in describing a journey

[2] Lucy Maynard to Abel Piper and Family, Canton, Illinois, December 3, 1835. The Lucy Maynard Letters, Illinois State Historical Library, Springfield, Illinois.
[3] James Robertson, *A Few Months in America*, 150.
[4] M. M. Quaife (ed.), *A Woman's Story of Pioneer Illinois by Christiana Holmes Tilson*, 31-32.
The above statement has been reproduced with the permission of R. R. Donnelley and Sons Co.

through Indiana declared, "the jolting of the wagon from the roughness of the road was almost intolerable."[5]

It is true that very often the wife of the family rode a horse, but such a mode of travel, day after day, particularly when very small children had to be cared for, was also a severe tax on the vitality of the woman. An Indiana newspaper editor wrote the following description of such a case in 1829, "We occasionally see a mother and some two or three half naked children, with a bag of old plunder,[6] mounted on a lantern ribbed pony, and the father, with five or six other little barefooted urchins walking along side."[7]

Then, in addition to the hardship of caring for many children during the trek westward, the hazards of floods often deeply concerned the emigrant women. It will be recalled that many families contemplating removal to the West were anxious to "get on the road" as early in the spring as possible. Hence they were compelled to traverse very muddy highways, and to ford streams swollen by the melting ice and snow as well as by the spring rains. It was a picture of flood conditions that provided Mrs. Mary H. Quillin with her first impression of Illinois. She wrote:

> We could see pieces of fences still standing, the tops of dead weeds and corn-stalks; and all the rest a dreary waste of water! At one place the horse had to swim, and the water came over the top of the wagon-bed. But at length we reached the bluffs, and then drove across the country for miles, through the mud, to our new home on the prairie. . . .
> When we came to Illinois, it was called: "A jumping off place!", "The outskirts of civilization!"[8]

[5] J. R. Beste, The Wabash, 314-315.
[6] "Plunder" was a slang term for personal belongings in frontier communities.
[7] An article from the Centerville Times (Centerville, Ind.), n. d., in The Mechanics Press (Utica, N. Y.), November 21, 1829.
[8] Mrs. Mary H. Quillin to the Illinois Woman's Exposition Board, Ipava, Illinois, June, 1893. In folio of manuscripts entitled "Stories of the Pioneer Mothers of Illinois," the Illinois State Historical Library, Springfield, Illinois.

At times the circumstances were such as to force both men and women to swim or wade across rather sizeable streams. In 1819 the English traveler, John Wood, observed a party of six or seven men and women in the Big Miami River (in southwestern Ohio) near its mouth. He declared that the water was "up to their middies, and the current was so strong they could hardly stand against it." [9]

But formidable to a far greater number of emigrants, was the problem of crossing the steep ridges of the Alleghanies. The British traveler, H. B. Fearon, who made some notations in the region east of Pittsburg in 1817, provides an interesting description of the problems involved. Three of the episodes related by him appear to be of special interest: one concerns the device of tying ropes to the vehicles and helping the horses pull the load over a grade:

> In difficult parts of this tract, their progress was so slow as to be hardly perceivable. Ropes were attached to each side of the waggons, at which, while some were pulling, others were most unmercifully, though necessarily, whipping their horses, which dragged the waggons five yards at an effort. The getting these waggons and families over the mountains appeared little less than a continuation of miracles.

Another incident concerns the sufferings experienced by a woman during the crossing of the mountains. The latter sex, said Fearon, were the "most communicative," since their husbands were engrossed in the problem of moving their wagons. One woman's experience is thus related:

> The first I conversed with was from Jersey, out 32 days: she was sitting upon a log which served for the double purpose of a seat and a fire: their waggon had broken down the

[9] John Wood, "Two Years on the English Prairie," Thwaites (ed), *Early Western Travels*, X, 179-357.

day before; her husband was with it at a distant blacksmith's: she had been seated there all night: her last words went to my heart: "Ah! Sir, I wish to God we had never left home."

Fearon also met a family from England. The wife and older daughter were each carrying an infant, while the husband and father was attempting to get the family property over the heavy grade. The woman longed to be in her native country once more, and all three adults deeply regretted their decision to migrate to the American frontier. Fearon's comment was, "I assisted them over a brook, and endeavored to comfort them with the hopes that once they got settled they would be well repaid for all their toil." [10]

While it is true that occasionally a family had sufficient funds to spend the nights at inns, these must have been most unsatisfactory from a woman's point of view. Travelers usually reported them to have been crowded, often infested with insects or strewn with drunkards, and occasionally the headquarters of bandits. They would complain also of the unavailability of soap at many taverns, and of the fact that the only articles which could be purchased were whiskey and rum. [11]

Mrs. Tilson, whose experience at a hotel in Shawneetown, Illinois in 1822 was far more pleasant than that of most immigrants, penned her impressions as follows:

> The finish was of the cheapest kind, the plastering hanging loose from the walls, the floors carpetless except with nature's carpeting, with that they were richly carpeted. The landlord—a poor white man from the South—was a whiskey keg in the morning and a keg of whiskey at night; stupid and gruff in the morning, by noon could talk politics and abuse the Yankees, and by sundown was brave for a fight. [12]

[10] H. B. Fearon, *Sketches of America*, 189-195.
[11] *Ibid.*, 192.
[12] M. M. Quaife (ed.) *A Woman's Story of Pioneer Illinois*, 47.
The above statement has been reproduced with the permission of R. R. Donnelley and Sons Co.

Regardless of whether these female pioneers traveled by foot, wagon, or on horseback, it was to be expected that many of them would become ill en route. To the dismay of many of these itinerants, they found that whiskey was not only the sole available beverage, but the only proffered medicine as well. Mrs. Tilson was one of the women who was therefore obliged to taste that strong drink for the first time. She later wrote, "Though always an impalatible beverage to me, I shall never forget how disgusted and outraged I was by that first taste at Shawneetown." [13]

Nor did many of those women who were fortunate enough to have the greater part of their journey by steamboat escape serious discomfort. While it was true that the practice of providing separate cabins for each sex, spared the female passengers from close contact with a bar room environment while aboard, still a week or two spent in a vermin-infested berth and cabin must have proven for many women a sadder experience than a single night in a tavern whose drawbacks included the same insects and drunkards as well.

Mrs. Farnham described her experience on a western steamer thus:

> I was fatigued and requested the chambermaid to prepare my berth as quickly as possible. She offered me a very disinterested piece of advice in reference to it, which I shall give here for the benefit of such as may be similarly situated without the like kindness to direct their choice. It was that I had better abandon the pen, otherwise state room, which I had chosen beside the cabin and take my berth in the latter apartment. "Kase," to use her own elegant language, "the bugs ain't a look in *hyur* to what they be in yander." Here was another volume of misery opened to my already oppressed senses. Seeing my consternation she added, "O, you needn't dread 'em so powerful; I broomed the berths

[13] *Ibid.*

today, and shook the 'trasses, so they won't be so mighty bad."

. .

That night brought on another general engagement between the passengers and the vermin. The latter held the berths by prior occupancy and could not be routed; but they were more than willing to enter into a treaty for joint tenancy with certain privileges in their favor. It was these privileges that made all the mischief. Like most questions of diplomacy, they were exceedingly difficult to settle; one party claimed and exercised them on all opportunities, the other denied them, and rarely failed to offer the most violent opposition to their use, even to the taking of life. It is due to the weaker party, however, to say that they gained by industry and perseverance what they never could by strength —the partial exercise of the prerogatives they claimed, and, in general, the final rout of their more powerful opponents."[14]

But in spite of the distressing travel situations which have been mentioned, much deference was shown to women passengers by individuals in charge of reservations and itineraries. Many men welcomed the opportunity to accompany a lady on a long journey, since such would frequently mean that they would be given preference over men traveling alone for seats in eating houses and in stage coaches.

If the majority of pioneer women had been obliged to undergo the ordeal of leaving one home and moving to another but once, their lot would have been an easier one. But one of the best-known facts of the American frontier is that the average settler, especially those of the hunter and squatter type, would oblige his family to move several times in the course of two decades. A famous example is that of Thomas Lincoln moving from Kentucky to Indiana, and then to Illinois. John Wood said of this group, "Some of the backwoodsmen have been following the Indians from the frontiers of Virginia, North and

[14] Eliza W. Farnham, *Life in Prairie Land*, 23, 35.

South Carolina, and Georgia, through the states of Kentucky, Tennessee, Ohio, Indiana, and Illinois, without being much more settled than the Indians themselves."

Moreover, if the majority of the women who experienced great discomfort of all descriptions in journeying to their new homes in the West had enjoyed a fairly comfortable existence after reaching their destination, they might have felt well repaid. But large numbers of these immigrant females were to endure hardships which almost might be called unique in the history of womankind.

2. THEIR TASKS AND DANGERS ON THE FARMS

Collot and a host of other travelers have made three principal groups of the western immigrants. The first to reach an area were called backwoodsmen or squatters. The latter would usually push further west when the government started to sell land in their neighborhood. The second group usually combined hunting and agriculture, but they too would often move westward after the area began to fill up with the third class, the bonafide farmers.[15]

Perhaps it is needless to state that it was the wives of the first arrivals who suffered most severely. Certainly they could hardly share their husbands' apparent enjoyment of the aboriginal features of their existence. Faux describes the backwoods cabins as "miserable holes, having one room only, and in that one room, all cook, eat, sleep, breed, and die, male and female all together."

The lack of privacy in these frontier abodes must have been most distressing to the female occupants, especially since so often the small cabins were frequented by males outside of the family. The extremely critical Faux declared (1819), "Males

[15] V. Collot, *A Journey to North America*, 109-111; E. P. Fordham, *Personal Narrative of Travels*, 125-126.

dress and undress before females and think nothing of it. . . .
If the female of the family is in bed, they stand and see her
get out and dress." [16]

In justice to the frontiersmen as a whole, however, it should
be stated that among the more refined of the border residents,
the males sought to accord all possible privacy to the female
members of their families. B. R. Hall, a frontier clergyman,
declared that often when strangers were guests in a one room
cabin, the men would afford the women a chance to dress or
undress by announcing that they were going outside to survey
the "weather prospects." Also, during all periods of the
frontier's advancement, many young men would seat themselves
outside the one room cabin while the young lady whom they
were to escort to some function, completed her preparations.
It would therefore be unjustifiable to accept Faux's intimation
that the average frontiersman of that day approached in-
decency. Nevertheless, one of his criticisms of the men whom
he observed in the new western communities finds all too ample
confirmation, "Time is not property to these men, they are
eternal triflers."

Moreover, these frontiersmen found so many reasons to be
away from home and hence leave their mate with all the respon-
sibilities and work of the homestead. There were the trips to
New Orleans or other marketing centers with produce, there
were the hunting expeditions, which many of the men seemed
to prefer to farm labor, and the excursions in search of better
land. Other critics declared they occasionally remained away
from home to dodge creditors.

Then too, there were a number of professional men, such as
physicians and lawyers, who would have been happy to remain
near their wives, but they were obliged to serve a very large

[16] W. Faux, A Journal of a Tour to the United States, 187, 236, and 316.

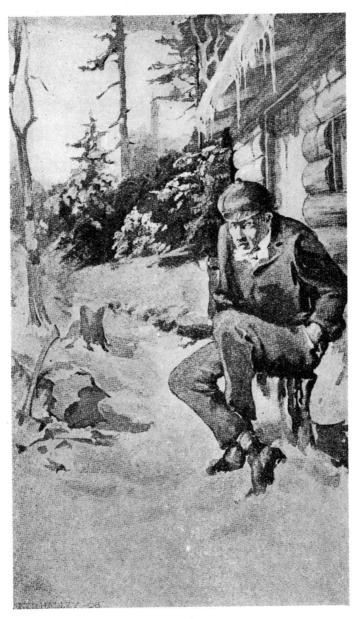

SITTING ROOM OF A BEAU AT A ONE ROOM CABIN
HOMESTEAD
(From Bell, *Pilgrim and Pioneer*)

territory, and thus had no recourse but to absent themselves from their families for weeks or even months at a time.[17]

As an illustration of the more shiftless type of pioneer, Thomas Lincoln is again one of the most frequently mentioned examples. Still more guilty of improvidence appears to have been the father of Anna Howard Shaw. It is evident that his daughter did not hesitate to reproach him for his thoughtless conduct when she wrote:

> Like most men, my dear father should never have married. . . . Thus when he took up his claim of three hundred and sixty acres of land in the wilderness of northern Michigan, and sent my mother and five young children to live there alone until he could join us eighteen months later, he gave no thought to the manner in which we were to make the struggle and survive the hardships before us. He had furnished us the land and the four walls of a log cabin.[18]

What was still more lamentable, however, was the fact that many of the western settlers remained away from home even when they could not plead business, marketing of produce, hunting, or the quest for more desirable land as an excuse. They appear to have spent far more of their time "in town" than do the rank and file of American farmers of the twentieth century. Mrs. Eliza W. Farnham observed that, ". . . the male population [Illinois] may be pronounced as unequivocally indolent. On a bright day they mount their horses and throng the little towns in the vicinity of their homes, drinking and trading horses till late in the evening." [19]

Singleton, after his western journey, declared that, "Too

[17] In a number of letters to his wife over the period, 1821-1835, an attorney, Mr. William Wilson, frequently wrote of his reluctance over making so many journeys. The William Wilson Papers. Illinois State Historical Library, Springfield, Illinois.

[18] Anna Howard Shaw, *The Story of a Pioneer*, 27. Reproduced with the permission of the copyright owner.

[19] Farnham, *Prairie Land*, 334.

many, instead of resting on one day in seven, work only one day
in six; and therefore ever remain poor." [20]

The following observations of F. A. Michaux also seem to
confirm such generalizations:

> With them [Kentucky pioneers, 1802], a passion for
> gaming and spirituous liquors is carried to excess, and
> sanguinary conflicts are frequently the consequence. They
> meet often at the taverns, particularly during the season of
> the courts of justice, where they pass whole days there.[21]

The abundance of wild life and the practice of allowing hogs
to seek food in the forests usually resulted in the pioneer
family having sufficient food, in spite of the failure of the father
to develop diligent habits. But a diet largely of salted meat
was far from being a healthy fare, and was one cause of
cutaneous diseases which long were rather common on the
frontier.

The fact remained, however, that a western man could spend
by far the greater part of his time as he chose, without his
family actually suffering want. In place of public opinion
against such indifference, there is evidence of a certain idealiza-
tion of the frontiersman—not for his services or defense of his
loved one against the Indians, ruffians, and wild animals—but
for his carefree existence. The following editorial of 1824
illustrates this view:

> In our western clime, where we breathe the air of inde-
> pendence, where we are not subject to the caprice of custom

[20] Arthur Singleton, *Letters from the South and West*, 93.
[21] F. A. Michaux, *Travels to the Westward of the Alleghany Mountains*,
239-241.
Other good accounts of the rude cabins and listless characteristics of the
western pioneers may be found in M. Birkbeck, *Notes on a Journey in America*,
122; F. Cuming, *Sketches of a Tour to the Western Country*, 118; A. Murat,
The United States of North America, 51; Thomas Nuttal, *Journal of Travels
into the Arkansa Territory During the Year* 1819, 38-39; and T. Power, *Impres-
sions of America*, I, 297-298.

or the restraints of dandyism; so far from degenerating, we are daily progressing in the career of all that is manly and noble. What are the vocations and amusements of the inhabitant of the West? They are all of the manly kind. The chief employment is agriculture.

But what do his amusements consist of? He assumes a hunting dress of buckskin, and with rifle and dog, explores the recess of the forest, or ranges the extensive prairie in pursuit of the panther, the bear, the wolf, the deer, or the turkey.[22]

The modern reader will be impressed by two facts regarding the above article. First of all, the hunting of the pioneer is stressed, not his farm work, and second, nothing is said about the tasks the hunter left undone at home. Twenty years later, another writer was far from perturbed over the consequences which might accrue to the family of the typical lazy frontiersman whom he called "Jack." Rather, he stressed the fact that the West was an ideal home for such an individual when he wrote:

The wild West is evidently the place for Jack. Where could he so well practice his favorite maxim "Live today and die tomorrow"? Where so freely indulge his unconquerable propensity for reversing the natural order of things—turning day into night, eating now six meals a day, now one in twenty-four hours—making his work a play or else no work at all? [23]

Such statements should serve to convince the reader that the hypothesis that many frontiersmen were lazy was not merely the view of critical travelers of that period, nor the opinion of historians of another generation. On the contrary, these shiftless habits were admitted by writers even in the West itself.

[22] From the *Kaskaskia* (Illinois) *Advocate*, n. d., in the *National Intelligencer* (Washington, D. C.), September 14, 1824.
[23] W. Kirkland, "The West, the Paradise of the Poor", *The United States Magazine and Democratic Review*, New Series, XV (August, 1844), 182-190.

But how different was the lot of virtually all women of the timber-prairie frontier! Michaux, in contrast to his general description of the men of the Kentucky frontier about 1802, made this statement about the women:

> They remain at home assicuously engaged with the cares of the house or employed in spinning hemp or cotton, which they afterwards make into cloth for the use of the family. This work alone is considerable, for there are few homes in which there are not four or five children. . . .[24]

John Reynolds, the governor of Illinois from 1830 to 1834, attributed the fact that he had a sufficient wardrobe to enter college, to the industry of his mother and other women in the vicinity of his home. He wrote, "My mother and female friends commenced to fix me up for college. They spun and wove from the raw material of wool, cotton, and flax, my clothing."[25]

Mrs. Trollope declared (1828-1829) that many of the farm women she met near Cincinnati wove all the cotton and woolen cloth for their families, knit all the stockings, and manufactured all the soap and candles used.[26] Nor is evidence lacking that at times these pioneer mothers actually assisted with the work in the fields. Of course, women engaged in farm labor was never as common a sight as it always has been in sections of Europe where females have more strength than American women have ever displayed, and where they make up a larger percentage of the population. Still they did at times lend their assistance. Mr. Thomas Hulme noted in his travel journal on June 22, 1819, the following:

> . . . Saw a Mr. Johnstone and his wife reaping wheat on the side of the river. They told us they had come to this

[24] Michaux, *Travels to the Westward*, 241-242.
[25] Reynolds, *My Own Times*, 69.
[26] Mrs. [Frances] Trollope, *Domestic Manners of the Americans*, Fourth Edition, I, 69-70.

sections for entry. The following statement reveals not only the very rustic accommodations which such travelers were likely to receive at the typical cabin, but also an idea of the inconvenience which they caused their hostess:

> You can imagine a crowded twelve or fourteen feet square, furnishing a bed-chamber for as many people. . . . A huge sack laid upon the planks served as the family bed. The mother and the oldest daughter would lie down on it at the opposite ends, so that each other's feet and head would be in contact, were it not for the little children, whom, to the number of three or four, we have seen stowed in . . . like mortar between the stones, to keep all tight.[30]

It is not surprising that in spite of the unavailability of more sumptuous appointments, guests would complain at times about sleeping arrangements such as sacks on cabin floors. Moreover, the log homes were often so poorly constructed that they admitted "the elements," and, as the English emigrant George Flower expressed it, were the "receptacles of the insect tribe." Such factors certainly enhanced the discomfiture of the guests. After having been the victim of many resultant complaints, one weary Illinois woman told Mrs. Farnham:

> If other folks 'ud stay at home, as I do, there wouldn't be no need of having every other house a tavern. . . . I had four gentlemen here last night and it rained in on their beds: they found fault with me, and I told 'em they might go farther and do better if they could. I didn't want 'em *hyur*. I had a right smart blow up with one of 'em.

The problem of performing the many tasks which custom and the western environment required of her, led the frontier woman to devise methods of doing two types of work at the

[30] Latrobe, *Rambler*, II, 252-253.
[31] Farnham, *Prairie Land*, 297-298.

same time. Perhaps one of the best known bits of lore con-
cerning the mothers of the timber-prairie West, is their practice
of rocking the cradle of their child while they knitted or sewed.
About 1808, the traveler Cuming observed the "young and
very handsome" Mrs. Cressop thus engaged.

In spite of the most obvious indispensability of their services,
however, the women of this frontier failed to enjoy the respect
and deference which was later to be accorded them in the
plains-mountain West. While passing through Ohio in 1834,
the traveler Abdy had an evening meal at the home of a
farmer, and subsequently wrote the following concerning the
experience:

> . . . he introduced me to his sons—two sturdy strapping
> youths, with good looks and appetites. One of his daughters
> made the tea, while the other drove away the flies. As soon
> as we had eaten and uttered as many good things as we could
> (for the whole party was merry as well as hungry,) the
> ladies sat down to their repast. This, as far as I had the
> opportunity to observe, is the usual order of things in the
> homes of the middle class. The masculine is more worthy
> than the feminine, and the feminine more worthy than the
> neuter. Hence the women eat after the men; and the blacks
> after the women. . . .[32]

It should be borne in mind, nevertheless, that many un-
promising regions witnessed no great activity over land entries
or speculation, and in these very few surveyors and other
travelers made their appearance. Hence, when husbands would
be ibsent for long periods, their wives would suffer greatly from
lonesomeness. Michaux, when traveling in Kentucky in 1808,
stopped at a cabin in the famous "Meadows" region of that
state. Upon entering the home, he found the wife surrounded
by many children, but the husband and father had been away

[32] Edward Strutt Abdy, *Journal of a Residence and Tour in the United States of North America,* III, 80-81.

for two months in search of new and more desirable lands. The
lady declared that she had seen no person other than those of
her own household for eighteen months.[33]

Many other travelers in the West during the first half of the
nineteenth century stopped at farmsteads where the women
were alone with their children. One farm wife declared to
Mrs. Trollope: "I expect the sun to rise and set a hundred times
before I shall see another human that does not belong to the
family."[34]

The party of Birkbeck stopped at a frontier cabin where the
woman was so lonesome that she begged them to remain a
while and converse with her. She told them that her husband
was kind to her, but was away on hunting expeditions most of
the time, and that she was quite overcome with "lone."[35]

This fact that women were left alone with their children for
such long periods cannot but have a greater significance for the
historian than the mere truth that they suffered loneliness. It
seems clear that very often, if not in a majority of cases, it
would be the mothers who would be obliged to seize a rifle and
protect the home from attacks of Indians and the notorious
"border ruffians," and not the husband and father. The lore
of the Kentucky frontier includes the story of a Mrs. Samuel
Daviess, who, in August, 1782, was able by cunning to prevent
an attacking party of Indians from scalping her seven children,
until help arrived. On another occasion when an outlaw came
to her home, she invited him to sit down and drink whiskey,
and then she seized his rifle which he had imprudently set near
a door, and held him captive until the return of her husband.[36]
Two of the most famous of the frontier brigands were the
Harpe brothers, known as "Big Harpe" and "Little Harpe,"
who terrorized the recently settled areas of Kentucky for

[33] Michaux, *Travels*, 174.
[34] Trollope, *The Americans*, I, 70.
[35] Birkbeck, *Notes*, 127.
[36] W. W. Fowler, *Woman on the American Frontier*, 200-202.

approximately six years, beginning in 1793. For a time women, children, and servants feared to leave their homes alone. In 1799, they killed a Mrs. Stegal, the wife of an innkeeper who was absent at the time. This murder, however, served to intensify attempts to apprehend them, and finally on July 22, 1799 "Big Harpe" was shot. A short time later his brother also perished at the hands of his pursuers.[37]

Had these journey-loving pioneers been generally kind to their spouses upon their return after long periods of absence, the latter might have believed their lives to be less empty. But evidence is all too ample that many of these men were anything but considerate on such occasions. Ashe vividly describes the homecoming of such a husband and father:

> On entering the house, which was a log one fitted up very well, the Kentuckyan never exchanged a word with his wife or his children . . . notwithstanding he had been absent several days. No tender enquiry, no affection or sentiment, but a contemptuous silence and a stern brutality which block up all the avenues to the heart. The poor woman whom I pitied (for 'tis a fact that the women do not degenerate in proportion to the men, but continue to this day amiable) made a large bowl of drink called *toddy*, composed of sugar, water, whiskey, and peach juice, and handed it to her husband with all the servility of a menial; he drank and passed it to me, who followed his example and found the liquor excellent. . . .[38]

But while the hard lot of many western women aroused the sympathy of travelers and occasionally local males, there is no evidence to indicate that these pioneer wives were willing to permit outside interference in the event that their husbands were extremely cruel. When western Tennessee was a frontier

[37] J. Hall, *Letters from the West*, 265-266; Lewis Collins, *History of Kentucky*, I, 25.

[38] Thomas Ashe, *Travels in America Performed in* 1806, II, 279-280.

section, one Ab Gaines happened to be passing a farmstead when he noticed in the yard the pioneer owner holding his wife by the hair and unmercifully beating her. Gaines rushed to the scene of the violence, and was about to attack the husband, but his wife seized an axe and hurled it into the back of her would-be rescuer.[39]

Although a variety of hardships which the women of the new western communities were obliged to endure has been cited, perhaps some statement should be made regarding the special problems of those wives who came to the frontier directly from Europe. Most of them apparently knew less of "what they were getting into," than did probably a majority of those from the older states of the Union. Moreover, they could hardly hope, as could the native American females, for the time when their section would include many residents from their old home neighborhood and its environs. Nor could they feel justified in harboring the same hope of meeting travelers from their native section, as other western women were able to do. Moreover, upon reaching the shores of the United States, they found themselves less able than the life-long residents of the country to withstand the sight of the floors of railroad cars, hotels, steamer decks, and in fact virtually every other public place smeared with tobacco juice. The vast majority of European travelers who visited America prior to 1850 expressed their disgust over this situation.

Also distasteful to many of these immigrant women from Europe, were the manners of the frontier people with whom they came in contact. While it is true that many travelers and immigrants from Europe expressed appreciation over the kindness and hospitality with which western people received them,

[39] J. S. Williams, *Old Times in West Tennessee*, 135.
The author of the above work went on to state that when a physician examined the injuries which Gaines had sustained, he declared that death would shortly ensue. Thereupon the wounded man expressed a desire for a gallon of whiskey as his last request. But ultimately the prediction of death proved to be incorrect, and Gaines recovered.

still Mrs. Trollope expressed the opinion of the majority of the females of this group when she complained of the "total want of manners, both in males and females."

During her sojourn in America, 1849-1850, the Swedish author and traveler, Miss Fredrica Bremer, conversed with the young wife of a Norwegian preacher, who lived near a place called Koshkonong, twenty miles from Madison, Wisconsin. She expressed her displeasure over her experiences on unclean canal boats, the brusque attitude of most of the people with whom she came in contact, the leaky roof of her dwelling, and of her loneliness during the periods when her husband was obliged to be away from home because of his duties. In summarizing her hardships, she spoke of "this dreadful America." [40]

Soon after Mrs. Burlend arrived in Illinois from England in 1831, she found that services of her chosen denomination were being held sufficiently near for her to attend. But she was disappointed, since they were not conducted in the quiet manner with which she was accustomed. Hence she complained of the "boisterous natives." [41]

The problems of the female members of the English settlement at Albion, Illinois, were somewhat different. There the men were largely satisfied with the land, and hence not seeking better. But many of the women had been used to a life of ease in England, and therefore much distressed when the unavailability of servants often forced them to do their own housework. Faux again displayed his contempt for America when he portrayed this household:

> Mr. and Mrs. Doctor Pugsley, late of London, live in the only house, which, if it had a servant, would boast of English comforts, politeness, and hospitality. She sighs to revisit

[40] A. B. Benson (ed.), *America in the Fifties: Letters of Fredrica Bremer,* 221-222.
[41] Rebecca Burlend, *A True Picture of Emigration,* 57.

England where she might see her friends, and rest her delicate hands, now destined to all kinds of drudgery.[42]

The frontier, then, was a leveling influence for women, just as it was for men; and plenty of work seemed predestined to be the lot of all females who ventured to the fringes of American civilization. Even Sunday was not always a day of rest for the women. For reasons that can only be conjectured, the Sabbath was not very well observed in any of the new sections of the trans-Alleghany West. Mrs. Trollope saw a poor country woman ironing on Sunday and asked, "Do you make no difference in your occupation on a Sunday?"

"I beant a Christian, Ma'am, we have got no opportunity," was the reply.[43]

Perhaps this lack of Sunday observance was due in some instances to the feeling that the time could not be spared, but more likely it was because the breaking of old social ties and the absence of churches in the new communities caused the settlers to lose the significance of the days of the week—in much the same way that the break in routine often does for the modern vacationer. It seems clear that many of the instances of Sunday work were not absolutely necessary.

This lot of the typical frontier woman—almost incessant work, loneliness due to a husband's absence or indifference, constant danger of attack by Indians, wild beasts, or ruffians, and homesickness, still might not have been as cruel as it actually was, had this timber-prairie frontier been a healthy place of residence.

3. THE RAVAGES OF DISEASE

Writers who wished to discount the desirability of settlement in the new communities of the timber-prairie region, seldom

[42] Faux, *Journal*, 269-270.
[43] Trollope, *The Americans*, I, 151.

failed to mention the annual recurrence of the "fever and ague."
This epidemic would appear in August or September, and if it
did not kill its victims, it would leave them with low vitality
for many months. Women seem to have suffered from this
disease worse, on the whole, than did the men. Ignorance
caused pioneers to declare that the use of liquor and tobacco
served to protect males from its ravages,[44] but there seeme little
doubt that if men were less often stricken, it was because of
their greater vitality, and because their constitutions were not
undermined by hard work and frequent periods of pregnancy.
Marryat reported after his travels in the West that triplets
were more common than twins in England.[45]

The general feeling was that proximity to water increased the
liability of becoming infected—hence one of the reasons for
settlement "up the rivers." In more recent years some have
observed that the disease germs were in the air, not the water,
and if the homeseekers had selected sites near the streams,
where there was a greater likelihood of breezes than upon hill-
protected upland plots, the liability of this disease might have
been lessened. Another frontier explanation for this prevalence
of illness nearly every autumn was the decay of the super-
abundant vegetation.[46] But had those pioneer days witnessed
the existence of modern health officers, it seems likely that
mosquitoes, crowded and unsanitary cabins, and carelessness
in the location of wells, would have been assigned a share of
the blame for such unsalubrious conditions.

There were also several epidemics of cholera on the timber-
prairie frontier, but since it was the fever and ague which
recurred virtually annually, travelers usually devoted most of

[44] J. S. Buckingham, *The Eastern and Western States of America*, III, 218.
[45] J. Marryat, *A Diary in America*, II, 205-207.
[46] A. D. Jones, *Illinois and the West*, 69.
Mrs. Sarah N. Worthington appears to have held this view, since she blamed
the presence of the fever and ague in her community to the decay of the turned-
over sod on the nearby prairies. See Appendix, Document Number 5.

their remarks to it, when they wrote of frontier health conditions. Latrobe declared that the "extreme liability to fever and ague, which is the lot of all the settlers in these abundant regions, under circumstances where medical advice is frequently unattainable, is perhaps the greatest trial which the settler of the West has to endure." [47]

An obvious result of these annual epidemics was that the afflicted women were unable to perform properly their many tasks. Traveling through Indiana and Illinois at a time when the lingering effects of the disease could still be seen, Faux complained of the "neglected farms, and indolent, dirty, sickly, wild-looking inhabitants."

But this author made what is perhaps his most unkind and unchivalrous statement of his travel narrative when he described one of the women who gave him shelter during his western trip. Still, it is to be feared that environmental factors rendered his remarks all too true a representation of the poor health of many pioneer females. He wrote, "My hostess would in England pass for a witch, having a singularly long, yellow, haggish, dirty, face and complexion." [48]

Melish describes a breakfast stop made at an Ohio hotel during October, 1811. Upon entering, he noted in one corner of the room a woman who was suffering from the fever and ague. He describes her as being "yellow as an orange" and "chattering in a corner like a pair of castanets." [49]

The family and circle of Abraham Lincoln probably furnish the best-known examples of premature death of frontier females —his mother, Nancy Hanks Lincoln, passed away in 1818; his

[47] Latrobe, *Rambler*, II, 252-253.
Other accounts of the effects of these diseases upon frontier people may be found in: Faux, *Journal*, 210, 221; C. F. Hoffman, *A Winter in the Far West*, II, 290; T. H. James, *Rambler in the United States and Canada*, 181-182; Marryat, *A Diary in America*, II, 205-207; and Mrs. E. A. Steele, *A Summer Journey in the West*, 151-152.
[48] Faux, *Journal*, 205, 221.
[49] John Melish, *Travels in the United States of America*, II, 251.

sister, Sarah Lincoln Grigsby, in 1826; and his sweetheart, Ann Rutledge, in 1835. Two causes for this rather appalling loss of comparatively young women, epidemics and overwork, have already been discussed. In addition, there were other contributing factors such as the want of a balanced diet, exposure, and the improper ventilation of homes.

It will doubtless be inferred from the preceding pages that not all the males who sustained the loss of female members of their families, were prostrate with grief. But like Lincoln, some men found themselves unable to cease their mourning. Many attempts were made to express the typical bereavement in song; a few of these have survived and will be discussed in the last chapter of this work. Most of the poems which depicted grief over the death of a female loved-one, however, have been all but forgotten. Among the many compositions of this character was the following by an unnamed author, which appeared in the issue of the *Home Journal* for February 6, 1847:

ROSE OF A WESTERN BOWER

Rose of a western bower,
Ah! Why so brief must be thy gentle stay?
Could thou not linger from thy home away,
But one sweet fleeting hour?

Thy beauty and perfume
Would soon all sadness from my heart dispel,
Where now alone a thousand sorrows dwell,
Uncheered by thy sweet bloom.

Bird of a western wild,
Why spread so soon they azure wing in flight?
My heart once felt a sense of strange delight,
By thy sweet voice beguiled.

. .

Maid of the west, farewell!
Dearer than all—flower, bird, and smiling star—
Thou leavest me; but in thy home afar
My heart shall fondly dwell.

Reliable mortality statistics for the period of the timber-prairie frontier are unfortunately lacking. But shortly after the Civil War, a survey was made in the cemeteries of Ohio, Illinois, and Michigan, and special care was taken to include only those which might be considered representative. The study of the tombstone inscriptions revealed that approximately fifty per cent more women than men had died between the ages of twenty and fifty in the communities which the surveyed burying grounds accommodated. On the other hand, a similar survey of the representative graveyards of several eastern states indicated that the number of each sex dying between the ages of twenty and forty, must have been about the same.[50] Skeptical as one may be regarding the accuracy of such findings, it should be borne in mind that during this same decade, the federal census bureau utilized the data provided by tombstones in an attempt to devise vital statistics for the earlier decades of the nineteenth century.

A statement of Latrobe serves as additional proof of the high mortality rate among the pioneer women of the West. He wrote, ". . . So many of these fair flowers of the West may be compared to the beautiful ephemera of their country, which are born and glitter for a day, dying, as it might seem, before their time; sinking to the grave, just as life reaches its period of greatest enjoyment. . . ."[51]

Still another troublesome feature of the timber-prairie frontier from the standpoint of health was the paucity of dentists. The year 1844 found Quincy, Illinois, a town of approximately four thousand persons which served a large rural area, entirely without the services of such a practitioner.[52] One of the more humorous citizens of the locality declared that the best remedy for a toothache was to fill the mouth with water

[50] *Bureau County Republican* (Princeton, Illinois), October 11, 1866.
[51] Latrobe, *Rambler,* II, 141-142.
Perhaps a more common name for the ephemera is the May fly.
[52] *Quincy Herald* (Quincy, Illinois) January 19, 1844.

and then to "sit on the stove until it boiled—a sure cure." [53]

It is a well-known fact among modern dentists and physicians, that if a woman begins a period of pregnancy with dental cavities, these are likely to grow larger—especially if she suffers from undernourishment. In view, therefore, of the great fecundity of the average pioneer mother, the ample evidence that many homes provided anything but a balanced diet, and the great amount of work that many mothers were obligated to do—even at such times, it would be difficult to believe that the frontier women did not suffer more from poor teeth than did the men.

Before dismissing the subject of the ailments of frontier women, homesickness should be mentioned. While this was not a serious factor when compared with the other maladies, still it often presented an irksome problem to the physician. To suppose that all immigrant women were able to resign themselves to the rigors of border life without complaints and fits of melancholia, would be expecting too much of the female nature. Occasionally when the physician would prescribe remedies which were about the best known in that day, their feminine patients would scornfully discount them. For example, they would sometimes insist that the quinine available in the West was less effective than that procurable in their home community in the East. A western physician's wife, after describing the problems presented by this type of patient, declared that her husband would rather undertake "a dozen cases of fever than one of homesickness." [54]

For those women of the poorer classes who were fortunate enough to withstand the rigorous frontier environment, life might have been more bearable, had satisfactory diversions been available. But evidence seems rather ample that such

[53] *Ibid.*
[54] *Maysville Herald* (Maysville, Ky.), November 20, 1848.

was hardly the case on the frontier or in the new states of the
timber-prairie region.

4. THE UNSATISFACTORY SOCIAL ENVIRONMENT

It appears that among western females, only the young and
unattached and the elderly found themselves with any appre-
ciable amount of leisure time. Since in the remote areas they
usually lacked opportunities for a variety of social and in-
tellectual activities, the young unmarried girls of the better-
situated families often taught themselves to manage horses
with a fair degree of skill. In writing of his visit to Kentucky
in 1818, Singleton stated that many of the young women whom
he observed could "canter off on the side saddles like young
huntress Dianas." Likewise, when Stuart traveled through
Illinois in 1830, he met many girls who displayed remarkable
horsemanship.[55]

But the unencumbered elderly women usually sought less
physique-taxing pursuits. Often they would attend the shoot-
ing matches of the men, and there they would knit, tell stories
of the Revolutionary War, and occasionally sell *metheglin*, a
non-intoxicating beverage consisting principally of honey and
water.[56] Moreover, most communities in which the services of a
physician were not available included an elderly woman whose
knowledge of remedies commanded considerable confidence.
Without venturing a conjecture as to the effectiveness of their
prescriptions, their visits as a rule probably imparted to the
ill both comfort and confidence. For the married women with
families, however, there were very few activities outside the
home.

The two most famous social gatherings in the frontier homes

[55] Singleton, *Letters from the South and West*, 95; James Stuart, *Three Years in North America*, II, 390.
[56] Reynolds, *My Own Times*, 52.

were the frolic and the quilting party. The first would be held for the purpose of completing some task about the farm. But a safe conjecture seems to be that while the frolic may have reduced the amount of work which fell upon the husband, it increased the labor and problems of the housewife, since it was her responsibility to see that the guests were fed and made comfortable. Cuming, after passing a party of merrymakers on the Ohio, wrote, "From their gaiety, [they] were apparently returning from some *frolick*—the epilet used in this country for all neighborly meetings for the purpose of assisting each other in finishing some domestick or farm business, which generally conclude with feasting and dancing, which sometimes lasts two or three days." [57]

Were, then, the famous quilting parties more satisfactory from the feminine viewpoint? They were attended by married and unmarried ladies alike, but whether or not such afforded the overworked farm wife much real rest and recreation, is at best only a supposition. One might assume on the spur of the moment that such gatherings would at least provide those who attended an escape from a "drinking atmosphere" for a few hours. But according to this description of Drake, such was not always the case:

> . . . Toward evening the young men would assemble, and amuse themselves by athletic exercises without, or talking to and "plaguing the gals" within the cabin. The quilt being removed, the supper table took its place, and after the ladies had risen from the cream of the feast, the gentlemen who had whetted their appetites by drinking whiskey and looking on, proceeded to glut themselves on the *reliquioe*. [58]

Since the quilting party also could hardly be called an ideal

[57] Cuming. *Sketches,* 124-125.
[58] Daniel Drake to Mrs. Harriet E. Campbell, Louisville, Ky., January 14, 1848. In Charles D. Drake (ed.), *A Series of Reminiscential Letters from Daniel Drake, M. D. of Cincinnati to his Children,* 173-223.

feminine diversion, the camp meeting will next be considered. Before doing so, however, it seems appropriate to state that many sources testify to the fact that there was a gratifying lack of animosity between the different faiths on the frontier and in the newer states.[59] Men were too busy planning how to become wealthy and women too bowed down by hard work to harbor ill-feeling toward individuals of other religious persuasions.

Several years would usually elapse before a community would begin the erection of places of worship, and during the interval certain "Evangelical" groups adopted a form of service called, as has been said, the camp meeting.

According to Colton,[60] it originated with the Presbyterians in the sparsely populated sections of North Carolina, Tennessee, and Kentucky. It soon was adopted by the Methodists, and is usually associated with them, although in reality it was peculiar to no one evangelical faith. Since in nearly every instance no building was available large enough to seat those who would come from great distances for these annual gatherings, they were held in the open. Also, since people traveled long distances in order to attend, they stayed more than one day as a rule, and hence, more than one speaker would have a part in the program.

American historians have come to look upon the camp meeting as a frontier institution, but a closer examination reveals unmistakably that it was also one in which women and girls took the leading lay part. The first step in offering an explanation for this fact might be to quote a statement of Mrs. Trollope regarding the American frontier, "I never saw, or read, of any

[59] *Niles Register* (Baltimore, Md.) June 29, 1839; William Oliver, *Eight Months in Illinois,* 77
Many other sources also confirm the absence of religious prejudice on the frontier.
[60] Calvin Colton, *The Americans,* 258-259.

county where religion had so strong a hold upon the women, or a slighter hold upon the men." [61]

Perhaps a more charitable reason why these camp meeting services made a deeper impression upon the women was that seldom did they have an opportunity of leaving home, and seldom did they have an opportunity to converse with those outside their own family circle. Hence they were more likely to be carried away by the excited harangues of the "exhorters." Supporting the assertion of Mrs. Trollope, however, were the observations of Brown.[62] He wrote that all of the penitents at a camp meeting near Berea, Ohio, were females, and that during services, men could be seen in groups smoking, drinking, chewing tobacco and talking politics.

Moreover, it seems impossible to avoid the generalization that most of the foreign travelers who visited camp meeting services and then wrote books on their journey to America, were not favorably impressed by these gatherings, nor with the manner in which they affected the women. Benjamin Henry Latrobe felt that these proceedings taxed too greatly the female nervous system, and declares that he constantly urged his wife not to be led by her curiosity into attending one of them.[63] The description of a service attended by Duncan is less indicting than the more notorious one of Mrs. Trollope, but it does seem to portray why such events would greatly tax the strength of females already suffering from overwork and malnutrition. It seems to show also why the average religious person of Europe would be critical of the camp meeting as an institution:

A great number of preachers attend . . . when one speaker is worn out another begins. . . . Their discourses and prayers are of course stimulating and alarming in the

[61] Trollope, *The Americans*, I, 101-102.
[62] William Brown, *Four Years of Residence in the United States and Canada,* 43.
[63] B. H. Latrobe, *Journal*, 250-257.

highest possible degree, the hearers become violently excited; groan, cry aloud, and throw themselves on the ground in paroxysms of mental agony. . . . Were the effects of camp meetings to spread no farther than this, it would be sufficient to characterize them as essentially detrimental to true religion. . . .[64]

Lieber also noted that most of the penitents who threw themselves unconscious upon the ground were females. He pointed out that the medical profession of his time held that a person could not experience such "nervous sleeps" without suffering some ill effects. Two bits of evidence, however, caused him to suspect that some of the younger female penitents feigned unconsciousness. One was that they seemed perfectly normal and not suffering from nervous distraction a short time later, and the other was that he thought that he saw one of the girls winking at her friend as they lay on the ground.[65]

Nor were foreign visitors the only critics of this type of frontier religious service. During her residence in Illinois, Mrs. Farnham of New York, whose writings indicate that she was a cultured lady, attended a service conducted by a "circuit rider." She too declares that females made up most of his audience. Part of her description is the following:

. . . Before I had this experience I should have considered any true description ironical or libelous. . . .
Like most empty speakers, these preachers have an abundance of furious action, a bellowing utterance, and a tone which renders it extremely difficult for the possessor of a cultured ear to preserve both gravity and patience through their interminable harangues. . . .[66]

None of the criticisms of the camp meetings and their

[64] J. M. Duncan, *Travels Through Part of the United States and Canada in 1818 and 1819,* II, 370-371.
[65] Francis Lieber, *The Stranger in America,* II, 238-240.
[66] Farnham, *Prairie Land,* 335-336.

speakers seemed to provoke the anger of the frontier people or the religious bodies sponsoring these services except the writings of Mrs. Trollope. This was probably because she was more outspoken in her indictment, and criticized other American religious services as well. One westerner was so aroused by the vindictive volumes of the English lady, that he named an unlikeable dog "Mrs. Trollope."

Colton, who was in Great Britain shortly after the publication of the two volumes on America by Mrs. Trollope, endeavored to vindicate the camp meeting as an institution of the charges of the English lady. He declared that Mrs. Trollope had been on the camp meeting grounds for only a few hours, and hence, her observations could not be considered representative. He added further that he had attended many such services as an impartial observer, and could state without hesitation that young women were not treated with ill-respect as Mrs. Trollope would have her readers believe.[67]

The author of this study feels that lack of respect for womanhood was the exception, rather than the rule, at this type of worship. It is also quite possible that a majority of the so-called "circuit riders" who sponsored them were sincere in spite of their lack of opportunities for education and culture.

Mention of the camp meeting as an institution is included here, however, solely for the purpose of determining its influence upon women. Beyond the fact that they provided many female members of families with their only journey from home of more than a day's ride during their entire lives, and afforded them an opportunity to meet and converse with other persons of their sex, the assumption that the camp meeting was a wholesome diversion for women must be doubted. From available evidence regarding the conduct of many females at these assemblies, it does seem possible to draw one significant con-

[67] Colton, *The Americans,* 257-280.

clusion: It will be recalled that historians often point out that the teeming mass of humanity at Whitehall which screamed for the signature of Charles I on the death warrant of Strafford, reflected all the dissatisfaction and anger over the "personal rule" of the king. It is occasionally stated also that the absolutely unrestrained grief which met the Lincoln funeral train in 1865 was not only a testimony of love and esteem for the martyred President, but also a manifestation of sorrow over all the tragic events incident to four years of civil conflict. In precisely the same manner, the conduct of women at the frontier camp meetings can be interpreted. In place of censuring any religious group for the convulsions and hysteria on the part of women (which prompted Mrs. Trollope to brand the camp meeting as a "saturnalia"), such might be viewed as the nervous reaction against all the suffering, loneliness, and neglect which large numbers of the frontier women had experienced.

Still, if neither the frolic, the quilting party nor yet the camp meeting offered the average frontier wife forms of diversion that exactly suited her needs, there remain other channels to survey. Perhaps it is safe to say that there is no form of recreation more eagerly anticipated by the average modern farm wife, nothing that does more to give her something to "live for," than do the weekly trips "to town." Did the typical small frontier settlement offer anything to give the women from the surrounding countryside an increased morale, a new interest in life?

Hardly, since in the general store where liquor was sold and where the indolent men of the community would loiter, it was not possible for them to look and shop amid the quiet and digni- fied surroundings that the dry goods establishment of later decades provided. It should be borne in mind also that it was not until after the Civil War that "ready-made" garments were available in any sizeable quantities for the inspection of curious feminine shoppers. In short, most available descriptions would

indicate that the frontier town was essentially a man's place, and usually overrun by idle members of that sex, thereby making it a spot in which the average woman would want to spend as little time as possible. Mrs. Farnham testified that on bright days the men would "mount their horses and throng the little towns in the vicinity of their homes." [68] Hulme's description (1819) of Princeton, Indiana, discloses a settlement that most certainly would fail to qualify as a center for feminine shoppers:

> Arrived at Princeton, Indiana, about twenty miles from the river. I was very sorry to see very little doing in this town. They cannot *all* keep stores and taverns. One of the storekeepers told me he does not sell more than ten thousand dollars value per annum; he ought, then, to manufacture something and not spend nine tenths of his time in lolling with a segar in his mouth.[69]

The statements of other travelers also would indicate that the small western towns of the first half of the nineteenth century would hardly enliven the spirits of rural women, even when their husbands would deign to drive them in from the farms, and provide them with money for purchases. There exists, nevertheless, at least one more possibility. Even the women of most savage and semi-civilized tribes find joy in the possession and wearing of articles equivalent to jewelry. Still, nothing would be more simple than to conjecture that very very few women of the frontier owned such valuable pieces.

It is equally easy to suppose that these females loved jewelry as have virtually all normal women of all ages. While on an Illinois River steamboat, Mrs. Steele formed an acquaintance with a young girl of about sixteen years of age, a resident of Peru, Illinois. She showed the older woman an inexpensive topaz pin which her brother had purchased from a peddler and

[68] Farnham, *Prairie Land,* 334.
[69] Thomas Hulme, *Journal,* June 25, 1819.

presented to her as a gift. In speaking of her pin the girl said, "This pin has lasted wonderfully, considering how much it has been borrowed. At every dance or party when I do not go, some of the girls borrow and wear it. It has been lent for ten miles around." [70]

It appears, then, that jewelry was very scarce in the West, even in sections that were no longer parts of the frontier, and among not only married women who very seldom had an opportunity to attend social functions, but among the young women who occasionally did.

Women were so necessary in western communities for the creation of values, tangible and intangible, that a student cannot but wonder why the men did not make some determined attempt to make life more tolerable for the weaker sex in the growing commonwealths. Had such been the case, there is little doubt that more eastern women would have been glad to leave the seaboard states. Had not so many western women been crushed by their environment as late as the eighteen-forties, but had possessed greater opportunities of embracing activities outside the home, the great demand for the services of their sex would have given a campaign for complete equality a fair chance of success. After the end of the American frontier about the year 1890, the need for feminine services was no longer acute. Yet executives and law makers were constrained more and more to give attention to the demands of the leaders of the various women's movements. These could hardly be ignored because in thousands of American communities there were well-read, and socially active women, which the average wife of the frontier, or of states a decade or two old, was not. But if these western females as a whole were in no position to press for an improved position in the eighteen-forties, other forces were at work which eventually would provide most potent assistance.

[70] Steele, *Summer Journey,* 157-158.

CHAPTER III

GAINS OF WOMEN ON THE TIMBER-PRAIRIE FRONTIER

1. PRESTIGE THROUGH SCARCITY

There can be but little doubt that the many premature deaths of frontier women would alone have resulted in a shortage of homemakers in the West. Another important cause of the predominance of males was the great number of single men who went to the frontier, planning to marry after they had achieved a fair degree of success. This could be illustrated by assuming that the Census of 1820 would be a representative one for the timber-prairie frontier, and pointing out that in the recently-settled states, there were more than 112 males over sixteen years of age to every 100 females of that category. In other words, there existed a deficit of 59,382 women of marriageable age.[1]

After the single men, those most likely to migrate to the frontier would be families with several stout sons. On the other hand, if a man had several daughters and no sons, he would more likely hesitate to move West. Hence there was a ratio of over 105 boys under sixteen, to every 100 girls of this age group in the same states.[2]

As previously noted, the immigrants to western states came largely from older regions of the country prior to 1820, but after that date, there was a marked increase in immigration from Europe. Slightly over three-fifths of this influx between 1820

[1] The above figures are based on the Census Volume for 1820, Table One. The states of Alabama, Mississippi, Louisiana, Tennessee, Kentucky, Ohio, Indiana. Illinois, and Missouri are included, and the territories of Michigan and Arkansas.

[2] *Ibid.*

and 1860 represented men, leaving less than two-fifths to repre-
sent women. It was pointed out in the first chapter that most
of these men came with a rural background, and hence were
anxious to take advantage of the cheap lands available on the
frontier.

In view of this evident preponderance of males, it is not sur-
prising that many men should experience great difficulty finding
suitable mates, as well as women to perform the services, with-
out which the so-called stronger sex was seriously inconven-
ienced, if not actually helpless. During the colonial period,
ship captains were usually able to bring to America any number
of women needed as wives or servants. Evidently, the only
sizeable number of single young women coming to America in
the first half of the nineteenth century, were the Irish group
which emigrated shortly after the great potato famine. But
most of these were eagerly sought for employment in wealthy
homes of the East, and probably very few reached the West
to become wives of frontiersmen.

There are many amusing episodes which illustrate the high
premium which eligible young women in western states com-
manded. In 1836 a conscientious young Wisconsin pioneer
desired to secure to help his wife, a woman whose services could
be depended upon, and not a girl who would shortly marry.
Hence, he chose the most homely "spinster" available, and, as
an additional safeguard, he prevailed upon her to sign a contract
stipulating that in the event of her marriage within one year,
her entire wages for the period should be forfeited. But it
developed that many single men reasoned, "She is not hand-
some, certainly, better than none tho." Hence, she soon had
several suitors, and in spite of the wage forfeiture clause in her
contract, she married before the end of one year.[3]

The English settlement at Albion, Illinois, also furnished a

[3] Reprinted by permission of the publishers, The Arthur H. Clark Company,
from Calhoun's *Social History of the American Family*, Volume II, Pages
104-105.

rather ludicrous episode which illustrates the demand for wives
in this period. About two years after the founding of the com-
munity, Richard Flower wrote, "Marriages here take place so
frequently that we are certainly in want of female servants;
even our Mrs. C., who lived with us upwards of twenty-five
years, and is turned of fifty, has not escaped; she is married to
a Mr. W., having first refused a Monsieur R., an Italian
gardener of very polite manners. . . ." [4]

This demand for women in Illinois still existed thirty-five
years later (1855), as a letter from the town of Rockford in
that state clearly indicates. Commenting upon reports that a
number of families in the older states were in want, the author
of the communication asks, ". . . Why do they not come West,
and get the comforts of life? The girls could get good places.
One hundred servant girls could find places in our town. The
scarcity of help grows out of the fact that the girls get married
as soon as they come West." [5]

The environment of the frontier often rendered a man's
motives for marriage very practical. If he remained single, it
would be difficult, if not impossible, to find suitable places at
which to lodge and board. If he planned to become a farmer,
it would be almost impossible to clear the land and cultivate it
properly, without the aid of several stalwart sons, since the
abundance of opportunity made male farm help both expensive
and undependable. Nor would it be likely that he would suc-
ceed in raising hogs, milch cows, or vegetables, if the assistance
of a wife were lacking. Little wonder, then, that the pioneer
bachelor often allowed expediency to overshadow sentimen-
tality.

When he went eastward in search of a wife and had a choice,

[4] Open letter of Richard Flower, Albion, Illinois, June 20, 1820, Thwaites
(ed.) *Early Western Travels,* X, 128-133.
[5] Letter from Rockford, Illinois, n. d., as cited in the *Chicago Times* (Chicago,
Illinois), January 20, 1855.

he usually selected one who appeared best able to stand hard work. Mrs. Farnham asked a recently married man in Illinois if it were true, as he had alluded, that he had married his wife merely because of her size. He replied, "Why pretty much. I reckon women are some like horses and oxen, the biggest one can do the most work, and that's what I want one for."

In reply to a query if he would be concerned if his wife became lonesome for her family and friends, he returned, "Wall, if she does, I expect I shan't mind it much, if she keeps it to herself." [6]

Nevertheless, if some men were willing to risk the consequences of such a practical attitude, the one assumed by many young girls was even more significant. Realizing that they were likely to have many flattering proposals of marriage, servant girls usually took on a strikingly independent attitude. As might be expected, those voicing the loudest denouncements of this situation were the English immigrants and travelers. In describing conditions in Minnesota, Farrar complained that they would do no more than "their share" of the housework, and expected to be introduced to visitors as "Miss So-and-So." [7] The girls could take such a stand because in Minnesota as in virtually all other new communities of the West, the situation was as described by Miss Bishop, "The supply is not equal to the demand, as this class of girls who come to Minnesota always have numerous advantageous offers of marriage. . . ." [8]

Many young women in the East, however, soon came to the conclusion that heavy odds existed against their finding happiness amid surroundings which were usually rustic and unkind from the feminine point of view. This apathy toward the West is well borne out by a song, "To the Prairie I'll Fly Not," the

[6] Farnham, *Prairie Land*, 38.
[7] Maurice Farrar, *Five Years in Minnesota*, 189-191.
[8] Harriet E. Bishop, *Floral Home, or First Years in Minnesota*, 135.

words and music of which were the composition of W. D. Brinckle:

I

To the prairie I'll fly not, young rover with thee,
Its wideness and wildness have no charms for me,
O'er its silken bosom though summer winds glide,
To the prairie I'll fly not a wild hunter's bride.
Though fawns in the meadow fields fearlessly play
And the landscape's enchanting and nature so gay,
To the prairie I'll fly not! then linger not here,
So far from the home of your light footed deer.

II

Tho' bisons, like clouds, overshadow the place,
And wild spotted coursers invite to the chase,
To the prairie I'll fly not, at least not with thee,
So away to your wild sports, and think not of me.
What, fly to the prairie? I could not live there,
With the Indian and panther, and bison, and bear;
Then cease to torment me, I'll give not my hand,
To one, whose abode's in so savage a land.

III

Besides, at the crack of a rifle I feel
A horror and dread, that I cannot conceal.
Then tarry no longer, my home ne'er will be
In a wigwam or tent, on the prairie with thee.
I love not the prairie, tho' rich be its hue,
I love not the life of a rover—nor you.
Then mount your courser, again let me say,
To the prairie I'll fly not, so bound, bound away.[9]

[9] W. D. Brinckle, "To the Prairie I'll Fly Not," *Godey's Ladys Book,* **XXI** (September, 1840), 140-141.

With the dearth of eligible young women in the West came some instances where the pioneers married Indian girls. An unnamed writer cited by Calhoun makes these remarks concerning the marriage situation in Tennessee in 1824:

> In 1824 there was no society worthy of the name. There were no ladies to visit. Indian women and black girls were in abundance; but not a respectable white woman was to be seen once a month. Two or three respectable men married Indian women, with the excuse that there were no white women about. In the Chattanooga region, some Scotch settlers courted and married Indian girls.[10]

In general, however, the men who failed to win a white wife remained single, with the result that these bachelors were ridiculed in much the same fashion as were the so-called "old maids" of the older communities in the nineteenth century. Approximately the same background and motive for making unmarried females an object of mild ridicule in the states where men represented a minority of the population, served to engender a similar attitude toward unmarried men in the West. Large numbers of males in the new states could find no mate in their own communities, nor induce any woman from the older states to brave the hardships of a new country and "share their lot." In noting the western discussions and rhymes on the subject of bachelors, therefore, it is well to bear in mind that they emanated from a region where many men were not single from their own volition, whereas the orthodox conception of a bachelor is nearer that of a man who is either shy of women, or reluctant to assume the responsibilities of family life.

A statement in one of the issues of *Western Citizen* of 1824 declared, "A bachelor is a sort of whimsical being which nature

[10] Reprinted by permission of the publishers, The Arthur H. Clark Company, from Calhoun's *Social History of the American Family*, Volume II, Pages 103-104.

never intended to create. He was formed out of the odds and ends of what materials were left after the great work was over." [11]

While the above remark might seem to indicate that some men were single from caprice or indecision, the following bit of verse entitled "The Bachelor" appears to hint that some men were single because of their inability to secure a wife:

> Yes loving is a painful thrill
> And not to love, more painful still,
> But sure it is the worst of pain,
> To love and not be loved again. [12]

Apparently for the purpose of adding to the ridicule which was heaped upon single men in this period, *The Focus* (Louisville, Ky.) of May 22, 1827, announced a move by a Mr. McClure of Ohio, to tax bachelors instead of dogs. The situation had changed but little twenty-two years later according to another western rhyme, one which indicates rather vividly the predicament in which many single men of the western states found themselves. It has for a title, "I Wish I had a Wife":

> By jove, I throw myself away,
> And linger on from day to day,
> And find no joys in life.
> I'm all alone without a friend,
> No one my trouserloons to mend,
> I wish I had a wife.

[11] *Western Citizen* (Paris, Kentucky), April 10, 1824.
[12] *The Kentuckian* (Frankfort, Kentucky), July 24, 1829. The author is not stated.

So heavily my hours do roll,
They almost crush my sickly soul,
 My days with ills are rife.
My coat is minus, short a skirt,
I have no buttons on my shirt,
 Where can I find a wife?

The above certainly seems to support the statement that:

A bachelor has no business in the backwoods; for in a wild country where it is almost impossible to hire assistance of any kind, either male or female, a man is thrown entirely upon his own resources. Let any one imagine the uncomfortableness of inhabiting a log cabin, where one is obliged to cut wood, clean the room, cook one's victuals, etc., etc., without any assistance whatever.[14]

Since so many bachelors who had migrated westward were hesitant about leaving their property and venture a trip eastward in search of a homemaker, it is not surprising that some should endeavor to initiate a courtship through the medium of advertising. Public opinion does not appear to have frowned upon such a procedure as it does at present. In 1849 a bachelor advertised for a wife to "share his lot," and soon thereafter an "anxious inquirer" solicited the newspaper for information concerning "the size of said lot."[15]

An advertiser of an earlier date evidently felt that since he was resorting to that means of securing a spouse, he could afford to be somewhat more discriminating than the gentlemen mentioned above apparently was. This wife-seeker ran the following advertisement in 1818:

[13] *Illinois Republican* (Belleville, Illinois), May 9, 1849.
This shortage of eligible girls in the new settlements is confirmed in Walter Donaldson to James Donaldson, Buffalo Grove, Ill., January 17, 1847. The William Donaldson Papers, Polo, Illinois.
[14] W. N. Blane, *An Excursion Through the United States and Canada during the Years 1822-23,* 168.
[15] *Illinois Republican,* June 6, 1849.

Wanted a WIFE, from fifteen to twenty-five years of age. She must be of a respectable family, liberally educated, inclined to industry so far as to look after domestic affairs, capable of arranging a dinner table in the most modern style, also of entering a drawing or ball room gracefully—edifying in conversation, truly chaste, and partial to children. . . .

Also revealing a somewhat critical attitude on the part of its author, in spite of the scarcity of eligible women west of the Alleghanies, was this insertion which appeared about six years after the above: "Wanted: for a wife a good looking modest girl (under 25), who can and will spin, knit, and by herself and not by deputy, attend to all the domestic affairs of the house. . . . One who is fonder of spinning cotton, flax, and woolen yarn, than street yarn. . . ." [16]

Other single western men, however, remained reluctant to resort to advertising for a mate. Hence, the following notice of a bachelor who finally decided to cast aside his prejudices against this means of initiating a courtship, appears rather interesting: "Having overcome my former scruples, it is with the greatest pleasure imaginable, that I hereby authorize you to announce me a candidate for—Matrimony! . . ." [17]

But apparently it was the lead mining areas of the Middle West which experienced the greatest difficulty in securing anything near a satisfactory number of women for the purposes of work and marriage. No profound understanding of the female character is necessary to deduct that many women who might be willing to migrate westward to a farm, there to become a wife or servant, would shrink from becoming associated in any form with men whose business demanded that they live near the "diggings." The following article seems to summarize well the services of women in northwestern Illinois and southwestern Wisconsin, and to emphasize the great demand for them:

[16] *Guardian of Liberty* (Cynthiana, Ky.), September 12, 1818; *The Microscope* (Louisville, Ky. and New Albany, Ind.), July 24, 1824.
[17] *The Microscope*, June 11, 1825.

There is certainly a great scarcity of women at the mines. Any industrious girl here can earn one hundred dollars per annum, besides her board, either as a domestic assistant, or by serving. It is strange that the girls have not enterprise enough to go where they can earn a comfortable living. Thousands of amiable, intelligent girls are living in penury in the Atlantic circles, who, if here, would be provided with comfortable homes. The influence of one virtuous and refined woman will subdue more ferocity than half a dozen green missionaries. We judge of what might be, by what has been. The old miners, who lived here early in those days of violence, when a digger was willing to pay a quarter of a dollar to look at a bonnet, well know this fact.

It is said that when the first woman came to the mines, more than one hundred applications for a lease of her were filed in one day in the office of the land agent. From that time until the present, as women have multiplied and the social ties and affections of men have been called into exercise, the tone of morals has improved, and society has grown more peaceful and more refined.[18]

No inducements, probably, would have resulted in a sufficient number of women migrating to the lead mining communities of Illinois and Wisconsin, but the single men of the more peaceful agricultural sections might have been more successful in prevailing upon working girls in the East to marry them and move west, if they had been more thoughtful about making their cabins habitable. Mrs. Farnham observed many homes where the husband was well able financially to provide wooden floors, and other simple conveniences, but did not.[19]

But at this point appears one of the many inconsistencies in the life and attitude of the typical frontiersman. While oftentimes he was totally unappreciative of the labors, dangers, and discomforts experienced by his spouse, still, he sent men to the

[18] From the *Wisconsin Herald,* n. d., in the *Quincy Whig* (Quincy, Illinois), March 26, 1846.
[19] Farnham, *Prairie Land,* 66-68.

state legislatures who were to provide his daughters the same
facilities for public education as accorded to his sons.

2. EARLY ACHIEVEMENT OF EDUCATIONAL EQUALITY

Two facts render the generally favorable attitude of the
trans-Alleghany people toward the education of young women
somewhat surprising. One is the opposition which existed in
certain eastern states as late as 1800, against providing equal
learning facilities for the children of both sexes. The second
is the apparent indifference toward the welfare of women which
was held by so many of the western men. As the first explana-
tion, the views of Thomas Jefferson on this subject seem to
have deeply impressed residents of the new states. He wrote
concerning his own daughters, "I thought it essential to give
them a solid education, which might enable them, when become
mothers, to educate their own daughters, and even to direct
the course for sons, should their fathers be lost, or incapable,
or inattentive." [20]

Either the attitude of Jefferson was accepted as expedient, or
many western citizens arrived at the same conclusion inde-
pendently. For after Peyton toured the Mississippi valley in
1848, he stated that the reason for western states offering equal
educational opportunities to both sexes was that the girls were
likely to become mothers and have a part in the education of
their children.[21] Newspaper editors also occasionally declared
such views, as the following will indicate, ". . . It seemed an
abuse of the gifts of providence, to deny to mothers the power
of instructing their children; to withhold the privilege of sharing
the intellectual pursuits of their husbands; to sisters and daugh-

[20] Jefferson to Nathaniel Burwell, Monticello, Va., March 14, 1818, Paul L.
Ford (ed.), *The Works of Thomas Jefferson*, XII, 90-93.
[21] John L. Peyton, *Over the Alleghanies and Across the Prairies*, 112.

ters, the delight of ministering knowledge in the family circle . . ." [22]

Moreover, the success of the private schools for girls in the West did much to convince observers that the fair sex was capable of pursuing all ordinary academic subjects with success. When Cuming visited Lexington, Kentucky, in 1807, he was surprised to find that there were three boarding schools for "female education." [23] Obviously these institutions did not educate any significant number of girls, but the performance of such pupils at tests and exhibitions was rather widely publicized. [24]

The academic education received by many young women of Cincinnati (1829) seems to have impressed even the critical Mrs. Trollope, who wrote, "The method of letting young ladies graduate, and granting them diplomas on quitting the establishment, was quite new to me; at least I do not remember to have heard of anything similar elsewhere." [25]

Some newspaper editors also imparted support to the cause of feminine education. Whether such policies were usually due to personal conviction or business expediency must remain but a guess. Said the editor of the *Maysville Eagle* in 1830:

> The cultivation of the female intellect cannot detract from the power, influence, and pleasure of man. It will bring no "rival in his kingdom"—it will not render her conversation less agreeable—it will not render her judgment less sure and certain in the management of the domestic concerns of the family. [26]

Finally, indications are not lacking that the ideals of democ-

[22] *Saturday Evening Chronicle* (Cincinnati, Ohio), April 21, 1827.
[23] Cuming, *Sketches,* 163.
[24] Accounts praising the girls of the "female academies" of Lexington, Kentucky, may be found in the *Kentucky Gazette* (Lexington, Ky.), October 18, 1817, and the *Western Monitor* (Lexington, Ky.), August 13, 1822.
[25] Trollope, *The Americans,* I, 112-113.
[26] *Maysville Eagle* (Maysville, Kentucky), July 27, 1830.

racy and equality, so prevalent in the early West, provided some impetus to this cause. Mr. Samuel Lewis, an educator of Ohio, made this statement in 1839:

> While democracy and republicanism exist in our state, while the elective franchise remains, we will have common schools, we will have the means of education for all our youth. . . . If there is one principle that is more than any other identified with democracy, republicanism, and liberty, it is that of universal education.[27]

The terms democracy and republicanism doubtless bore some reference to female education, since doubtless many parents of the poorer classes felt that if the rich were sending their daughters to "female seminaries," the state should provide their daughters, as well as their sons, with at least a common school education. An editorial of 1840 declared that "an intellectual woman, now, is considered an ornament rather than a disgrace to society. . . ."[28] Certainly the rather extreme western democratic philosophy which Andrew Jackson fostered would not deliberately allow the daughters of the poor to grow to young womanhood devoid of all intellectual ornamentation.

Unfortunately, all of the above views did not render the majority of western property owners anxious to support proposals for school taxation on a state-wide basis. Some of the more opulent of the early residents of the western states felt that since they could afford private teachers for their children, such legislation would not benefit them. Gradually, however, sentiment favoring public schools, grew. One rather interesting and ingenius argument was employed by the proponents of such taxation to secure the votes and influence of the wealthy parents. They pointed out that hiring a private teacher for a family of children required an outlay of from three hundred to

[27] *Liberty Hall and Cincinnati Gazette* (Cincinnati, Ohio), May 9, 1839.
[28] *Godey's Lady's Book*, XX (February, 1840), 92-93.

five hundred dollars per year, while the taxes for state-supported schools would be but a fraction of such cost in most cases.[29]

Significant among the education acts of the early western legislatures, were the Illinois law of 1825, and the Kentucky statute of 1838. Neither were as comprehensive as the school laws adopted by many western states in the eighteen-fifties, and they prescribed taxation upon a local, rather than a state basis.[30] Still the proceeds from the sale of the "school sections" of new townships, enabled the "common schools" of the West to enjoy a fair growth, despite the absence of more satisfactory school laws.

Moreover, the willingness to educate both sexes soon bore fruit. The census returns for 1850 indicated that about the same proportion of the respective numbers of boys and girls of school age in the states of the Middle West, were enrolled as pupils.[31] Also, while the schoolmaster loomed large in the period before 1830, several factors combined after that date to increase the number of female teachers. Just as in the twentieth century, after the vast majority of the elementary teaching positions had been occupied by women, statements were made that young boys should have some male instructors; it was pointed out in this early period, 1842, that female teachers

[29] *Argus of Western America* (Frankfort, Ky.), October 29, 1819.

[30] "An Act Providing for the Establishment of Free Schools in Illinois", in *The Revised Statutes of Illinois*, 1833, 556-559.

"An Act to Establish A System of Common Schools in Kentucky", in *Acts of the General Assembly of the Commonwealth of Kentucky, December Session,* 1837, 274-283. Also to be found in the *Observer and Reporter* (Lexington, Ky.), January 13, 1838.

[31] The following figures are to be found in the volume of the Seventh Census of the United States, Table XLI, p. lix:

State	Male Pupils		Female Pupils
Illinois	97,245		84,724
Indiana	119,496		100,538
Iowa	18,677		16,779
Michigan	55,546		50,208
Missouri	51,146		44,099
Wisconsin	29,096		27,258

should have a part in the education of girls.[32] But without doubt the greatest reason for the appearance of many "school-mistresses" was the fact that more and more men left the teach-ing profession to enter other fields, as the possibilities of the West were unfolded. Not all of these new teachers in the West were well educated. Mrs. Sigourney admitted that many of these women were "the sole architects of their own educa-tion." [33]

But fortunately many girls had received a good education in the New England states. There, because of the exodus of young men to new states, many girls were entering spinsterhood. But education had not yet progressed sufficiently, even in that cultured section of the country, to provide teaching positions for all eligible females who might apply. The lady who was to perform a great rôle in the progress of western education by making it possible for many young women of this class to teach in the new states, was Miss Catharine Esther Beecher (1800-1878).

The early eighteen-twenties had found this oldest sister of Henry Ward Beecher and Mrs. Harriet Beecher Stowe, en-gaged to the young and energetic Yale professor, Mr. Alexander Metcalf Fisher. But he perished in 1822, when the ship on which he was bound for Europe was lost at sea. Miss Beecher, therefore, prepared for a teaching career, and soon opened the Hartford Female Seminary.[34] After nine years, however, she decided to accompany her father, the Reverend Lyman Beecher, who had accepted a responsible position in Cincinnati. She had concluded that this western city would provide a more fruitful field for her activities than the Connecticut metropolis.

Although her "Western Female Institute" failed in 1838,

[32] Margaret Coxe, *Claims of the County on American Females*, II, 141.
[33] Lydia H. Sigourney, "Self Educating Teachers", in *Godey's Lady's Book,* XX (March, 1840), 140-142.
[34] Harriet B. Stowe, "Catharine E. Beecher," *Our Famous Women* (A. D. Worthington and Co.), 75-93.

Miss Beecher had already formed plans broader and more comprehensive in character. Her trips through several western states caused her to estimate that in these commonwealths two million children were growing to maturity without the advantages of any formal education. There, she reasoned, several thousand well educated New England girls would find professional opportunities.

Speaking tours to the East ensued, also disappointments over failure to win the support of noted educators of that period, such as Henry Barnard of Connecticut. But the movement was still pressed. In 1845 Miss Beecher published a work entitled, *The Duty of American Women to Their Country.* Of course, its sole purpose was to set forth the author's plan for sending eastern girls to western school districts. Perhaps the following might be regarded as the core of her scheme:

> In all parts of our country, especially at the West, there are multitudes of flourishing towns and villages willing and anxious to have good schools and able and ready to support them, but unwilling to do anything to sustain the miserable apology for teachers within their reach. . . .
> Now there are hundreds and thousands of enterprising, benevolent, and, many of them, well educated women, who would rejoice to go forth as missionary teachers to these destitute children.[35]

The volume, however, contains several other statements of great significance. It called attention to the fact that in the West, men were becoming interested in other fields, thus leaving an opportunity for thousands of women to embrace teaching as a career. Said Miss Beecher, "This is the way in which a profession is to be created for woman—a profession as honorable and as lucrative for her as the legal, medical, and theological for men."[36]

[35] C. E. Beecher, *The Duty of American Women to Their Country,* 114.
[36] *Ibid.,* 64.

This work also provides some interesting data regarding a number of female teachers who had already accepted positions in the West. It cites the instance of a girls' school sending out four hundred teachers in a nine-year period, eighty-eight of whom went to the South or West. At the end of these nine years, sixty-four of these eighty-eight were still teaching, twelve doing so after marriage.[37]

Such successful performance enabled Miss Beecher to argue that the feasibility of her proposal was already evident. Moreover, she insisted that these teachers had done much to improve home and community life in their respective districts. She cited one young instructor, who, while "boarding around," had imparted her knowledge of the latest developments in domestic science to the wives and daughters. For example, she demonstrated the best practices for preparing yeast, baking bread, and designing bonnets.[38]

Encouraged by the promise of help from Mr. William Slade, one time governor of Vermont, Miss Beecher went to Burlington, Iowa early in 1848, to establish a training school. She began by starting housekeeping with her limited funds, and invited all female teachers who were ill or temporarily without a school to come there and reside.[39] Her plan to found a normal institution in Burlington failed, however, apparently due to the fact that disagreement between herself and Mr. Slade had caused this once enthusiastic citizen to lose interest in her project.

Efforts to plant one institution in every state nevertheless continued, and at Quincy, Illinois, Miss Beecher succeeded in establishing a school in 1850. At Milwaukee, Wisconsin, where several citizens had already contemplated such a move, a

[37] *Ibid.,* 117.
Since Miss Beecher was associated with the Hartford Female Seminary for a corresponding length of time, it is probably the school to which she refers.
[38] *Ibid.,* 129.
[39] M. E. Harveson, *Catharine Esther Beecher, Pioneer Educator,* 102-103.

normal school was established in 1851. In the following year, Miss Beecher sponsored the organization of the American Woman's Educational Association to further her plans. In 1854, activity was resumed in Iowa with the opening of a normal institute in Dubuque.[40]

Of these, however, only the one at Milwaukee was destined for permanency. Necessary funds were simply not forthcoming; eastern philanthropists were largely interested in other causes, while in the West, sentiment for co-educational state normal schools was growing. Miss Beecher was therefore not able to train as many girls for the teaching profession as she desired; still, the West appreciated the intellectual and practical contributions of the young women whom she had encouraged to teach in the new states. Their presence seems to have frequently impelled the sons of the pioneers to be more thoughtful and attentive than the preceding generation of western men as a whole had been toward their wives and sweethearts. McConnel, often quoted in discussions of western types, wrote this description of the average New England woman who went West as a school mistress:

> She was never above the medium height . . . her arms were long, and, indeed, a little skinny, and she swung them very freely when she walked; white hands of no insignificant size, dangled at the extremities, as if the joints of her wrists were insecure. She had large feet too. . . . She had, however, almost always one very great attraction, a fine, clear, healthy complexion—and the only blemishes upon this, that I have ever observed, were a little red on the tip of her nose and on the points of her cheek bones, and a good deal of *down* on her upper lip.
>
> Life was too solemn a thing with her to admit of thoughtless amusements . . . but she well understood metaphysical distinctions, and was tolerant, if not liberal to marriageable men. . . .

40 *Ibid.,* 121-145.

But the man who courted her must do so in the most sober, staid, and regulated spirit.

. . . In the course of time the schoolmistress became a married woman; and as she gathered experience, she gradually learned that New England is not the whole "moral vineyard." [41]

The eighteen-forties, moreover, witnessed the training of thousands of American girls in state normal schools and "teachers' institutes." Not infrequently school boards would hire young women thus trained, even when men were available, tor the reason that their services could be obtained for half the compensation males would expect.[42] As result of all the factors favorable for the entry into the teaching profession by women, Illinois had almost the same number of female teachers as male in 1856.[43] Although the decline in business and the retardation of frontier expansion which resulted from the panic of 1857, caused many men to reenter the teaching field, the Civil War, and the post-war prosperity were to permit women to outnumber men in the field of elementary teaching in all sections of the nation.

Since some statements have been made regarding the social results of the entry of female teachers into western schools, it appears pertinent to add at least a very brief survey of important changes of a school and professional nature which this group was able to effect. In the period when virtually all public school-teachers were males, little respect for the profession was prevalent. Most of the more able and aggressive western men sought more lucrative means of livelihood. Hence, many—if not most—of the men who "kept school" were both unprogressive and distressingly ignorant of the subjects they purported

[41] J. L. McConnel, *Western Characters*, 328-330.
[42] *The Daily Sanduskian* (Sandusky, Ohio), May 14, 1849.
[43] The number of male teachers is listed as 4,952, and the total number of female instructors as 4,369. *Third Biennial Report of the Superintendent of Public Instruction of the State of Illinois* (1860), 13.

to teach. Episodes which depict the lack of knowledge of even simple facts on the part of numbers of this group, comprise a sizeable portion of what is called "frontier humor." But when large numbers of rather well-trained women entered the vocation of teaching, less was said of the "ignorant school-teacher."

Another lamentable situation—one which certainly could not have been so general, had the schoolmasters enjoyed even a slight degree of public respect—was that of "barring out." A few days before Christmas, the teacher, upon reaching the door of the school, would find his entry blocked by his boy pupils. The latter would pass a note under the door stating that he must "treat." The inference was that he should supply them with whiskey, usually about two gallons, and other ingredients for the mixed alcohol drinks that happened to be popular in the region.

Of course the teacher would usually resist such demands. At times, if there were no fire built, he would attempt to enter the building by means of the chimney, or, if there was a fire, he would frequently attempt to "smoke them out." Such however, caused the innocent small children to suffer. Mr. Samuel Willard, the interesting historian of the Illinois public schools, relates that a teacher in Turkey Hill (Illinois) in 1825, carried on the contest by marching around the school building each class day for a week, carrying his sword and musket. Neither his determination nor his martial weapons, however, saved him from capitulation, and he was finally obliged to provide the "treat." If a luckless teacher was successful in forcing the boys to leave the school, he was frequently rolled in the snow until his assent was obtained.

A schoolmaster in Champaign County, Illinois, in 1838, was forced to provide whiskey and molasses for a drink called "blackstrap." The boys became intoxicated, and after the holiday season, the teacher decided not to return the following year. His successor was a preacher, but he too was finally

"persuaded" to provide the supplies for the annual celebration. But with the coming of many women teachers, this custom soon disappeared. Such requests or such violence being directed against a female would of course be unthinkable. Willard states that the last occurrence of "barring out" in Illinois took place in 1844.

Still another flagrant school practice which existed in the day of all male instructors, was the "loud school." Masters of such schools were of the opinion that a pupil was not actually study-ing, unless he was stating the material of a text aloud, and often they believed that the louder the child shouted, the more dili-gent were his efforts. Needless to say, no modern educator would attach the slightest value to such "learning activity," nor did the well-informed women who were entering public school work in the West about the middle of the nineteenth century. According to Willard, the last "loud school" of Illinois was in Brown County in 1852.[44]

The last, but by no means the least deplorable of the con-ditions which the first female teachers found in the frontier schools, was that of very poor buildings. Many of the latter had nothing to serve as windows, save a cut in the logs which the teacher was expected to cover with oil paper during in-clement weather. In many western counties, the majority of the schools lacked even the outbuilding type of sanitary facili-ties. Such situations, however, disappeared rather rapidly in districts where women teachers were assigned.[45] It is by no means difficult to discern why such a change would be effected. The average female personality is certainly better equipped to

[44] Samuel Willard, "Brief History of Early Education in Illinois", in *Fifteenth Biennial Report of the Superintendent of Public Instruction of the State of Illinois*, 1884, pp. xcviii-cxxiii.

[45] The writer, while making an analysis of the reports of the Illinois super-intendent of public instruction for the two decades, 1850-1870, noted that in every instance where the county superintendent or commissioner boasted of modern school plants, women teachers were either in the majority, or at least their numbers nearly equaled those of the male instructors.

crystalize public sentiment to remedy such abuses than is that of the average male. No less certain is the assumption that many school board members would cast aside their indifference regarding such matters, when a young woman appeared as the teacher—even though her personality might be hardly more than mediocre.

But the opportunity of entering the teaching profession was not the sole educational development in favor of young women in the three decades after 1830. Of almost equal significance, was the rise of co-educational institutions in the West on the college level. The first that was to enjoy permanence was Oberlin College in Ohio, which opened in 1833. The quasi-frontier environment of the latter may be noted by the fact that its announcement of 1834 called the college an "infant institution in the wilderness."

Antioch College adopted co-education in 1853, and the State University of Iowa two years later.[46] Then the passage of the Morrill Land Grant Act in 1862, led to the organization of a number of state universities which became co-educational immediately, or shortly following their inception. Finally, in 1870, when the University of Michigan opened its doors to women, it was evident that in the West at least, the struggle for equal educational privileges had been won. But in these same decades when educational opportunities were being unfolded for the daughters of the West, there was developing a growing appreciation of the services of an older generation of women whose toil and sacrifices had made possible the evolution of such a vast new empire.

3. BELATED RECOGNITION OF HER SERVICES

In attempting to understand this growth in veneration of the

[46] E. P. Cubberley, *Public Education in the United States*, Revised Edition, 275.

rôle of the frontier woman, it is well to remember that when the
first families ventured beyond the Alleghanies, many believed
that they were virtually severing all ties with civilization, just
as many who had occupied the "Old West" had done. The
transportation problem seemed insurmountable for all areas
except those bordering navigable streams, market prices for the
various commodities suffered from wide fluctuations, and the
pessimists did not fail to publicize the dangers of attack or the
ravages of disease. Hence many persons believed that the
West offered only a resort for the misfits of society, and for the
individualists who demanded virtual isolation. Faux had made
this pessimistic statement which represented the views of many,
"The west is fit only for the poor men, who are the only proper
pioneers. I do not think the land will improve in value, but
that much money will be wasted on improvements." [47]

But many developments had changed all this by 1830. The
Erie Canal had been completed, the railroad promised to open
up many areas for settlement and to provide an outlet for
produce, the Indians soon were to be moved across the Missis-
sippi, many found that they had, by several years of western
residence, built up resistance to the fever and ague, and Europe,
in the midst of the Industrial Revolution, was viewed as a
promising market. Western commitments, which once had
appeared to many as not even a good gamble, rather suddenly
came to be regarded as a "sure thing." This realization seems
to interpret the vast speculative activity of the eighteen-
thirties. The West had "made good."

With this rather sudden and phenomenal expansion in the
values of western property and western produce, came the
realization on the part of a few men at least, that women had
played an important, if not the major rôle, in the creation of
this vast new economic wealth. They had reared large families

[47] *Journal,* 196.

—sons and daughters who were to assist in pushing the borders of American civilization still further westward. As pointed out in the first chapter of this study, foreign immigration was most insignificant as a factor in frontier development until the late eighteen-forties.

Moreover, farm wives had not only done much to develop their homesteads, but oftentimes they alone were at hand to stand between their children and the attacks of Indians or border ruffians. A rejoinder to such arguments might be that in this period a part of the great increase in western wealth represented the enhancement of real estate values in the cities which were rising, and that such construction represented exclusively the product of the commercial and engineering skill of men. But while it is true that abilities exclusively in male hands in that epoch were indispensible if new towns and cities were to appear, still, it would be difficult to name a middle-western city which did not owe its growth to its potentialities for serving a growing countryside as a market center. For example, to these towns came the meat products such as hams and barrel-salt pork which had not been prepared in packing houses, but on the farms, and more often than not with female help.

Before such services were fully comprehended, editorials in western newspapers appear to have usually stressed the duties of a wife rather than her services, as the following example will indicate:

> The good wife is one who, ever mindful of the solemn contract which she hath entered into, is strictly and conscientiously virtious, constant and faithful to her husband. . . . She looks well to the ways of her husband, and eateth not the bread of idleness.[48]

[48] *Western Citizen*, May 29, 1830.

Very soon after the appearance of the above remarks, how-
ever, views of a decidedly different tenor became increasingly
frequent. Whether these were prompted solely by the convic-
tions assumed by the editors, or whether the latter were judging
the attitude of their subscribers, can be only a guess. Probably
both factors played a part in the issuance of these articles. At
all events, statements praising the loyalty and industry of the
"fair sex" became almost common in western journals during
the eighteen-thirties and eighteen-forties.[49]

Nor would the growth of this veneration of women, permit
the politically ambitious to remain silent. In an address deli-
vered before the Old Settler's Society of Walworth County,
Wisconsin, on October 5, 1869, Mr. Charles M. Baker said:

> The country was all open and free to roam over, as one
> great park. There was excitement in all this—a verge and
> scope, a freedom, and independence and abandon, suited to
> our rougher nature and coarser tastes. We could roam and
> fish, or hunt as we pleased, amid the freshness and beauties
> of nature.
>
> But how was it with our wives? From all these bright, and
> to us fascinating scenes and pastimes, they were excluded.
> They were shut up with the children in log cabins . . . rude
> huts, without floors, often, and not infrequently without
> windows. . . . Here in one small room, filled perhaps with
> smoke, without furniture, except a little extemporized of
> the rudest kind,—without cooking utensils, save perchance
> a kettle, a skillet, and a frying pan; destitute of crockery,
> and with little tin ware, they were called upon to do unaided,
> the duties of a housewife.[50]

[49] Representative editorials of this type may be found in the *Cincinnatti Com-
mercial* (Cincinnati, Ohio), October 6, 1843; the *Louisville Public Advertiser*
(Louisville, Ky.), June 16, 1838; the *Public Ledger and Commercial Bulletin*
(Louisville, Ky.), May 11, 1846; and the *Quincy Herald*, January 12, 1844, and
June 5, 1844.

[50] Charles M. Baker, "Pioneer History of Walworth County [Wisconsin]",
Report and Collections of the State Historical Society of Wisconsin, VI (1869-
1872), 436-475.

But editors and political leaders went farther than to merely praise the accomplishments and character of western women. They soon began to support the movement for laws which would ameliorate the status of the other sex in regard to the ownership of property of all types, and which would provide them with some form of legal redress in the event that a husband proved unworthy or unfaithful.

4. THEIR IMPROVED LEGAL STATUS

United States Senator George Frisbie Hoar (1826-1904) once declared that he had come to favor woman suffrage because he had found that he could not argue against it for five minutes without denying the fundamental principles of representative government. Why then, one might ask, did the democracy-professing West so long delay the grant of increased political and legal rights to women?

Speaking of the unjust legal position of women, a western editor blamed the English common law, saying:

> As to the rights and privileges of women, I must have leave to tell them that they are really very few; in the eyes of the law I mean. The first thing I read about in some of our law books is that women in England, with all their movable goods, so soon as they are married, are wholly *potestate Veri*, that is, at the will and disposition of their husband. They cannot let, set, sell, give away or alienate any thing without their husband's consent.[51]

It is well known that the typical frontiersman considered laws irksome. But instead of changing statutes or legal principles which he considered unjust or undesirable, he was prone to place jurisprudence in the same category as bitter medicine —something to be utilized only when absolutely necessary.

[51] *Kentucky Whig* (Lexington, Ky.), March 23, 1826.

Hence the legal concepts which were prejudicial to women long remained unmodified.

Of course, there were a few self-assertive feminine souls who were able to demand their rights and more—just as there were after the frontier had pushed beyond the edge of the "timber country." Perhaps one of the best examples of this type is Mrs. Pamelia Mann of East Texas. She was one of the women who kept hotels in Texas during the colonial period. It was said of her that she was prosecuted for more different crimes than any man of her time.

When the army of General Sam Houston was moving northward in 1836, prior to the battle of San Jacinto, Mrs. Mann agreed to loan the forces a yoke of oxen, the understanding being that the body of troops would proceed northeastward in the direction of Nacogdoches. But they left the route agreed upon, Mrs. Mann heard of it, and came galloping up to Houston. She shouted: "General, you told me a d—— lie, you said that you was going on the Nacogdoches road. Sir, I want my oxen."

The animals were reluctantly returned to the woman, and the episode was sometimes called "Houston's defeat." He apparently nursed no anger over this humiliation, however, since at the wedding of Mrs. Mann's son two years later, he, then president of the Republic of Texas, served as best man.[52]

There are apparently no instances, however, where women attempted to vote on the timber-prairie frontier. Concerning western inaction upon woman suffrage, a cause is rather easy to discover. The influence of Thomas Jefferson in shaping the political mind of the frontier has already been mentioned. Jefferson favored education for women, but not their participation in politics. It will be remembered that this great Virginian received his liberal ideas from the French philosophers of the

[52] The direct quotations relating to the above episode are from: William Ransom Hogan, "Pamelia Mann: Texas Frontierswoman", in *Southwest Review* XX (Summer, 1935), 360-370.
Quotation reproduced with the permission of the copyright owner.

eighteenth century, and while he admired many of them, he apparently blamed the interest in politics for the characteristics of some of their female associates. Hence, in writing to a friend, he included:

> Were our State a pure democracy, in which all its inhabitants should meet together to transact all the business, there would yet be excluded from their deliberations, 1. infants, until arrived at years of discretion. 2. Women, who to prevent depravation of morals and ambiguity of issue, could not mix promiscuously in the public meetings of men. 3. Slaves, from whom the unfortunate state of things with us takes away the right of will and property.[53]

Nevertheless, in 1837—eleven years after the death of Jefferson—there was in existence a definite movement to improve the status of women regarding property holding. On September 21, 1837, the *Liberty Hall and Cincinnati Gazette* called the attention of the public to the need for more just property rights for women.[54] It was not long after the appearance of this Cincinnati statement that several states began to take definite action. By an act of the Kentucky legislature, approved February 16, 1838, widows or unattached women over twenty-one years of age who owned and resided upon property subject to taxation for school purposes, could vote for elective school officials in their respective districts.[55] One year later the famous "Ladies Bill" passed the Mississippi legislature and was approved on February 15, 1839. This act provided that married women might retain control of their own property after marriage, and, under specified conditions, receive gifts

[53] Jefferson to Samuel Kercheval, Monticello, Va., September 5, 1816, Ford (ed.), *The Works of Jefferson*, 15-16.

[54] Another noteworthy article of the period was one which appeared in the issue of the *Daily Picayune* (New Orleans, Louisiana) for April 12, 1839. It declared that state laws should be more nearly uniform in regard to female property rights.

[55] See Note 22 of this chapter.

and bequests, as well as make additional property purchases under their own names.[56] The Kentucky legislature passed a bill to protect the property rights of married women on February 7, 1846,[57] and Article VII, section 19 of the first constitution of the state of Texas, adopted in 1845, and Article X, section 14 of the first constitution of the state of California, adopted in 1849, contain almost identical clauses providing protection for married women's property rights.[58] Other western legislatures also soon took steps to revise their laws in favor of feminine rights.

While western women were registering their early legal gains, a development of a somewhat different nature was strengthening the bargaining position of their eastern sisters. To be sure, the state laws were generally a handicap to acquisition of securities and property by women prior to the middle of the century. Yet the commerce of the nation, and its expanding property values were creating great increases in the national wealth, and a portion of it came to rest under feminine names. In 1840 slightly more than eight per cent of the shares of the United States Bank were held by women. In the same year fifty-one other banks made reports which indicated that women held a total of 39,860 shares of stock in them.[59]

It is, of course, quite obvious that the percentage of financial interest in banks and corporations of 1840 was extremely

[56] "An Act for the Protection and Preservation of Property Rights of Married Women", in the *Code of Mississippi: Being an Analytical Compilation*, 1848, pp. 496-497.
[57] Collins, *History of Kentucky*, I, 52.
The *Quincy Whig* of December 20, 1843, and several secondary works state that the Tennessee senate passed in the latter year, a law to protect the property rights of married women. Nevertheless, the author was unable to find evidence that the bill proceeded further toward enactment.
[58] First Constitution of the State of Texas, Austin, 1845, in H. P. N. Gammel, *The Laws of Texas, 1822-1897*, II, 1277-1304; Constitution of California of 1849, in Thomas J. Farnham, *Life Adventures and Travels in California*, 479-509.
[59] *Niles Register*, February 29, 1840.
It must be admitted that the second statement on banks is not of great value, since neither the total capitalization of the banks, nor the par value of the shares was included in the article. It shows only the rather wide distribution of investments under names of women.

modest compared to the very much larger portion held by women of the twentieth century. But even more significant was the growth of the amount of life insurance in force—in 1850 exceeding sixty-eight million dollars—another paltry sum in comparison to the figures of a few decades later, but again indicating a significant start. In the middle of the nineteenth century, it was more than likely that at least eighty per cent of the beneficiaries under these policies were women; this is approximately the present proportion. Needless to say, the possession of insurance policies on the lives of their husbands gave women a greater sense of security and independence, and greatly reduced their fear of being dependent upon male relatives or charity after the passing of their mates.

A financially independent and unattached female could often live where she chose. Hence, with the number of women with means and the list of western states according liberal property rights to that sex both increasing, several eastern legislatures felt constrained to consider a revision of their statutes regarding the legal rights of females. But the mere exodus of eastern families to the western states and territories had also brought emphatically to the attention of residents of the older section, the problem of feminine rights to property. Obviously when a family was preparing to emigrate, not all chattels could be taken ; a part would have to be sold, or disposed of in some other manner. In many homes there were articles which the wife considered to be her own, including wedding gifts and presents from members of her family. Hence, when the prospective emigrant prepared to relinquish a portion of the movable property of the family, he would find that his mate expected to have a voice in determining what articles were to be sold, or in disposing of the funds realized from the sale. Mrs. Nancy Carey, who lived for a time on the Michigan frontier, and whose husband long wandered more or less aimlessly from

one border area to another, complained rather bitterly of the manner in which her spouse had sold her property on several occasions. While in Ohio, the traveler John Eyre met a woman who was "sobbing as if she was inconsolable," because her husband had sold their property in the East and had brought her to such an "uncultivated place." [60]

It would seem, therefore, that eastern legislatures had the unique opportunity of promoting justice, rendering their states an ideal place for female residence, and at the same time impeding the plans of many men to move to newer sections of the country, by adopting statutes which would reduce or eliminate the power which men held to control the real estate and movable property of female members of their families. This situation was not wholly disregarded, and among the new statutes of this category, perhaps those of the state of New York were most widely publicized. A law of April 7, 1848, had for its purpose the protection of the rights of a wife to the property which she had owned prior to her marriage, while an act of April 11, 1849, permitted married women to receive real estate or other assets as grants or gifts, to enter into business negotiations, and to receive the interest or profits therefrom, just as they would if unmarried. [61]

Although the effect of such enactments by eastern states upon the social status of women already in the West could hardly be called great, still the indirect results were to be most significant, since these new laws expedited the aquisition of fortunes by females in the older portions of the nation, and it was largely through the contributions of women with spare funds at their disposal, that the campaigns for feminine rights were financed. Moreover, this rather early growth of feminine

[60] "Autobiography of Mrs. Nancy Carey", *Michigan Pioneer and Historical Collections*, XXXVIII (1912), 168-171; John Eyre, *Travels Comprising a Journey from England to Ohio*, 107.
[61] *Laws of the State of New York Passed at the Seventy Second Session of the Legislature*, 528-529.

wealth seems to have encouraged certain western states to devise another class of statutes, those of a type which the reader may or may not feel advanced the true interests of American womanhood. These were laws facilitating divorce.

During the first quarter of the nineteenth century, the general practice of the American states appears to have been to sanction divorce only when a petition for the same received the special approval of the legislature in the home state of the parties involved. But in January, 1827, the general assembly of Illinois, either because a majority of its members believed that such a move would serve the interests of the women of their state, or because they hoped that such legislation would attract wealthy potential divorces, enacted two drastic divorce laws. The first provided that:

(1) The bonds of matrimony might be severed for the following causes: impotency, adultery on the part of either male or female subsequent to marriage, desertion without cause for two years, extreme cruelty, and habitual drunkenness for two years.

(2) The circuit court was authorized to grant divorces.

(3) One year's residence in the state was required for a decree.

(4) Alimony might be allowed for the maintenance of the wife and custody of any children.

(5) Any woman suing for divorce who might satisfy the court that she could not defray the cost of the action, should have her complaint prosecuted without charge on the part of the officers of the court.

But probably still more significant was an act, approved by the governor on the same day, January 31, 1827, which provided that the authorized courts might hear pleas for divorce not based on grounds included in any state law, and if satisfied

as to the expediency of the decree, such could be granted.[62] Ohio, in 1834, followed the lead of Illinois and liberalized her divorce laws.[63] In Indiana, the constitution of 1816 forbade divorces unless especially granted by the legislature. But a new basic law, approved by the voters in 1851, enabled the general assembly of the state to determine upon what grounds the courts could dissolve marriage ties. How quickly the legislators took advantage of the opportunity can be appreciated by noting this article in the *Bureau County Republican*:

> "Every hotel or tavern has one or more of those bewitching vixens, domiciled with them for ten days, which makes them citizens and residents of the state of Indiana. . . . At the expiration of ten days, a suit is commenced against some vile husband—if for no other cause than incompatibility of temper. Here are congregated from all states of the Union (except Illinois, who is a competitor for this profitable trade) all the disconsolate grass widows. . . ." [64]

In spite of certain implied liberalism of such Indiana statutes, Illinois remained the most notorious state for the granting of divorces, and Chicago, as late as the eighteen-eighties, was internationally known as a resort for those seeking divorce.[65] Writing in that period, De Rousiers declared, "If a New York, Boston, or Philadelphia husband wants to break the bonds of wedlock, he jumps the cars for Chicago." [66] Incidentally, it seems obvious that if Nevada altered her earlier divorce stat-

[62] Acts Concerning Divorces, January 31, 1827, in *The Revised Laws of Illinois*, 1833, pp. 234-235.

[63] *The Sun* (New York, N. Y.), May 10, 1834.

[64] *Bureau County Republican* (Princeton, Illinois), July 22, 1858.

[65] For the twenty year period, 1867-1886, Illinois courts granted 36,072 divorces, thus leading the entire nation. Second was Ohio which authorized 26,327 decrees, while Indiana was third with a record of 25,193 divorces granted during the two decades.—E. J. Phelps, "Divorce in the United States," *The Forum*, VIII (December, 1889), 349-364.

[66] P. De Rousiers, *American Life*, 285.

utes of 1861 and 1875 to augment business in the state,[67] she was only following the practice of certain older commonwealths when they were regarded as "far western."

While such enactments cannot be totally ignored, the purpose of this section is to emphasize those laws passed for the purpose of aiding the women residing in the West. It seems clear that a sufficient number of such statutes were considered favorably by western legislatures to confirm this generalization of Fowler, "Woman is the unconscious legislator of the frontier." [68] Moreover, this western situation was aiding indirectly the economic advancement of many eastern women, just at a time when the intriguing plains-mountain frontier was being opened for exploitation and settlement.

[67] Nevada Divorce Law of February 20, 1913, in *Statutes of the State of Nevada, Passed at the Twenty-Sixth Session of the Legislature,* 10-11.
The above law required but six months residence in the state before divorce pleas would be considered, while eastern states usually demanded one year.
[68] Fowler, *Woman on the American Frontier,* 525.

CHAPTER IV

Opening Up the "Last West"

1. THE NEW FRONTIER ENVIRONMENT FOR WOMEN

From the standpoint of pioneer settlement, as well as from general geographical features, the territory west of the ninety-eighth meridian may be divided into three areas: the timbered regions of the Pacific Coast, where the homeseekers hoped to experience an environment and climate not unlike what they had known in the East; the Rocky Mountain district, where mining potentialities were long to afford the greatest attraction; and the so-called Great Plains east of the mountains. It is one of the well-known facts in American history that the Pacific section of this vast area was the first to attract the attention of the American people. In 1842 parties began to cross the plains and mountains for the Oregon country.

Almost immediately men were impressed by the ability of the women of these parties to adapt themselves to the unhospitable plains and mountain conditions. Two episodes will illustrate the manner in which these female pioneers were able to provide home comforts amid such discouraging surroundings. James Clyman, a member of the Oregon party of 1844, told how a young woman succeeded in baking bread on the plains, despite the strong winds. Clyman, an interesting writer, but a poor speller, wrote in his journal:

> . . . and here let me say there was one young Lady which showed herself worthy of the bravest undaunted poieneer of [the] West for after having kneaded her dough she watched and nursed the fire and held an umblella over the fire and her

skillit with the greatest composure for near 2 hours and baked bread enough to give us a very plentifull supper and to her I offer my thanks of gratitude for our last nights repast.[1]

Then, during the following year, a journalist was much surprised over the ingenious fashion with which an emigrant woman had equipped her covered wagon. He noted at Independence, Missouri, the rendezvous of the parties bound for Oregon by the overland route, the following:

On looking out at the passing train, we see among the foremost a very comfortable covered wagon, one of the sheets drawn aside, and an extremely nice-looking lady seated inside, very quietly sewing; the bottom of the wagon is carpeted, there are two or three chairs, and at one end there is a bureau, surmounted by a mirror; various articles of ornament and convenience hanging around the sides—a perfect prairie boudoir. Blessed by Woman! Shedding light and happiness wherever she goes; with her the wild prairie will be a paradise! Blessed be He who gave us this connecting link between Heaven and man, to win us from our wilder ways! [2]

Of course the women of the party observed by this editor, were not bound for the vast plains between the Missouri River and the Rockies. Still, his prediction that they would make possible a happy existence in that area certainly materialized. Of all the examples of resourcefulness of the American woman, her ability to establish and maintain comfortable homes in the dust and wind-swept "plains environment," is apparently the one which has been demonstrated over the longest period.

The movement to Oregon, hardly represented the real begin-

[1] Reproduced through the courtesy of the Henry E. Huntington Library and Art Gallery, San Marino, California, owner of the Clyman manuscript.
The quoted portion of the diary was printed in the *California Historical Quarterly*, IV (December, 1925), 307-360.
[2] From *The Expositor* (Independence, Mo.), May 3, 1845, as cited in the *Daily Union* (Washington, D. C.), May 26, 1845.

ning of the conquest of the great domain known as the "last West," since the number of families migrating thither cannot be called significant. It was the discovery of gold in California in 1848 which caused the American people to become intensely absorbed in the prospects of this frontier. With this new lure of the West, came a more or less unpremeditated rush to the areas thought to offer easy wealth; hence there was much more suffering by the families of the "forty-niners" than had existed among the parties going to Oregon.

A number of the heads of families who had proven themselves to be lazy and shiftless on the timber-prairie frontier started westward—apparently not because they were willing to work hard for gold—but because of sheer restlessness. In her work *Eighty Years and More*, Mrs. Elizabeth Cady Stanton tells of an instance where a father of ten children, living on an Illinois farm which was owned by the wife and mother, prevailed upon her to dispose of the Illinois property and to start with him toward the plains. There was no evident reason except mere wanderlust. Before the family had reached a new home, the mother and her youngest child had died. On the whole, however, such instances could not have been numerous, for reports were not long in reaching the older states that this was a vastly different West, one which was by no means a paradise for the listless: in fact it was an area in which a man was obliged to labor profitably or perish.

But another circumstance seems to have proven more irksome for the females of the Far West than somewhat similar instances had been for the women of the earlier border regions; this was the dependence of many single men upon the few married women for certain services and the hospitality of their homes. Mrs. Duniway wrote the following in regard to such use of her residence at Cincinnati (Oregon) in the eighteen-fifties, "It was a hospitable neighborhood composed chiefly of bachelors, who found comfort in mobilizing at meal times at

the homes of the few married men in the township, and seemed especially fond of congregating at the hospitable cabin home of my good husband." [3]

Moreover, the first families to settle upon the plains of Kansas faced an undesirable situation from the standpoint of health. It will be recalled that the majority of these immigrants hurried into the region because they believed that their presence might result in the future state having the laws regarding slavery which they desired. Such pioneers not only overtaxed the strength of themselves and their families, but were apparently even less mindful of considerations of health than had been those who peopled the states east of the Missouri River. Also the lack of adequate supplies of timber resulted in the erection of cabins which were very often even more crowded than those constructed farther East. And finally, the seasons of drouth found many of the settlers yielding to the temptation of using water which was "brackish." The comment of Mrs. Ropes, one of the pioneer women of Kansas, was:

> There was no water that we could relish, even to wash us in; and we were stinted necessarily to the smallest possible quantity. . . .
> I believe that the first thing which impressed me . . . was the sickly look of everybody. All elasticity seemed to have been drawn away from them. [4]

With the men of frontier Kansas, including even some of the physicians, spending such a large part of their time upon projects associated with the slavery controversy, it frequently happened that women were obliged to attend the sick to the

[3] Abigail Scott Duniway, *Path Breaking*, 9-10.
[4] Mrs. Hannah Anderson Ropes, *Six Months in Kansas*, 47-48.
The unhealthy environment of early Kansas and the problems which it created for the few women in the territory, are described in the writings of two other pioneer women: Sarah T. L. Robinson, *Kansas; Its Interior and Exterior Life*, 63; and Mrs. Adela Elizabeth Orpen, *Memories of the Old Emigrant Days in Kansas*, 47.

best of their knowledge, without the aid of the medical profession.

Nor were the early American arrivals in California always fortunate in avoiding serious illness. There, as on the timber-prairie frontier, the greatest number of deaths occurred among the females. Said a correspondent of *The Republic* in the issue of that journal for October 16, 1849: "Pulmonary complaints abound, and, though the deaths are few among the male population, the females seem to be fated. Female strangers are almost certain to lose their health, if not their lives, in California. . . ."

But in the bulk of the territory between the Missouri River and California, there is ample evidence that the health factor was not the baffling problem that it had been in earlier border communities. The autumnal malady known as the "fever and ague" was far less prevalent, probably due to the fact that many of the immigrants had already acquired a resistance to it, also to the less favorable conditions for the breeding of mosquitoes. It is true, of course, that frontier life continued to exact a heavier toll of women than men. Such is borne out by the available mortality statistics of four territories where the population was almost entirely Anglo-American, Dakota, Nebraska, Utah, and Washington. For the census period from June 1, 1859 to May 31, 1860, these divisions of the "last West" disclose a death rate for women which was approximately twenty-two and one-half per cent higher than that of the men, violent deaths excluded.[5] Such did, however, represent

[5] The figures upon which the above statement was based are the following:

| Territory | Population | | Deaths (excluding violent deaths) | |
	Men	Women	Men	Women
Dakota	1,592	984	3	1
Nebraska	16,689	12,007	180	179
Utah	20,178	19,947	173	147
Washington	8,225	2,913	18	23
TOTALS	46,684	35,851	374	350
Deaths per ten thousand persons			80	98

Preliminary Report of the Eighth Census of the United States, pp. 291-294.

an improvement over the timber-prairie frontier, where the excess of female deaths appears to have been much greater.

But if fewer women died from illness and overwork, and if more husbands were kindly, there were other elements to disturb the female peace of mind. The dust storms, the almost incessant winds, the great danger of attack by the fierce Indian tribes, the bleak, treeless, and uninviting terrain, and the rather frequent invasions of grasshoppers were but a few of the distressing features. In his work *Across the Plains*, Robert Louis Stevenson said, "Day and night, above the roar of the train, our ears were kept busy with the incessant chirp of grasshoppers—a noise like the winding up of countless clocks and watches." Confirming the remarks of Stevenson as to presence of these insects on the plains during the frontier epoch is this statement of a St. Louis newspaper, the *Daily Missouri Republican* of September 20, 1863: "The plains are alive with vermin."

It is reasonably certain also, that the novel and formidable plains-mountain surroundings continually reminded the female traveler that she was far from home. Mrs. Frizzell, who went to California in 1852 by the overland route, made the following entry in her journal just after she and her husband had crossed the plains in safety and were about to enter the treacherous mountain trails:

> We are about fifteen ms. [miles] from South Pass, *we are hardly half way.* I felt tired and weary. O the luxury of a house, a house! I felt what some one expressed, who traveled this long and tedious journey, that, "it tires the soul." I would have given all my interest in California, to have been seated around my own fireside, surrounded by friend & relation. That this journey is tiresome, no one will doubt, that it is perilous, the deaths of many will testify, and the heart has a thousand misgivings, & the mind is tortured with anxiety, & often as I passed the freshly made graves, I have

glanced at the side boards of the waggon, not knowing how soon it might serve as the coffin for some one of us; but thanks for the kind care of Providence we were favored more than some others.[6]

For the woman who settled upon the plains, the wind, dust, and insects created many housekeeping problems. Log and sod domiciles would obviously offer no effective check against wind-blown sand and vermin, while hewn timber usually shrinks with the high evaporation factor of the plains, and hence a structure of that material is not always a bulwark against these elements. Firewood was often very scarce, and hence the hay burning stove was devised. Such a fixture represented, perhaps, the ingenuity of the inventors of the last half of the nineteenth century, but it is safe to say that not a single woman enjoyed using it to cook the meals of her family. An old lady of the Texas frontier made a statement which came to be regarded as such a truism that it was still current in a modified form when Theodore Roosevelt was living in the West, nearly half a century later. It was that the West is "a heaven for men and dogs, but a hell for women and oxen." [7]

While conditions on this frontier did not cause women to die in large numbers as those on the preceding one had done, evidence is not lacking which indicates that a few of the plainswomen lost their minds. Such an instance is related in the novel of Dorothy Scarborough, *The Wind*. One might well debate the question which frontier was the most unkind to the weaker sex on the whole.

It should be borne in mind also, that in the Far West, settlement was not an orderly advance of new communities, but selection and occupancy of the sites which seemed advan-

 [6] Victor H. Paltsists (ed.), *Across the Plains to California in 1852, Journal of Mrs. Lodisa Frizzell,* 28-29.
 [7] Noah Smithwick, *The Evolution of a State or Recollections of Old Texas Days,* 15.

tageous for farming or mining. Hence many of the mining and agricultural communities of the territories of the plateau region were several hundred miles from the western fringe of the more compactly-settled part of the nation. In spite of his well-known enthusiasm regarding the potentialities of the West of his lifetime, Horace Greeley wrote the following concerning Colorado in the issue of the *New York Tribune* for July 2, 1859:

> Nearly every sort of provisions and supplies of every kind must be hauled by teams from the Missouri River, some 700 miles distant, over roads which are mere trails, crossing countless unbridged water courses, always steep-banked, and often miry, and at times so swollen as to be utterly impassable by wagons. Part of this distance is a desert, yielding grass, wood, and water only at intervals and then only scantily.

Obviously the isolation of the mountain settlements not only rendered very difficult all types of communication; it also presented a very grave Indian peril. A number of the tribes of the plains-mountain area assumed, at times, a very hostile attitude toward the immigrant whites, and in case of the Sioux, Comanches, and Apaches, such represented a most serious threat, since these tribes were probably as good fighters and horsemen as the human race has produced. In fact, it was not until near the end of the frontier period that the armed forces of the United States succeeded in definitely removing this menace. Although the traveler Darby called the plains "dry but more healthful" than the older frontier, he stressed the fighting ability and fierceness of the plains tribes, calling them the "Tartars of North America."[8]

This Indian danger was one which sent fear into the hearts of women in particular. The history of the plains-mountain West is replete with instances of Indian bands capturing

[8] William Darby, *View of the United States*, 315.

females of all ages. Often such unfortunates never saw civiliza-
tion or their families again. Mrs. N. D. White, who was a
victim of the famous Sioux raid upon Minnesota communities
in 1862, includes the following in her description of the experi-
ence:

> Many times have I reluctantly retired for the night on
> the cold damp ground with my child on my arm, unable to
> sleep, thinking of my friends and home. If by chance my
> eyes were closed in sleep, I would sometimes dream of seeing
> Indians perpetrating some act of cruelty on innocent white
> captives. Occasionally I would dream of having made my
> escape from my captors, and was safe among my relatives
> and friends in a civilized country. But on awakening from
> my slumber, Oh the anguish of mind, the heart-crushing
> pangs of grief, to again realize that I was still a prisoner
> among the Indians! [9]

Nor did the women of the settlements on the edge of the
southern plains have less reason to dread such attacks. Hence,
many women of the Texas frontier took the precautions as
described by Mrs. Looscan:

> Careful women so situated usually slept in dark-colored
> gowns, and never retired without making provisions for
> escape should danger threaten, by having a loose puncheon
> or board in the floor, leaving space sufficient for a person to
> pass through and lie or crawl under the house until the
> danger had passed, or favorable opportunity offered for
> seeking shelter in a thicket or tall prairie grass. . . . Many
> are the instances recorded where the lives of the family were
> saved by their exercise. . . . [10]

The Indians of the Far West were a special threat to women,

[9] Mrs. N. D. White, "Captivity Among the Sioux, August 18 to September 26,
1862," *Collections of the Minnesota Historical Society*, IX (1912), 395-426.
[10] M. Looscan, "The Women of Pioneer Days in Texas," D. G. Wooten (ed.),
A Comprehensive History of Texas, 1685 to 1897, I, 649-668.

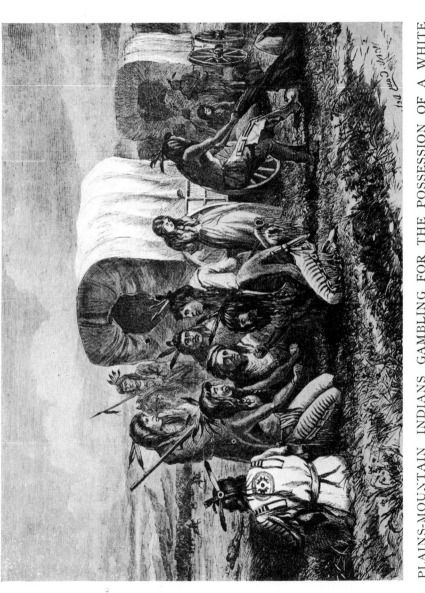

PLAINS-MOUNTAIN INDIANS GAMBLING FOR THE POSSESSION OF A WHITE
FEMALE CAPTIVE

(From *Harper's Weekly*, March 26, 1870)

a fact recognized by all experienced army officers. In 1875, when a detachment was crossing an Indian-infested portion of Arizona and was about to enter a mountain pass, Lieutenant John W. Summerhayes handed his wife a pistol and bade her to lie quietly at the bottom of the wagon. He told her also that if he were killed, not to allow the savages to take her or their infant son alive. No Indians were encountered, but nervousness from the fright, the ensuing journey over an alkali plain, the illness of her son, and the typical western environment of their camp site, prevented Mrs. Summerhayes from sleeping that night. She wrote concerning it:

> The mournful and demoniacal cries of the coyote filled the night; they seemed to come close to the tent, and their number seemed to be legion. I lay with eyes wide open, watching for the day to come. . . .
> At dawn everybody got up and dressed. I looked in my small hand-mirror, and it seemed to me my hair had turned a greyish color, and while it was not exactly white, the warm chesnut tinge never came back into it after that day and night of terror.[11]

It was not revenge alone which prompted these Indians to attempt the capture of white women. Being scarce in the West, white females were objects of curiosity for the savages. At times the refusal of a pioneer to consent to the demand that his wife be exchanged for livestock or other chattels, would precipitate danger of depredations. When the natives accosted one newlywed Wyoming immigrant and asked him to exchange his bride for several ponies, he, thinking it merely a joke, consented, and agreed to consummate the exchange on the following day. But when he revealed the affair to an old frontiersman who understood the Indian character, he was urged to send

[11] Martha Summerhayes, *Vanished Arizona*, Second Edition, 126.
Mrs. Summerhayes had come to the frontier as a bride about a year before these experiences.

his wife to Denver immediately, for he declared that the tribe as a whole would expect the bargain to be kept, and might make trouble if they were confronted with a refusal. The young man took the proffered advice, and when the Indian returned with the stipulated number of ponies, it was possible, after a long parley, to send him away by presenting him with several gaudy articles.[12]

Included in the survey of the hardships of women on the older frontier, was a discussion of the limited shopping opportunities. In this last West also, the scarcity of good stores provided an irksome, if not a dangerous, handicap for women. Before the coming of railroads to the new territories, many merchants in the isolated areas apparently assumed a most independent attitude, and made little attempt to satisfy the wants of their patrons. Burnett tells of asking an Oregon retailer for satinets, jeans, calico, and brown cotton, and being told in rather indifferent fashion that the only articles in stock were tools.[13] While journeying to Colorado in 1859, Richardson came upon a tent bearing the sign "Grocery," but he could note little else except a bearded man sitting on the ground between two barrels of whiskey. The following conversation ensued:

"Have you any crackers?"

"Nary cracker."

"Any bread?"

"Any what?"

"Bread."

"No Sir (indignantly), I don't keep a bakery."

"Any ham?"

"No."

"Any figs?"

[12] Mrs. George Gillard, Pioneering in the Seventies," *Annals of Wyoming*, V (July, 1927), 19-24.
[13] Peter H. Burnett, *Recollections of an Old Pioneer*, 185.

"No."

"Well, what have you?"

"Why, I have sardines, pickled oysters, smoking tobacco, and stranger, I have got some of the best whiskey you have ever seen since you was born." [14]

Notwithstanding all of the factors which have been described as possibly making life difficult for women of the plains-mountain settlements, the writer is still not sure that the latter sex suffered more than a previous generation of women had done on the older frontier. It has been pointed out that beyond the ninety-eighth meridian, health conditions registered at least slight improvement. Moreover, it is well known that few considerations mitigate the sufferings of normal women more successfully than does the manifestation of proper respect and consideration by the so-called "stronger" sex. Of the existence of a higher regard for the rights and comforts of females on the part of the men of this "last West," than had been common in new territories east of the Mississippi River, there can hardly be reasonable doubt. Even Susan B. Anthony, always sparing in praise of the sex which she felt had treated her own unjustly, refers to this new attitude. [15]

Among the reasons for this new male attitude, was the fact that so many men born west of the Alleghanies remembered the trials and services of their mothers and other female relatives. Another reason, not infrequently stated, was that after the War between the States, many Southern men went West with the hope of regaining the fortune they had lost as a result of the conflict, and the example of their chivalrous attitude helped to set new male standards.

But this new gallantry appears to have had another source also. In a few sections of the Far West, the Anglo-American civilization was to merge with the older Spanish-Mexican cul-

[14] Albert D. Richardson, *Beyond the Mississippi*, 162.
[15] Susan B. Anthony and others, *History of Woman Suffrage*, IV, 518.

ture. The outward signs of courtesy toward women which men of Hispanic descent manifested, impressed not a few travelers and the immigrants from "the states." [16] A fourth, but by no means the least important cause was the fact that in many isolated regions of the Far West, the pioneers were obliged to live for long periods totally without the comforts which it seemed that women alone could provide.

As a result of this new deference toward the fair sex, and the greatly reduced number of listless males on this frontier as compared to that of the older border area, females seldom worked in the fields except during periods of emergency. Beadle noted that among the industrious Scandinavian families of Dakota, women would help reduce the harvest-time shortage of labor by lending their assistance in the grain fields.[17] Also, the issue of the *New York World* for May 20, 1865, reported that in the vicinity of La Crosse, Wisconsin, a number of farm wives had started the spring plowing prior to the return of their husbands from army service. But as a rule, women were spared from the necessity of performing such tasks.

Another evidence of this new frontier respect for women, was the general unwillingness of men to imbibe in the company of respectable women. During his travels in the West, Bell was impressed by the fact that men would take out their bottles at the stagecoach stations, only after they had left the company of the female passengers.[18]

Not only did this chivalry serve to render life easier for those women who were willing to migrate to these territories, but the hopeful state of mind which the majority of these women seemed to possess, must also have done much to lighten their burdens. When the frontier travelers of an earlier period

[16] Josiah Gregg, *Scenes and Incidents in the Western Prairies*, 215-223; James F. Meline, *Two Thousand Miles on Horseback*, 168; James F. Rustling, *The Great West and the Pacific Coast*, 92.
[17] J. H. Beadle, *The Undeveloped West*. 239-240.
[18] John C. Bell, *The Pilgrim and the Pioneer*, 393.

entered the home of a settler, and had an opportunity to converse confidentially with the wife, they seem to have discovered, more often than not that she maintained an air of hopelessness and frustration. But how different were to be the responses accorded the majority of those who were making observations in the plains-mountain country!

When Miss Lippincott stopped to visit Greeley, Colorado in 1871, she was prepared to hear from the women the same note of despair which was so familiar to the older generation of frontier *voyageurs*. She assured the women she met that she sympathized with them for having been torn from comfortable eastern homes and friendly neighbors, as well as from customary church and shopping facilities. But she was soon informed that any such sympathy had been badly misplaced, and that they considered themselves "never so happy and healthy as right on the edge of the Great American Desert." [19] Miss Lippincott made this generalization after noting the cheerful atmosphere which so greatly surprised her, "In fact, I find Colorado women everywhere, on the mountain or plain, in town or on ranch, singularly courageous and cheery."

Meline, who, during his trip to Colorado in 1866, stopped at a ranch twelve miles from Colorado City for a glass of milk, was received by the owner's wife, who appeared to be in a very optimistic frame of mind. She informed him that her only complaint was the absence of opportunities for conversing with other members of her sex. [20] Likewise, Bell was impressed by the sanguine outlook of a Mr. and Mrs. Marks, who were operating a Colorado mine in 1874. They agreed that, "If we do not cut it [the ore vein] our children will grow up and they will find that pay streak. We are working day and night now to catch it in time to educate them." [21]

[19] Sarah Jane Lippincott, *New Life in New Lands*, 62-63.
[20] Meline, *Two Thousand Miles*, 89-90.
[21] Bell, *Pilgrim and Pioneer*, 148.

Hardly less hopeful were the first residents of two plains territories, Dakota and Nebraska. The Sioux Falls correspondent of the *Washington Union* wrote in 1859:

> Who are the sons and daughters of the East, of the Middle and Southern States, and of the West—the respectable representatives of nearly every State in the Union—who have pushed out into the undressed garden of the sun-set land, to seek, honorably, each a home and a competence? They have come in good faith, have driven their stakes, and have gone at rough nature with an earnestness equal to any pioneering colonies before them.
>
> They find in Dakotah a salubrious clime, a rich and inexhaustible soil, they find woodland prairies, sparkling mountain lakes and rivulets, grand water-falls and famous rivers, coal and mineral productions. . . .
>
> They look to a year or two hence when they will see on the Upper Missouri, on the Big Sioux and James rivers, fleets of lofty steamers, astonishing the natives with their shrill whistles, and filling up the land with people and merchandise.[22]

It was doubtless this realization that they had a real financial interest in the project of opening up the plains-mountain area, which helped to engender such a surprising morale among the feminine settlers. Some women actually held large western investments in their own names—a Mrs. Buttles for a time was one of the principal stockholders and a managing director of the Boulder Canyon Railroad. A rich lady from New York City, Mrs. E. Thompson, not only held financial commitments in Colorado, but manifested her intense interest in the social and intellectual welfare of a settlement in Boulder County of that state, by donating $45,000 for erecting and equipping a

[22] *Washington Union* (Washington, D. C.), January 22, 1859.
A similar attitude was maintained by many of the first settlers in Nebraska, as letters such as the following will indicate: G. W. Nevell to William R. Foster, Forret Calhoon [Fort Calhoun], Washington County, Nebraska, April 9, 1855. The Charles E. Wickliffe Papers, Chicago, Ill.

public library for the community.[23] Interesting also is the fact that one of the principal owners of the cattle which roamed the plains of West Texas during the early eighteen-eighties was Mrs. Cornelia Adair.[24]

Nor did western women permit the men to utilize all the opportunities for exploitation and profit which the Indian reservations offered. It is well known, of course, that during all stages of American frontier history, many white men married Indian women, and while they were generally looked down upon by other frontiersmen, they were often able to amass large profits from the fur-trading and cattle-raising activities which intermarriage facilitated. But Wissler describes the career of an energetic white woman known as Maxine who married a dull Indian, and shortly began cattle operations under the name of her spouse in the tax-free environment of his reservation. Apparently this "white squaw" was not looked down upon as were so many of the "squaw men"—on the contrary—she was admired for her resourcefulness and enterprise.[25]

Moreover, the possibilities for profit in the Far West were not confined to married women. The *Illinois Republican* of February 13, 1850, contained a most fascinating account of two young women who journeyed to California by water in 1849, accompanied only by an old and trusted slave of their family. They acquired "diggings" about thirty miles from any other mining camp, and sought gold with their own hands. Since the slave was too advanced in years for heavy labor, he cooked and maintained the living quarters for the sisters. The writer of the article declared that the girls had already amassed about seven thousand dollars worth of gold dust, and that they

[23] John H. Tice, *Over the Plains, on the Mountains,* 125, 150.
[24] Mitchell County (Texas) Brand Record, Vol. I; Nolan County (Texas) Record of Marks and Brands, Vol. I.
[25] Clark Wissler, *Indian Cavalcade, or Life on the Old-Time Indian Reservation,* 228-229.
It would appear that Maxine's ranching exploits took place sometime during the last two decades of the nineteenth century.

planned to remain until the value of their findings had reached ten thousand dollars. Unfortunately, it is not known whether or not these plucky girls succeeded in acquiring the desired amount of gold, or whether they ever returned in safety to their home in the deep Southland. It is unthinkable to believe that their male relatives would have countenanced such an expedition; evidently they decided to run away from home, having first prevailed upon the old servant to accompany them. What is virtually certain, however, is that they trusted implicitly in the chivalry of the men of the West.

Daring as was this project, it required some capital. But one enterprising girl was able to set out for the land of gold with none. She answered the advertisement of a party of men desiring a cook to accompany them on the overland journey, and agreed to countenance a raffle for her hand in marriage, the understanding being that if she did not love the winner, she would proceed westward under the protection of the entire party. A shoemaker was the successful contestant, but since he aroused in her heart no sentimental response, she journeyed westward as the ward of the whole group.[26]

The mining regions of the West, however, were not alone in offering enterprising females the opportunity of procuring a modest "nest egg." Virtually every traveler in the newly-opened agricultural areas mentioned the demand for servant girls. Curley, in discussing conditions in early Nebraska, pointed out that it was very often easier for a woman to complete the process of acquiring a homestead than it was for a man, since there were invariably places at good wages awaiting women who were willing to do housework, but sometimes it was difficult for a man to "hire out" by the day.

There are a number of instances where western domestics would take a few days leave from their employment, enter

[26] *Watchman of the Prairies* (Chicago, Ill.), February 15, 1849.

homestead claims on a piece of land which seemed desirable, and then return to their positions for six months (the maximum legal period which a homesteader might be absent from entered land). During these months they would have shacks built upon their claims, and when they would return once more for a few days, contracts would be signed with nearby farmers for plowing and cultivation. Thus at the end of five years many women found themselves the owners of farms. Curley's comment upon these episodes was, "Strange as it may seem, a self-reliant woman may obtain a farm in Nebraska without hardship, while a man, equally poor, must endure great privation to obtain it, and very probably fail in the attempt." [27]

A few venturesome women continued to seek western farms, in spite of the unhospitable Great Plains environment. This statement can be confirmed by two episodes. After President Benjamin Harrison opened a large section for entry in the spring of 1889, large numbers of anxious immigrants rushed into the region to claim the most desirable lands. One young woman devised a novel plan to assure herself of a favorable site. She prevailed upon a locomotive engineer to agree to allow her to ride the pilot of the engine which he was about to run, and to slacken his speed sufficiently to allow her to alight whenever she gave the signal. Upon espying some land which appeared desirable, she got the engineer to reduce his speed, and then leaped off, removed a skirt, and tied it to a tree as an evidence of her right to the claim.

The attention which Mrs. Stewart received as a result of moving to a Wyoming homestead twenty years later, or in 1909, came through the publication of some of her letters. While the choice western acreage had been claimed by the above date, she declared that a woman who faced the responsibility

of supporting a family would fare better as a homesteader than as an unskilled urban worker.[28]

Nevertheless, few unattached women ventured into the new states and territories when compared with the number of single men who migrated westward. Hence life in the Far West was to suffer from a heavy preponderance of males, and many years were to pass before several of the new commonwealths could claim anything like a normal social atmosphere.

2. THE CONTINUED SCARCITY OF WOMEN ON THE FRONTIER

Even prior to the decade of the spectacular rush to the mining regions of the Far West, 1849-1859, the number of women on the frontier had grown more and more inadequate as the latter was pushed farther and farther westward. In part this was due to increased opportunities for girls to find employment in the offices and factories of the East, and in part to the results of larger numbers of Europeans landing on American shores. Johnston, writing upon this subject (about 1850), declared:

> As the immigrants spread themselves over the land, the unmarried females among them are picked up before they have proceeded far from the seaboard; and thus the scarcity of the sex increases the farther westward we go; and the value at which they are estimated by the men and by themselves increases, till, in the Far West, they attain a famine price, and there we have the paradise of women.[29]

The scarcity of women in the settlements of the Far West about 1850 can also be supported by the census figures of that

[28] The Oklahoma incident is described in C. B. Glasscock, *Then Came Oil, The Story of the Last Frontier* (Bobbs-Merrill Co., Indianapolis and New York, 1938), 73. The experiences of the female homesteader in Wyoming are related in Elinore Pruitt Stewart, *Letters of a Woman Homesteader*. Boston and New York (Houghton-Mifflin Co.), 1914.

[29] James F. W. Johnston, *Notes on North America*, II, 461.

year. An analysis discloses that there were over 144 males to every 100 females in the frontier states and territories. The preponderance of men was the greatest in California, where the ratio was over twelve males to each female.[30] Returns of the 1860 census disclosed population statistics for Colorado, Dakota, Nevada, Nebraska, New Mexico, Utah and Washington territories showing an average of 166 males for every 100 females. For Colorado a ratio of over twenty males to each female was shown.[31] These statistics disclose the fact that mining speculation had attracted large numbers of single men to western diggings. For most of these speculators, finding a mate in the West was of course to be an impossibility. In fact, it was to prove very difficult for them to procure from women, certain services which most males of that period had not learned to do for themselves. One "forty-niner" wrote home, "My washwoman has condescended to do my washing for $6 per dozen." [32]

For fully a decade after the gold rush, unattached women were so scarce in many of the interior towns of California that it was virtually impossible to obtain their services as chambermaids in hotels. At times guests would be constrained to perform themselves the chores associated with hotel rooms. Then again, males who lacked sufficient resources to start prospecting for gold would be retained by proprietors for the duties of the chambermaid.

The loss of both female society and services resulted in many strange actions on the part of the early miners of the West. Soon after the rush of 1849, a prospector of Tuttletown on the Stanislaus, a place "yet unblessed with the presence of women,"

[30] *The Seventh Census of the United States,* p. xlii, Table xxi.
Included in this computation were the states of Arkansas, California, Iowa, Missouri, and Texas, and the territories of Minnesota, New Mexico, Oregon, and Utah.
[31] *Preliminary Report of the Eighth Census,* 1860, pp. 291-294.
[32] "W. H." to Brother, San Francisco, January 20, 1849, *New York Weekly Tribune* (New York, N. Y.), April 11, 1849.

in some way gained possession of an "attractive" feminine boot. He held it up before a group of men, and after listening to several offers to purchase it, exclaimed, "Now see here boys— the chunk ain't found that can buy this boot. Taint for sale— no how!" [33]

In some of the camps, however, a means of holding dances was devised, in spite of the total absence of the fair sex. With only men on the dance floor, the caller would nevertheless shout, "Ladies chain," "Set to your partner," and other traditional directions. Then after a time he would say: "Promenade to the bar and treat your partners."

All participants would be bearded men wearing heavy boots and having revolvers and bowie knives handy. Those assuming the rôle of ladies wore a rather large canvass patch on their trousers. Such patches were regarded as "stylish" during the womanless period in the settlements.[34] The famous boys' author of the post Civil War period frequently pictured his poor but worthy heroes sustaining such taunts from their rich schoolmates as, "Patches must be in style." Actually, they had been in style a few years before in the California mining camps.

Perhaps more touching than these dance or boot episodes, however, is this incident mentioned by Burnett. In 1849 a young miner living with his uncle, received news that a lady had come to a camp forty miles distant. He at once requested and obtained the permission of his uncle to take the only mule the two possessed, and rode steadily until he reached the domicile of the recently-arrived woman. It developed that she was married, but he was kindly received, since she was deeply touched by such a sincere compliment to her sex.[35] There were other instances of young men undertaking rather long juorneys

[33] Hittell, *California*, III, 185.
[34] J. D. Bortwick, *Three Years in California*, 319-321.
[35] Burnett, *Recollections and Opinions*, 301-303.

with the same end in view, but strikingly grotesque was the episode provoked by the arrival of the first woman at a mining camp on Cañon Creek in the Sierra Nevada Mountains. Upon espying her upon an elevated portion of the trail which overlooked their diggings, the miners gave "three lusty cheers," ran to meet her, lifted the mule on which she was riding, and actually carried both animal and lady down the slope.[36]

With so many pioneers and prospectors starving for the mere sight of a female face, young women—and even small girls—with artistic ability were almost sure to be richly rewarded if they would consent to perform for the miners during their visits to the camp localities. It was a rather common practice of the men thus favored to throw rather large coins upon whatever surface that was used as a stage, as an expression of appreciation for the singing or dancing number. Apparently not all the mothers who accompanied their daughters to western settlements seriously objected to such exhibitions; in fact a few actually boasted of the great value of the gifts which their daughters had received. Even a rather elderly New England spinster who happened to be passing through Virginia City, Nevada, in November, 1862, succeeded in obtaining two money sacks full of half-dollar pieces for singing before an audience of men.[37]

Many of the more modest women, however, were considerably dismayed over receiving so much publicity and having large sums offered them. The first woman to arrive at the "Coyote Diggings" of California apparently reached the camp with her husband one night unnoticed by the miners, for the next morning these men were much surprised to find the covered

[36] Bates, *Incidents on Land and Water*, 217-218.
[37] California episodes of this character are described in R. H. Gabriel (ed.), *Frontier Lady, Recollections of the Gold Rush and Early California*, (Yale University Press, 1932), 115; while those taking place in Nevada are discussed in George D. Lyman, *The Saga of the Comstock Lode* (Charles Scribner's Sons, 1934), 198-200.

wagon and a washing hung out to dry. Since among the sus-
pended garments were several that only a female would wear,
they immediately concluded that a woman was in the party, and
soon a large crowd of miners had gathered. Upon drawing
back the wagon curtain, the husband was at first greatly
alarmed, but the leaders of the assembled group assured him
that they intended no harm, and only desired to obtain a good
glimpse of the lady. She was extremely hesitant about step-
ping from the wagon, and hence, as an inducement, the miners
raised a fund which actually amounted to between two and
three thousand dollars. She was told that it would be hers if
she would walk out so that all could see her, and receive it.
Finally, after stepping out several times only to run back, the
woman summoned sufficient courage to reach the spot where
the leader of the men was holding the coins. But the experi-
ence resulted in the couple leaving that vicinity rather
promptly.[38]

This shortage of women did not exist only in the mining
communities of California, Nevada, and Colorado, but was to
be found in the northern Pacific settlements as well. Mrs.
Abigail Scott Duniway declared that as late as 1872 there were
virtually no unmarried women in that section of the country.[39]
This assertion is confirmed by two rather interesting newspaper
statements. The *Oregon State Journal* (Eugene City, Oregon)
of July 20, 1865, mentioned a man being told that the way to
get a good wife was to "Take a good girl and go to the parson."
His immediate reply, however, was, "But my friend, ain't they
about as scarce as 'hens' teeth'?"

Moreover, the following article in the issue of the *Quincy
Whig and Republican* (Quincy, Illinois) for July 26, 1862, en-
titled "Great Chance for Old Maids," seems to make it clear

[38] *Reminiscences of Senator William M. Stewart of Nevada*, 77-80.
[39] Abigail Scott Duniway, "A Few Recollections of a Busy Life," in M. O.
Douthit (ed.), *Souvenir of Western Women*, 9-12.

that a similar shortage of marriageable women prevailed in British Columbia during this period:

> There is a grievous lack of women in the colony of British Columbia. A curious letter on this subject written by Sir Henry Verney appears in the *London Times* embodying this curious extract of a note from a functionary in a high position in the colony:
>
> "Oh, if fifty or one hundred women would arrive from England every month until the supply equaled the demand, what a blessing it would be to us and to the colony at large! Women! Women! are the great want. The normal state is man without a helpmate for him, and if something is not soon done either by the imperial or colonial Government, or by some philanthropist at home, I know not what will become of us. Poor man goes sadly down hill if he remains long without the supporting influence of woman. Get some Miss Faithful to turn her attention to these promising lads, and supply them with women.
>
> It is lamentable to see hundreds of fine fellows with plenty of means living in single misery, and no one to help them get out of their trouble."

With virtually all portions of the Far West apparently offering even the rather plain women such glittering opportunities, it is not surprising that a few who lacked strong character and fixety of purpose should succumb to their desires for adventure, and take rather hasty departures from their family circles. One of the "forty-niners" succeeded in bringing his wife and two daughters, fifteen and seventeen years of age, safely across the plains and mountains to California. He stopped at one of the mining camps, but before he had completed the erection of his tent, the young men of the diggings were conversing earnestly with his daughters. Within three days a young miner had eloped with the youngest daughter, and the oldest girl also married a few days later. The last female of the family was

also to depart. It happened that no satisfactory diggings could be found in that immediate locality, and hence the father of the girls left his wife in camp for a few days, and went in search of virgin areas for exploitation. Upon his return, he discovered that his spouse had likewise run away with a miner.[40]

The prospector who is accorded a large share of the credit for the discovery of the immense silver deposits in Nevada which bear his name, H. T. P. Comstock, also experienced considerable difficulty when he embarked upon a marriage venture shortly after his mining success. Comstock's biographers do not credit him with having an especially strong mentality, and certainly his manner of courting would offer no contradiction of this view. He actually purchased the woman known as his wife from a man surnamed Carter, who was alleged to have been a polygamous Mormon. After the consideration of sixty dollars had been paid, and Carter had departed, Comstock suddenly ordered the husband to return and furnish a bill of sale.

But if the famous prospector had hoped that such a slip of paper would render his home secure and happy, he was destined for disappointment. Within a few weeks his "bride" had twice attempted to escape with a male companion, but each time Comstock's men succeeded in apprehending her before she had gone far. Following the second return, Comstock summoned his friends, and proudly informed them that his "wife" had promised to settle down and change her ways. The pair did remain together during the winter of 1858-1859, but in the following spring, Mrs. Comstock was to make her third and successful attempt to leave the home into which she had been virtually forced. Says Wright regarding her final departure:

By practicing eternal vigilance Comstock managed to keep

[40] Anna P. Hannum (ed.), *A Quaker Forty-Niner, The Adventures of Charles Edward Pancoast on the American Frontier*, 274.

his wife that winter, but in the spring when the snow had gone off, and the little wild flowers were beginning to peep up about the rocks, and around the roots of the tall pines, she watched her chance, and ran away with a long-legged miner, who, with his blankets on his back, came strolling that way.

Mrs. Comstock finally ceased to roam; she came to anchor in a lager-beer cellar in Sacramento.[41]

Episodes such as the career of Mrs. Comstock and the sad experience of the forty-niner mentioned by Pancoast, prompted some who wrote upon frontier life to philosophize upon the "fraility of woman." Still, in view of the most uncomfortable crossing of the hot and dry plains and the snow-swept mountain passes, with the fear of Indian attacks always present, it seems nothing short of remarkable that thousands of the wives of "forty-niners" were able to preserve both sanity and fidelity to their husbands and families.

But in addition to wanderlust, there were two other feminine reactions to the unique prestige of their sex in the Far West. One was an attitude of indifference as to whether or not their marriage was a success. After his trip to California in 1875, Dixon wrote that one "pretty young woman" of San Francisco had remarked, "Guess my husband's got to look after me and make himself agreeable to me if he can, if he don't, there's plenty will."

Also this scarcity of women encouraged a few to be very disagreeable in their business relations. Mrs. Strahorn, in relating the incidents of her journey from Utah to Montana in 1878, mentioned an eating place along the route which was operated by such a lady. She called herself Mrs. Corbet, and claimed to be a relative of "Long John" Wentworth, early Chicago publisher and politician. It was said of her that she

[41] William Wright, *History of the Big Bonanza*, 77-80.

would meet each stagecoach with a pistol in hand, and compel the passengers to alight and order dinners—at the cost of one dollar per plate.

Mrs. Strahorn stated that she and her husband, not finding the notorious lady on hand to meet them when their stage reached the "home station" of Mrs. Corbet, resolved to eat their lunch in the conveyance. But when they requested drinking water, they were informed that it could be procured from the river. The driver later explained that Mrs. Corbet failed to appear because of an illness. A widely-circulated story concerning her, was the treatment accorded two Montana gentlemen. While dining at this famous eating place, they very imprudently asked the waitress if she called "that stuff coffee?" The proprietress overhead the complaint, and acted most promptly. Hastening to the table of the luckless travelers, she forced them to remit the full price of the meals, and then ordered them to leave immediately.[42]

But by serving faithfully in whatever position circumstances had placed them, the vast majority of the women of the Far West were to render unfounded the belief of those European observers who held that attempts to people that section would fail because of the shortage of females. The "home station" visited by Mrs. Custer in 1867 was operated by a woman of this desirable type. Mrs. Custer explained that this eating place was the only one between Fort Hays and Fort Harker where a woman was on duty, and continued:

I looked with more admiration than I could express upon this fearless creature. . . . She was as calm and collected as her husband, whom she valued enough to endure with him this terrible existence. How good the things tasted that she

[42] William H. Dixon, *White Conquest*, I, 166; Carrie Belle Strahorn, *Fifteen Thousand Miles by Stage*, 84-86.
 Mrs. Strahorn added that she later met the two travelers whom Mrs. Corbet had evicted.

cooked, and how different the dooryard looked from those of other stations! She had a baby antelope, and the apertures which served as windows had bits of white curtains, and, altogether, I did not wonder that over hundreds of miles of stage-route, the Home Station was a place the men looked forward to as the only reminder of the civilization that a good woman establishes about her.[43]

Many western women in less conspicuous places also found opportunities to render valuable services. Mrs. Esther McQuigg Morris, who settled at South Pass, Wyoming, found numerous opportunities to be of assistance in cases of illness, since both physicians and women capable of nursing were few in number. She is said to have been obliged to take full charge of a difficult obstetrical case on one occasion, due to the unavailability of a surgeon. The husband and father greatly appreciated her saving the lives of his wife and child, and when he subsequently was elected to the territorial legislature (1869), he listened favorably to the plea of Mrs. Morris that he support the bill granting the voting franchise to women.[44]

Of interest also is the career of Mrs. Mary Hezlep Knight, who went from Minnesota to Wyoming as a bride in 1876. The rather bleak, sage brush environment disheartened her at first, but she soon adjusted herself to western conditions as so many women have done before and since that time. Although told by older residents that the raising of flowers was virtually impossible because of the high altitude, high wind, and insufficient precipitation, she succeeded in growing several varieties of flowers. She also was very solicitous of the welfare of the cowboys of her section of the territory, frequently entertaining them in her home, and caring for many of them when they were ill.[45]

[43] Elizabeth Bacon Custer, *Tenting on the Plains*, 663.
[44] Shaw, *A Pioneer*, 243.
[45] H. K. Orr, "A Pioneer Bride," *The Annals of Wyoming*, IX (July, 1932), 666-673.

In view of the urgent need for feminine service in that part of the nation, it appears lamentable that moves to send many worthy and underprivileged young women of the eastern states to far western communities, were not very successful. A lady who endeavored to sponsor such a migration was Mrs. Eliza W. Farnham. Visiting California shortly after the start of the "gold rush," she noted the conditions in the mining towns. She soon concluded that three or four overworked miners' wives were not sufficient to give a town a high moral tone. Especially was she startled by the manner in which the new environment had affected small boys. She reported:

> I saw boys from six upward, swaggering through the streets, bigirt with scarlet sash, in exuberant collar and bosom, segar in mouth, uttering huge oaths, and occasionally treating men and boys at the bars. A mother with whom I was talking, saw from my window, a young hopeful of ten walking into a rum shop opposite, and call up two or three men and large boys to drink.
>
> The lady admitted the boy was her son, and explained that he and his companions were able to earn from three to five dollars a week by washing gold. When asked by Mrs. Farnham if she could not restrain her boy, she replied sadly:
>
> "No, I cannot. There are so many boys in town that do what you see him do, that it is impossible to stop one; and the fact is that out here our boys grow old very fast, anyhow. There is no school to send them to, and no church, and it's useless trying to make good boys of them, when they see men behave so badly, and hear so much swearing and bad language."[46]

It was the observation of such conditions during her first trip to California in 1848 that convinced Mrs. Farnham that the sole method by which community life in the mining settle-

[46] Eliza W. Farnham, *California Indoors and Out*, 357-359.
 Mrs. Farnham stated that at the time of her preparation of the above work, the middle eighteen-fifties, the state was rapidly remedying the school situation.

ments could be elevated would be the immigration of a sizeable number of refined single young women. She well realized also that there were many such in the East for which settlement in California would represent a definite opportunity. Hence on February 2, 1849, she announced a plan for bringing a number of young women to the Pacific coast, issuing a statement, a part of which is the following, ". . . Believing that the presence of women would be one of the surest checks upon many of the evils that are apprehended there, I desire to ask the attention to the following sketch of a plan for organizing a party of such persons to emigrate to that country. . . ." [47]

She proceeded to indicate that candidates must be at least twenty-five years of age, and present certificates of good character. She added also that the party would be limited to one hundred and thirty persons, each of whom would be obliged to contribute two hundred and fifty dollars toward the expense of the sea voyage.

The proposal received the support of the famous New York editor, Horace Greeley, but it was destined for failure. Mrs. Farnham was ill during the two months following the issuance of her announcement; moreover, virtually all of the girls who were willing and qualified to undertake the journey, saw no possibility of remitting the required two hundred and fifty dollars. As a consequence, when Mrs. Farnham finally returned to California, only three young women were accompanying her.

Four years later, or in the spring of 1853, the *Home Journal* of New York City also initiated a movement to encourage the emigration of unattached young females to the Pacific coast. [48] But like the enterprise of Mrs. Farnham, its results were insignificant. Still, while such projects were being contemplated and subsequently abandoned, the domestically-inclined young men of California had not been lax in seeking means of their

[47] *Ibid.*, 25-26.
[48] *The Home Journal* (New York, N. Y.), April 2, 1853.

own to learn of eastern girls who might be willing to risk a journey across the continent and help them establish a home. As might be expected, resorting to the devise of making their desires through advertisements was a common practice, even more so than it had been on the older frontier. But not all these bachelors had confidence in such a procedure, and many questioned their friends and acquaintances with the hope that they might know of girls in the older states who were willing to settle in the Far West. Taylor declared that during his sojourn in California, a "great many" young men sought from him intelligence regarding marriageable young women. This latter method resulted in a few happy marriages, and as might be expected, the arrival of refined eastern women very soon raised the moral tone in the mining camps. Writing in the late eighteen-fifties, Taylor testified that, "The introduction of virtuous women and good families is working a hopeful social reform throughout the mining regions." [49]

But observers realized that other promising sections of this "Last West" greatly needed well-intentioned girls as well as California. Writing from Denver on May 20, 1867, the noted publisher, Alexander K. McClure, mentioned the fact that in Colorado Territory the ratio of men to women was still ten to one, and declared that good female cooks could earn from seventy-five to one hundred dollars per month. [50] Commenting further upon the situation, McClure said, "The importation of several hundred virtuous and industrious single females into

[49] William Taylor, *California Life Illustrated,* 206; 285.

[50] Bell (*Pilgrim and Pioneer,* 506) relates an incident which confirms the fact that domestics received high wages in this period, and thus had ample funds for clothing. A five-year-old girl of Cripple Creek (about 1874) asked a Mrs. Kent if she were a "hired girl." Upon being asked why she had made such a supposition, the child shyly replied, "Cause you are dressed so fine."

Such would certainly indicate that many western wives were more concerned over the prospects of their adopted section, than over the latest fashions of the day.

Colorado would be a great benefaction, both to the females themselves and to the people of the territory." [51]

The completion of a railroad connection between Denver and the East in June, 1870, had one undesirable effect upon the territory. It was now relatively easy for the dance hall operators to import a type of young woman who could assist them in drawing profits from the mining and railroad camps. It will be recalled that in the eighteen-seventies, Colorado was the scene of railroad construction—not only of trunk lines— but a network of smaller railroads to serve the mining centers as well. Engineering problems caused these operations to be extended over a long period. The result was that Colorado was obliged to sustain the evils of the "terminal towns" for a longer period than other western states. [52] Saunders describes the young women at a dance hall in Garland City, Colorado, a temporary town of 1878 on the line of the Denver and Rio Grande Railroad. He said that many of the girls dancing with the rough men were not over twelve years of age. [53] Like McClure, he stressed the need for the immigration of large numbers of refined young women, and pointed out that the few who had arrived were already improving the life of the settlement.

There was never to be a mass movement of thousands of young homemakers to the Far West as many public spirited persons would have welcomed. But a small group of determined, mature, and well-educated women from the older states were to affect the future of the West more vitally than would a successful crusade to supply a good wife to every bachelor pioneer have done. They approached the West, however, not

[51] Alexander K. McClure, *Three Thousand Miles Through the Rocky Mountains*, 105.
[52] The practice of moving the buildings housing the stores, saloons, gambling houses, and dance halls, on cars whenever the construction of the roadbed had progressed well beyond these temporary metropolises, together with their unsavory reputation, won for them the appellation of "hell on wheels."
[53] William Saunders, *Through the Light Continent*, 48-50.
For a description of hotel life in another Colorado town, see Appendix, No. 7.

with the problem of female migration as a paramount interest. They came, rather, to enlist the support of the new states and territories for the cause of equal suffrage and women's rights. It seems pertinent, therefore, to summarize the gains and defeats which that cause had experienced in the older states during approximately two decades.

3. EASTERN SUFFRAGE LEADERS FACE WEST

The lady most often identified with this eastern feminist movement, Miss Susan Brownwell Anthony, was in one sense of the word a daughter of the timber-prairie frontier. She was born in South Adams, Massachusetts, on February 15, 1820. Her father, a manufacturer of cotton goods, was ruined financially by the Panic of 1837, and like thousands of other men, sought to repair his financial position by migrating westward. It will be recalled that western New York was settled about the time that the frontier development in Tennessee, Kentucky, and Ohio was taking place, and hence he settled in Rochester when the latter was still a "new community." Susan began to teach at the Canajoharie Academy at wages anything but lucrative, and the year 1848 found her very much interested in the cause of woman suffrage, and the friend of two other leaders in the movement, Mrs. Lucretia Matt, and Mrs. Elizabeth Cady Stanton.

Since these women lacked facilities for a widespread campaign of advertising, their first important meeting at Seneca Falls, N. Y. on July 19-20, 1848, was predominately local in character. Most of those who attended came in wagons and carriages. The nature of the discussions can well be imagined by noting the "Women's Declaration of Independence," which most of those who attended, signed. It is a rather good summary of what the advocates of women's rights considered to be their greatest grievances. It will be readily noted that it pos-

sesses almost the same style as do portions of the great declaration of 1776:

(1) He [man] has made her, if married, in the eyes of the law, civilly dead.

(2) He has taken from her all right in property, even to the wages she earns.

(3) He has made her morally an irresponsible being, as she can commit many crimes with impunity, provided they be done in the presence of her husband. In the covenant of marriage, she is compelled to promise obedience to her husband, he becoming to all intents and purposes her master— the law giving him the power to deprive her of her liberty and to administer chastisement.

(4) He has so framed the laws of divorce as to what shall be the proper causes, and in case of separating, to whom the guardianship of the children shall be given, as to be wholly regardless of the happiness of the woman—the law in all cases going on the false supposition of the supremacy of man, and giving all power unto his hands. . . .[54]

It will be also readily observed that the above resolution attempted to represent a composite of all state laws which the delegates of the convention considered to be objectionable and unfair. As already noted in the preceding chapter, several states had already repealed many of their more unjust laws pertaining to the rights of married women.

Nevertheless, this so-called "declaration of independence" attracted rather wide attention. One newspaper writer declared that the convention and its resolutions were the results of the activity of "divorced wives, childless women, and some old maids." Such discounting of their activities, however, did not deter the formation of plans for vigorous campaigns for equal rights in virtually all of the eastern and mid-western states. In spite of the fact that several influential and liberal

[54] A portion of the "declaration of independence" resolution, as quoted in Anthony, *Woman Suffrage*, I, 70-73.

men were lending their support for the movement in the East, the following portion of a letter by Mrs. Stanton seems to suggest that she realized the possibility of the first victories taking place in the commonwealths about to be formed in the West, "I see a brighter, happier day yet to come, but woman must say how soon the dawn shall be, and whether the light shall first shine in the East or the West."[55]

The first step of the suffrage campaigners following their initial meeting at Seneca Falls, was to hold an adjourned session of the convention in the nearby city of Rochester on August 1 of the same year. Miss Anthony took part in its deliberations, as did the chief sponsors of the earlier gathering, Mrs. Mott and Mrs. Stanton. Being held in a larger center and better publicized, this second convention attracted a few women from a great distance. The New York City *Evening Express* for August 7, 1848, reported that Mrs. Stanton read the "declaration of independence" which had gained the endorsement of the Seneca Falls meeting, and that one western woman was accorded a prominent place on the program. A Mrs. Saniford of Michigan delivered an address in which she stressed the right of women to vote and hold office. Other speakers declared that in the past men had appropriated all types of employment to the exclusion of women, but that in the future the weaker sex should be granted an opportunity to secure the lighter types of work, such as those of cashier and bookkeeper.

As far as the vocational demands were concerned, they were satisfied to a fair degree in the eighteen-fifties, due in a large measure to the accelerated exodus of men to the promising sections of the West. The female gains in the teaching field have already been noted, and the *Home Journal* of New York City for June 18, 1853, observed that because of the dearth of men, increasing numbers of women were being employed as wait-

[55] Letter of Elizabeth Cady to the Salem, Ohio, convention, Seneca Falls, N. Y., April 7, 1850. In Anthony, *Woman Suffrage*, I, 810-812.

resses in eating houses. But more interesting, perhaps, are the notations of two Englishmen who toured America late in the decade, and saw the effects of the movement westward upon the female vocational environment. "Women," they wrote, "find employment in America in many occupations confined to men in England, and in printing offices may be seen elegantly dressed and full-hooped women composing for the press." [56]

Several developments, however, were to prevent any gains in the direction of full suffrage until two decades after the New York meetings of 1848. Still the leaders worked with great determination. The first "National Woman's Rights Convention" was held at Worcester, Massachusetts, in October, 1850, and in the next few years the friends of suffrage formed several state organizations, those of a western commonwealth, Indiana claiming the honor of being the first to organize.[57] The women of this state organized a few weeks after the Seneca Falls convention. Nevertheless, the liberal-minded and influential men upon whom the feminists depended for support were more enthusiastic adherents of the prohibition and anti-slavery crusades. Equally unfortunate for this movement was the dress reform which a few of the suffragists advocated. This cause has been associated with the name of Mrs. Amelia Jenks Bloomer, who, for the greater part of her life, resided at Council Bluffs, Iowa.

In 1849, while still a resident of Seneca Falls, N. Y., Mrs. Bloomer took up the project of more drastic changes in the traditional attire of women. The type of garment which was to bear her name, however, is said to have first been conceived by a Mrs. Elizabeth Smith Miller. It has been said also that the rather full Turkish type of pantaloons suggested the idea of loose trousers gathered at the ankles. Eventually the name

[56] *The United States and Canada as Seen by Two Brothers in* 1858 *and* 1861, 120.

[57] C. C. Catt and N. R. Shuler, *Woman Suffrage and Politics*, 26.

"bloomer" was attached to any divided skirt or knickerbocker costume worn by women.

The only explanation that can be offered why Mrs. Bloomer was associated with this reform more than the other suffrage leaders, is the fact that from 1849 to 1854, she was the publisher of a periodical called the *Lily*. It was the first magazine of its kind to be supervised and edited by a woman. For its issues she wrote articles not only on the subject of dress reform, but also ones which criticized the injustice of existing marriage and voting laws.

Whether this publication could have been financed indefinitely is by no means certain. But soon after Mr. and Mrs. Bloomer had moved to the frontier town of Council Bluffs, Iowa, which then lacked railroad connections with the East, and hence rapid mail service, it was decided that to continue the publication of the *Lily* would be unfeasible. Hence it no longer appeared after 1854.

Whether the criticism and ridicule which the public at large heaped upon Mrs. Bloomer for advocating dress reform for her sex was one of the deciding factors in moving her family to a small town almost on the edge of the Great Plains, is not known. Nevertheless, it is a fact that Miss Anthony and Mrs. Stanton decided that they could not allow their co-worker to bear all the attacks of the conservatives. Both women made for themselves outfits of the new type, and for a time, wore them. But no handful of women, however courageous, could withstand the impact of an outraged public opinion of that day. They were shrewd enough to realize very soon that unless they quietly abandoned their proposed mode of dress, the other objectives of the feminist program would very likely be impossible to attain. So abandon it they did. Still, if the public refused to accept their reasons for a clothing change, at least these women learned that they should advocate but one reform at a time.

Two comments upon this episode might be mentioned. A

British citizen who was a resident of America during this period declared, ". . . There were ladies in the rural districts and some of wealth and position who engaged in this movement, assumed the dress, and advocated its use . . . but their influence and example were powerless against fashion and crinoline." [58]

In a letter to the editor of the *London Punch,* a writer who called herself Theodosia E. Bang, M. A. of Boston, said, ". . . Mohammed warred under the petticoat of his wife Kadiga. The American female Emancipist marches on her holy war under the distinguished garment of her husband. . . ." [59]

In the midst of this bitter controversy, some intelligent individual might have defended those proposing the dress reform, by pointing out the fact that a similar attire had been worn by women on the frontier for at least a quarter of a century. It was noted by B. R. Hall, who resided in Indiana during the eighteen-twenties. He wrote that he first saw a female in such a costume while out riding one September morning. Continuing his narrative, Hall described the woman in this manner:

A strange figure emerged from the tall rank weeds into the road before us, and continued to move in front, apparently never having noticed our approach. The figure was undeniably human; and yet at bottom it seemed to be a man, for there were a man's tow-linen breeches; at top, a woman; for there was the semblance of a short gown, and indeed a female kerchief on the neck and a sun-bonnet on the head. . . . It originated in the necessities of a new country, where women must hunt cows hid in tall weeds and coarse grass on dewy or frosty mornings. [60]

[58] Thomas L. Nichols, *Forty Years of American Life,* II, 23-24.
[59] *Harper's Magazine,* III (August, 1851), 424.
The date and place of the letter are not cited.
[60] B. R. Hall, *The New Purchase,* Second Edition, 201.

Although rather seriously hampered by apathy toward their cause which the above experiment had incited, the zealous feminist leaders did concentrate upon the objective of equal suffrage. Two developments seemed to be in their favor. They had succeeded in obtaining the support of many prominent abolitionist leaders, including Theodore Parker, William Lloyd Garrison, Wendell Phillips, Ralph Waldo Emerson, and Henry Ward Beecher. Encouraging also was the fact that three new western states, Minnesota (1858), Oregon (1859), and Kansas (1861), all adopted constitutions with liberal provision for the rights of women. These privileges in general included the right of women, both married and single, to hold property, make a will, dispose of their own earnings as they saw fit, and more voice in the rearing of their children in the event of divorce. It will be recalled that all of these categories were subjects of complaint in the "declaration of independence" of 1848. Another indication of the progress made by the outbreak of the Civil War, is indicated by a statement of Miss Anthony before the tenth annual national suffrage convention, held in New York City on May 10, 1860. She announced that, "the press has changed its tone. Instead of ridicule, we now have grave debate." [61]

By the close of the struggle over the slavery question, women had made noteworthy progress toward breaking down prejudice against their entering certain trades and professions. In the momentous year of 1848, Miss Elizabeth Blackwell received the degree of Doctor of Medicine from Geneva Medical College. Since the idea of a woman becoming a physician did not meet with popular approval during the period of her professional study, even the other lodgers at her boarding house refused to speak to her. But western communities, often short of physicians and dentists, were less particular as to which sex pro-

[61] Anthony, *Woman Suffrage*, I, 688-689.

vided those trained to heal physical ailments. The *Illinois Republican* of April 10, 1850, declared, "Female doctors are becoming all the rage." The returns of the census taken two decades later disclosed that the early hostility toward women entering the professions was breaking down, since they showed that there were 525 female physicians in the United States.

Then too, women had entered the employ of the federal government. As early as 1854, there were 128 "postmistresses" in the nation,[62] and during the Civil War, several departments at Washington began to engage females for clerical work. Moreover, according to the census of 1870 showed for the nation as a whole, a total of 1,836,288 females gainfully employed.[63]

Important also was the fact that many women had acquired economic influence as a result of inheriting the property of male members of their families who had lost their lives in the recent war. In this connection it should be pointed out that the Civil War deaths did not create a shortage of males in the country as a whole, since single immigrants continued to arrive from Europe in numbers sufficient to maintain a preponderance of males.[64] But it is also true that these newcomers generally possessed but slender financial resources. Hence the percentage of the national wealth in the hands of women rose rather substantially in the decade known as the eighteen-sixties, a fact which those interested in the development of western states were not to overlook.

Also it would seem that the assistance rendered by women in the development and defense of the frontier, together with further demonstrations of their ability to assume responsibility during the years of civil conflict, would have created for them

[62] *Quincy Whig*, July 10, 1854.
[63] *Report of the Ninth Census of the United States*, I, 686.
[64] According to the Census of 1860, there were 105.3 males to every 100 females in the United States, while the returns for 1870 indicated 102.8 males for each 100 females.

a rather sound claim to the voting privilege in 1865. But the anti-suffragists now stressed the argument that since men alone defended the nation in times of war, they alone should enjoy the elective franchise. Among those embracing this view was one of the former supporters of equal voting rights, Horace Greeley.

Actually, however, the conflict had shown to both North and South the indispensability of many services which women were capable of performing in such a time of crisis. The making of clothing and bandages, and nursing the wounded in the army hospitals, represent feminine war activities on both sides of the lines. But what is far more surprising, is the fact that the western environment produced a number of northern and southern young women who were actually willing to fight beside the men. The *Quincy Whig and Republican* for April 12, 1862, contained a description of an attempt of the Confederate recruiting officers to obtain volunteers at Palo Alto, Texas. Upon noting that but five men responded, fifteen girls stepped forward and declared that they would join those leaving for the front unless their places were taken by men. The article was concluded with the terse statement, "They were."

In the states of the Union which were then regarded as "western," several young women actually succeeded in disguising themselves as males, and in serving in the armies of the United States for surprising lengths of time before their sex was discovered. The *Home Journal* for April 2, 1864, told of a Miss Frances Hook of Chicago who assumed the name of Frank Miller and enlisted in the Nineteenth Illinois volunteer regiment. After being taken as a prisoner by the Confederate forces near Chattanooga, she was shot in the leg while attempting to escape. It was only then that her sex became known. She was subsequently exchanged. Interesting also is the case of Miss Sarah E. E. Seelye. She enlisted on May 17, 1861, in

the Second Michigan volunteer infantry, and was honorably discharged nearly two years later, or on April 19, 1863.[65]

As wage earners, as holders of property, and hence taxpayers, and as potential defenders of their country, therefore, it would seem that women were entitled to the ballot in 1865. But evidently what afforded leaders such as Miss Anthony the greatest hope was the idealism, after a fashion, that existed. The Northern political leaders were about to amend the federal Constitution to permit the extension of citizenship and suffrage to the "freedmen" of the South, and there seemed reason to hope that any such amendments would include the women of the country as well. Since prior to the war, many staunch abolitionists had tendered a favorable gesture toward the suffrage cause, such hopes were hardly unfounded. But bitter disillusionment was in store for the advocates of equal rights.

While visiting her brother at Leavenworth, Kansas, in the summer of 1865, Miss Anthony read the proposed draft of the Fourteenth Amendment to the Constitution. This text seemed to make it clear that the congressional leaders were determined to accord the ballot to men of African descent, but not to white women. Needless to say, Miss Anthony and her colleagues were much aroused over what they termed the "backward step of writing the word *male* into the Constitution." Protests con-

[65] The author is greatly indebted to the office of the Adjutant General of the United States for confirming the fact that several women entered the military service of the Government during the war period of 1861-1865. A portion of the letter from that office is quoted below:

The records show that a number of women served in the military service of the United States during the period of the Civil War. . . .
A record of correspondence on file in this office shows that one Sarah E. E. Seelye claimed service in Company F, 2d Michigan Volunteer Infantry, under the name of Franklin Thompson, and for which it appears she received a pension.
The records show that Franklin Thompson was enrolled May 17, 1861, at Fort Wayne, Michigan; was mustered into service May 25, 1861, as a private of Company F, 2d Regiment Michigan Infantry, and was honorably discharged April 19, 1863. . . .

Major General E. S. Adams to William Forrest Sprague, Washington, D. C., December 9, 1938.

tinued to pour in to congressmen for several months, or until the proposed amendment had passed both houses of the national legislature and submitted to the states on June 16, 1866. The cause would have been far less devoid of hope, had the ardent friends of emancipation not become lukewarm in their attitude toward it, once their own pet objectives seemed assured of consummation. Wendell Phillips and Horace Greeley seemed especially guilty of deserting their suffrage associates. Their attitude and that of the congressional leaders was that the period was "the Negro's hour." On the other hand, the feminine leaders felt they should certainly not be ignored if an amendment extending voting rights was to be drafted.[66]

Despairing of the help of either Congress or the so-called liberals of the East, the women turned to the states. The New York constitutional convention of June, 1867, seemed to offer an opportunity. But Horace Greeley, as chairman of the Elections Committee, submitted an adverse report on the proposal for woman suffrage, and hence it failed of adoption. The suffrage movement failed also to register any progress in other states of the East or Middle West. Not one seemed to offer hope of extending the ballot to women at an early date. Old ideas, old standards seemed firmly entrenched.

Smarting under their many eastern defeats, but sustaining no loss of zeal or determination, the exponents of equal rights turned their faces westward. There they were to find men who had lived for nearly twenty years in an environment which labored under the handicap of too few female settlers. The resultant contact was, in a sense, a turning point in American political and social history.

[66] Francis Minor, "Woman's Legal Right to the Ballot," *The Forum,* II (December, 1886), 351-360.

4. WOMEN POLITICALLY EDUCATING THE WEST

The success of the new strategy of the feminist leaders was of course not immediate. Western voters were no more anxious than their eastern brothers to sanction any arrangement that would contribute to the degradation of womanhood; hence, they weighed carefully the poignant argument of the anti-suffragists that equal voting rights would likely produce such a result.

The western suffrage campaign began in Kansas. The reader will recall that this commonwealth is one of that tier of states whose eastern portions are in the "timbered country," while approximately the western halves belong to the Great Plains area. Local conditions in the state during the post-war years were not unpromising. The first constitution, that of 1861, had granted women the right to vote in all school elections. While in some sections, the women manifested no eagerness to exercise this prerogative, in others they would turn out to vote almost *en masse*. Many were elected school officials, and apparently filled such offices in an entirely satisfactory manner. Richardson was impressed by the business ability that these women displayed in drawing up plans for new school buildings, receiving bids, and letting the contracts. His comment was, "Nowhere did I hear a single complaint against the practical workings of the law." [67]

In 1867 the state legislature submitted to the voters of Kansas, two proposals for constitutional amendment: one to extend the ballot to Negro males, and the other to accord full voting privileges to women. In addition to the apparent feasibility of women school suffrage, there were other grounds for believing that the voters would act favorably upon the referendum for female voting rights. The republican governor and a majority of the papers of the state were supporting the

[67] Richardson, *Beyond the Mississippi,* 555.

proposed amendment, and not yet had its backers despaired of
receiving favorable words from the *Anti-Slavery Standard,*
edited by Wendell Phillips, the *Independent,* headed by
Theodore Tilton, and the *New York Tribune* controlled by
Horace Greeley. But all of these eastern publications withheld
any statement of support, and evidence was not lacking that
powerful eastern republicans urged their fellow partisans of
Kansas to support the amendment for Negro suffrage, but not
the one granting the vote to the other sex.[68]

In spite of their intensive campaign, therefore, the woman
suffrage crusaders were doomed to defeat. Still, it was not a
defeat which heralded failure in the entire West. Prominent
leaders of the movement were convinced that the influence of
eastern politicians and the silence of powerful eastern publica-
tions had contributed to their failure. For these campaigners,
the struggle in the West had only begun.

Luckily for the suffrage crusaders, there was extant no public
opinion against American women traveling alone. As early as
1851, Miss Bang had declared:

> The American female—for I do not like the term Lady,
> which suggests the outworn distinctions of feudalism—can
> travel alone from one end of the states to the other; from
> the majestic waters of Niagara to the mystic waters of the
> Yellowstone; or the rolling prairies of Texas. . . .[69]

The matter of finance often threatened to hinder the speak-
ing tours of Miss Anthony, Mrs. Stanton and other prominent
suffrage workers. But it appears that Miss Anthony's tours
were financed at least in part by suffrage organizations, and
Mrs. Stanton in 1869 was successful in gaining a place on the

[68] The *New York Herald* (New York, N. Y.) of October 2, 1867, mentioned
this campaign and confirmed Miss Anthony's belief that Horace Greeley was no
longer among the friends of equal rights.

[69] Theodosia E. Bang to the editor of the *London Punch,* n. p., n. d., *Harper's
Magazine,* III (August, 1851), 424.

staff of the Lyceum Bureau, which sent speakers of note on tours. During her twelve years of association with this agency, she had many opportunities to travel in the West and to further its political education. Both she and Miss Anthony went to the Pacific Coast in 1871, where they made many speeches at important points.

It fell to Mrs. Stanton to speak at Salt Lake City. She declared that the Mormon women usually took their rather numerous children with them to meetings, since they seldom had servants. She describes the resultant difficulty as follows:

> It was rather trying to me at first to have my glowing periods punctuated with a rhythmic wail from all sides of the hall; but as soon as I saw that it did not distract my hearers, I simply raised my voice, and with a little added vehemence, fairly rivaled the babies.[70]

It seems to have been during either the eastward or westward journey of this tour that she had an opportunity at Lincoln, Nebraska, to stage what might be considered a typical example of the nature of the political education which these women imparted to western settlements.

A celebration was being held over the completion of a railroad. One of the speakers of the occasion said in the course of his address, "This state was settled by three brothers, John, James, and Joseph, and from them have sprung the great concourse of people that greet us here today."

Mrs. Stanton then turned and asked the governor of the state, who was seated near her on the platform, if all the people had sprung, Minerva-like, from the brains of John, James, and Joseph. Mrs. Stanton continued thus:

> He urged me to put that question to the speaker; so in one of his eloquent pauses, I propounded the query, which

[70] Stanton, *Eighty Years*, 285-286.

was greeted with loud and prolonged cheers, to the evident satisfaction of the women present. The next speaker took good care to give due need of praise to Ann, Jane, and Mary.[71]

Another suffragist who helped to impart liberal political ideas to the West, was Mrs. Abigail Scott Duniway. She was also a "daughter of the frontier, born in Tazewell County, Illinois, in 1834, and in 1852 went to Oregon with her father, invalid mother, and a large number of brothers and sisters. The man she married, Mr. Ben Duniway, seemed to be a promising young rancher, but not long after their union, an injury incapacitated him for active work, and Mrs. Duniway had the task of supporting him and their children.

But she was able to find time to be active in the suffrage movement, and when Miss Anthony visited the Pacific Coast in 1871, the two women founded suffrage organizations both in Oregon and in Washington Territory. Like her two famous co-workers of the eastern states, she was very capable of phrasing prompt retorts to all who would, by any inference, challenge the claim of women to equality with men. On one occasion a local judge said to her, "Of course, Mrs. Duniway, you are a lady, you are not expected to understand the intricacies of the law."

"But we are expected to know enough to foot the bills, though," was her prompt rejoinder.

One of the most common of the stock arguments of these suffrage lecturers in this period, was the hard lot of the pioneer wives and mothers on the timber-prairie frontier. Promptness on their part to associate this memory with the suffrage cause, is borne out by a conversation recorded by Mrs. Duniway between herself and her brother, Mr. Harvey W. Scott:

[71] *Ibid.*, 301-302.

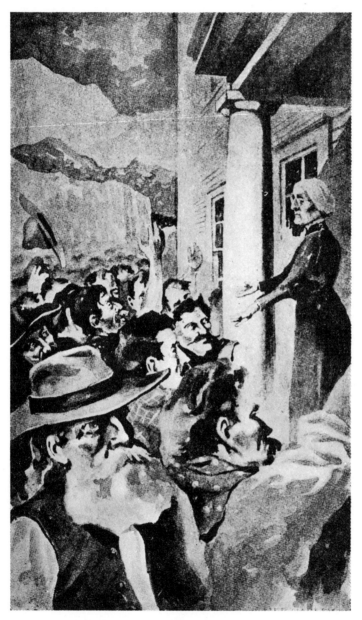

MISS ANTHONY ADDRESSING THE MINERS
(From Bell, *Pilgrim and Pioneer*)

He told me once . . . that sometimes he would awaken at night, and recalling our mother's arduous lot, would rise and pace the floor, the victim of unavailing retrospection and regret. "Yes, brother," I said in reply, "and her memory, added to my own experiences, and those of our surviving sisters, led me long ago to dedicate those maturer years of my life to the enfranchisement of women." [72]

That the arguments of these leaders deeply impressed large numbers of western men, there can be but little doubt. Miss Anthony spoke to a group of miners at Lake City, Colorado, in the centennial year, 1876. As might be expected, she summarized the legal and political handicaps of women. In addition, she made two interesting statements regarding the economic position of her sex, "Woman will be ruled by man as long as man holds the purse strings. . . . If woman has equal wealth and equal independence, she will be another individual." [73]

When she had finished, a "half acre of bronzed-faced miners" accorded her their applause. They also acquiesced to this statement of one of their number, "You are quite right, my good lady, we shall stand behind you until full justice is done your sex in Colorado."

The fact that the latter state became the second in the nation to embrace equal suffrage is an indication that they probably kept their word. Although Miss Anthony's words soon died away in the western winds, the author believes her remarks concerning the economic status of the two sexes represent truisms, the pungency of which will be increasingly appreciated as the twentieth century progresses.

Another of these campaigners, one who also included the semi-tragic narrative of her pioneer mother among her arguments, was Dr. Anna Howard Shaw. One of her instatements

[72] Duniway, *Path Breaking*, 8-9.
[73] Bell, *Pilgrim and Pioneer*, 259-262.

reveals the intensity of the equal rights crusade in the West during the eighteen-nineties:

> Of the preliminary suffrage campaigns in Kansas made in company with "Aunt Susan," I have already written. . . . In 1890, '92, and '93, we again worked in Kansas and in South Dakota, and with such indefatigable and brilliant spirits as Mrs. Catt (to whose efforts also were largely due the winning of Colorado in '93). . . . In '94, 95, and '96, special efforts were devoted to Idaho, Utah, California, and Washington. . . .[74]

But while these speaking tours were in progress, other women were indirectly but convincingly demonstrating to the West that their sex was qualified for the responsibilities of public life. In spite of the relative paucity of females in this section of the nation, members of that sex very early established schools in the new communities. This was true even in Nevada where the preponderance of males in the population was especially heavy. The first woman to settle in Carson City, Miss H. K. Clapp, formerly of Ypsilanti, Michigan, founded the "Sierra Seminary" in 1860.[75] Moreover, with the preoccupation of the large mass of even the well-educated men with more profitable pursuits, the majority of the western public school teachers were women by 1870.[76] Since the teacher in most small communities must necessarily be something of a public character, western residents were afforded ample opportunity to observe that public life need not cause the feminine character or personality to deteriorate. And incidentally, probably few would

[74] Shaw, A Pioneer, 242-243.
"Aunt Susan" designated Miss Susan B. Anthony.

[75] H. H. Bancroft, History of Nevada, Colorado, and Wyoming, 1540-1888, 171.

[76] By compiling figures as reported in the Ninth Census of the United States, I, p. 452, it was disclosed that in twelve western states and territories, California, Colorado, Dakota, Idaho, Kansas, Montana, Nebraska, Nevada, New Mexico, Oregon, Washington, and Wyoming, 2,708 teachers were males, while 3,054 were females.

dispute the assertion that efforts for public education in the West would probably have been severely handicapped, had female instructors not been available.

While the activities of the feminists during the three decades following the Civil War were not confined to the Far West, it was there that the outlook for ultimate success appeared most sanguine, since in most eastern states, the movement was often opposed by the politicians and the "better element" alike. How the West aided the cause of equal rights will be discussed in the following chapter.

CHAPTER V

THE LAST WEST GIVES EQUAL SUFFRAGE ITS FIRST CHANCE

1. THE WYOMING EXPERIMENT

Wyoming Territory was formed by detaching portions of the older territories of Dakota, Idaho, and Utah, in accordance with an act of Congress of July 25, 1868. Organization of this region of 97,883 square miles, larger than Illinois and Indiana combined, was prompted by two developments. The construction crews of the Union Pacific Railroad had reached the southern part of the area, and it was evident that a more efficient administration than the officers of Dakota Territory could furnish, was imperative. Also, the discovery of gold quartz in the valley of the Sweetwater River in 1867, had resulted in a modest "rush" of prospectors from California, Nevada, and Colorado, to the vicinity of South Pass City. President Grant named Mr. John A. Campbell the first governor, and he assumed his office on April 15, 1869. Cheyenne was designated as the territorial capital.

It might be said that woman suffrage in Wyoming was the product of four unique conditions. In the field of politics, the failure of the woman suffrage referendum in Kansas two years previous, had been laid at the door of the eastern republicans. Hence some of the Wyoming democrats believed they could improve the position of their party at large by supporting a move permitting the women of the territory to vote.

A second explanation involves the administrative problems of the new district. Unlike older territories of both East and West, Wyoming did not have the opportunity to extend its

jurisdiction as immigration expanded the existing mining or agricultural communities. On the contrary, the completion of the railroad across the southern portion of the territory, and the presence of mining camps along the rivers and creeks farther north, necessitated the immediate extension of all governmental services and responsibilities to virtually the entire territory. Instead of organizing counties of normal size as the inflow of settlers required, the year 1869 found all of Wyoming divided into five longitudinal strips; counties bearing the names of Laramie, Albany, Carbon, Sweetwater, and Unitah.[1] Little wonder, then, that the aid of the western woman was sought to solve the resultant problems.

Moreover, there was another administrative difficulty that concerned the permanent resident. The territorial election of August, 1869, had shown the power of the transient voters, those who did not intend to make Wyoming their home. This group included railroad employees, miners, those stationed at army posts, and cowboys, for Wyoming in those years was "the center of the open cattle range."[2] Nothing could seem more evident than the ability of women voters to strengthen the position of the "home element" at the polls.

Finally, it should be recalled that most property holders in the West hoped for the time when immigration would enhance substantially the value of their holdings, and that in Wyoming it was evident that people must come in quickly, else taxes would be uncomfortably high. The problem of taxation very early attracted the attention of Governor Campbell; he ordered that assessments should be as light as possible.[3]

Available evidence, therefore, impels the statement that another cause for the institution of woman suffrage in Wyoming was what might be called "a real estate man's attitude." The

[1] F. B. Beard, *Wyoming from Territorial Days to the Present,* I, 210-211.
[2] "Diary Kept by W. A. Richards in the Summer of 1873," *Annals of Wyoming,* VIII, 492-505; William M. Thayer, *Marvels of the New West,* 350.
[3] Beard, *Wyoming,* I, 210-211.

region hardly possessed mining or resort potentialities equal to those of California or Colorado, still settlers were badly needed. In the East, women had just lost decisive contests for the elective franchise, the attitude of the suffrage leaders seemed to indicate that many women desired the ballot most ardently, and moreover, not a few women now had money to invest, or were in a position to influence their husbands in the selection of a new home. Whether the experiment were successful or unsuccessful, it would lend a feature so important in land sales, namely, publicity. This hope for actual profits from the adoption of woman suffrage is confirmed by a statement which the famous humorist E. W. Nye, who was acquainted with conditions in Wyoming in this period, ascribed to a mining prospector, Buck Bramel:

> I don't know what kind of a fist the women will make of politics, but I am prepared to invest with surface indications. The law may develop a true fissure vein of prosperity and progress, or a heart-breaking slide of the mountain. . . . It'll take time to show what there is in it. My opinion is that women can give this Territory a boom that will make her the bonanza of all creation.
> We've got mighty pretty blossom rock already in the intelligence and brains of our women—let us be the means of her advancement and thus shame the old and mossy civilizations of other lands. Thus in time we may be able to send missionaries to New England. I cannot think of anything more enjoyable than that would be. . . .[4]

But these political and economic factors, favorable as they were for the cause of female suffrage, probably would not have alone made possible the experiment. But among the few women who settled at South Pass City during the boom period of 1867-1868, was Mrs. Esther McQuigg Morris, who has already

[4] Statement of E. W. Nye in *Collections of the Wyoming Historical Society,* I, 264-267.

been mentioned as an example of the western women who performed unusual acts of good-neighborliness. **Prior to her** migration westward, she had heard a speech of Miss Anthony, and had become an enthusiastic supporter of the suffrage program.

Before the legislative elections of September 2, 1869, she invited several men who were candidates for the territorial assembly and influential in politics, to her home for dinner. At these repasts, she appears to have gained powerful support for the later legislative bill to enfranchise women. One might ask, however, "Is it not unusual that politicians should both readily make and keep promises regarding such an important matter?"

The reply would be, that even in the second quarter of the twentieth century, the lack of suitable eating accommodations for single men and travelers in parts of the West, renders an opportunity to eat a normal meal in a home, a favor not likely to be discounted. Such prospective guests usually are already aware of the problems involved in preparing palatable meals, and are not likely to leave the table of their hostess except with an enlarged appreciation of the contributions of women to the dusty, sagebrush environment of the plains-mountain area.

One guest of Mrs. Morris, Mr. William H. Bright, not only was elected to the territorial council, or upper house of the legislature, but also was chosen president of that body. Shortly after the legislature convened on October 12, 1869, he sponsored a bill granting the voting privilege to all women over eighteen years of age. It passed by a vote of six to two, and then went to the territorial house of representatives. There it was referred to a special committee, which soon recommended its passage. When it was debated on the floor of the house on December 6, its chief opponent was Representative Ben Sheeks. He sought to postpone consideration of the measure until July 4, 1870, and when that move failed, he moved that the term "ladies" be used to replace "women" on the bill, and that it be

amended further to include the words "all colored women and squaws."

Needless to say, both proposals failed, although the house did amend the bill in order to make the minimum voting age twenty-one years, instead of eighteen. It then passed by a vote of six to four, with one member absent.[5] The council accepted the change in the minimum voting age, and Governor Campbell signed the bill on December 10. The final draft of the law read as follows:

> Section 1. That every woman of the age of twenty-one years, residing in this territory, may, at every election to be holden under the laws thereof, cast her vote. And her rights to the elective franchise and to hold office shall be the same under the election laws of the territory, as those of electors.
> Section 2. This act shall take effect and be in force from and after its passage.[6]

Prior to its adjournment in the same month, December, 1869, this legislature adopted other laws of the type demanded by eastern feminists. One concerned property rights. It provided that the assets owned separately by a married woman, could not be subjected to "disposal, control, or interference" by her husband. Another stated that for all positions in the government of Wyoming Territory, women would enjoy the same compensation as men, for the same type of work. Obviously, school teaching was included in the above category, and rendered the act rather significant, since great as the demand had been on the older frontier for both female residents and well-trained teachers, the women who had entered the schools usually received but a fraction of the salaries paid to men.

Interesting also, is the fact that the newly enfranchised group almost immediately gained an opportunity of fulfilling a duty

[5] Beard, *Wyoming*, I, 216-218.
[6] G. R. Hebard, "The First Woman Jury," *Journal of American History,* VII (November 4, 1913), 1293-1341.

which accompanies the voting privilege. Strangely enough, such seems to have been suggested in the arguments of the anti-suffragist, Ben Sheeks. As a final attempt to block the suffrage bill, he had proposed an amendment that "women who exercise the voting franchise shall perform all the other duties of citizens." The latter, like all the other obstructive motions of this legislator, was voted down. But several women of the territory soon found opportunities to accept his challenge. Mrs. Morris, who had been instrumental in creating among the members of the legislature, sentiment in favor of the equal rights measures, became what is tantamount to the first woman judge in the United States. She was chosen as the justice of peace for her home community, South Pass City. In the frontier sections of Wyoming, this position involved many of the duties of judges of local courts, but Mrs. Morris is said to have made such judicious decisions, that not one of them was appealed to a higher tribunal.

Many other women saw service as jurors. On March 7, 1870, a female grand jury, including a lady bailiff, was chosen at Laramie, Albany County. The officiating Chief Justice Howe of the territorial supreme court addressed the jurors at the beginning of their deliberations as follows:

> It is a novelty to see, as we do today, ladies summoned to serve as jurors. The extension of political rights and voting franchise to women is a subject which is agitating the entire country. . . . The eyes of the world are today fixed upon this jury in Albany County. There is not the slightest impropriety in any lady occupying the position, and I wish to assure you that the fullest protection of the court shall be accorded to you.[7]

At the same session of the court a petit jury of six men and six women was picked to try a murder case. A Mrs. I. N.

[7] *Bureau County Patriot* (Princeton, Ill.), March 22, 1870.

Hartsough was selected as the foreman. Unlike most modern juries composed of both sexes, the deliberations of the members of each sex were held in separate rooms. Nothing developed to give rise to any authoritative assertions that the innovation was not a success. The famous paper of Horace Greeley, no longer a firm supporter of the suffrage movement, could only announce, "The ladies of the jury were much fatigued. They were four days and nights in coming to an agreement."[8]

In his message to the next session of the territorial legislature Governor Campbell declared:

> There is upon our statute book "an act granting the women of Wyoming Territory the right of suffrage and to hold office," which has now been in force two years. Under its liberal provisions, women have voted in the territory, served on juries, and held office. It is simple justice to say that the women, entering for the first time in the history of the country upon these new and untried duties, have conducted themselves in every respect with as much tact, sound judgment, and good sense, as men. . . ."[9]

The importance of these developments in Wyoming was not that any great number of women were to vote, serve on juries, and hold office during the territorial period, but rather that the country at large had an opportunity to observe the success or failure of the experiment. It is interesting to note that the statements of both Governor Campbell and Judge Howe disclose the liberal attitude of the men of the West toward the opposite sex. Nor was Judge Howe entirely incorrect when he said that the "eyes of the world" were upon the innovation. Upon receiving reports of the employment of women for jury service in Wyoming, King William of Prussia sent a cablegram

[8] *New York Weekly Tribune*, March 16, 1870; *Oregon State Journal*, April 10, 1870.
 The decision in this case was "Manslaughter in the first degree."
[9] *Council Journal, Wyoming Territory, Second Session*, 10-20.

of congratulations to President Ulysses S. Grant upon this "evidence of progress, enlightenment, and civil liberty in America." [10]

Pine, who described the possibilities of Wyoming soon after· the enactment of the famous law, seems to have shared the view that it would aid in attracting residents. He wrote:

> The law here gives both sexes the same rights as to voting; and that class of ladies who truly wish to enjoy such privileges, can very soon (with the present traveling facilities) not only see, but be landed in a short time safely in this promised land for them. . . .
>
> Incidentally we would also say that most of these legislators are traveling the road of life alone, as is (are) also most of the large hearted men in this country, and those single ladies who come here to have their rights (denied them at home) will, on coming here, be more fully persuaded that it is not good always to live alone, more especially among a class of such men who are the first to offer them all the civil and political privileges they possess. [11]

If any of the Wyoming settlers of 1869 entertained any serious hope that woman suffrage would make their political unit "the bonanza of all creation," they were of course destined for disappointment. Still, there was disclosed nothing to indicate that woman suffrage could not be a success elsewhere. In the words of Catt and Shuler, "Wyoming served as the leaven which lightened the prejudices of the entire world." [12]

Both the history and fiction of this plains-mountain frontier point out the difficulties of law enforcement in this period. It seems significant, therefore, that one territory, in the very heart of the last West, sought the aid of women to solve the

[10] G. R. Hebard, "The First Woman Jury," *Journal of American History,* VII (Nov. 4, 1913), 1293-1341.
[11] George W. Pine, *Beyond the West,* 181-182.
[12] *Woman Suffrage,* 84.

problem of administering justice, and they apparently assisted with success. Moreover, the same winter which saw the establishment of equal political rights in Wyoming, witnessed an entirely different set of circumstances extending the right of the ballot to the women of another territory.

2. MORMONISM AND THE UTAH SUFFRAGE EXPERIMENT

The Mormons were a problem for the American West for more than half a century. The group, whose full name is the "Church of Jesus Christ of Latter Day Saints," had its origin in the state of New York in the late eighteen-twenties, and after making Kirkland, Ohio, and then the vicinity of Independence, Missouri, their home for brief periods, they obtained a municipal charter very favorable to themselves from the Illinois authorities, and settled at Nauvoo, a site on the eastern bank of the Mississippi River, nearly opposite the mouth of the Des Moines, in 1839.

It is well-known that at none of these localities did they succeed in living peaceably with the people of circumjacent communities. The underlying causes for the resultant antagonism should not be hastily determined. One of the assigned causes is that in Illinois they were charged with attempting to create a "state within a state." But the average frontier mind had not allowed itself to be brought to an attitude of frenzy with the hate of those known to have had a part in the plot of Aaron Burr or the formation of the "State of Franklin." [13] In fact, many frontiersmen almost seem to have been strangely tolerant or indifferent toward those attempting revolts.

Was this anti-Mormon feeling, then, more due to the diligence of the latter? Was the none too aggressive and very

[13] A government set up in the present state of Tennessee in defiance of the North Carolina authorities, by John Sevier and his associates. It existed but three years or from 1785 to 1788.

individualistic type of Westerner jealous of the material gains of the "Saints"? This explanation also has been suggested, but on the other hand thousands of men by their hard work or speculation acquired comfortable fortunes in the various frontier states without arousing the ire of the population as a whole.

In seeking a third condition as a possible explanation, one will recall that reports of polygamous practices among the Mormons, were circulated far and wide. Could it be assumed that this feverish antagonism was the product of a sheer sense of decency among the western men of the eighteen-thirties and eighteen-forties?

Very likely such was not exactly the case, otherwise the Mormons, however fiendish they might have been portrayed, could not have been the sole victims of their wrath and violence. What seemed to irk the western man more than any of these alleged propensities of the Mormons, was the fear that the sect would attract many women. In Missouri, Illinois, and Utah, the "Saints" were in an environment where many men could not attain a normal, monogamous existence because of the scarcity of marriageable females.

Then it is well to bear in mind that few new religions with energetic leadership have failed to attract sizeable numbers of American women as converts. That such must have been true in the case of Mormonism could be supported by the fact that in 1860, Utah alone of all the new territories of the West, had a female population which almost equaled that of the male.[14]

It also seems fairly clear that men near the Mormon settlements had some grounds to fear that the stability of their homes, as well as the safety of their daughters, might be threatened. The skill of the Mormons in spreading their ideas among the "Gentile" [15] women near Nauvoo can be shown by two brief episodes. Early in 1844, when the great storm against the

[14] The Census of 1860 reported for Utah 20,178 males and 19,947 females.
[15] A term used by the Mormons to designate any non-member of their faith.

Mormons was brewing, the "Gentile" men of nearly communi-
ties adopted the slogan of "One country, one wife, one home." [16]

Two years later, when the great Mormon trek westward
began, the fears of several husbands and fathers were shown
not to have been groundless. Their wives deserted them, took
the children, and joined the emigrating "Saints." When the
outraged husbands registered loud complaints, one Lieutenant
Prentiss of the United States army was detailed to adjust
matters.[17]

While it can be said without hesitation that the vast majority
of western women would never have been shaken by the argu-
ments of the Mormons, the fear of their being converted to the
new faith was probably the chief cause of the so-called
"Mormon Wars." Beadle seems to have summarized very well
the attitude of western men who pondered over the Mormon
question:

> There being one woman to one man in the world at large
> —not nearly so many in the Territories—and all men being
> "created free and equal," who gave one man the right to
> take five men's share of womanly sweetness? What robbery
> so bad as that which robs a man of any chance for a wife or
> domestic sweetness? [18]

The removal of the bulk of the Mormon population to Utah
in the years 1846 and 1847 provided them with something like
isolation for two decades, since high mountains and unhospit-
able deserts separated them from the rest of the United States.
Since in Utah the women represented a larger portion of the
total population than in other far western territories, it seems
pertinent to discuss their hardships at some length. While

[16] *Quincy Whig*, February 24, 1844.
[17] *Ibid.*, February 28, 1846.
[18] Beadle, *The Undeveloped West*, 144.

no doubt the Mormon officials would have preferred that these could have been avoided, such was physically impossible.

In the first place, few Mormon women could have had that confidence that one day the West would bring them wealth, a state of mind which enabled so many of their sisters of other territories to keep cheerful amid dust, wind and isolation. Moreover, since Utah was the oldest Anglo-American settlement between the Missouri River and the Pacific commonwealths, it was obliged to endure semi-isolation for a longer period. How this effected the women can be seen from their manifestations of joy when the "Forty-Niners" appeared. They hoped that goldseekers could proffer some news of their friends, or old communities. Said Ferguson:

> They would stop us on the streets and call to us from the doors of their houses to come in, so anxious were they to learn where we had come from, hoping to hear through us from their old home in the states, or possibly from England, Sweden, Denmark, and even from the borders of Finland. They invariably asked us to eat, and would hardly take *no* for an answer.[19]

Trades were negotiated also between the Mormon ladies and those bound for California. The reader will recall that most deals between the forty-niners and the Mormon men, usually seemed to result in the latter getting the advantage, since many of the travelers were anxious to get light wagons in place of their heavy ones, and to dispose of some of the implements which they were conveying. But a number of the emigrants were carrying sewing articles, the weight of which was certainly no problem; these the Mormon women desired, and hence were willing to suggest tempting exchanges. Continued Ferguson:

> A spool of thread would buy anything of the women, and,

[19] Charles D. Ferguson, *The Experiences of a Forty-Niner*, 67.

as most of the boys' mothers had fitted them out bountifully
with needles and thread, they were thus enabled to drive a
brisk trade with the Mormon ladies, especially in the line of
vegetables, that being the first season of plenty for them.[20]

The above statements concerning the scarcity of dry goods
in Mormon settlements are confirmed by Rae. He wrote of
meeting a man on a western train who boasted of making large
sums by selling at high prices in the Mormon settlements
second-hand or old-fashioned silks and satins.[21]

Much discussed among non-Mormons, was a "doctrine"
which the leaders of that faith were alleged to have imparted
to their female members. It was that the place of women in the
"Divine Plan" was very small unless they became attached to
some male.[22] Said Bowles, "Down East, you know, many a
husband calculates on stealing into heaven under the pious
petticoats of his better wife; here the thing is reversed, and
women go to heaven because their husbands take them along." [23]

Large numbers of the Mormon wives had not grown up on
the American frontier as had so many of the other female
pioneers of the plains-mountain West. On the contrary, it has
been estimated that three-fourths of the new arrivals in the
Salt Lake area came directly from Europe. The women of this
group did not succeed in adjusting themselves physically to the
plains-mountain hardships as did their sisters who had been
reared in the new states. Hence their children frequently
lacked vitality and the infant death rate of Utah was therefore
high. Rivington and Harris cite an episode concerning two
wives of a Mormon who lost their offspring at about the same
time, and hence weeped together. But when the husband
found them thus, the following remarks were overheard, "Dry

[20] *Ibid.*, 68.
[21] W. F. Rae, *Westward by Rail*, 218-219.
[22] C. L. Russell, *Diary of a Visit to the United States,* September 28, 1883;
W. G. Marshall, *Through America,* 188.
[23] Samuel Bowles, *Our New West,* 253.

up, I say, dry up! The Lord was pleased to give us three children in three weeks last year and now has taken only two in two weeks. Therefore dry up!" [24]

There are no indications that any great number of polygamous husbands were so heartless: moreover, certain statement of two writers regarding the family life of the Mormons must be questioned. Travelers apparently less prejudiced failed to note as great a prevalence of jealousy among Mormon wives as the English traveler Samuel P. Day described. Also the statement of Beadle that in Utah, "Old men traded daughters about as coolly as they traded cows," should probably be regarded as an exaggeration.[25]

There appears to be rather ample evidence, however, that many Mormon wives had thrust upon them the financial responsibility of providing for themselves and their children. Obviously not all of the polygamous Mormon men were wealthy, and hence many of the wives found it necessary to set up a home and utilize the same means of securing a livelihood as if they were widows. As early as 1852, the American army officer, J. W. Gunnison, made this statement concerning the economic status of these women: "In some instances several wives occupy the same house and the same room, as their dwellings have generally only one apartment, but it is usual to board out the extra ones, who most frequently 'pay their own way' by sewing and other female employments."

Some remarks of Bowles portray a somewhat similar situation:

In many cases, the Mormon wives not only support themselves, and their children, but help support their husbands. Thus a clerk or other man with similar limited income, who

[24] W. J. Rivington and W. A. Harris, *Reminiscences of American in 1869*, 273.
[25] Samuel P. Day, *Life and Society in America*, 250-253; J. H. Beadle, "The Mormon Theocracy," *Scribner's Monthly*, XIV (July, 1877), 391-397.

has yielded to the fascinations and desires of three or four
wives, and married them all, makes his home with number
one, perhaps, and the rest live apart, each by herself, taking
in sewing or washing, or engaging in other employment, to
keep up her establishment and be no charge to her husband.
He comes around once in a while to make her a visit, and
she sets out an extra table and spends all her accumulated
earnings to make him as comfortable and herself as charming
as possible. . . . Thus the fellow, if he is lazy and has turned
his piety to the good account of getting smart wives, may
really board around indefinitely.[26]

In fairness to the Mormons, it should be said that it was not
the policy of the leaders to sanction such arrangements as
Gunnison and Bowles describe in the above. Nevertheless, the
fact that so many women of Utah were actually householders
was later to furnish the suffragists with a potent argument for
their enfranchisement.

Finally, one might ask whether, since Mormonism was the
chosen faith of these women, their religion did not shield them
from unhappiness over their hardships and disappointments.
To such a question, no definite reply can be offered. Tenney,
however, quoting the remarks of an authority whom he believed
to be unprejudiced, wrote that not one Mormon sermon in ten
had any reference to religion, most of the discourses being con-
cerned with the land speculations of the leaders, and advice
concerning farm operations.[27] Tenney or his informer prob-
ably forgot to add vindictive criticism of the policies of the
federal government.

The fact remains that many travelers were struck by the
uncheerful expressions of most of the Mormon women they
encountered in Utah. Such were the observations of Boddam-
Whetham:

[26] J. W. Gunnison, *The Mormons, or the Latter-Day Saints in the Valley of
Great Salt Lake,* 71; Bowles, *Our New West,* 125.
[27] E. P. Tenney, *Colorado and New Homes in the West,* 113.

I noticed a peculiar air of depression and even sadness, amongst the Mormon women—a patient, suffering look, which seemed to be the natural consequence of adopting a creed, many of. whose doctrines must be repugnant to the chaste impulses of woman's nature, however sincere her faith may be in its strange dilutions. The Mormon men looked particularly jolly and free from care, and certainly appeared to leave the burden of the "Cross," which they talk a good deal about, to be borne by their wives.[28]

In the late eighteen-sixties, interested eastern residents heard many similar reports that the Mormon women were suffering from a gloomy frame of mind. Many of them assumed that polygamy was the cause, and hence determined that it should be stamped out of the Mormon communities. Although the Utah Mormons had sanctioned such a practice in 1852, the agitation over slavery diverted the attention of the eastern reformers. Likewise, the Civil War ensued, closely followed by the turbulent reconstruction epoch; these absorbed the interests of citizens of the states farther east. Congress passed an anti-polygamy law which was signed by President Lincoln on July 2, 1862. It prescribed punishments for violations, not exceeding a fine of five hundred dollars and five years imprisonment.[29] But until strengthened twenty years later, this statute was all but a dead-letter. In most trials, the Mormon defense succeeded by shrewd and resourceful tactics to block the progress of the prosecution; moreover, it was almost impossible to procure juries in Utah that would return a conviction in polygamy cases.

[28] J. W. Boddam-Whetham, *Western Wanderings,* 75.
The above writer could hardly be called "prejudiced." He praised the accomplishments of the Mormon "president," Brigham Young, toward making Salt Lake City modern. He also spoke favorably of the gardens and irrigation works of the "Saints."
Nor did most of the other travelers in Utah which have been cited, overlook these commendable features. While they could not affirm that Salt Lake City was quite as free from gambling and drinking as Mr. Young represented, nevertheless, they pictured it as a quiet city of homes.
[29] *Statutes at Large of the United States of America,* XII, 501-502.

Still, the Mormon executives anticipated sterner tactics on the part of the federal authorities after the close of the Civil War. When Mr. Schuyler Colfax, famous congressional leader of the period, visited Brigham Young at Salt Lake City in 1865, the Mormon leader "blurted out," "Well, now that you have conquered the South and abolished slavery, what are you going to do with us and polygamy?" Mr. Colfax replied with his usual tact that he had no authority to speak for the government, but hoped that the Mormon leaders would have a new "revelation" on the subject.[30]

Believing that a majority of the Mormon women really detested the practice of plural marriage as a part of their faith, many eastern observers were confident that the whole problem could easily be solved by granting the adult females of Utah Territory the right of suffrage. Early in 1870, it seemed not unlikely that Congress would enact such a measure in the hope that the new voters would outlaw polygamy in the territory.

The Mormon-controlled legislature of Utah, however, acted first. A bill granting women the ballot, passed both branches of the legislature, and was signed by Governor S. A. Mann on February 12, 1870. The law read:

> Section 1. Be it enacted by the Governor and Legislative Assembly of the Territory of Utah: That every woman of the age of twenty-one years, who has resided in this Territory six months next preceding any general or special election, born or naturalized in the United States, or who is the wife or widow or daughter of a naturalized citizen of the United States, shall be entitled to vote at any election in this Territory.
>
> Section 2. All laws or parts of laws conflicting with this act are hereby repealed.[31]

[30] Bowles, *Our New West*, 238.
[31] O. F. Whitney, *History of Utah*, II, 402.

Following this Utah action, a drastic anti-polygamy bill, sponsored by Representative Shelby M. Cullom of Illinois passed the lower branch of Congress on March 23, 1870.[32] The senate took no action, however, since that body feared that a sudden uprooting of the institution of plural marriage would cause many Mormon children to suffer, and reduce large numbers of wives to the status of white slavery. That body still looked for woman suffrage or some other development which would prompt the voluntary abandonment of the objectionable practice.

But those harboring such hopes were soon disillusioned. Almost immediately it was demonstrated that female voting would not end polygamy in Utah. Hence the woman voters of the territory were no longer regarded as the means of solving a very difficult problem for the federal government; on the contrary, they were called "tools of the Mormon priests."

In fact, the attitude of many Mormon women on the subject of polygamy was to be disclosed even before they had an opportunity to exercise the right of franchise. Eastern reformers who long had wondered how the female members of the sect regarded the much-discussed practice, could hardly have been pleased upon reading their statements. About three thousand Mormon women met at the old "tabernacle" at Salt Lake City on January 13, 1870. There were many speeches of protest against the two anti-polygamy bills. A Mrs. Levi Riter declared:

> We have not met here, my beloved sisters, as women of other states and territories meet, to complain of the abuses inflicted upon us by our husbands, fathers, and sons, but we are happy and proud to state that we have no such afflictions and abuses to complain of. . . .[33]

[32] *Congressional Globe*, Forty-First Congress, Second Session, 1367-1373.
[33] Whitney, *Utah*, II, 397-398.

Similar meetings were held at other cities in the territory. At the gathering in Ogden, a Miss S. C. Bingham, fourteen years of age, said, "I am sorry that Congress is engaged in measures for the destruction of the Latter Day Saints. We cannot look with silent indifference. The mission of the Saints is to reform abuses which have corrupted the world for ages." [34]

Upon the same occasion a Mrs. Martha H. Brown submitted this interesting revelation of her views on the anti-Mormon agitation:

> In my childhood I was robbed of a dear father and brother who fell martyrs to the truth in Nauvoo. My aged mother is now helpless and suffering through the exposures and relentless persecution to which we have been subject; and now I would rather die than to bring myself down to the level of those who talk of freeing the women of Utah. [35]

These remarks and many others of a similar tenor, indicate clearly that even under these special circumstances, a faith may thrive when its members feel they are the subject of persecution. Still the world at large wondered if it could be possible for the polygamous wives of the "Saints" to be so content with their status, and if they ever experienced the pangs of jealousy, as normal women would be expected to do under similar circumstances. One answer to this query was an interview which Lady Duffus Hardy chanced to have with a Mormon wife. Replying to the question of her British visitor if she desired her daughters to contract polygamous marriages, she said, "If I chose, they would each be the one wife of a good husband, but that must be as God pleases." [36]

But if such feelings were harbored by any number of the

[34] *Illinois State Journal*, April 13, 1870.
[35] *Ibid.*
[36] Lady Duffus Hardy, *Through Cities and Prairie Lands*, 117-118. The entire interview appears in the Appendix, Number 8.

Mormon women, they were not to result in an open revolt. The great tide of immigration to the western states and territories, however, had greatly enhanced the "Gentile" population of Utah by the late eighteen-seventies. The female members of this group did not hesitate to register vigorous protests. They gave evidence of being as determined to stamp out polygamy in the territory, as were the Mormon women to maintain all the institutions of their sect. On November 7, 1878, about two hundred women met in Salt Lake City, and organized an Anti-Polygamy Society. A resolution was addressed to the wife of the president of the United States, Mrs. Rutherford B. Hayes, and to the women of the entire nation. It urged that their influence be used to curb the Mormon power in Utah. A portion of this statement read as follows, "Our legislature is composed almost entirely of polygamists and friends of the Mormon priesthood, and has thrown around polygamy every possible safeguard." [37]

It was not until more than three years had elapsed, however, that Congress finally acted once more upon the Mormon question. Senator George F. Edmunds of Vermont successfully sponsored a law which bears his name, and the date of March 22, 1882. The Edmunds Law was an attempt to give potency to the law of 1862. There was no great change in the punishments prescribed, other than providing that convicted polygamists and their wives should lose their voting privileges.[38]

This legislation, like the earlier enactment, failed to prove effective. The Mormon leaders impeded its enforcement by charging illegality because of alleged *ex post facto* stipulations. They declared that any such law should be directed only against the polygamists of the future.[39] About five years after the

[37] Whitney, *Utah*, III, 61-62.
[38] The Edmunds Law in *The Statutes at Large of the United States of America*, XXII, pp. 30-32.
[39] Russell, *Diary of a Visit to the United States*, September 28, 1883.

passage of this statute, or on March 3, 1887, President Grover Cleveland allowed the more drastic Edmunds-Tucker Act to become a law without his signature. The maximum prison sentence was raised to three years for ordinary cases of polygamy, and provided for prison terms as long as fifteen years if incest were involved. Then, to decrease the political power of the Mormon leaders, the act abolished women suffrage in the territory.[40]

Thus the women of Utah lost the right of suffrage after exercising it for seventeen years. It must be said that their failure to devise some means of ending polygamy through the ballot was a keen disappointment to many eastern reformers, and to a slight degree at least, it injured the entire suffrage cause in the nation. Certainly it must be doubted if this period of equal franchise aided that movement, aside from supplying a precedent to the state constitution makers of 1895. It was the Wyoming example, and not that of Utah, to which the enthusiastic feminists would point with pride in their writings and speeches. Doubtless they realized that the Utah situation was replete with controversial factors, and mentioning it would probably engender a demand for an explanation as to why those feminine voters had failed to uproot polygamy.

Defenders of the Utah female voters pointed out, however, that plural marriage was not a political institution, but one sponsored by a religious group. Moreover, the practice was deemed sufficiently successful to cause Utah to enter the Union with a constitution providing for woman suffrage less than nine years after the appearance of the Edmunds-Tucker law. But the year 1887 found the suffrage question at a crucial stage in still another territory of the Far West.

[40] *Congressional Record*, Forty-Ninth Congress, Second Session, 1896-1904.

3. SUFFRAGE IN WASHINGTON TERRITORY

This territory was organized by an act of congress dated March 4, 1853. Like other sections of the Far West, it was in dire need of more female settlers in the third quarter of the nineteenth century. Soon after the Civil War, two pieces of legislation seemed to afford the few women of the territory a hope of gaining the right to vote. A territorial law of 1867 declared that "all white American citizens twenty-one years of age," were entitled to vote. Also it will be recalled that the famous Fourteenth Amendment became effective on July 28, 1868, and one of its provisions declared that, "All persons born or naturalized in the United States, and subject to the jurisdiction thereof, are citizens of the United States, and of the State wherein they reside."

In the following year, 1869, a prominent suffrage leader of Olympia, Mrs. Mary Olney Brown, attempted to vote, and cited the above laws as grounds which entitled her to do so. The right was refused her, however, election officials declaring that such provisions could not be interpreted as according the ballot to women.[41] At the same time, nevertheless, the sister of Mrs. Brown, Mrs. Charlotte Olney French and several other women actually voted in Grand Mound, a settlement twenty-five miles south of Olympia.[42]

It should be remembered that this episode took place about three years before the famous attempt of Miss Anthony and her associates to vote at an election in the state of New York. While the ballot was subsequently denied the women of Washington Territory, there seems to have been no attempt made to prosecute the suffragists who cast their vote at Grand Mound —a marked contrast to the rather ridiculous attempt to punish

[41] S. E. Pearce, "Suffrage in the Pacific Northwest," in *Washington Historical Quarterly,* III, (1908-1912), 99-114.
[42] *Ibid.*

the Anthony group. Neither officials nor the citizens of remote
Washington were so un-Machiavellian as to desire to press such
charges against members of a sex so badly needed for the whole-
some growth of the territory.

Then too, the memorable visit of Miss Anthony to the Pacific
Coast in 1871, saw the cause of woman suffrage definitely
launched in Washington. Twelve years later the first legal
fruits of the suffragist efforts appeared. The Washington terri-
torial legislature extended full rights to women to vote and hold
office in the autumn of 1883. As a result women served on
juries, just as was permitted in Wyoming.

Free from the embarrassments which were involved in the
Utah situation, this Washington law gave promise of setting an
example for the suffrage cause, as valuable as that of Wyoming.
Friendly comments from high officials were not absent. In
1885, Chief Justice Roger S. Greene of the territorial supreme
court wrote:

> I am more and more impressed with the fundamental
> wisdom and practical excellence of women suffrage. Not a
> single ill consequence as yet appears. Five-sixths of those
> who were qualified voted at our last general election, and I
> do not believe that there is in our territory today a single
> well-informed and decent woman who would willingly give
> up her right to vote.[43]

The law seems to have operated smoothly until 1887. In
that year a gambler named Jeff J. Harland was arrested for
cheating at a card game. Five members of the jury which
indicted him were women. Hence he pleaded that under the
laws of the territory, jurors were to be householders, and that
these women were not, since they were all married and living
with their husbands. The case went to the territorial supreme

[43] Henry B. Blackwell, "Woman Suffrage Problems Considered," *The Forum*,
III (April, 1887), 131-141.

court, which declared the suffrage law of 1883 to be defective, since its purpose was not properly described in the title.[44]

A newly-elected legislature, chosen at a time when the women still voted, hastened to enact a second suffrage law, since the friends of the equal rights movement were very anxious to have another test case reach the territorial supreme court prior to the meeting of the constitutional convention of the proposed state. The new measure was passed by the legislature on January 18, 1888.[45] In the hope of protecting the voting privilege, these words were included in the new statute, "Nothing in this act shall be construed as to make it lawful for women to serve as jurors."

This attempt to salvage the right of suffrage for women was rather ingenious, but grave doubt existed as to whether it would be upheld by the highest court in the territory. A test case was therefore desired by the friends and foes of the measure alike. A Mrs. Nevada S. Bloomer attempted to vote at a municipal election in Spokane on April 3, 1888. A ballot was refused her and the case soon reached the territorial supreme court. This body on August 14 of the same year rendered a decision declaring that the legislature had no right under the organic act of the territory to accord the voting privilege to women.[46]

It will be noted that two of the three territories granting the ballot to women were forced to dispense with their respective suffrage statutes within a period of eighteen months. In neither case, however, was unfeasibility the reason, Utah losing her law by virtue of the Edmunds-Tucker Act, and the Washington statute being voided by a supreme court appointed by the executive department at Washington, D. C.

[44] C. A. Whitney, *History of Washington*, IV, 276; *Harland v. Territory*, 3 Washington, 131-163 (1887).

[45] *Council Journal of the Legislative Assembly of Washington Territory*, Eleventh Session, 24.

[46] Bloomer v. Todd, Gandy and Clarke, 3 Washington, 599-623 (1888).

Nor did the failure of the Washington people to sanction equal suffrage in their first constitution, exactly represent apathy of the men toward women's rights. By 1888, the territory had enough people to prepare for statehood, and in accordance with the congressional enabling act, a constitutional convention met to devise a basic law for the proposed state. Its members decided to submit to the voters a separate article on the matter of woman suffrage. But there existed in all western territories in 1889, a belief that Congress would not approve of any new state constitution embodying a provision for female suffrage—a fear born of the Edmunds-Tucker Act. This doubt helped the anti-suffrage group to defeat the measure, since most of the residents were anxious for as little delay as possible in obtaining statehood.[47] Hence Washington became a state in 1889 without providing women with the elective franchise. The Wyoming constitutional convention of the same year, however, was more determined that women should continue to enjoy equal citizenship rights with the men.

4. WYOMING THE FIRST SUFFRAGE STATE

The eve of the assembling of the Wyoming constitutional convention found the suffrage supporters confident, in spite of the possibility that Congress might frown upon a basic law with an equal rights cause. Certainly, there were many testimonials by well-informed observers which seemed to confirm their several arguments. Testifying before a special committee of the Massachusetts legislature in 1876, former Judge John W. Kingman of the Wyoming Supreme Court declared:

At our last election a larger portion of women voted than

[47] The returns disclosed 35,613 voters opposed to women suffrage, and 16,527 in favor of it.

men. We have no trouble with the presence of women at the polls. . . . The women manifest a great deal of independence in their preference of candidates, and have frequently defeated bad nominations. . . . As jurors women have done excellent service. They are less subject to the distracting influences which sometimes sway the action of men in the jury box. . . .[48]

In this period many students of the suffrage question asked whether or not women allowed the opinions of their husbands to influence their selections of candidates. In answering this question Mrs. Stanton quoted an article from the *Laramie Sentinel* (Laramie, Wyoming) of December 16, 1878:

While women in this territory frequently vote contrary to their husbands, we have never heard of a case where the family ties or domestic relations were disturbed by it; and we believe that among the pioneers of the West there is more honor and manhood than to abuse a wife because she does not think as we do about politics or religion.[49]

Such a result seems more or less obvious to students of the second quarter of the twentieth century, but it was probably a revelation to citizens of that day who were interested in the question. Moreover, those skeptical over both the feasibility of equal suffrage and the significance of the Wyoming experiment, raised these questions: "What percentage of the women vote? and, Is not the population of Wyoming too small to provide a valid test? Mrs. Blackwell's article answered both questions. It contained an estimate that nine-tenths of the women eligible to vote did so, and a most ingenious counter in regard to the paucity of people in the territory. The author argued that ancient Athens also had a comparatively small

[48] Elizabeth Cady Stanton, "The Other Side of the Suffrage Question," *North American Review*, CXXIX (November, 1879), 432-439.
[49] *Ibid.*

population, but its experiments in democratic government had an immense significance in the history of the world, while the great empires such as ancient Persia or India had virtually none.[50]

The many favorable comments, of which the above are but samples, served to make the equal rights advocates feel both confident and determined when the constitutional convention met on September 2, 1889. Among its forty-five delegates, none seemed willing to oppose openly the plan to include a suffrage provision in the state's first constitution. A resolution to submit such an article to the voters separately, was supported by only eight votes. As in the case of Washington, some delegates feared that Congress would reject a constitution which included woman suffrage, but a letter from the politically powerful Thomas B. Reed, speaker of the house of representatives, assured them that such would not be the case. Hence the finished document contained this provision.

> The right of citizens of the state of Wyoming to vote and hold office shall not be denied or abridged on account of sex. Both male and female citizens of this state shall equally enjoy all civil, political, and religious rights and privileges.[51]

The constitution was approved by the people of the territory at a special election held on the following November 5. Bad weather, however, rendered the vote very light, and while the constitution received the approval of the voters, their paucity was to constitute one argument against admitting Wyoming as a state, when the fifty-first congress took up the question early in 1890.

Also it seemed for a time that the anti-feminist leaders in Congress would succeed in preventing the admittance of the

[50] Blackwell, loc. cit.
[51] Article IV, Section 1 of the Wyoming Constitution of 1889, as cited in G. R. Hebard, The History and Government of Wyoming, 55.

territory to the union with a suffrage provision in their con-
stitution. Territorial Delegate Joseph M. Carey thereupon
telegraphed this fact to the Wyoming legislature, then in ses-
sion. But the general view in the territory seemed to be, "We
will remain out of the Union a hundred years rather than come
in without woman suffrage." [52]

The bulk of the opposition came from southern congressmen
and from democratic leaders who feared the new state would
send republican senators and representatives to the national
capital. But their efforts were unavailing, and both branches
of Congress approved of the Wyoming constitution.[53] The
signature of President Benjamin Harrison on July 10, 1890,
made Wyoming the forty-fourth state of the Union, and the
first state, as well as the first territory, to embrace equal suffrage
and political rights for women. But in the plains-mountain
West, where people, and especially women, were badly needed,
citizens of a commonwealth would think seriously before allow-
ing a sister state to be more just and hospitable to the fair sex
than they. It is thus not difficult to surmise why female
suffrage, successful on the whole in Wyoming, was to be adopted
by three other western states in that momentous decade known
as the eighteen-nineties.

[52] Anthony, *Woman Suffrage*, IV, 999-1000.
[53] The vote in the house of representatives was 139 to 127. In the senate it
was 29 to 18.

CHAPTER VI

WESTERN FEMINISM IN THE NINETIES

1. COLORADO SUFFRAGE AND THE POPULISTS

The Anglo-American settlement of the region now compris-
ing the state of Colorado began soon after the discovery of gold
near the site of modern Denver in 1858. The "rush of fifty-
nine" to the valley of the South Platte proved to be almost as
feverish as that to the Sacramento Valley of California a decade
previous. Moreover, the immigrants were largely men in
Colorado as in California, the census returns of 1860 disclosing
a male population of 32,654, and but 1,577 women.[1] The hard-
ships of the "fifty-niners" were in some respects greater than
those of the California prospectors, since the water route for
bringing in supplies was lacking, and there were fewer Orientals
to perform menial services. Very early in the history of
Colorado, therefore, the men had an opportunity to enhance
their appreciation of the services and comforts the few women
could contribute in so isolated a community.

Those expecting to find much gold in Colorado were dis-
appointed, although the production of silver continued to be
large for several decades. Fifteen years after the discovery of
the mineral resources, or by 1873, the territory already enjoyed
more diversified channels of income. Not only did some of
the valleys offer grazing and agricultural potentialities, but
also the vicinity of Colorado Springs had begun to attract "a
large number of tourists seeking health, recreation, and pleas-

[1] *Preliminary Report* of the *Eighth Census of the United States,* 291-294.

ure."[2] With the tourist element, came many persons of "progressive" principles, those who not only favored equal rights for women themselves, but were in a position to influence others to seek residence in the commonwealth, should a benevolent attitude toward the fair sex be adopted.

Colorado entered the Union in 1876, and the first state constitution extended to women the right to vote in "school elections." In the following year, 1877, there was a referendum on the question of full female suffrage, but it was defeated, due, according to Miss Anthony, to the opposition of the Mexican communities in the southern part of the state.[3]

Shortly after 1890 however, three circumstances seemed to favor the success of the movement for full suffrage, these were the increase in the number of men with so-called "liberal" political inclinations, the example of Wyoming, and the rise of the People's party. Apparently encouraged by the brighter outlook for their cause, the women of the state took increased interest in the elections of school officials in 1891. In the general campaign of the following year, the People's party, which had included a suffrage plank in its state platform, was generally successful in the efforts to elect its candidates for the legislature.

Hence, when the new lawmaking body assembled, it authorized a referendum on the suffrage question, to be held in November, 1893. The proponents of equal rights carried on an intensive campaign; the very famous Mrs. Elizabeth Tabor donated for the use of the suffrage workers, two rooms of her residence in the "Opera House Block." When the ballots had been counted, it was disclosed that the proposal had carried by

[2] "T. J. C." to the editor of the *Illinois State Journal,* Golden City, Colorado, September 22, 1873, in *Illinois State Journal,* October 1, 1873.
 As early as 1866, a traveler predicted that Colorado would become the "Switzerland of America." Bayard Taylor, *Colorado: A Summer Trip,* 166.
[3] Anthony, *Woman Suffrage,* IV, 509-510.

a comfortable majority.[4] The reasons assigned by Miss Anthony for the victory were: the chivalry of the western men, less prejudice against suffrage in western communities, and the strength of the populists at the time.[5]

In addition to being the second state of the Union to adopt woman suffrage, Colorado has, since 1893, granted women a definite place in the public life of the state. The people of Colorado have generally considered that the position of super-intendent of public instruction is a woman's post, the leading political parties usually selecting an educator of that sex as their candidate. In 1895, three women entered the state house of representatives, while others served in many county positions. In the years 1897 and 1898, two women served as coroners for their counties.

The participation of women in the political life of the state to such a marked degree, while post-dating the Wyoming experi-ment, is perhaps more significant. Colorado contained not only more people and more varied types of communities than her northern neighbor, but also possessed a greater tourist popula-tion. Many of this group would reside in the state long enough to note the feasibility of woman suffrage in both rural areas and in large cities like Denver. When they returned to their home states, their refutation of the anti-suffrage arguments very frequently impressed those skeptical of its proving suc-cessful. In a word, Colorado became the new proving ground for the feminists of the nation.

[4] The vote stood:

For Woman Suffrage	35,798
Against Woman Suffrage	29,451
Majority in Favor	6,347

—Anthony, *Woman Suffrage*, IV, 518.

[5] *Woman Suffrage*, IV, 518.

2. MORMONISM AND THE UTAH CONSTITUTION OF 1895

About 1890, when many other western territories were gaining statehood, the conviction on the part of congressional leaders and federal executive officials that the Edmunds-Tucker anti-polygamy law was being consistently violated by large numbers of the Mormons, seemed to preclude the possibility of Utah's early entry into the Union.

It is, of course, true that in these years many non-Mormons were entering the territory, and sooner or later, they could force the legislature to take drastic steps to end plural marriage, and thus open the door to the advantages enjoyed by other American commonwealths. But several factors were to induce the Mormon leaders themselves to repudiate the institution of polygamy.

First of all, while the number of Mormon women approximated, but never exceeded that of the men, the system of plural marriage could not have been universal. In fact, it was necessary for many men of the sect to seek Indian women as consorts.[6] Moreover, there was a tendency among the younger Mormons to adhere more to the general ideals of the nation of which they were a part, and less fervently than their fathers did they venerate the Book of Mormon, or the memory of Joseph Smith and Brigham Young. The system appeared so repugnant to many daughters of Mormons, that they left the settlements and married "Gentiles." Among those who remained, jealousy of a rival wife was a source of embarrassment for both the husbands in question, and the Mormon hierarchy as well. Two young single Mormon men are credited with this reflection, "This polygamy would be all right, only the women, you know, pull hair so like darnation."[7]

[6] Beadle, *The West*, 661.
[7] Bowles, *Our New West*, 251.

Thus as the year 1890 approached, Beadle's observation of twenty years before seemed more and more apparent, "Old Mormons die, young ones grow up infidels, and the whole system moderates to a mild protestantism." [8]

In view of these circumstances, talk of a possible "revelation" on the subject of matrimony, increased among influential Mormons. As early as 1865, when Mr. Colfax had expressed a hope to Brigham Young that such a "revelation" might be forthcoming, the Mormon president is said to have replied that he would welcome such, since both wives and husbands were constantly bothering him with their troubles.

Mr. Young had died in 1877, and the year 1890 found Mr. Wilford Woodruff serving as the "president" of the Mormon organization. After the latter had been subjected to considerable pressure on the part of the younger and more liberal faction, he yielded and issued an important decree renouncing polygamy on September 24, 1890. It included these words:

> Inasmuch as laws have been enacted by Congress forbidding plural marriages, which laws have been pronounced constitutional by the court at last, I hereby declare my intention to submit to those laws, and to use my influence with the members of the Church over which I preside to have them do likewise. . . . [9]

This resolution was ratified by the "general conference" of the sect on October 6 of the same year. American citizenship, however, would still have been beyond the reach of many Mormons, because of alleged violations of the Edmunds-Tucker Act. President Benjamin Harrison was therefore requested to pardon all convicted violators of the federal anti-polygamy statute. This he did on January 4, 1893, but "on the express

[8] *The West*, 665.
[9] Whitney, *Utah*, III, 744-745.

condition that they shall in the future faithfully obey the laws of the United States . . . and not otherwise." [10]

The acceptance of this offer of presidential clemency paved the way for still another step toward statehood: Congress adopted the "Enabling Act" for Utah, and it was signed by President Cleveland on July 16, 1894. [11] Almost immediately preparations were made by the suffragists to present their demands at the constitutional convention. The nature of their arguments may be surmised by noting this portion of the address of a Utah feminist, Mrs. Emmeline B. Wells, at a national suffrage convention held in Atlanta, Georgia, in January, 1895:

> There are two good reasons why our women should have the ballot, apart from the general reasons why all women should have it—first, because the franchise was given to them by the Territorial Legislature and they exercised it seventeen years, never abusing the privilege. . . , second, there are undoubtedly more women in Utah who own their own homes and pay taxes than in any other state with the same number of inhabitants. [12]

There is every reason to believe that the second argument of Mrs. Wells was well founded. It will be recalled that many Mormon wives maintained their own homes and supported their children. Moreover, the Edmunds-Tucker Act had provided that when the plural marriages of the more wealthy Mormons were broken up, sufficient assets would be diverted in each instance to support the wives and children concerned. It had stipulated also that in cases where the practice of polygamy had been discontinued and the other provisions of the act observed, children which had been born of plural marriages might be considered legitimate.

[10] *The Statutes at Large of the United States*, XXVII, 1058.
[11] *Ibid.*, XXVIII, 107-112.
[12] Anthony, *Woman Suffrage*, IV, 945.

The fact that so many women were thus rendered heads of families, and the realization that woman suffrage had been considered successful during its seventeen-year trial in Utah, 1870-1887, both placed the equal rights cause in a favorable position when the constitutional convention considered the qualifications for voting. The proposal not to include sex as a bar was approved by the delegates by a vote of seveney-five to six.

It is true that there existed among the delegates some doubt whether or not Congress would approve of a state constitution permitting women to vote—a fear harbored because of the anti-suffrage provisions of the Edmunds-Tucker Law. But the Wyoming precedent was recalled, and the first constitution, including the equal rights provision was approved by the voters at a special election on November 5, 1895. The negative vote was virtually insignificant. The national congress gave its endorsement of the document in the following month, and the signature of President Cleveland on January 4, 1896, rendered Utah the forty-fifth state of the Union. The returns from the election the following November disclosed that two women had been elected to the state legislature, one to the senate, and the other to the house of representatives.[18]

One would doubtless be correct in stating that the women of Utah received more attention from the American public at large, and were the subject of more bitter controversies, than did the females of any other western state or territory. Lady Hardy wrote that one of the most bitter complaints which the Mormon wives lodged with her was that travelers seemed to regard them as "zoological curiosities."[14]

In all probability both the Mormons and "Gentiles" of Utah hoped that the repudiation of polygamy by the leaders of the sect, and the admittance of the commonwealth to the Union,

[18] *Kansas City Star* (Kansas City, Mo.) November 6, 1896.
[14] Lady Duffus Hardy, *Through Cities and Prairie Lands,* 117-118.
The entire interview of Lady Duffus Hardy is quoted in the Appendix, No. 8.

would quickly end both this undesirable publicity and the bitterness of the long legal and legislative feud over polygamy. But unfortunately for the great body of Mormons who sincerely endeavored to abide by the laws of their religious leaders and those of the national and state governments, the controversy lingered on for a dozen years more. In Utah, politicians are known to have accused their opponents of "new Mormonism," which they did not hesitate to say was tantamount to concubinage. No such "new Mormonism" was officially sanctioned by the leaders of the faith, but it was pointed out that the alleged secret practice of polygamy gave the women thus involved none of the protection afforded by the "old Mormonism." [15]

Perhaps the most famous instance of alleged "old Mormonism" serving as a political football, is the attempt to oust Mr. Reed Smoot from the United States Senate during the second administration of Theodore Roosevelt. Mr. Smoot admitted that he subscribed to the Mormon faith, but insisted he had not violated the resolution of October 6, 1890. In the course of the senatorial debate, Senator Joseph B. Foraker of Ohio estimated that in 1890, there were approximately twenty-four hundred polygamous families in Utah, and that about four hundred remained in 1907. Finally, on February 20, 1907, the Senate voted that Mr. Smoot was entitled to his seat in that body and hence not guilty of violating any federal anti-polygamy statute. [16]

Notwithstanding the well-known efficiency of the United States government in meting out justice to those who infringe upon its laws, the student of the policy of federal officials toward Mormonism can hardly escape the impression that it was characterized by caution, tact, and forbearance. Caution, since

[15] For a discussion of these charges see F. J. Cannon and H. J. O'Higgins, *Under the Prophet in Utah*, Boston (C. M. Clark Publishing Co.), 1911.
[16] *Congressional Record*, Fifty-Ninth Congress, Second Session, 3415.

Republican office holders and members of Congress doubtless bore in mind that their party had been blamed by citizens of the southern states for several unfortunate military incidents of the Civil War, and therefore could not afford to risk the danger of having one of the potential western states assume a similar attitude toward the organization. Tactful, because the marital status and hence honor of several thousand women were involved. Hastily drawn legislation might not only have rendered the reputed position of these wives more distressing, but also might have inspired the women in question to feats of retaliation and vindictiveness, which would not only have greatly embarrassed the most self-confident official, but ruined him politically as well. It is doubtful that Congress or the federal judges ever lost sight of the fact that resourceful western women were involved in the controversy.

Finally, this federal policy was characterized by forbearance since the factor of religious freedom had to be considered. It was of course true that the American people as a whole appeared to be opposed to plural marriage. It was true also that the United States Supreme Court had ruled in 1878 that the anti-polygamy statute then in force was not an infringement of religious liberty as guaranteed by the Constitution.[17] But the religious issue continued to reappear and impede the progress of trials of alleged polygamists. Little wonder that many easterners, in Congress and out, had hoped that some indirect development, such as woman suffrage, would solve the problem for them. Perhaps it might be said that the desire of virtually all the people of Utah for statehood finally did so. But in the same year that Utah formally entered the Union, a fourth western commonwealth was to extend to its female citizens the right of franchise.

[17] Reynolds v. The United States, 98 United States, 145-169 (1878).

3. BORAH AND THE IDAHO SUFFRAGE MOVEMENT

It has been stated that several Democrats of Wyoming sponsored the successful movement for equal suffrage, and that in Colorado the People's party seems to have been the political group most instrumental in bringing the suffrage campaign in that state to a successful close. In Idaho, the political support for the equal rights movement seems to have been furnished by the young and energetic Republican, William E. Borah.

Idaho had been admitted to the Union in 1890. At the Republican state convention in 1894, Borah successfully sponsored a resolution that the Idaho organization of the party endorse woman suffrage. It will be recalled that the year 1894 witnessed Congressional and state elections in which the Republicans scored important gains, and among the legislatures over which they secured control was that of Idaho. When the branches of the assembly convened early in 1895, the Republicans, in conformance with their campaign pledge, introduced a measure which provided for a popular referendum on the question of female suffrage. It passed the Senate unanimously on January 11, 1895, and the House of Representatives six days later by a vote of thirty-three to two.

Since the referendum was not to be held until the election of November, 1896, the suffrage campaign workers, headed by Mrs. J. H. Richards, had ample time to plan for the contest. Two outstanding western women assisted in the campaign, Mrs. Duniway, and Mrs. Carrie Chapman Catt. The frontier background of the former has been related in this study, and the background of Mrs. Catt should be sketched. She spent her girlhood on an Iowa farm, later she worked her way through Iowa State College, at Ames, and until 1885 she held several positions in the public schools of Iowa. In that year she married Mr. Leo Chapman; he lived but a short time, however,

and after his death, she entered the ranks of the equal suffrage proponents.

Besides the efforts of these two "daughters of the American frontier," those of the Idaho women themselves were both determined and ingenious. They journeyed in the "dry heat" of the summer and autumn of 1896 to speak in the remote communities of the state, and then, on election day, they stood in the snow and distributed bills urging the men in favor of the suffrage amendment to the state constitution. Another device to which they resorted, was not only a further revelation of the ingenuity of the campaigners, but also of the new type of American home. Some of the more enthusiastic women urged all the males serving their families, such as the post men, milk men, and even garbage collectors, to vote favorably upon the proposition. Perhaps this situation is another explanation for the growing prestige of women in the last half of the nineteenth century: less often were they on isolated farmsteads, unable to exert any political or social influence whatever; each year was finding more and more American females living in an environment where they were served by many male business, professional, and tradesmen. None of these groups could afford to ignore the desires of the homemaker who very largely controlled the purchasing of the family.

All of these favorable factors contributed to the victory of the Idaho suffrage amendment on November 3, 1896—a victory far more sweeping than that in Colorado. In the majority of nearly two to one, no observer could have had much justification for doubting the future trend of the West concerning women.[18] As a final attempt to prevent the women of the state from voting, the opposition contested the referendum on the grounds that it had failed to receive a majority of the total number of votes cast. The case went to the supreme court of

[18] The vote for the amendment totaled 12,126 while that opposed registered only 6,282.

the state, where Mr. Borah and other liberal attorneys donated their time to argue on behalf of the amendment. Finally the court ruled that a majority of all votes cast on the question was sufficient, and Idaho became the fourth commonwealth of the Union to embrace the principal of equal franchise for women. The story of the movement in the state is contained in the brief statement of the editor of the *Boise Daily Statesman*, "We wanted it, we went after it, and we got it." [19]

Since their adoption of equal suffrage, the people of Idaho have accorded women the opportunity of holding many public offices, just as Colorado has done. They were soon to be found in the state legislature, and in the position of superintendent of schools, both for the state and the several counties. There have been instances also where women have served as county treasurers and county clerks.

Moreover, there is evidence that the participation of women in the public life of these western states resulted in some drastic readjustments. Says Mr. Balderston:

> The change went into effect so smoothly as though the women had always been accustomed to voting. There was, though, a remarkable improvement in the conduct of elections. A better tone was observed at once. The presence of women at the polls had an effect similar to their presence at any other place—rowdyism disappeared and gave place to a quiet, genteel polling place atmosphere comparable to that observed in a dry goods store, or any other place where the sex gathers.[20]

Thus before the close of the nineteenth century, women held voting rights in four American states—all in the West, all until very recently a part of the so-called frontier, and all in the

[19] William Balderston, "Woman Suffrage in Idaho," M. O. Douthit, *The Souvenir of Western Women*, 117-118.
[20] *Ibid.*

plains-Rocky Mountain area. There seems reason to believe that in all of these commonwealths, the desire for more women was one motive for the adoption of woman suffrage. The census of 1890 disclosed total population figures for these commonwealths which indicated 140 males for every 100 females.[21]

With the persistence of the preponderance of men in the other western states also, the enfranchisement of women in the balance of the commonwealths west of the ninety-eighth meridian was only a matter of time—actually about two decades. But the question might be raised whether the presence of suffrage in four suffrage states exerted any influence on national politics after 1896. Little doubt but that it did.

It is of course true that the popular vote of these four states would not be of any great consequence in a presidential election. But the total of fourteen electoral votes could hardly have been taken lightly by either the Republican or Democratic organizations. None of the presidential contests between 1868 and 1896, inclusive, could be regarded as "landslides," hence it must have seemed possible that these four states might decide a presidential contest. Moreover, while Wyoming as a territory had furnished a political laboratory which proved to the satisfaction of many open-minded individuals that the entry of women into the political sphere would not lower their moral standards or jeopardize home life, still, four sovereign states could provide a much more satisfactory basis for further observation.

It is well known that political experimentation in the Far

[21] The numbers of each sex in these states and territories as shown by the 1890 census reports are as follows:

	Males		Females
Colorado	245,347		166,951
Idaho	51,290		33,095
Utah	110,463		97,442
Wyoming	39,343		21,362
Totals	446,443		318,850

—*Compendium of the Eleventh Census of the United States*, Part III, Table 24.

West did not end with the settlement of the suffrage question. The feminist leaders had taught the citizens of western states not to accept as faultless time-honored eastern political philosophies, institutions, and practices. Hence it might be said that the great contribution of the women of the timber-prairie frontier was economic, while their daughters helped to engender a tradition of liberalism in government in the new states farther West. But this new generation of pioneer women went still further. As members of legislatures, as constituents, and as leaders of public opinion, they were to have a part in the colorful movements for political and social reform which more or less convulsed America in this last decade of the nineteenth century.

4. WESTERN WOMEN AS POLITICAL REFORMERS

It would be most surprising if the female electors and legislators of the four suffrage states of the West had not sought certain legal changes in their favor. Well known is the fact that women have ever sought laws to foster the practice of their sex receiving the same pay for the same class of work. One occupational group which state statutes could easily reach was that of public school teachers. Hence many western women pressed for the passage of enactments providing for a single salary schedule for male and female instructors in the public schools. Although efforts toward this end were apparently successful only in Wyoming during this period, the resultant law was considered a good argument for equal suffrage. Senator Joseph M. Carey of Wyoming was asked to appear before a committee of New York state lawmakers in 1894. They first inquired if the women voters had been able to abolish gambling houses in the state. The western senator replied that since gambling was a "characteristic vice of a mining community" it could only be reduced as the commonwealth became more

civilized, and that in the diffusion of civilizing agencies, women had assumed a prominent place. But when his interrogators pressed questions which revealed their continued skepticism regarding feminist voting, the senator became impatient and said, "I will tell you one effect of woman suffrage: Wyoming is the only State of the Union where the women school-teachers receive as high salaries as they would if they were men." [22]

Colorado women, on the other hand, seem to have been more concerned over the establishment of a school for the training of underprivileged girls, and shortly after the opening of the new century their efforts met success. The bill for an industrial school for girls, sponsored by a woman state representative, Mrs. E. Heartz, passed both branches of the legislature, and was approved by the governor on April 9, 1901. [23]

Western feminists also used their influence to have the "age of consent" for young women raised. Their attempts to set the age at twenty-one were successful in Wyoming, but failed in Colorado. The legislature of the latter state, and those of Idaho, Utah, and Washington, however, did provide that eighteen years should be the "age of consent." [24] This was considerably higher than existed in most eastern states during the early years of the twentieth century.

As the old century was drawing to a close, the younger women of the West were giving promise that they would soon command a place in the intellectual life of the nation—a promise indicated by a survey of the educational statistics from the census figures for 1900. In eleven states of the Far West, they indicated 78,416 young white women between the ages of fifteen to twenty in educational institutions, but only 68,580 young men in the same category. These figures are even more impressive

[22] Mary P. Jacobi, "Status and Future of the Woman Suffrage," *The Forum* (December, 1894), 406-414.

[23] *Laws Passed at the Thirteenth Session of the General Assembly of Colorado*, pp. 49-50.

[24] H. G. Cutler, "Why Do Women Want the Ballot," *The Forum* (June, 1915), 711-727.

in view of the fact that the percentage of young people of this age group in schools or colleges was higher for this group of western states than for any other section of the country, and the fact that men outnumbered the women in the West.[25]

The legislative program of the older group of feminist leaders of the Far West, and the noteworthy numbers of girls upon school rolls might have made possible another decade of success for the cause of equal rights. But the eighteen-nineties had witnessed several women taking prominent places in movements of a national character, and not all of the latter group conducted themselves in the dignified and intelligent manner of the suffragists who led the state contests for the ballot.

Since the beginning of the movement for equal rights, many of its leaders had maintained close relations with "temperance" organizations. One western woman, Mrs. Duniway, was shrewd enough to see that such a policy was ill-advised. She felt that an alliance with the Women's Christian Temperance Union would be a mistake, and would impede the possibility of the major political parties aiding the suffrage cause.

This lack of harmony in the ranks of the suffragists was to result in Mrs. Duniway finding many church buildings closed to her meetings in the eighteen-eighties. She spoke before the national woman suffrage convention at Washington, D. C. in February, 1889, and once again stressed both the inadvisability of prohibition, and the plan for joining forces with prohibitionist groups. After her speech, Miss Anthony came to her and said, "Mrs. Duniway, you shocked a great many good people by your speech tonight."

The reply was of the type so characteristic of most of these

[25] The states which the Census Bureau included in this western group were Arizona, California, Colorado, Idaho, Montana, Nevada, New Mexico, Oregon, Utah, Washington, and Wyoming.

The total male population in these states between the ages of fifteen to twenty, inclusive, totaled 234,399 while the number of females was but 220,352.

These figures were computed from the state statistics in Vol. II, Part II of the *Twelfth Census of the United States.*

pioneers of feminism, "Glad to hear it. Time was when you
shocked good people. And that was the way you got your
start." [26]

But it was not this mild disagreement which caused the
equal rights advocates the greatest embarrassment from the
prohibitionists' sphere after 1890. Rather it was the emergence
of radicals who had no apparent affiliation with the suffrage
groups. Their leader was Mrs. Carry Amelia Nation.

It is known to well informed individuals that the agitation
for prohibition was not confined to any one section of the
country, and that the National Prohibition party, organized in
1869, the Women's Christian Temperance Union, founded in
1874, and the Anti-Saloon League which was started in 1893,
were all organized on a national basis. Nevertheless, when the
subject of prohibition is suggested, many persons will mention
a single western woman—Mrs. Nation.

She was born in Kentucky in 1847. Her father lost his
slaves and his fortune as a result of the Civil War, and went to
Belton, Missouri, with the hope of making another start. There
Amelia married a young physician and former Union army
officer, Dr. Charles Gloyd in 1867. Although she admitted that
he was the one love of her life, they had a home together for
but a short time, since he turned out to be a habitual drunkard
and died of alcoholism about six months after their daughter
was born.

The young widow then supported herself, her daughter, and
her mother-in-law until 1877 by teaching school. In that year,
she married Mr. David Nation, a widower nineteen years older
than herself, with whom she had little in common. He pro-
fessed to be an attorney and a preacher, but he apparently did
not always succeed in gaining a livelihood from either vocation,
since the family spent about ten years in Texas, where Mrs.

[26] Duniway, *Path Breaking*, 197-198.

Nation supported its immediate members, as well as a rather motley group of "in-laws," by hotel management. It was not until their removal to Medicine Lodge, Kansas, in 1889, that the career of Mrs. Nation as a militant prohibitionist began.

In that year the Supreme Court of the United States ruled [27] that an importer of liquors from any other state or country could himself or through his agents sell such liquor as long as it remained in the original package. Very soon, therefore, much liquor was shipped into Kansas, in spite of the fact that this state had adopted prohibition in 1880. Moreover, the decision resulted in the revival of a form of the saloon—which apparently flourished despite the Congressional enactment of 1890 known as "Wilson Law," which declared that liquors shipped into the so-called dry states would be subject to local police regulations as soon as they crossed the state boundary.

Living, as she did, close to the frontiers of Indian Territory, Mrs. Nation had an opportunity to observe how this interstate liquor traffic was nullifying the state prohibition regulations. Recalling how an extreme case of alcoholism had robbed her of happiness in her first marriage, she became obsessed with the determination to oppose this revival of the liquor business in the state. She became confident that her purpose, saving the young men of her section from becoming alcohol addicts, as well as the questionable legal status of this revived sale of strong drinks, both justified the means she was to employ. "The saloon," she declared, "has no rights that anybody is bound to respect."

She and other ladies of the same persuasion decided, therefore, to resort to force. Armed principally with hatchets, they started a campaign of destroying saloon property, emptying whiskey barrels, and smashing expensive glassware, mirrors, furniture and obscene paintings. Their first raid took place at

[27] Leisy v. Hardin, 135 United States, 100-125 (1889).

Kiowa, Kansas, very near the Oklahoma border,[28] but later these acts of vandalism were extended to the larger towns and cities of the state, including some famous and luxurious bars of Wichita.

Whatever opinions one might hold as to the legal or moral justification for the existence of these liquor establishments, one reflection can hardly be avoided. A survey of the illicit traffic in intoxicating beverages during the era of national prohibition, 1920-1933, reveals that many of its participants did not hesitate to resort to force in order to maintain profits. Evidence that those affected by the hacking expeditions of Mrs. Nation were largely unwilling that these women should experience violence, seems to be at least a slight tribute to the chivalry of the men in the southwestern Kansas settlements.

She was, of course, brought into court for most of these depredations, but was usually charged only with "disturbing the peace." She paid her numerous fines by the sale of souvenir hatchets and by lecture appearances. After 1900 her lecture programs and prohibition agitation was on a national rather than local scale. No doubt her sensational method of destroying saloon appurtenances, her sale of tiny hatchets, and her speaking tours, caused many people to look upon her as a more important factor in the prohibition movement than she actually was. It is entirely possible that her career did impede the movement to repeal the Kansas prohibition law, but there were no other positive results of her activities. But since by her own admissions she was not normal mentally at times, many who regarded all women in public life as "freaks," felt more than ever that their convictions were justified. The position of the moderate and intelligent feminists suffered as a consequence.

Prejudicial in the end to the equal rights cause, was the campaign of another small group of western women, those identified

[28] Carry A. Nation, *The Use and Need of the Life of Carry A. Nation,* 60.

with the populists. One will recall that most of the women who migrated to the plains-mountain West, did so with a confidence of material success. Hence when the early eighteen-nineties brought very unsatisfactory prices for both silver and agricultural products, many western women became as interested as the men in the platform of the new People's party, which promised to seek remedies for these depressed markets.

Most colorful and outspoken among this circle of women, was Mrs. Mary E. Lease who had been a resident of Kansas since 1873, and was thirty-five years of age when the populist movement assumed noteworthy proportions in 1890. She was the mother of four children, but had studied law, being admitted to the bar in 1885. In the late eighteen-eighties, she was in demand as a speaker at Farmers' Alliance meetings, and seemed to understand the discontent of the agricultural regions. Her speeches with their "terse, strong sentences" in which the "greedy governing class" was denounced, drew the attention of the western farm women, as well as men.[29]

Many accounts reveal the great enthusiasm displayed by these women who supported the Farmers' Alliance and the People's party. Farm life had been a "treadmill" for many of this group, but probably their noisy demonstrations were more largely due to disappointment over the failure of their new homes to yield them profits and the comforts for which they had hoped. Said Mrs. Diggs:

> Farmers' wives and daughters rose earlier and worked later to gain time to cook the picnic dinners, to point mottoes on the banners, to practice with the glee clubs, to march in the processions. Josh Billings' saying that "wimmin is everywhere" was literally true in that wonderful picknicking, speechmaking Alliance summer of 1890.[30]

[29] Annie L. Diggs, "The Women in the Alliance Movement," *The Arena*, VI (July, 1892), 161-179.
[30] *Ibid.*

Such enthusiastic activity afforded Mrs. Lease considerable prestige as long as it appeared possible that the labor and farm elements which had united to form the People's party, might succeed in carrying out their economic plans. General James B. Weaver, the populist candidate for president in 1892, once spoke of Mrs. Lease as "Our Queen Mary." With the success of her party's state ticket came her appointment as a member of the State Board of Charities at twelve hundred dollars a year. But after the elections of 1893 indicated a decline in populist strength, she began to criticize the policies of her political colleagues almost as violently as she had once flayed those of the two old parties.[31] Needless to say such tactics merely served to hasten the decline of the populists, and her own political oblivion.

Associated with this party were many other western women of education, intelligence, and milder views. Had the new organization enjoyed a longer life, they might have been of real assistance. Less likely would this have been so in the case of Mrs. Lease. Although a modern reader is amused over her statement, "What you farmers need to do is to raise less corn and more hell,"[32] he should not be too sure that such remarks did not enhance the conviction of many persons that the political atmosphere corrupted the speech and actions of women. Hence, while both Mrs. Nation and Mrs. Lease were undoubtedly sincere, and their struggles before entering public life commendable, still their careers were probably one cause for the fruitless years for the equal rights movement, 1897-1909.

[31] *Kansas City Star*, November 10, 1893.
[32] John D. Hicks, *The Populist Revolt*, 159-160.

CHAPTER VII

THE WEST AND THE FINAL SUFFRAGE VICTORY

1. REASONS FOR THE "FRUITLESS YEARS"

The elevation of William McKinley to the presidency on March 4, 1897, and the fair degree of prosperity which returned to the nation after the Spanish-American War seemed to represent a victory for those who opposed drastic departure from time-honored political practices. Conservative success not only caused women reformers of the radical type—such as Mrs. Nation and Mrs. Lease—to be frowned upon by the general public, but rendered further progress by the suffragists impossible for more than a decade. Moreover, it will be remembered that the year 1899 found an increased number of people "imperial minded." The administration of the recently-acquired colonial possessions, the American Far Eastern interests, and the Yukon gold discoveries, all served to render Americans less "western-minded," and less "reform-minded." As stated in the first chapter of this study, imperial interests feel, less than those of the frontier, the need of female assistance.

Even after the death of President McKinley and the succession of President Theodore Roosevelt, extra-territorial concerns still held the attention of a large portion of hte American public. With the best lands of the plains-mountain region already claimed by homesteaders, and with no comprehensive proposals for the reclamation of the remainder as yet acted upon, the West was not in a good position to regain public attention.

Nor were the suffrage reformers. The latter had three reasons to hope that President Roosevelt might accord their

movement a favorable gesture. He had spent a large part of his young manhood in the West, where the equal rights strength was greatest, he appeared to be considered a reform president, and he had, while governor of New York, advised the legislature to extend voting privileges to women.[1] But upon becoming chief executive, he consistently refused to issue any statement regarding the expediency of equal rights. More than this aloofness, however, his many remarks in praise of large families were regarded by millions who idolized him, as an indication that he believed woman's place was in the home. Says the biographer of Miss Anthony in regard to his suffrage attitude, "Roosevelt, either because he was in love with the idea of enormous families as the salvation of society, or because he was over-mindful of political fences, changed his mind after becoming the nation's chief executive." [2]

Some persons endeavored to intimate that woman suffrage was not a success in some of the states which had adopted it. It was pointed out that while there had been three women in the Colorado house of representatives in 1895, none were present in 1905. The same writer also furnished a number of episodes which might indicate that equal voting rights had not always resulted in honest and dignified elections.[3] Actually women had not disappeared from the legislature because of any obvious inability or inefficiency of their sex as parliamentarians, but because most of their early feminine political leaders had been affiliated with the People's party, which was almost non-existent by 1905.

[1] "I call the attention of the legislature to the desirability of gradually extending the sphere in which the suffrage can be exercised by women."—From Roosevelt's first annual message to the legislature, Albany, N. Y., January 4, 1899. In *Journal of the Assembly of the State of New York at the One Hundred and Twenty-Second Session*, 1899, 15-44.

[2] R. C. Dorr, *Susan B. Anthony*, 331.
Statement reprinted with permission of the copyright owner.

[3] Laurence Lewis, "How Woman's Suffrage Works in Colorado," in *The Outlook*, LXXXII (January 27, 1906), 167-178.

The number of women serving in Colorado as county super-intendents of schools, however, had not declined. In 1906, thirty-four of the fifty-nine counties of the state had women acting successfully in that capacity. There is evidence, more-over, that during this period, the women of the plains-mountain area were taking at least a slightly greater interest in civic affairs than those of other sections. For example, of the eleven outstanding examples of civic activities cited by Mrs. Mill-spaugh, seven were from this area.[4] This continued interest by western women in civic problems was to accrue to the benefit of their cause, when a time more favorable to further progress of the equal rights movement came.

And come it did, after the close of the Roosevelt administra-tion. That president seemed more interested in the welfare of the West during his two last years in office, than in imperial affairs. It will be recalled that in his messages to Congress, he recommended irrigation projects, inland waterway develop-ment, conservation, and laws to accelerate the settlement of Alaska. Moreover, with his retirement, a new wave of liberal-ism swept the West, one which was to accrue to the benefit of the feminists. Several of the new progressive leaders favored the development of America's last frontier, Alaska.

2. WOMEN AS ALASKA PIONEERS

Although Alaska was purchased by the United States from Russia in 1867, it did not interest greatly any number of Americans until the discovery of large gold deposits toward the end of the nineteenth century. In 1896, gold in paying quan-tities was discovered along Klondike Creek, a tributary of the upper Yukon in Canadian territory. A rush of prospectors ensued, a few of whom brought their wives with them. The

[4] Mrs. Charles F. Millspaugh, "Women as a Factor in Civic Improvement," *The Chautauquan*, XLIII (March, 1906), 312-319.

reactions of these women to such a cold and unhospitable land, of course, varied. Mr. Sheldon Jackson, who was well-known to the Alaskans of the eighteen-nineties for his missionary and political activities, and who never seems to have been particularly sympathetic toward the Alaska pioneers, relates an episode showing that one woman who traveled to the gold fields by the most comfortable route, was not brave in sustaining the boredom of the long voyage. After she and her husband had spent three weeks on a river steamer which was slowly making its way up the Yukon, she exclaimed, "Will it never come to an end? Must I continue to go on forever and ever?"[5]

But since there is rather ample evidence to confirm the charge of many of the Alaska pioneers that Jackson was allied with interests which sought to postpone indefinitely the influx of large numbers of white immigrants into the territory, there is no reason to believe that the statement of the lady mentioned above should be regarded as the typical attitude of the pioneer women of Alaska. In fact, all other available evidence shows clearly their great fortitude in facing the problems of this frontier with its novel environment. A majority of the Klondike goldseekers were obliged to take the most difficult and most perilous route, namely, across the mountains which separated the Yukon Valley from the coast of the Gulf of Alaska.

Interesting to note is the fact that while many parties of men perished while attempting the journey, two women made the trip alone in the spring of 1900, with a horse and sleigh. Although the horse almost fell into holes in the ice several times, they arrived at Dawson City safely. Another woman who accompanied her husband from the coast to Dawson City, exhibited more courage than he. This was a lady interviewed by the traveler Edwards in 1903. The couple had been among the first to reach the settlement after the news of the discovery

[5] Sheldon Jackson, "Alaska and the Klondike," *The Chautauquan*, XXXVIII (November, 1903), 235-249.

of gold had reached the outside world. Edwards added that her many favors to settlers and travelers had caused her to be called a "Streak of Sunshine," and that her hotel was the only good one in the town. In speaking of her journey to the Klondike, she said:

> We were among the first. We came up from San Francisco in a waterlogged schooner through the wash of ice and winter gales to Dyea, and then mushed over Chilkoot Pass on snowshoes with the dogs. I shouldered my pack like the men. And John, John would have backed out or died of weariness if I hadn't told him that if he quit, I would come on just the same. Yes, I carried my gun—I didn't have to use it but once or twice. Yes! We've done very well in Dawson, very well. . . .[6]

Among other Alaskan and Klondike women who prospered and became widely known for their acts of service and bravery, was Mrs. Harriet Pullen. The news of the discovery of gold in the upper valley of the Yukon River found this daughter of a wealthy family of the state of Washington, a widow with three small sons. She decided to migrate northward, and since she was almost penniless upon reaching Skagway, she accepted a position as cook in a mining camp. But she shortly entered the most daring business of transporting goods from the coast over the dangerous passes to the gold fields, and her profits from a single season amounted to one thousand dollars; sufficient to enable her to open a hotel. Her many acts of kindness to miners and prospectors won for her the name of "Mother of the North."[7]

Other women aided the territorial authorities of Yukon in apprehending smugglers. Since an export tax of two and one-half per cent had been levied on all gold exported, females

[6] W. S. Edwards, *In To The Yukon*, 168.
 The term "mush" is an expression used in Alaska and northwestern Canada to denote travel with a dog team.
[7] Frank G. Carpenter, *Alaska, Our Northern Wonderland*, 304-305.

frequently served as the accomplices of the outlaws. Hence, to assist the Northwest Mounted Police, women served as their assistants to search carefully the persons and baggage of all females leaving the Yukon.

Soon, however, there was to be a rich gold field wholly within United States territory. The accidental discovery of deposits of this precious metal on Nome Beach, precipitated a rush of prospectors to the Seward Peninsula in 1899. September of that year found Nome City a settlement of between four and five thousand persons. One woman became rather wealthy by operating a hotel during a single season.[8] Reaching the new gold fields from the North Pacific coast of the United States did not involve the same hardships as did the routes to Dawson City, since the entire journey could be made by sea. But unfortunately many persons perished in the attempt to travel from Dawson to the new fields in western Alaska. Added to the expected hardships of the Arctic winter, the absence of a pure water supply and proper sanitary facilities resulted in much sickness in the Nome area. The *St. Louis Globe-Democrat* for April 16, 1900, stated that the cold months had witnessed about three hundred cases of typhoid fever in the colony, with thirty resultant deaths.

As a consequence, the women of the area, early the following spring, began to press demands for the installation of adequate sanitary systems. In commenting upon the public-spirited attitude of these women, a journalist said:

> There are a thousand women in the district, and they have, as usual, taken vigorous action with the sanitary question; brave, noble, energetic, self-sacrificing American women— God bless them!—mothers, wives, daughters, sisters, and

[8] William J. Lampton, "The Cape Nome Gold Fields," *McClure's Magazine* XV (June, 1900), 134-142.

sweethearts who urge upon those near and dear to them the pressing need of better sanitation. . . .[9]

The above writer might have supported his words of praise still further by mentioning the invaluable services of those females who had been capable of nursing the sick persons during the previous winter. It seems clear that such an obligation must have been a most formidable one, since in all the Alaskan settlements, as was the case in those of the older American frontiers, the male population greatly exceeded the female.[10] Nevertheless, the reports of the hard winter failed to dampen the ardor of those seeking wealth in the North, and the rush to Nome and its vicinity was resumed as soon as the season opened in 1900. Obviously, quarters for all arrivals were not available, and many were forced to camp in the open. The willingness of the women of the group to adapt themselves to such conditions, indicates that they retained the spirit which a previous generation of females had displayed on the earlier frontiers. In describing this situation at Nome, a reporter said:

> Many persons off the steamers have been ashore a week and their baggage has not come yet. They are lying anywhere, without cover save their coats or what their more fortunate friends can divide with them. There are many ladies among those so situated.
> I saw one party of ladies calmly camped against a pile of freight, surrounded by pieces of hand baggage and partially covered by a tarpaulin. I heard another lady tell how she had been sleeping in a goods box.[11]

[9] George Edward Adams, "Cape Nome's Wonderful Placer Mines," *Harper's Weekly*, XLV (June 9, 1900), 529-531.
[10] The census returns for 1900 disclosed that the white population of Alaska included 27,293 males and 3,200 females. *Twelfth Census of the United States*, Vol. I, Part I, Table 16, p. 490.
[11] Tappan Adney, "The Gold Fields of Cape Nome," *Collier's Weekly*, XXV (August 4, 1900), 18. The article was written at Nome on June 20, 1900.

Other women, those less speculatively inclined, were to enter Alaska as public school teachers. Prior to the gold rush, Sheldon Jackson, in his capacity as general agent of education in Alaska, had opposed the ingress of unattached female teachers. He said in his report for 1886, "Teachers should be married men accompanied by their wives insofar as possible, though in a few places where they can have a home with a private family, it will be proper to employ unmarried ladies." [12]

With the sizeable inflow of settlers after 1898, however, such caution was no longer tenable. The first public school in the interior of Alaska was opened by Miss Anna Fulconer at Circle City in the autumn of 1897. In describing her first day of teaching, she said, "It was so cold that day, half the session I was shivering, and sometimes my teeth chattered." [13]

The agreement between the federal government and the Circle City community was that the former should furnish the instructor, the light, and the fuel, while the school district would provide the building and furniture. Hence, three weeks after the opening of the term, the school board held a dance to defray the cost of the structure. Miss Fulconer was told that she *must* attend, since more miners would be present if they knew the teacher would be on hand. Said the latter in her article, "So I pocketed my prejudices and attended a dance in a mining camp."

This affair was handled somewhat differently than the dances of the "forty-niners." In place of using men to take the part of the unavailable girls, young female natives were admitted to the hall. Native men, however, were barred.[14]

Other women came to Alaska as instructors, and according to the census of 1910, there were 119 women but only 76 men

[12] Statement of Jackson as cited in Katherine M. Cook, *Public Education in Alaska, United States Department of Interior Office of Education Bulletin,* 1936, No. 12, p. 27.
[13] Anna Fulconer, "The Three R's at Circle City," *The Century Magazine,* LVI (June, 1898), 229.
[14] *Ibid.*

as teachers in that area.[15] It seems pertinent to note also that in this year, fifty-seven females were serving there as professional nurses. But while the women who were brave and enterprising enough to go to Alaska rendered the same great services as their mothers and grandmothers had done on previous frontiers, it can hardly be said that their fortitude had any great effect upon the masculine attitude toward the weaker sex in the country as a whole. The resumption of progress toward national woman suffrage was to be the product of other forces.

3. A DECADE OF SUFFRAGE SUCCESS, 1910-1920

Aside from the concern over development projects which President Theodore Roosevelt had manifested during his last two years in the White House, there were other factors which aided in the creation of a new atmosphere favorable to the extension of woman suffrage in the West. A new generation of colorful liberal leaders had risen by 1910. Mr. Hiram W. Johnson, who had won national prestige by fighting corruption in California, and the friend of Idaho suffragists, William E. Borah, then a prominent member of the United States Senate, were but two examples. Contributing also to this rise of a new western liberal movement were developments in the first twenty months of the Taft administration. Many westerners felt that the enactment of the Payne-Aldrich tariff law with schedules too high to please their section, and the veto of the proposed Arizona constitution were indications that Roosevelt's successor had "sold out to the conservatives." Upon his return from the hunting trip to Africa in 1910, former President Roosevelt toured the West, where he both spoke and wrote of the "new nationalism" and "conserving womanhood and chil-

[15] *Thirteenth Census of the United States,* IV, p. 108, Table Eleven.
 The total white male population of Alaska in 1910 was 30,334, and the white female population 6,066.—*Ibid.*

dren." He did not directly advocate equal suffrage at this time, but in his remarks he at least "straddled" the issue.

The impact of this new movement soon bore fruit for the suffragists. The legislature of Washington authorized a suffrage referendum at the regular November election in 1910. In the wave of liberalism which defeated many conservative candidates that autumn, the proposed amendment carried, and Washington became the fifth state to embrace woman suffrage. Moreover, the California legislature decided to refer this question to the people of the state at a special election to be held October 10, 1911. The feminist leaders worked diligently to win this state, knowing that many conservative counties would return adverse majorities. They were well satisfied, therefore, when results disclosed a majority of 3,587 votes for the amendment.[16]

The crucial years for the crusade, however, were to be 1912 and 1913. In August of the former year, the Progressive party was organized at Chicago for the purpose of supporting Theodore Roosevelt for the presidency. One of the planks in the new party's platform endorsed the principle of woman suffrage. Well known is the failure of this progressive or "bull moose" ticket in the autumn election. Nevertheless, results of the voting showed that three more western states had adopted equal suffrage, Arizona, Kansas, and Oregon.

Instrumental in placing the movement in a position for final victory was the Illinois partial suffrage law of 1913. That year found the progressives holding the balance of power in both houses of the legislature. The governor, Mr. Edward F. Dunne was anxious to redeem a pre-election pledge, and secure the submission of an initiative and referendum proposal to the voters. The state constitution precluded the possibility of submitting both the latter amendment and one concerning

[16] Anthony, *Woman Suffrage*, IV, 49-50.

suffrage to the people of the state. The governor, therefore, was unwilling to support an amendment for woman suffrage, but did indicate that he would not oppose whatever extension of the voting rights that could be gained by legislative action only.

It had often been suggested by legal authorities friendly to this cause, that the several state legislatures might accord women "presidential suffrage" since Article Two, Section One of the federal constitution stipulated that the latter bodies should designate the manner of choosing the presidential electors for their respective states. It was held also that the Illinois legislature might extend to women the right to vote for all other offices not mentioned in the state constitution. A bill granting women the right to vote for that category of officials and for presidential electors as well, was therefore drafted and presented to the legislature. Aided by the strategic position of the progressives, the most ingenious campaign of the suffrage workers under Mrs. Grace Wilbur Trout, and the friendly attitude of Governor Dunne, the proposal passed both houses and was approved on June 26, 1913.[17] Later the state supreme Court upheld the constitutionality of the law.

This action did not render Illinois the tenth suffrage state, since there remained a large number of places for which women could not vote, among them being those of United States senators and representatives. But if the law did not necessarily strengthen the position of the feminists in Congress, politicians were quick to appreciate the greatly increased importance of the female vote in presidential elections. Two more states voted for full suffrage on November 3, 1914, Montana and Nevada. The total strength of the eleven suffrage states plus Illinois in the electoral college was to be ninety-two votes in 1916.

[17] *Daily News Almanac and Yearbook for* 1914, 491.

Partly because of this fact, and partly, no doubt, due to the belief that national suffrage was only a question of time, both Republican and Democratic platforms for the 1916 campaign endorsed the principle of equal suffrage. Election results for that year caused many observers to feel convinced that the feminine vote in the twelve states with presidential suffrage, decided the election.[18] Of these commonwealths, only Oregon and Illinois showed a plurality for Mr. Charles E. Hughes, the Republican candidate. The other ten named electors for President Woodrow Wilson. If western women did decide this election, their preference is thought to have been influenced by the belief that Mr. Wilson would be more likely to keep the nation from entering the World War than would Mr. Hughes. If this hypothesis be true, the wishes of these feminine voters were frustrated, but nevertheless, they were a large factor in not only American, but the world history of the period.

Prior to the American entry into the European conflict, all of the equal suffrage states were to be found west of the Missouri River. The progress of this movement after 1916 was due largely to wartime idealism and the desire of cautious politicians to leap to the winning side. A suffrage amendment, drawn up by Susan B. Anthony more than forty years earlier, passed the House of Representatives on May 21, 1919, and the Senate on June 4 of the same year. Ratification by the states was rapid, and after Tennessee, the thirty-sixth state, had approved of the proposed amendment, Secretary of State Bainbridge Colby declared it operative on August 26, 1920.[19] The women's leader in this campaign for ratification was Mrs. Carrie Chapman Catt, a native of the Iowa frontier. Commenting upon the proclamation of this Nineteenth Amendment, the *New York Times* declared, "It is a fair guess and indeed a fact

[18] Malvina Lindsay, "Mrs. Grundy's Vote," *North American Review,* CCXXXIII (June, 1932), 485-491; also cartoon comment of *Chicago Tribune* (Chicago, Illinois), November 11, 1916.
[19] *New York Times* (New York, N. Y.), August 27, 1920.

already exemplified, that one distinctive interest of the woman politician will be in what is called welfare legislation."[20] The examples of which the *Times* editor spoke had been furnished by the western states. In fact, one western woman interested primarily in welfare legislation had already been honored by being sent to Congress.

4. FIRST WESTERN WOMEN IN HIGH POSITIONS

Prior to 1916, many women in the western equal rights states had served in the legislatures, on state commissions, and as school and county officials. It was not until that year, however, that a woman was sent to Congress. This honor went to Miss Jeanette Rankin of Missoula, Montana. She was born in the latter town on June 11, 1880, and had spent most of her life in social and woman suffrage activities.[21] Miss Rankin was elected representative at large from the state of Montana as a Republican in November, 1916. She was one of the thirty-two members of her party who voted against the declaration of a state of war against Germany in April, 1917; a fact which partly explains her failure to lead a successful campaign for re-election in the super-charged martial atmosphere of the Congressional election of 1918. Nor did her wartime tenure in Congress afford Miss Rankin a favorable opportunity to sponsor successfully her social program.

The year 1924 is remembered in political history chiefly for the re-election of Calvin Coolidge as president, but it also witnessed the elevation of two women to the governorships of their respective states. In the November elections, Mrs. Nellie T. Ross was named to serve the remaining two years of the term of her late husband, William B. Ross. In Texas, Mrs.

[20] *Ibid.*, August 29, 1920.
Reproduced with permission of the *New York Times.*
[21] *Chicago Tribune*, November 11, 1916.

Miriam A. Ferguson, the wife of former Governor James E. Ferguson, waged a successful campaign for the constitutional gubernatorial term of two years, 1925-1927. In 1932 she was elected for a second term. Both Mrs. Ross and Mrs. Ferguson were natives of the West, Mrs. Ross having been born in St. Joseph, Missouri, in 1880, and Mrs. Ferguson in Bell County, Texas, in 1875.

Still another woman might be included in this group, Mrs. Hattie W. Caraway, the first woman to be elected United States Senator. Following the death of her husband, Senator Thaddeus H. Caraway on November 6, 1931, she was named provisionally for the seat by the governor of the state. At the regular November election the following year, Mrs. Caraway was chosen by the voters of the state for a six-year term. She was returned for a similar period in November, 1938.

With the coming of the New Deal, the West was to lose its unique position in this regard. The first women to hold several other high positions were residents of other sections. Nevertheless, these places have been appointive and not elective as were the western instances cited. Of the four latter, that of Miss Rankin is no doubt most outstanding, not only because it substantially antedated the others, but since in her case alone, no political affiliation of a late husband played a part in her election. Still, in the political careers of all four women, as well as in the state grants of full suffrage before the World War, the West was, in a sense, merely recompensing womanhood for the services which had rendered its phenomenal development possible.

CHAPTER VIII

SOCIAL AND CULTURAL RESIDUE

1. THE CONTINUED SHORTAGE OF WOMEN IN THE WEST

In the states of the timber-prairie frontier, the preponderance of males over females consistently decreased as these commonwealths were transformed from communities of frontier settlements to thriving agricultural and industrial areas. Such, however, has not been true of all the plains-mountain states. For example, Illinois, according to the 1860 census returns, had but one hundred and eleven males for every hundred females, in spite of the heavy immigration of the eighteen-fifties. That census was taken about forty-two years after Illinois attained statehood. On the other hand, six states of the plains-mountain region, all of which except Arizona had been in the Union forty years or more in 1930, appeared to have more than one hundred and twelve males to every hundred females.[1]

One explanation for this condition is that the immense public land acreage in these states permitted entries by a large number of persons long after 1890. In fact, if one were to accept a large volume of immigration and public land entries in place of an Indian menace as a criterion for determining the existence of a frontier, it would have to be said that the American frontier environment ended not in 1890 but in 1914.

Just as had been the frontier situation for more than a century, large numbers of those taking up public land in the period

[1] The states with their respective ratios of males to females, are: Arizona, 113.2; Idaho, 114.3; Montana, 130.0; Nevada, 140.3; Washington, 112.1; and Wyoming, 123.8.—*Fifteenth Census of the United States*, 1930, Vol. III, Part II, p. 1371.

before the World War were young single men. In the absence of any sizeable immigration of young unmarried women, many of these males were to remain bachelors. A similar situation in the Canadian provinces caused a writer to speak of the "crying need for women." [2]

Perhaps even more important as a cause for this recent large excess of males in the West, however, is the nature of western agriculture and industry. The plains-mountain states are essentially areas for "producer's goods," for example, oil, ore, timber, grain, and cattle. It can be readily seen that such operations would offer far fewer employment opportunities for female workers than do those sections of the country which manufacture the so-called "consumer's goods." Thus while a few western people are proud of the fact that their section has never become industrialized in the latter sense,[3] the result has been that the non-professional young woman has often found it expedient to migrate to other sections of the country for employment. The movement of western girls to New York City for positions was noted as early as 1896.[4]

A third explanation involves the continued speculative appeal of the West for men. While mining operations are now largely carried on by corporations, there are still other inducements for enterprising males. On the plains, the sowing of wheat involves a rather large risk, but if the crop is a good one, the planter often finds himself with a comfortable "nest egg." In the mountain regions, the railroads pay higher rates to their operating employees than do those of the remainder of the country.

It will be recalled that many pioneer women of the plains-mountain region were well satisfied and optimistic. But these early settlements were chiefly on more desirable plateaus. With the occupation of the less desirable plains with their uninterest-

[2] Leo Thwaite, *Alberta, An Account of Its Wealth and Progress*, 217.
[3] Katharine F. Gerould, *The Aristocratic West*, 33.
[4] Mary G. Humphreys, "Women Bachelors in New York," *Scribner's Magazine*, XX (November, 1896), 626-636.

ing terrene, isolation, harsh climate, and reduced speculative appeal, women had less reason to be happy. The typical plains-mountain community is still small, it still possesses limited social possibilities, and great distances still provide an isolation which modern transportation can but partially remedy. Moreover, three physical factors almost seem to have grown more irksome in recent years, the dust, the termites, and the wind.

A logical consequence is that thousands of women seek to leave this section as soon as they or their husbands can obtain employment in another part of the nation. Also eastern employers, well aware of this feminine attitude, often send single men to serve in their western branches in small communities. With numbers of women leaving these plains-mountain states, and with many classes of single men migrating to them for one reason or another, the possibilities of young women finding mates continue to be greater in those commonwealths than in any other section of the nation. The census returns for 1930 disclosed that 64.9 per cent of all females over fifteen years of age in the eight mountain states were married, as compared to but 55.9 per cent in the New England region, where the women slightly outnumber the men.[5]

The excess of males in the plains-mountain West, the physical features of the country which women generally find so repugnant, and the several instances of new cultures modifying existing ones, all have provided interesting data not only for the traveler and the historian, but for the novelist as well. Both the writings of female travelers in the early West and the more recent productions of feminine novelists represent a most important contribution to general English literature with an American background.

[5] The eight states are Arizona, Colorado, Idaho, Montana, Nevada, New Mexico, Utah, and Wyoming. *Fifteenth Census,* Vol. III, Part II, 854.
The writer finds that his statements regarding this modern scarcity of eligible young women in the West are generally supported in Gretta Palmer, "There Are Plenty of Bachelors," *Ladies' Home Journal,* LVII (February, 1940), 25.

2. SOME REPRESENTATIVE WOMEN WRITERS OF THE WEST

Of the hundreds of accounts of travel in the Middle West, while that section was either a frontier or a new section, none received more world-wide attention, none made other travelers more anxious to visit the American West, than did the two volume work of Mrs. Frances M. Trollope (1780-1863), which was first published in 1832. These volumes bore the title of *Domestic Manners of the Americans,* and have been cited several times in this study. Mrs. Trollope landed at New Orleans in the late eighteen-twenties, and went up the Mississippi and Ohio Rivers to Cincinnati, where she hoped to establish her son as a merchant. The failure of "Trollope's Bazaar" to become a financial success seems to have embittered slightly this mother. But upon her return to England, she decided to write her impressions of the portions of America which she had visited. While her prejudice and unstinted criticism caused a storm of protest in many sections of the West of that day, the work enjoyed a wide sale. Fidler, who was in New York City in 1832, the year the volumes were first published, tells of asking a bookseller for a set. The reply was that he would not keep them in his store. When Fidler offered to apologize in the name of all his countrymen if any of the lady's statements could be proven untrue, the merchant replied with a series of oaths.[6] In spite of such opposition, the work went through five editions in the lifetime of Mrs. Trollope, and through it she found the wealth sought in Cincinnati.

Five years later there appeared the two volume travel work of another English lady, Miss Harriet Martineau (1802-1876). This bore the title of *Society in America,* and like the famous production of Mrs. Trollope, it enjoyed great popularity and hence was reprinted several times. Miss Martineau traveled in the West more extensively than did Mrs. Trollope, and she

[6] Isaac Fidler, *Literature, Manners, and Emigration in the United States,* 238.

was very careful to note changing social conditions. She was among the first foreigners to observe the fact that the influence of women was increasing in America.

For social conditions on the Wisconsin-Minnesota frontier of the late eighteen-forties and early eighteen-fifties, there is no better authority than Miss Fredrica Bremer, 1801-1865). The American travel writings of this Swedish lady bore the title *America in the Fifties,* and were first published in 1853. This book was significant for two reasons; it called the attention of prospective Scandinavian emigrants to the fact that Wisconsin and Minnesota possessed an environment much like their homeland. Then, for the American reader, her contempt for the indolent Indian males, as well as her admiration and sympathy for the colored people, were of special interest.

Turning to the far Southwest, a safe speculation seems to be, that the history and story of that region converge in the writings of Helen Hunt Jackson (1830-1885) as they never can in those of any other author. A native of Amherst, Massachusetts, she visited California in 1872, and spent the winter of 1873-1874 at Colorado Springs, Colorado. During other western travels, she became increasingly interested in the welfare of the Indians. Her renowned work, *A Century of Dishonor* was published in 1881. This production severely criticized the Indian policies of the United States government.

So famous did this volume render Mrs. Jackson, that in the following year she was named a special United States Commissioner to make a report on the condition of the California Indians. Partly due to the feeling that the federal authorities were not giving her plans sufficient consideration, she brought out her famous novel *Ramona* in 1884. Her untimely death took place the following year. The well-known lecturer, John L. Stoddard, once said, "What *Romola* is to medieval Florence, *Ramona* is to Southern California. It has embalmed in the memory of a nation a lost cause and a vanished race."

After the disappearance of the open frontier, other female writers gave their readers vivid pictures of western life through their novels. One of the stories of Dorothy Scarborough (1877-1935), *The Wind,* is almost a classic as a piece of fiction which depicts the effects of the "plains environment" upon women. Statements such as the following were of course most true to life, "The wind is the worse thing. . . . The work out here is hard on women. Can't get any help, and can't have the conveniences they have in other sections." [7]

While not exclusively a writer of western stories, Edna Ferber (1887-) produced one novel which seems destined to remain one of the immortals of western fiction. This is *Cimarron* (Garden City, N. Y., Doubleday, Doran and Co., 1930), a narrative which depicts the rush of anxious homeseekers to the newly-opened lands of Oklahoma in 1889. In 1931 a motion picture version of the story appeared, and was considered by several critics to be one of the best productions of the year.

Willa Sibert Cather (1875-) has written many western stories, but perhaps one of her greatest contributions has been the vivid descriptions of the problems faced by Central Europeans after emigrating to the West. A novel including some adjustments made by such immigrants is her *My Antonia* (Boston and New York, Houghton, Mifflin and Co., 1918).

But perhaps the novelist who has done the most thorough work in describing, through the avenue of fiction, the problems of a foreign group in the West, is Martha Ostenso (1900-). Being of Scandinavian descent, and well acquainted with soil and climatic conditions in the American states and Canadian provinces of the northern plains, she has been in an excellent position to portray the economic, social, and psychological problems of the Danish, Norwegian, Swedish, Finnish, and Icelandic

[7] Dorothy Scarborough, *The Wind* (New York, Harper and Brothers, 1925), p. 21.

settlements. Two of her more recent novels are *The Stone Field* (New York, Dodd, Mead and Co., 1937) and *The Mandrake Root*, which was brought out by the same firm in 1938.

While the amount of literature on the West produced by women may not be noteworthy for its volume, still such writings have often been definite contributions. The great accomplishment of the female writers during the frontier period was apparently their ability to enlist the attention of a large public in America and in Europe, in regard to their observations upon western conditions. What seems most impressive in regard to the post frontier novelists is their ability to portray a western culture modified by many national groups as well as by geographical and climatic conditions. Since woman, more than man, is regarded as a civilizing agent, perhaps she is in the best position to analyze the forces which created the blended civilization of this "last West." But the historian should also consider more of the social consequences produced by both of the trans-Alleghany frontiers.

3. SOCIAL REVERBERATIONS OF BOTH FRONTIERS

The middle nineteen-thirties witnessed rather widespread public interest in the matter of child marriages. These appear to have originated in America as a result of frontier conditions, and to have been so common that they usually aroused unfavorable comment only from foreign travelers. The *Kentucky Reporter* of August 4, 1823, announced the marriage of a Revolutionary War veteran, Mr. Charles McGee, aged ninety-four, to a Miss Mary Walker, who was but fourteen. The only comment was, "McGee distinguished himself in several engagements in the revolutionary struggle, and in his declining years has taken to his bosom a young bride, which will aid in rewarding him for his patriotic efforts during times that tried men's souls."

But Bernhard, in writing of a girl from the same state who married at the age of twelve, said that the "females of Kentucky marry much too young." [8] Mrs. Trollope, who wrote in regard to the same situation in 1829, said, "They marry very young, in fact, in no rank of life do you meet with young women in that delightful period of existence between childhood and marriage." [9] James tells of seeing a girl in St. Louis (in eighteen-forties) who was both a widow and a mother at the age of fifteen. His comment was, "They no sooner put down their dolls than they take up their infants." [10] These early marriages, moreover, continued to take place as the frontier moved farther westward. When writing of Kansas frontier life, Ebbutt mentioned a Mrs. George Dyson, who had married at thirteen, while her daughter entered wedlock at the age of fifteen. He added that Mrs. Dyson was a "proud grandmother at the age of thirty-one. Go-ahead people—the Americans, are they not?" [11]

In attempting to explain the very early marriage of so many western girls, one might first of all recall the historian's statement that frontier life was a retrogression toward the primitive, and then the fact that anthropologists frequently point out the early maturity of many primitive peoples. Still, a number of social factors should not be overlooked. It seems safe to conjecture that many girls of isolated communities, denied the opportunity for the social relationships so necessary to normal children in their early "teens," accepted offers of marriage in the hope that their husbands would take them to more interesting and tolerable localities.

It will be remembered, furthermore, that many frontier mothers died prematurely, leaving a number of children. Mrs.

[8] Bernhard, *Travels Through North America During the Years* 1825 *and* 1826, II, 183.
[9] Trollope, *The Americans*, I, 163.
[10] T. H. James, *Rambles in the United States and Canada*, 151.
[11] P. G. Ebbutt, *Emigrant Life in Kansas*, 45.

Farnham describes a home where a group of young ones thus bereft, did not find life agreeable in the home of their step-mother.[12] In such situations, the daughters would be likely to consider marriage proposals at an early age.

But the westward movement modified marriage in many of the older states as well. In New England, there was a shortage of young men before the Civil War, since many left either for the West or for a maritime career, while most of the young immigrants who remained in the East settled in the Middle States. Hence, many New England girls married men much older than themselves. Miss Martineau wrote, "I was struck with the great number of New England women whom I saw married to men old enough to be their fathers." [13]

Largely because of frontier conditions also, the common notion, still prevalent, that women age more rapidly than men, was augmented. The English traveler in America during the early eighteen-fifties, Mr. J. R. Beste, relates that an Indiana woman was much surprised over the youthful appearance of Mrs. Beste, the mother of eleven children.[14] Approximately thirty years later, an article in a Kansas City newspaper declared that there were many fine looking "male specimens" between thirty-five and fifty years of age, but very few "comely women" in that age group. The journalist continued, "Woman is expected to daily endure a strain that no man would tolerate for any length of time. Until what is modestly called house-keeping is recognized as a noble science that it really is, and is carefully studied, the slaughter of women by overwork will continue." [15]

Foreign visitors, moreover, noted that in America the social world paid less attention to the married woman than was true in Europe. The logical explanation for this difference seems

[12] Prairie Land, 132.
[13] Martineau, Society in America, II, 242.
[14] Beste, The Wabash, 301-302.
[15] Kansas City Evening Star (Kansas City, Mo.), November 8, 1881.

to be that in Europe of the first half of the nineteenth century, society was very largely an end in itself. The married woman with sophistication and mature experience could enliven the atmosphere of the salon in a way no unmarried girl could do with propriety. There, cheap domestic help enabled many housewives to keep themselves informed regarding the topics of the day, as well as the *belles lettres*.

In the United States, on the other hand, the unavailability of household help rendered even many of the wealthy women household drudges, wholly without time for the perusal of works considered "cultural." Moreover, society outside of the religious sphere was largely confined to those seeking mates. It was obvious that no permanent or healthy settlement of the West could be effected except through the establishment of new homes. The unmarried woman, therefore, usually monopolized the attention which the world was willing to accord her sex. Says the traveler Mackay:

> Another feature in American society which soon excites the surprise of the stranger . . . is the little attention paid in the social circle to married women. . . . After a very short time, in the great majority of cases, she disappears altogether, only again to cross the threshold of society when her taste for its enjoyments is blunted, when her cheek is faded, and her youth is gone, and when she has a daughter of her own to introduce.[16]

Also the issue of *Morris's National Press* for October 24, 1846, contained an interesting though probably exaggerated description of the same situation:

> To a person just arrived from England or the continent, the most striking variation of the society which he finds from that which he has left, consists in the difference in the

[16] A. Mackay, *The Western World*, I, 216.

age of those whom he sees in the foreground of display. At the first party he goes to, he fancies that he has walked by mistake into the nursery; he wonders all evening when the married women will begin to arrive: and at the conclusion goes away a little piqued at having been invited to a children's party, when he thought himself a fit companion for persons a little more advanced in life. The second, the third, and the thirtieth evening it is the same thing. . . .

But accompanying the new chivalrous attitude toward women which sprang up on the plains-mountain frontier, was the general view that men also should remain close to their families after marriage. Said E. W. Howe, "Western society is made up of young people. . . . The middle aged man who attends a social affair is an oddity, so firmly rooted is the impression that as soon as a man married he ought to retire from everything except business." [17]

The reader may feel that the foregoing effects of the frontier upon American womanhood have become less pronounced. He might recall that child brides now appear only in remote sections of the country for the most part, that modern travel reduced the likelihood of girls being obliged to marry men "old enough to be their fathers" in order to have a home, that a new realm of political and social activity has been opened up for the married woman, and modern home conveniences and the science of beauty culture have reduced the number of women appearing prematurely old.

But the frontier brought into being an attitude concerning a certain group of women, one which was a drastic departure from conventional Anglo-Saxon tradition. This was the willingness to overlook the immoral acts of young unmarried women. If the American people are not becoming more lenient in their views regarding such conduct of girls, there is at least con-

[17] E. W. Howe, "Provincial Peculiarities of Western Life," in *The Forum,* XIV (September, 1892), 91-102.

siderable debate and discussion regarding the seeming ability
of some of this group to avoid becoming social outcasts. Why
the frontier began to ignore the past questionable conduct of
unmarried women, is not hard to see. The western settler
appears very often to have harbored less idealism when seeking
a wife, than the average man displays under normal circum-
stances. He needed someone to care for his home and to give
him sons who could aid him in the development of his land.
The paucity of available women would not always allow him
to inquire too closely regarding the past conduct of a pros-
pective mate. Perhaps this attitude was another indication
that on the frontier, man returned to the primitive in many
respects. An unnamed writer quoted by Calhoun made this
statement regarding the girls of western Tennessee during the
frontier period:

> I would like to give an account of the young ladies that
> flourished here at that time. It is due to them to say that
> they did not generally partake of the rude spirit of the man,
> though the few who did were not for that reason excluded
> from society. They could not be spared, as all of them made
> but a small-sized party.[18]

The writer mentioned no definite date, but other factors
indicate that he had in mind the early eighteen-twenties. This
attitude of toleration, therefore, had apparently developed on
the fringes of Anglo-Saxon civilization less than half a century
after the death of Oliver Goldsmith, 1728-1774. Probably
few would dispute that Goldsmith's character in his novel, *The
Vicar of Wakefield*, Dr. Primrose, expressed the sentiment of
the bulk of the Anglo-Saxon world of the eighteenth century on
this subject. It will be recalled that the vicar, regretfully but
without hesitation, branded as an outcast his daughter who

[18] Reprinted by permission of the publishers, the Arthur H. Clark Company,
from Calhoun's *Social History of the American Family*, Volume II, Page 103.

thought herself to be the victim of a faked marriage ceremony. The frontiersmen, however, were often guided more by expediency than by the standards of Great Britain or the American seaboard.

But there seems to have been another reason why western women with a somewhat marred past were successful in their attempts to return to normal society, namely, their possession of wealth. Because of the great scarcity of single women in the mining centers, females of this type were occasionally able to marry men of means, or those who later became comfortably situated financially. Mrs. Bates described the career of a young lady from the "Granite State" who accompanied her brother to California during the gold rush. Although she obtained a rather good position as a governess, the large sums which attractive girls might earn presiding at gambling tables seem to have resulted in her entrance into what was considered the lower strata of society. But she finally married a wealthy prospector with whom she had lived for several months, and the couple left California to make their home in an eastern city. Mrs. Bates, after raising the question whether or not the woman's new and respectable friends would desert her, should her past indiscretions become known, declared: "I am rather inclined to think they would 'wink' at them rather than to lose a *wealthy friend.*" [19]

In spite of the sad background, however, a far more desirable "frontier residue" involving females, are the numerous songs concerning girls who had passed away. Inexact but rather convincing sources disclose that the excess of the female death rate was usually heavier on the frontier than in any other section of the country, in spite of the rather large number of deaths from consumption among the women of New England in the first half of the nineteenth century. Hence many articles appeared which stressed the poor health of the American

[19] Bates, *Incidents on Land and Water,* 331-334.

woman. Significant though exaggerated was this portion of an editorial in the *Harper's Magazine* for June, 1856: "A man can only be married in this country by installments. He must lead one—two—or perhaps three brides to the altar before he can realize what marriage is defined to be—a state of permanent union. . . ."

The student is likely to be impressed by the fact that the same decade appears to have witnessed the zenith of the popularity of musical productions of this type.[20] What was perhaps the last of the more famous of such airs, was written during the same decade in which the open frontier ceased to exist. It was, "On the Banks of the Wabash Far Away" (Paul Dresser, 1899).

But the frontier provided a motivation for such themes, aside from its high feminine death rate. Soon after the settlements reached the edge of the Great Plains, came accounts of girls being captured by the Indians—girls who sometimes were never restored to their place in civilized society. Their fate created a profound impression in the new states. Southwestern historians still speculate in regard to the fate of Cynthia Ann Parker, who, as a small child, was captured by the Indians a short time before the Civil War. Equally sad, was the instance of Miss Minnie Lockhart, a kind and popular young woman of the Texas frontier settlements. She was seized by a band of Indians in 1854. After holding her in captivity for some time, the savages killed the girl to prevent her rescue by the Texas

[20] A few examples of such compositions which were published during the period of frontier expansion, are:

"Sister, Thou Wast Mild and Lovely," William Nutting, 1840.
"Ben Bolt," Nelson Kneass, 1848.
"Jeanie with the Light Brown Hair," Stephen C. Foster, 1854.
"Listen to the Mocking Bird," Richard Milburn and Alice Hawthorne, 1855.
"Gentle Annie," Stephen C. Foster, 1856.
"Darling Clementine," Percy Montrose, Reconstruction Period.
"Sweet Genevieve," George Cooper and Henry Tucker, 1870-1880.
The files of the Library of Congress failed to yield more complete data regarding the date of publication of the last two songs cited.

rangers.[21] There can be but little doubt that such episodes increased the receptiveness of the American people for such songs, since they depicted losses which any growing community could ill afford.

During the Civil War one of these melodies touched the heart strings of the greatest of frontiersmen. A Kentucky lady came to Washington to plead clemency for her son, who was under a death sentence for association with a band of guerrillas. With this mother went her daughter. The following is a description of their interview with President Lincoln:

> There were probably extenuating circumstances in favor of the young rebel prisoner, and while the President seemed to be deeply pondering, the young lady moved to a piano nearby, and taking a seat, commenced to sing "Gentle Annie," a very sweet and pathetic balled, which before the War, was a familiar song in almost every household in the Union, and is not yet entirely forgotten, for that matter. . . .
>
> During its rendition he arose from his seat, crossed the room to a window in the westward, through which he gazed for several minutes with a sad, far-away look. . . . President Lincoln drew a large red silk handkerchief from his coat-pocket, with which he wiped his face vigorously. Then he turned, advanced quickly to his desk, wrote a brief note, which he handed to the lady, and informed her that it was the pardon she sought.[22]

Nor is Lincoln's display of emotion over a song suggesting the memory of Ann Rutledge, the sole example of the success of this group of compositions in approximating the feelings of a more thoughtful generation of western men, who, like Lincoln, never recovered from an early bereavement. Perhaps the his-

[21] A large portion of the work of James Swisher, *How I Know*, (Cincinnati, 1881) is devoted to the description of such raids.

[22] Article from the *Virginia Enquirer* (Virginia, Illinois), March 1, 1879, as quoted in Alexander K. McClure (ed.), *Lincoln's Own Yarns and Stories*, 311-312.

torian should not feel too certain that his professional posterity of the next century will not accord these rustic ballads of the epoch of frontier expansion a rather high place among the source materials of western history.

To the women of the West who enjoyed normal longevity, the environment imparted a most happy trait, that of adaptability to new conditions. The latter did not pass with the frontier, but in some way has been able to permeate the consciousness of most American women of all sections and classes. Since this adaptability was to have the opportunity of proving its effectiveness during the depression years following 1929, its discussion will make up the concluding section of this study.

4. THE ADAPTABILITY OF WESTERN WOMEN

The manner in which families moved from one site to another on the American frontier, seems to furnish a most unique circumstance in the history of medieval and modern European peoples. Certainly in the Middle Ages the condition of feudalism allowed for no such promiscuous migrations, no more than did police and trade restrictions after the emergence of national states. Moreover, in the colonial period of American history, many factors combined to keep the bulk of the population close to tidewater.

The quasi-nomadic existence to which thousands of women were subjected by the restless nature of their husbands provided them with a rather unique training. Very often did they find themselves obliged to change most drastically their mode of life. A few years on an Alleghany upland farm might be followed by a half dozen more in the midst of an Indiana forest, after which the husband would move to the Illinois prairies. A log cabin, a half-faced camp, and a sod house were all familiar as domiciles to large numbers of these frontier wives.

European men and women of the lower classes rarely if ever,

had the same necessity for constantly readjusting their mode of life. Unless famine, war, or an epidemic would strike their province, they would live for centuries as their ancestors had done. Nor did the average American male. If he did not find one environment to his liking, if he felt that an easier existence awaited him farther to the West, he would usually break old ties and migrate. Such a type of independence was idealized by many Americans—even in the twentieth century. But such an existence did not encourage a man to endeavor to find a place for himself in his home community. It did not engender an ability for self-adjustment.

But the frontier women, on the other hand, developed this happy trait of adaptability. Says Latrobe concerning the first families to cross the Alleghanies:

> The pliancy of the female character and the facility with which woman, despite her softer sex, will rise superior to the weakness of her nature, when circumstances imperatively demand sacrifice and exertion, were never more strikingly portrayed. She watched, and learned to read the signs which betokened danger, and to aid in repelling it.[28]

It has been noted that after 1830, many newspaper editorials praised the accomplishments of western women. Several of these concerned the trait of adaptability. Said the *Maysville Eagle* of August 8, 1833:

> There is an originality—a raciness—among the women of the West which is eminently attractive. They touch the confines of civilization and barbarism with such daring grace, that the precise *petits maitres* of the Atlantic (coast) are thunderstruck or turned into gasping statues at their fascinating wildness and enchanting audacity. . . . The western belle dances thro' the crowd as she would through the river mounted on horseback. Nothing impedes her. . . .

[28] Latrobe, *Rambler*, I, 94.

By no means were all the women who had the opportunity to prove their adaptability to western conditions from the poorer and less educated groups. Miss Bishop, who went to Minnesota to teach in the late eighteen-forties, wrote the following account of the manner in which she adjusted herself to novel conditions:

> It is said that honey may be extracted from the bitterest flowers. This is true in the moral as in the physical world. I found a moral necessity, as well as a moral philosophy, in closing my eyes and seeing only the fair side of the picture; in short, of making the best of everything, and awaiting the change that was fast developing. And every difficulty and trial surmounted have but attached me more closely to my adopted home.[24]

The resourcefulness of the western female was expressed in still another fashion by a writer named Lino Carr in the *Home Journal* of August 11, 1855:

> The western young lady is a cross between the southern and eastern—the intelligence of the one, and the grace in showing it of the other, with a spice of half a dozen European nations thrown in, and a fearlessness and *dash* which belong only to a rearing west of the lakes and Alleghanies.

Since Mrs. Frances M. Trollope was regarded as such an unkind critic of Americans generally, and since her experience in the western states fell far short of being a happy one, it might be interesting to note the observations regarding western young women which were made by her famous son, Mr. Anthony Trollope. He wrote of them, "They have faith in the destiny of their country, if in nothing else; but they believe that destiny is to be worked out by the spirit and talent of the young women." [25]

[24] Bishop, *Floral Home*, 324.
[25] Anthony Trollope, *North America,* 396.

Also among those who praised the abilities of western women is the twenty-sixth president of the United States, Theodore Roosevelt. Having lived for several years during his young manhood upon the Great Plains, he was in a position to estimate the worth of all frontier groups. In writing of the average wife of the plains country he declared, "Peril cannot daunt her, nor hardship and peril appall her." [26]

The *Kansas City Star* of September 24, 1889, made the following statement concerning American women: "Our women are becoming more renowned for adaptability than all the women the world over." Such a remark indicates that the impact of this trait which western women developed, was already being felt in the older sections. In the same year a European traveler declared that the western type of female might be regarded as typical of all America. Said Mr. Boyesen:

> The first woman whose acquaintance I made in the United States (in 1869) was a pretty western girl. . . . She was slangy in her speech, careless in her pronunciation, and bent upon "having a good time" without reference to the prohibitions which are framed for the special purpose of annoying women. . . . Patriotic she was—bristling with combativeness if a criticism was made which implied disrespect of American manners or institutions. She was good-natured, generous to a fault, and brimming with energy.
>
> This young girl is the type of American womanhood which has become domesticated in European fiction. She is to the French, English, and German authors, the American type par excellence.[27]

Not only had the accomplishments of western women caused them to be regarded as typically American by 1890, but already

[26] Theodore Roosevelt, "Frontier Types," *The Century Magazine*, XXXVI (October, 1888), 831-843.
[27] Hjalmar Hjorth Boyesen, "Types of American Women," *The Forum*, VIII (November, 1889), 337-347.

education and communication seem to have been at work for the extension of these famous characteristics to the feminine population of other sections. Said Mrs. Palmer regarding Wellesley College, "The farmer's daughter from the western prairies is beside the child whose father owns half a dozen mill towns of New England." [28]

Not only the girls who went from the West to eastern colleges, but those who entered the great cities as workers, were to influence life in the older sections. As a part of her description of the attitude of western girls in New York, Mary G. Humphreys wrote: "She is perfectly sure that if she observes quietly she will find out everything without being told. . . . She will say for example, 'I'm never afraid to undertake anything. It just means doing one thing rather than another.' " [29]

During the next thirty years, the motion picture, the phonograph and the radio also served to render persons of the various sections more uniform as to dress, thoughts and actions. In this process, the adaptability of the frontier woman was not lost. When the depression of 1929 arrived, one heard many women remarking both orally and in articles that they had been inspired to make adjustments by the experiences of their mothers or grandmothers. Also probably more was said than would please male vanity about the superiority of women over men in making the adjustments which the depression years demanded of millions of individuals.

Cannon wrote regarding the adaptability of so many women, "They are congenital frontiersmen and there is nothing to restrain them." [30] Capek, six years later, declared, "Woman

[28] Alice Freeman Palmer, "A Review of the Higher Education of Women," The Forum, XII (September, 1891), 28-40.

[29] See Note No. 4 of this chapter.

[30] Poppy Cannon, "Pin-Money Slaves," The Forum, LXXXIV (August, 1930), 98-102.

. . . is a universal, many-sided soul, not given to intense application, but full of surprising interests."[31]

One of the writers who has portrayed the success of female workers in effecting necessary post-depression vocational readjustments, is Lorine Pruette. The facts which she discloses seem to render rather convincing the hypothesis that women have displayed a certain adaptability since 1929—a talent for discovering new channels in which to procure a livelihood that no thinking person would likely ascribe to any large block of the male population of the United States.[32] And just as her article describes adaptability of employed women, Caroline A. Henderson's "Letters from the Dust Bowl" indicate the resourcefulness of American farm women during the same period.[33]

Many other articles might be cited—all of which include remarks of a similar tenor. What appears to be both interesting and significant, is their resemblance to observations of the nineteenth century concerning western women only. Little doubt exists, therefore, that the greatest heritage which the pioneer women of both the great trans-Alleghany frontiers bequeathed to their daughters, granddaughters, and to their great-granddaughters, was not farms, cities, states, or any other form of material wealth. Instead, it was the art of solving novel difficulties. Whether any number of men have acquired this happy faculty in recent years, must remain for the present a conjecture. But if the bulk of American womanhood is able to retain this ingenious feature of the personality of the frontier women, the future of the American people is undoubtedly secure.

[31] Karel Capek, "Women and the Professions," *The Atlantic Monthly*, CLII (May, 1936), 579-580.
Reproduced with permission of the copyright owner.
[32] Lorine Pruette, "Women Workers Have Come Through," *The American Scholar*, V (Summer, 1936), 328-336.
[33] *Atlantic Monthly*, CLVII (May, 1936), 540-551.

APPENDIX

We reached the ground about an hour before midnight, and the approach to it was highly picturesque. The spot chosen was the verge of an unbroken forest, where a space of about twenty acres appeared to have been partially cleared for the purpose. Tents of different sizes were pitched very near together in a circle round the cleared space; behind them were ranged an exterior circle of carriages of every description, and at the back of each were fastened the horses which had drawn them thither. Through this triple circle of defence we distinguished numerous fires burning brightly within it; and still more numerous lights flickering from the trees that were left in the enclosure. The moon was in meridian splendour above our heads.

. .

At midnight a horn sounded through the camp, which, we were told, was to call the people from private to public worship; and we presently saw them flocking from all sides to the front of the preachers' stand. Mrs. B—— and I contrived to place ourselves with our backs supported against the lower part of this structure, and we were thus enabled to witness the scene which followed, without personal danger. There were about two thousand persons assembled.

One of the preachers began in a low nasal tone, and, like all other Methodist preachers, assured us of the enormous depravity of man as he comes from the hands of his Maker, and of his perfect sanctification after he had wrestled sufficiently with the Lord to get hold of him, *et cetera*. The admiration of the crowd was evinced by almost constant cries of "Amen! Amen!", "Jesus! Jesus!", "Glory! Glory!" and the like. But this comparative tranquillity did not last long; the preacher told them that "this night was the time fixed upon for anxious sinners to wrestle with the Lord"; that he and his brethren

"were at hand to help them"; and that such as needed their help were to come forward into "the pen." The phrase forcibly recalled Milton's lines:

> "Blind mouths! that scarce themselves know how to hold
> A sheep-hook, or have learned aught else the least
> That to the faithful herdsman's art belongs!
> .
> —But when they list, their lean and flashy songs
> Grate on their scrannel pipes of wretched straw;—
> The hungry sheep look up, and are not fed,
> But swoln with wind, and the rank mist they draw,
> Rot inwardly—and foul contagion spread."

"The pen" was the space immediately below the preacher's stand; we were therefore placed on the edge of it, and were enabled to see and hear all that took place in the very centre of this extraordinary exhibition.

The crowd fell back at the mention of the *pen*, and for some minutes there was a vacant space before us. The preachers came down from their stand, and placed themselves in the midst of it, beginning to sing a hymn, calling upon the penitents to come forth. As they sang they kept turning themselves round to every part of the crowd, and, by degrees, the voices of the whole multitude joined in chorus. This was the only moment at which I perceived any thing like the solemn and beautiful effect which I had heard ascribed to this woodland worship. It is certain that the combined voices of such a multitude heard at dead of night, from the depths of their eternal forests, the many fair young faces turned upward, and looking paler and lovelier as they met the moonbeams, the dark figures of the officials in the middle of the circle, the lurid glare thrown by the altar-fires on the woods beyond, did altogether produce a fine and solemn effect, that I shall not easily forget; but ere I had well enjoyed it, the scene changed, and sublimity gave place to horror and disgust.

The exhortation nearly resembled that which I had heard at "the Revival," but the result was very different; for, instead of the few hysterical women who had distinguished themselves on that occasion, above a hundred persons, nearly all females,

came forward, uttering howlings and groans so terrible that I shall never cease to shudder when I recall them. They appeared to drag each other forward, and, on the word being given "Let us pray," they all fell on their knees; but this posture was soon changed for others that permitted greater scope for the convulsive movements of their limbs; and they were soon all lying on the ground in an indescribably confusion of heads and legs. They threw about their limbs with such incessant and violent motion, that I was every instant expecting some serious accident to occur.

But how am I to describe the sounds that proceeded from this strange mass of human beings? I know no words which can convey an idea of it. Hysterical sobbings, convulsive groans, shrieks and screams the most appalling, burst forth on all sides. I felt sick with horror. As if their hoarse and over-strained voices failed to make noise enough, they soon began to clap their hands violently. The scene described by Dante was before me:

"Quivi sospiri, pianti, ed alti guai
Risonavan per l'aere
Orribili favelle
Parole di dolore, accenti d'ira
Voci alti e fioche, *e suon di man con elle.*"

Many of these wretched creatures were beautiful young females. The preachers moved about among them, at once exciting and soothing their agonies. I heard the muttered "Sister! dear sister!" I saw the insidious lips approach the cheeks of the unhappy girls; I heard the murmured confessions of the poor victims, and I watched their tormentors, breathing into their ears consolations that tinged the pale cheek with red. Had I been a man, I am sure I should have been guilty of some rash act of interference; nor do I believe that such a scene could have been acted in the presence of Englishmen without instant punishment being inflicted; not to mention the salutary discipline of the treadmill, which, beyond all question, would, in England, have been applied to check so turbulent and so vicious a scene.

After the first wild burst that followed their prostration, the moanings, in many instances, became loudly articulate; and I then experienced a strange vibration between tragic and comic feeling.

A very pretty girl, who was kneeling in the attitude of Canova's Magdalene immediately before us, amongst an immense quantity of jargon, broke out thus: "Woe! woe to the backsliders! hear it, hear it, Jesus! when I was fifteen my mother died, and I backslided, oh Jesus, I backslided! take me home to my mother, Jesus! take me home to her, for I am weary! Oh John Mitchel! John Mitchel!" and after sobbing piteously behind her raised hands, she lifted her sweet face again, which was as pale as death, and said: "Shall I sit on the sunny bank of salvation with my mother? my own dear mother? oh Jesus, take me home, take me home!"

Who could refuse a tear to this earnest wish for death in one so young and so lovely? But I saw her, ere I left the ground, with her hand fast locked, and her head supported by a man who looked very much as Don Juan might, when sent back to earth as too bad for the regions below.

One woman near us continued to "call on the Lord," as it is termed, in the loudest possible tone, and without a moment's interval, for the two hours that ye kept our dreadful station. She became frightfully hoarse, and her face so red as to make me expect she would burst a bloodvessel. Among the rest of her rant, she said: "I will hold fast to Jesus, I never will let him go; if they take me to hell, I will still hold him fast, fast, fast!"

The stunning noise was sometimes varied by the preachers beginning to sing; but the convulsive movements of the poor maniacs only became more violent. At length the atrocious wickedness of this horrible scene increased to a degree of grossness, that drove us from our station: we returned to the carriage at about three o'clock in the morning, and passed the remainder of the night in listening to the ever increasing tumult at the pen. To sleep was impossible. At day-break the horn again sounded, to send them to private devotion; and in about an hour afterwards I saw the whole camp as joyously and eagerly employed in preparing and devouring their most substantial breakfasts as if the night had been passed in dancing; and I

marked many a fair but pale face, that I recognized as a demoniac of the night, simpering beside a swain, to whom she carefully administered hot coffee and eggs. The preaching saint and the howling sinner seemed alike to relish this mode of recruiting their strength.

After enjoying abundance of strong tea, which proved a delightful restorative after a night so strangely spent, I wandered alone into the forest, and I never remember to have found perfect quiet more delightful.

We soon after left the ground; but before our departure we learnt that a very *satisfactory* collection had been made by the preachers, for Bibles, tracts, and *all other religious purposes.*[1]

2. EXTRACTS OF A DIARY KEPT BY MRS. NARCISSA WHITMAN ON HER TRIP TO OREGON IN 1836

August 1. Dearest Mother: We commenced our journey to Walla Walla July 18, 1836, under the protection of Mr. McLeod. The Flathead and Nez Perce Indians and some lodges of the Snake tribe accompany us to Fort Hall. Have traveled two months. Have lived on fresh meat for two months exclusively. Our ride to-day has been so fatiguing. Felt a calm and peaceful state of mind all day. In the morning had a season of prayer for my dear parents. We have plenty of dry buffalo meat. I can scarcely eat it, it appears so filthy, but it will keep us alive, and we ought to be thankful. Do not think I regret coming. No, far from it. I would not go back for the world; am contented and happy. Feel to pity the poor Indian women. Am making some progress in their language; long to be able to converse with them about the Savior.

August 3. Came to Fort Hall this morning. Was much cheered with a view of the fort. Anything that looks like a house makes us glad. Were hospitably entertained by Captain King, who keeps the fort. It was built by Captain Wyeth from Boston, whom we saw at the Rendezvous, on his way to the East. Our dinner consisted of dry buffalo meat, turnips and fried bread, which was a luxury. Mountain bread is simply

[1] From Mrs. Trollope, *Domestic Manners of the Americans,* Fourth Edition, I, 229-242.

coarse flour mixed with water and fried or roasted in buffalo grease. To one who has had nothing but meat for a long time, this relishes very well.

August 4. Enjoyed the cool retreat of an upper room this morning while writing. Was there ever a journey like this? performed when the sustaining hand of God has been so manifest every moment. Surely the children of Israel could not have been more sensible of the "Pillar of cloud by day and the pillar of fire by night" than we have been of that hand that has led us thus safely on.

August 12. Came to salmon fishing; obtained some fish and boiled for breakfast; find it good eating. They are preparing to cross Snake river. I can cross the most difficult streams without the least fear. There is one manner of crossing husband has tried, but I have not. Take an elk skin and stretch it over you, spreading yourself out as much as possible, then let the Indian women carefully put you in the water and with a cord in the mouth they will swim and drag you over.

August 19. Arrived at Snake fort about noon. Left wagon at this fort.

August 29. We are now on the west side of the Blue mountains. Crossed them in a day and a half. Dearest mother, let me tell you how I am sustained of the Lord in all this journey. For two or three days past I have been weak and restless and scarcely able to sit on my horse, but I have been diverted by the scenery and carried out of myself. This morning my feelings were a little peculiar. I felt remarkably well and strong; so much so as to mention it, but could not see any reason why I should be any more rested than on the morning previous. When I began to see what a day's ride was before us I understood it. If I had had no better health to-day than yesterday, I should have fainted under it. Then the promise appeared in full view, "As the day is so shall thy strength be," and my soul rejoiced in the Lord and testified to the truth of another evidently manifest, "Lo, I am with you always."

September 1. Arrived at Fort Walla Walla. You may better imagine our feelings this morning than I can describe them. When it was announced we were near, Mr. McLeod, Mr. Pambrun, the gentleman of the house, and Mr. Townsend

sallied forth to meet us. After the usual introduction, we entered the fort.

They were just eating breakfast when we rode up, and soon we were at the table, treated to fresh salmon, potatoes, tea, bread and butter. After breakfast we were shown the novelties. We were shown to the room Mr. Pambrun had prepared for us, on hearing of our approach. It was the west bastion in the fort, full of port holes in the sides, but no windows, and was filled with firearms. A large cannon, always loaded, stood behind the door by one of the holes. These things did not move me.

At 4 we were called to dinner. It consisted of pork, potatoes, beets, cabbage, turnips, tea, bread and butter. I am thus particular in my description of eatables, so that you may be assured we find something to eat beyond the Rocky mountains. I have not introduced you to the lady of the house. She is a native born from a tribe east of the mountains. She appears well; does not speak English, but her native tongue and French. Mr. Pambrun is from Canada; is very agreeable and much of gentleman in appearance. About noon Mr. and Mrs. Spalding arrived with their company.

September 7. We set sail from Walla Walla to Vancouver yesterday. Our boat is an open one, manned with six oarsmen and the steersman. I enjoy it much. The Columbia is beautiful.

September 12. We are now in Vancouver, the New York of the Pacific Coast. Before we reached the house of the chief factor, Dr. McLoughlin, were met by several gentlemen who came to give us welcome. Mr. Douglas, Dr. Tolmie and Dr. McLoughlin of the Hudson's Bay Company, who invited us in and seated us on the sofa. Soon after we were introduced to Mrs. McLoughlin and Mrs. Douglas, both natives of the country (half-breeds). We were invited to walk in the garden. Here we found fruit of every description. I must mention the origin of the apples and grapes. A gentleman twelve years ago, while at a party in London, put the seeds of the apples and grapes he ate into his vest pocket, and soon after took a voyage to this country and left them here. Now they are greatly multiplied. Returning from the garden we were met by Mrs.

Copendel, a lady from England, and Miss Maria, daughter of
Dr. McLoughlin, quite an interesting young lady.

September 13. This morning visited the school to hear the
children sing. It consists of about fifty scholars, children who
have French fathers and Indian mothers, and many orphans.
No person could have received a more hearty welcome or be
treated with greater kindness than we have since our arrival.

September 22. Dr. McLoughlin has put his daughter in my
care, and wishes me to hear her recitations. I sing with the
children also, which is considered a favor. We are invited to
ride as often as once a week. To-day Mrs. McLoughlin rode
with us. She prefers the old habit of riding gentleman fashion.
I sing about an hour every evening with the children, teaching
them new tunes, at the request of Dr. McLoughlin. Mrs.
McLoughlin has a fine ear for music, and is greatly delighted.
She is one of the kindest women in the world. Speaks a little
French, but mostly loves her native language. She wishes to
go and live with me; her daughter and Mrs. Douglas also. The
Lord reward them for their love and kindness to us. The doctor
urges me to stay all winter. He is a very sympathetic man; is
afraid we will suffer. Husband is so filled with business that
he writes but little. He is far away now, poor darling, three
hundred miles.

I intended to have written this so plainly that father and
mother could read it. Adieu,

Narcissa Whitman.[2]

3. A WOMAN'S DESCRIPTION OF AN ILLINOIS PRAIRIE

I fell asleep [on stagecoach], and when I was awakened at
dawn this morning, by my companion, that I might not lose
the scene, I started with surprise and delight. I was in the
midst of a prairie! A world of grass and flowers stretched
around me, rising and falling in gentle undulations, as if an
enchanter had struck the ocean swell, and it was at rest for-
ever. Acres of wild flowers of every hue glowed around me,
and the sun arising from the earth where it touched the horizon,
was 'kissing with golden face the meadows green.' What a

[2] From M. O. Douthit, *The Souvenir of Western Women*, 19-21.

new and wondrous world of beauty! What a magnificent sight!
Those glorious ranks of flowers! Oh that you could have 'one
glance at their array!' How shall I convey to you an idea of a
prairie[?]. I despair, for never yet hath pen brought the scene
before my mind. Imagine yourself in the center of an immense
circle of velvet herbage, the sky for its boundary upon every
side; the whole clothed with a radiant efflorescence of every
brilliant hue. We rode thus through a perfect wilderness of
sweets, sending forth perfume, and animated with myriads of
glittering birds and butterflies:—

"A populous solitude of bees and birds,
And fairy formed and many colored things."

It was, in fact, a vast garden, over whose perfumed paths,
covered with soil as hard as gravel, our carriage rolled through
the whole of that summer day. You will scarcely credit the
profusion of flowers upon these prairies. We passed whole
acres of blossoms all bearing one hue, as purple, perhaps, or
masses of yellow or rose; and then again a carpet of every color
intermixed, or narrow bands, as if a rainbow had fallen upon
the verdant slopes. When the sun flooded this Mosaic floor
with light, and the summer breeze stirred among their leaves,
the irredescent glow was beautiful and wondrous beyond any-
thing I had ever conceived. I think this must have been the
place where Armida planted her garden, for she surely could
not have chosen a fairer spot. Here are

'Gorgeous flowrets in the sun light shining,
Blossoms flaunting in the eye of day;
Tremulous leaves with soft silver lining
Buds that open only to decay.'

The gentle undulating surface of these prairies, prevent same-
ness, and add variety to its lights and shades. Occasionally,
when a swell is rather higher than the rest, it gives you an
extended view over the country, and you may mark a dark
green waving line of trees near the distant horizon, which are
shading some gentle stream from the sun's absorbing rays, and

thus, 'Betraying the secret of their silent course.' Oak openings also occur, green groves, arranged with the regularity of art, making shady, alleys, for the heated traveller. What a tender benevolent Father have we, to form for us so bright a world! How filled with glory and beauty must that mind have been, who conceived so much lovliness!

. .

'All aboard' cries the driver, and we were again upon our course, our horses prancing gaily as if refreshed by their breakfast. A tree appeared against the horizon, looking exactly like a sail in the distance—others followed it, and soon beautiful groups of forest trees were sprinkled over the prairie in front. This was the token of the vicinity of water, and in a short time we found ourselves upon an elevated bank from which we looked down upon a verdant valley through the center of which ran a silver stream. This was the valley of the Des Plaines— having every appearance of being the bed of a broad and deep river. Many geologists, among them, Prof. Sheppard, thinks this and the valley of the Illinois, have been scooped out, by a vast torrent from Lake Michigan. Upon the opposite shore of the river and in this vale, at the foot of the ancient banks, stands the pretty town of Joliet, improperly spelt Juliet. The whole scene was one of great beauty. We descended the banks, which is nearly one hundred feet high, and is composed of yellow water-worn pebbles. Winding down the road upon the high bank opposite, was a long train of covered waggons, filled with a household upon its way to 'a new home' upon the prairies. After fording the stream, now rendered shallow by the summer heats, passing over the green sward we found ourselves before the door of the principal hotel in the town.[3]

4. DEATHBED STATEMENT OF A FRONTIER WOMAN [4]

Such, and so heartwringing, were these last communions. I had never seen her so beautiful as she was in those days. Her mind, too, seemed to act with more than its usual strength of

[3] Eliza A. Steele, *A Summer Journey in the West*, 125-130.
This journey was apparently made in the summer of 1840.
[4] Made by the sister of Mrs. Farnham during the latter's visit to Illinois. Found in Farnham, *Prairie Land*, 227-245.

reason. It was thronged with images of beauty which took the most appropriate and eloquent forms of expression. There was a kind of painful pleasure in listening to these feebly enunciated thoughts and sentiments, which I could not deny myself.

I remember one bright day, when she felt unusually well, she was sitting up in the bed supported by pillows, and looking upon the growing world outside. She had just heard her little boy recite the Lord's Prayer, and dismissed him to play, when she turned suddenly to me, and said "To-day is the eighth anniversary of my wedding."

"Is it possible?" I said, struck by the painful thought that it must be the last she would ever see; but as we were accustomed to suppress our feelings in her presence, I remained silent.

"Yes, it is eight years to-day, and just about this hour, too," glancing at the clock, "since I stood by my husband's side with a heart overflowing with strength and hope. We were both young; I was but seventeen, and he some four years older. We had health, energy, intelligence enough to enjoy the highest pleasures within our reach, and, above all, that affection for each other, without which all these blessings would have been of little avail to secure happiness. Eight years! I spoke of it this morning, but it was so painful to John to recall the pleasant recollections of that day, that I forbore. I feel strong now, and you must let me talk. Do you know we have never been acquainted since we were little girls?"

I looked up in surprise.

"I mean," she added, "that we have never enjoyed that full revelation of thought and feeling, which alone can constitute acquaintance between sisters. There has never been an opportunity for this till since you came here, and you have thus far been too much engrossed with other affections to admit of it. Do not think I speak reproachfully; I have rejoiced in your happiness, but the young wife and mother could hardly find time and affection to bestow, in those deep, heart-searching communings, which should make each thoroughly known to the other. There have been long years of event, and ages of emotion in the life of each, since we lived together unengrossed by

our love for others. Now you must listen, and let me tell you something, such as my weak memory and weaker powers will permit, of those many years of separation.

"You remember the little home in the little village surrounded by mountains, where we first found ourselves. You remember one chilly, dark afternoon, when we returned from the small schoolhouse in the woods, we were met at the gate by an older schoolmate, a relative of the family, who told us to come softly in, for our mother was dying! You remember the awe which these words inspired, and the solemnity with which we were led through the tearful crowd collected in the room, to her bedside; and how we gazed with bursting hearts into her dim eyes, to which the full day already seemed faint twilight; how we took timidly hold of her hands, that were wandering in air to grasp the children she could no longer see. You remember how next morning, when you asked to go in and see her, she lay upon a hard board, straight and cold, and how we turned away from the pale face and leaden eyes, and refused to believe that it was our dear mother; how we stayed home from school, and wandered all that day about the silent house, scarcely speaking above a whisper, and occasionally peeped fearfully into the dark room; how the next day, mourning garments came; and a coffin that struck us with such dread we could not be brought to look on it, till a great crowd of people gathered about, and our father led us up, and asked us to look once again at our mother, before she was put in the cold earth. I recollect you were not tall enough, and he raised you in his arms by my side, and little Henry, still younger, looked down from his uncle's arms and lisped coaxingly to her to get up and take off her cap. A few minutes after, the coffin was closed and borne away! We fellowed it, and when it was covered in the grave, returned home, scarcely knowing what had happened, but having a dim impression that some great sorrow had come upon us.

"From that day we had no longer a home in common; when we met, it was as visitors. This was a great affliction to me, for our continual companionship had ripened in my older mind to warm attachment, and I was grieved to be denied its object. You were more easily satisfied with little Henry's company;

though I remember no one's arrival ever gave you so much pleasure as mine. All your most charming resorts were shown me, all the choice mementos that had been laid carefully away since my last visit were brought forth, and many little things exchanged by way of remembrancers. Those were delightful visits that I paid you at grandfather's. The dark pine-tree that stood before the door used to play music that held us spellbound many an hour, while we sat beneath it. I remember at these times, and when we lay in bed, while the rain was pattering on the roof close to us, you always began to talk of "ma," and expected her return. You used to ask me if I thought she would come back in the cap and night-gown she had on when she went away; and where she would stand when we first saw her. At last these visits ceased. We were wholly separated. You went many hundred miles from us all, with strangers, and the remaining four gathered once again under our father's roof. But no longer in the little village; we were now in a great city, and I was old enough to begin to learn that life had more painful realities than had come to us, when we were together. Seven years! what may not seven years—from nine to sixteen, from seven to fourteen—do for children such as we were? What did they, till we met again, bring us? what sorrow, keener than all that had gone before, in the loss of our last parent! to you, what oppression and bondage among heartless strangers! Those were dark volumes to be opened by gay-hearted girls, that we learned to read during those seven years: gloomy commentaries on the world in which we were left to make our way to happiness or ruin. Mine taught me to shrink continually from the world, to regard it as an enemy ever on the watch to destroy my peace, ever waiting with lies and deceit, to lead me away from my true path. The greatest blessing was, that I had a pretty clear perception of what this was. Many a poor girl who started under fairer auspices than myself, has made a total wreck. Since I have come to years of maturity, I have learned that our mother was gifted with a superior mind and great depth of purpose and feeling; and if we have struggled successfully against tides that have borne others to ruin, we owe praise and gratitude to Him who gave us such a parent. But I had some terrible trials in the great heartless city during

those years! I remember one fierce conflict of four days, that came near destroying my reason. I have never been able to look back upon it without a shudder. On the one hand, misfortune and suffering among those who were dearer to me than my own life; on the other, ceaseless labor by day and night for a pittance which I tremble to think is now lessened by nearly half to thousands of unfortunate females, similarly situated. How could I escape the tempters, who never tired in spreading their diabolical nets for my weary feet? I will tell you the nature of this fierce trial some other day, when I am stronger. Let me hasten on now. When I was little more than fifteen, I received an offer of marriage from a young man who had shown himself an honest and firm friend from the first day of our acquaintance. He was several years my senior, the son of wealthy parents, and bore an unexceptionable character. All these things made him what the world calls a 'very desirable match.' Our friends thought it almost heaven-sent. Everybody was so pleased with my fortune that I too thought it must be good, and with much encouragement from others, and sanguine hopes of the increased happiness I should be able to afford those I loved, I finally entered into an engagement with him. But it did not require much reflection on my part, after this relation was established between us, to discover that the affection which should be the first and holiest motive to marriage, was wanting in me. All the other requisites of happiness —wealth, integrity, an agreeable person, and certainly as high an order of intelligence as most girls of fifteen look for, were present. But I soon saw that these would not do. Poor as I was, and welcome as would be the means of ease, and the opportunity of intellectual pursuits which I most craved, I could not perjure myself to obtain them. Better my two hands and a subsistence daily earned with them, I thought, than wealth, and a spirit oppressed with so great falsehood! So I told Mr. H. that I was convinced I should consult the happiness of both, by begging him to release me from the engagement. After many conversations and much reasoning, which continually strengthened my previous conviction of the right, I prevailed, and turned from the high anticipations of those few weeks again to my needle. But I must not linger over those

days; in less than eighteen months I entered into the engage-
ment which was fulfilled eight years ago to-day. It will soon
be severed now. This was one of the heart. There was no
wealth, no position superior to my own, but only those personal
qualities which assured me that, without these, our happiness
would be enhanced by a union. I loved my husband, and that
was a stronger motive than all that had operated in the other
case combined.

"During those eighteen months I had found another source of
tranquillity, in higher and more clearly defined perceptions of
religious duty than I had ever before experienced. I had found
that there was positive and exalted happiness in approaching
my Maker as a tender father and friend. And thanks be to
Him, who deserves our most elevated affections, this never
failed me in my hours of severest trial. It was a safeguard and
shield. Armed with this newly awakened sentiment, I felt
secure and quiet amid all temptations. Most young persons
think their enjoyment of life will be diminished by an allegiance
to the laws of christianity, but I think they are in error. Mine
was infinitely increased! I wished every one to feel as I did.
It was in this state of mind, and just after I had formed the
engagement with my husband, that I met you after the lapse
of those seven eventful years. Such a period, spent as that had
been by you, not only in a natural but moral wilderness, away
from society, away from schools, away from everything but the
tyranny of a selfish, passionate woman, and that woman—oh
most wonderful phenomenon!—that woman an Atheist—a
defier of her God—had wrought startling changes in you. The
timid, inquiring child from whom I had parted with such agon-
izing tears, met me almost a woman in stature, and with more
than a woman's boldness of thought and speech;—they were
an atheist's! Judge now—but no, you cannot; you never can
until you are similarly situated, of the anguish I experienced
on the first evening of our reunion, when, as we all knelt down,
my heart overflowing with a gratitude which God alone could
measure for your restoration to us, you walked away to the
door, saying you wanted no part in such delusive mummery!
I never remember to have felt a keener pang; and when, after
much persuasion, I induced you, through your affection for

me, to rejoin the circle and wait while thanks were offered and petitions put up for yourself, you turned impatiently away and requested that you might be made the subject of no more prayers until you saw the necessity of them. You remember, that our conversations almost always took the form of controversies; that I found you conversant with the works of Paine, Volney, Voltaire, and nearly the whole school of infidel writers, modern as well as early; that every consideration which I proposed was instantly gainsayed by an appeal to them, or by some fearless suggestion of your own mind. You had not only made these men your standard, but even exceeded their impiety, and by your impious reasoning, made up of the boldest conceptions and the most unshrinking conclusions, led yourself to renounce all belief. I was at last compelled to give up in despair, trusting to time and better influences to eradicate these frightful errors.

"A few weeks parted us again. I have sometimes, when looking over our past lives, compared ourselves to two helmless, rudderless ships, floating on the storm-wrought ocean. For a moment they approach each other, and seem as if they would journey on together, but the next, they are parted and driven about on the waste for years; perhaps never to meet again till they decay and sink into a common sepulchre. It has been almost so with us. We parted; you to seek the education and mental culture which should have been the work of earlier years; I to make such preparation as I might, for the great event before me. The next spring I was married. You know my husband had meantime visited this country, and returned a few weeks previous to our union, with such glowing descriptions of its beauty and advantages, that his father gathered the little means he had, and proposed that we should all start west together after our marriage. We did so, and it will be eight years in a few weeks (I may live to see the day), since we bade adieu to our friends and commenced our journey. This state at that time was thought, among the stable population of our mountain region, to be almost beyond the knowledge of civilized man. Our friends bade us farewell as if we were about to plunge into the deserts of the old world, instead of the richest and most beautiful region of the new.

"I rejoiced in that journey. It was the season of life fullest of hope and trust, and all nature seemed like me, exulting in the future that was opening before it. We journeyed several weeks through the blooming orchards and fields of the cultivated country, and at last plunged into the heavy forests of Ohio and Indiana. Here we sometimes slept in our waggon or on the ground, and took our meals in the woods. At last we emerged upon the great prairie which extends from the Wabash, west and north, nearly three hundred miles. Here the magnificence of the country to which we were bound began to appear. I remember, as we journey day after day across its heaving, verdant bosom, that I seemed to be living in a new world. All the noise, all the selfish hurry and turmoil in which my past years has been spent, faded away. They seemed as remote as if the barrier of eternity had been placed between me and them. A new creation was around me. The great, silent plain, with its still streams, its tender verdure, its lovely flowers, its timid birds and quadrupeds, shrinking away from our sight; its soft winds, its majestic storms—was a sublime spectacle! Occasionally a herd of deer bounded across our path, or a solitary pair of grouse, startled from their parental cares, rose and cleft the air like the arrows of their old pursuers; but save these we were alone, in silence broken only by our own voices. I thought how many ages that plain had been spread out beneath those soft skies and that genial sun; how its flowers had bloomed and faded, its grasses grown and decayed; how storms had swept over all its wide expanse, and the thunder echoed from its bosom; how the solemn winds of autumn had sighed over it, and the raging fires marched in unrestrained fury from one border to the other; how long all this power and magnificence had displayed itself unseen of any eye, save His who made it! How long all these mighty and beautiful phenomena had followed each other, and awoke no human emotion, appealed to no enlightened *soul*. Nature disporting with herself, frolicking in merriment, fading in sadness or raging in anger; the sole witness of her own acts!

"Then as we crossed the narrow, deep-worn trail of the dark people who had traversed it so long before us, I thought how much emotion had dwelt here; how much love, hospitality,

friendship, and fierce hatred had grown, matured, and been extinguished here. How many fearful war-shouts had resounded; how many death fires had been kindled in the distant groves; how many wailings for the lost had mingled with the solemn winds.

"In imagination, I could still see files of dark warriors stealing silently along, unmindful of the flowers and the bright skies, the gay birds and the happy creatures who reveled in the rich world of vegetation around them; intent only upon the fierce butchery to which they were marching. And my blood used to chill under these fearful visions. But my husband enjoyed them. He had more sympathy with the stern and implacable in the Indian character than I, and he delighted to think of the free warriors roaming, fearless of their foes, fearless of storm or tempest, in search of their enemies. Later years have quenched much of this feeling in him, but he still loves those legends of the olden time.

"As we advanced into the midst of this immense prairie, our horses were tortured by a large fly that gathered in great numbers upon them, and drove them almost to madness. At length we were obliged to stop during the day, and travel all night. There were houses at long intervals, situated sometimes in the points of groves that projected into the plain, and sometimes several miles from the woodland. These were usually our stopping-places, where we remained during the day and then traveled on. My heart ached for the men. They could sleep little during the day, and two or three (there were five of them, you know) were obliged to be continually on foot at night to guide the horses. Their fatigue was almost insupportable. My husband has told me, that he was conscious of having often walked several rods at a time when he was asleep; that his eyes closed in spite of all his efforts to keep awake, and at length a stumble or a word from some of the party would startle him, and he would find himself walking along beside the team as usual. They were faithful creatures, those horses, You have caused and enjoyed many a hearty laugh at their expense; but if they had borne you patiently over nearly two thousand miles, of roads without bridges; traveled night and day with you, you would feel something of that sentiment which

has often restrained me, when Tyler's peculiarities have set your powers of ridicule in operation.

"But we left the prairie at last; I was not sorry; neither could I rejoice, except for those who suffered more than I. But the long journey, the excitement attendant upon the strange features of the country, and the broken rest, were too much for me. When we reached the crossings of the Mackinaw, about thirteen miles from here, you know where it is, I was in a raging fever. We traveled on, however, for there was then no house where we could stop. Our people heard in some way that this 'claim' was for sale. They wished to buy an improved one— that is, one with a cabin in which we could live till a house was built, and with grain enough on the ground for the season's use. I have pointed out to you the very small, low cabin which we found here. There were also several acres of grain growing. We all liked the situation, and so a bargain was soon made with the owner, or the 'squatter,' as he termed himself, for his place. But there was one circumstance which was very awkward for us. He could not leave the larger cabin till autumn, and we were therefore obliged all to live in that little pen until our people could build another. I scarcely know how things went on those few weeks. I was sick and wretched in person; but at last the other cabin was finished, and we felt ourselves very comfortable in it. When the family of the 'squatter' left us, John and I moved into the old one, and lived there until the framed house was built. That was our first introduction to cabin life. The summer was considerably advanced when we arrived, and our people were soon engaged in the harvest. The grain was stacked in the cow-yard, for there were then no barns or outbuildings of any description. When the harvest was over, they began their preparations for carrying on farming more systematically the next year. They made fences, ploughed and sowed, and built a small log stable for their horses.

"I remember the whole land seemed to me a paradise that summer and autumn. The profusion of late flowers and wild fruits, the abundance of game, the richness of vegetation, the mildness of the climate, the sublime storms, and the soft musical winds, delighted me. Our men worked much in the woods, and I used at noon to take a small basket of dinner to them. The

sound of their distant axes, and, as I drew nearer, of their cheerful voices, contrasted delightfully with the silence of the sleeping grove.

"We all had good health so far, and appetites that led to many jokes between ourselves about famine, et cet. You have now learned by experience how this climate acts on the appetite, and you may judge of the amount of food which nine persons, in this stage of acclimation, would consume. But we had plenty of grain stacked, and meats more delicious than the daintiest markets of the east afford, were abundant everywhere, so we only exulted in our fine health, and pursued our labors joyfully.

"The prairie below us where there are now so many pleasant farms, was then unsettled. There was no house on the south between us and the Mackinaw, and at the crossings of that stream was the only family whom I visited for the first two years. You ask if those were not lonely years. I answer that there were many, many hours when John and I talked of the friends we had left, when the cheerful social circles where we had sometimes met, were named with moistened eyes, and yet there was no day of them all when we would have returned and forsaken the land of our adoption. Much as we wished for the society of our absent friends, we could not have consented to exchange for it, the joys we had won in the new country. We loved everything in the new land too much for that. But I was telling you that the prairie was all unsettled when we came. I believe it remained so two years. The autumn fires raged then much more fiercely than now that they are trodden or partially fed. You cannot estimate, from what you now see, the sublimity and fury of those early conflagrations. One afternoon late in October, the prairie below us took fire by accident, or was set on fire by some one on the other side. There was little wind, and the flame came lazily over the grassy surface; it seemed as if a breath would extinguish it. It was a fine spectacle, however, to us newcomers, and we watched it occasionally, almost wishing that it might show a little more energy. No one thought of danger. Toward sunset the wind rose slightly and the fire increased; as darkness came, the breeze freshened till it became almost a tempest, and the plain around was a sea

of roaring flames as far as the eye could reach. It daunted us a little, but was too sublime a spectacle to turn away from, till one of the family suggested that it came with such fury the stacks might be in danger. The thought was instantly acted upon, and every precaution taken to secure them, but vainly! The fire came on with such irresistible energy that, like the wind itself, it overleaped all barriers. In less than an hour, our grain was burned to ashes! The houses, farming utensils, et cet., were barely saved, and we were left in this thinly inhabited region with but a mouthful of bread stuff! It was a severe blow to us with our small finances, and the difficulty of procuring grain, independently of that.

"But I enjoyed that fire. The finest spectacle was when the danger had passed. While the stacks were burning more slowly, the flames swept furiously onward through those shrub oaks. That was a magnificent sight. They mounted quite to the tops of the tallest trees, and went roaring and cracking through the silent barrens with a noise that contrasted strangely with the usual stillness of the hour. The blackness and desolation of the following morning, and the reflection that we had lost all our grain, were painful consequents of such an entertainment. There was, however, no danger of real suffering. The greatest abundance of fine game abounded in our vicinity, and it could not be impossible, so we thought and said, to find something whereof to make bread. Our houses and other property were spared, and we were thankful.

"By the next summer the unnatural appetite which had beset us all, disappeared, and the succeeding stage of acclimation came on. Part of our number were prostrated with bilious fever, which in almost every case was followed by ague, and the others were visited with that cutaneous disease which you know sometimes takes the place of prostrating fevers. It is the safer process, but scarcely the more agreeable. Some of our people suffered extremely with it. Their arms and hands were perfectly denuded of skin, and in such a state, that, for two or three weeks, those who were not so afflicted had to feed them as if they were infants. My husband and I both underwent the severe ordeal of a long fever, succeeded by ague, but we came through, apparently with unimpaired constitutions. All

recovered in time, and there has been little sickness among us since, except the poor invalid sister, who seems to have been born to suffer.

"Still we have had many seasons of trial. There has been more or less sickness in the country every summer, and we cannot sit down in our own homes in peace when our neighbors are afflicted. I have sometimes rode one, two, or three miles every day, or every alternate day, to visit a sick neighbor; and here our visits are not calls. We go to perform the duties of nurse for a day or night, and having no servants at home, are obliged to return as soon as possible, and, notwithstanding our weariness, proceed at once to the cares of the family. We had beside, as I have already informed you, many strangers in our homes, some of whom were long and dangerously ill while there; and these circumstances increased our burthens: nevertheless we were happy. In the fall of the third year our little boy came to cheer us with his beautiful presence. Oh that was a happy day when I first heard myself spoken of as a mother, and happier still were those that followed, as our darling grew under our care. He is a brown boy now, since he has gone abroad so much, but he was a beautiful babe. He had dark eyes and hair, and a clear skin, with cheeks that deepened like the heart of the rose whenever he slept. We moved into this house the next spring. I had a great deal of labor to perform, and the dear child used to sit and creep on the floor from morning till noon. Many a time, when I have been too much engaged to attend to him, my ear has been struck by the cessation of his prattle, and I have turned to find his cheek pillowed upon the naked board, and his wearied faculties lost in profound sleep. I have laid him on the bed, sometimes with smiles, sometimes with tears. I was seldom lonely now, even when his father was away all the long days in the field or wood. He was a world to me. Our society increased, too, about the country. Many intelligent and excellent families came into our neighborhood, and the little towns that had grown around us, improved our social life very much. Still we were not so dependent on society as you might suppose. The charms of the country, which never tired with us, the delights of building a new home and beautifying it ourselves, of having everything

grow from nature, under our own hands, and the pleasure we began to anticipate in your arrival, were ample sources of happiness. Every tree and shrub which we planted in our grounds was a companion, whose growth it was delightful to watch. Every strawberry-bed that I discovered about the house was counted on as a means of enjoyment when we should all be once more assembled.

"I must be a dreamer, for I have had delightful visions of our wandering together long years hence, over these little spots, our children gathering the fruit, while we looked on and applauded their kind zeal. But that is all past now; I have striven to make my home pleasant. I have wrought within and about it harder, perhaps, than will ever be the lot of another. I have loved its natural and its cultivated beauties better, perhaps, than any one else can, and now I must leave them! It is hard, but hardest of all to leave my husband, who has shared these pleasures and tasks, and my boy, for whom we have most rejoiced to perform them. Yet I desire not to remain. The solace which, under lighter afflictions, I learned to draw from divine sources, is more precious now than ever; and though, to the human eye, I seem to have toiled through these twenty-five years to gain this spot in life, and my blessing is yet unenjoyed, still, I doubt not, it is best so. I have, perhaps, had my share of happiness. If I have endured bitter griefs, I have enjoyed intense emotions of pleasure. If I have buffeted storms and tempests, my sunshine has been proportionally bright. If I have been oppressed with cares and labors, my rest and freedom have brought delights enough to compensate for them. If I have been repeatedly and long separated from those I loved, I have felt the most unalloyed pleasure in meeting them. I would fain persuade myself that the last two years have repaid all the ardent prayers I offered for the presence of my brothers and sisters, and that I am ready to depart and leave you all! Once I should have felt it my duty to bow with unqualified submission to my fate, as to a special expression of my Master's will. I should have attributed no part of it to the effect of natural causes which were left to human control. Now I feel otherwise. I have learned within the last few years to be wiser, though I humbly trust not less a christian. If my resig-

nation is not entire and blind, it is because I feel that the responsibility of my early death rests on human beings, and that the will of the Almighty is expressed in it only so far as to remove me in kindness when repeated transgressions of His law have placed it out of my reach to be longer happy and useful. Do not weep. I am tired now; take away the pillows, and let me lie down. I have talked long, and yet have failed of relating half that I desire, or expressing what I feel. Bring me a rose from my favorite bush. I would have something fresh and beautiful to win repose after this long effort."

5. THE EXPERIENCES OF MRS. SARAH N. WORTHINGTON IN FRONTIER ILLINOIS [5]

. . . Mr. W. succeeded in finding a man who would risk finding the Rapids in two or three days by following the i[I]ndian trail. I think he did not find the trail for any i[I]ndian would have known better than to have taken such a road. I will not dwell on the sufferings of that ride! Tho I cannot pass over the night we spent on the road. We had passed one log cabin after leaving Savanna and our driver said he thought we should reach another before night; but it was after dark before the long looked for light appeared and it seemed an age before we reached it. When my husband inquired if we could be accommodated for the night, the answer in a rough voice "No we are full" caused my heart to sink. But I had strength to almost cry out "I cannot go another step."

Then another voice from within asked if there was a woman out there. "Yes, indeed there is," I said, and in a minute the blessed form of a woman appeared and my babe was in her arms, and the "come right in" was the sweetest music I ever heard. We had had no food after the horrid mess of the morning, and the odor of the supper that was being prepared seemed to put new life into us. I shall never forget the appearance of that blessed woman. I cannot recall her name, but I know it is recorded in Heaven.

[5] Mrs. Worthington and her husband left Wilkesbarre, Pennsylvania for Northern Illinois in April, 1837. After traveling by boat down the Ohio and then up the Mississippi River to Savanna, Ill., they prepared to journey overland to their new home in eastern Whiteside County.

My husband was anxious to learn all he could about our new home, and our host, being questioned, seemed as willing to distinguish himself in that line as his wife was in hers. The language was not of the most refined character, and I paid very little attention to it, but one sentence took too deep a hold ever to be forgotten. In answer to one question, the reply was "Oh its a Heaven for men and horses but (a very different place) for women and oxen." I know that man was very glad that he was a man. I am not so sure that I was glad that I was a woman. The remainder of the journey was without incident, unless [except for] the continual pitching into the gullies that often brought our carriage almost on the horse's back. . . .

However we did *survive*, and actually found Harrisburg [6] the Eldorado (on paper) that was to supply every human need. Has the reader ever built any castles in the air? If so she—for I intend that this shall be read by women only—will know something of the feelings produced by *my* castles dissolving into four log cabins, three of them tenanted by hoosier families direct from the Wabash. The fourth was the one that was to cover our defenseless heads. It already had two men and a boy, two women and a girl, but they took us in. It is a mystery to me to this day how they managed to stow us away. The abode contained one apartment below about 14 feet square, with a loft reached by a ladder. A stove occupied the center of the room. A large dry goods box reconstructed into a dish receptacle fitted into one corner, and a bed another. The usual large fireplace with chimney built of sticks and mud, was wanting, and its place supplied by the stove pipe passing through the roof.

Now commenced my lessons in that branch of western life which was [were] to qualify me to portray its pleasures (?) to future generations, but the educational process with so dull a pupil has been a very slow one, for I have not graduated yet. Shall I depict our privations and pains, or our pleasures and pastimes?

Provisions were scarce, and I have passed many a night

6 This small settlement should not be confused with the town by the same name in southern Illinois, the seat of Saline County.

when I would have give $5 in gold for a loaf of bread. Still our privations were not greater than fell the lot of all the emigrants at that time. I will omit details for they might create doubts of my verasity. As to the *pains*, I will try to recall those in which we took pleasure, and were of a nature to encourage each other to hope for better times.

An invitation to a party was received a few days after our arrival, and will be a good starting point in the place we live. The boy who brought it said his grandmother had a "lot of wool to pick," and wanted help. We were totally ignorant of the process. It might have been from the sheep's back for anything we knew, but we accepted it "with pleasure" and were enlightened by the sight of a huge mass of greasy wool. The "pleasure" was derived from meeting with all the other ladies within a radius of six miles—numbering about eight—the most distant—Mrs. Kilgore, mother of the late Col. Kilgore, came alone on horseback from the Elkhorn, but the family had spent a dismal winter there; and anything for a change. In the cabin to which we were invited religious services were held on Tuesday afternoons at five o'clock, at intervals of three weeks —by the Rev. Amos Miller.

The arrangements for the entertainment of the preacher over night were of the most primitive kind, but made with such genuine hospitality that he certainly enjoyed them.

Eventually we commenced the erection of a frame house, and on the 4th of July, 1837, the first structure of such majestic proportions was presented to the view of the lovers of grand architecture who had come from miles around to have the honor of assisting at the raising—only one of the number a carpenter.

I hope to be excused for mentioning the fact of the house being placed on a lot presented to the writer by the "town proprietors" on condition of her opening a school as soon as possible. The "possibility" did not transpire until April 1st, 1838, when the first school in what is now Whiteside County was opened.

As I have alluded to privations, I must not omit pastimes. As the season advanced and the fear of starvation retreated and the prospect of plenty appeared, we "women folks" were

allowed the *pastime* of grappling into potatoe hills with our *fingers* and taking any the size of walnuts, without disturbing those still growing. As soon as the corn was fit to boil on the cob, that was an added luxury, but when too old for that process we were in a dilemma. Grating was suggested, but where were the grates? We had read of Aladdin's wonderful lamp, but who ever dreamed of an old tin lantern containing a genii that could be evoked by a rub with an ear of corn? But so it proved, and with results exceeding by far any of Aladdin's wonders.

After a very severe winter, the spring of /38 opened with promise. I think Pandora must have reversed her box and perforated the nether end, for Hope had certainly escaped and became omnipresent! All fear of malaria was dispelled, and we assured our friends "back east" that we had not heard of a single case of sickness, omitting to state less agreeable disappointments. Flour could be obtained, hens cackled loudly over their eggs with fifty cents per dozen: other provisions in proportion. Social intercourse augmented by intelligent families coming within ten or fifteen miles, and we were becoming reconciled to our new mode of life. We exchanged visits with our Dixon neighbors *only twelve miles* away.

During the past summer and autumn there had been extensive "breakings," where the prairie ploy drawn by eight-yoke of oxen had difficulty in cutting into the sod surmounted by grass four feet high. The result might easily be imagined: all this vegetable matter doing the work assigned by nature in her laboratory under a sun that did his work faithfully.

By the first of September there was scarcely a well family to be heard of, and in many cases not one individual able to assist another. This caused sad changes in the spirit of our dreams. A few became discouraged and sought refuge in timbered locations. Those of us who lived on and hoped on have been rewarded by witnessing such a change as was reasonably to be expected time would insure to so lovely a locality. . . .[7]

[7] From a letter of Mrs. Sarah N. Worthington to the Illinois Woman's Exposition Board, Sterling, Ill., April 24, 1893. The Stories of Pioneer Mothers, manuscript folio at the Illinois State Historical Library, Springfield, Illinois.

6. CAMPAIGNING FOR WOMAN SUFFRAGE IN KANSAS AS TOLD
BY MRS. ELIZABETH CADY STANTON

In 1867 the proposition to extend the suffrage to women and to colored men was submitted to the people of the State of Kansas, and, among other Eastern speakers, I was invited to make a campaign through the State. As the fall elections were pending, there was great excitement everywhere. Suffrage for colored men was a Republican measure, which the press and politicians of that party advocated with enthusiasm.

As woman suffrage was not a party question, we hoped that all parties would favor the measure; that we might, at last, have one green spot on earth where women could enjoy full liberty as citizens of the United States. Accordingly, in July, Miss Anthony and I started, with high hopes of a most successful trip, and, after an uneventful journey of one thousands five hundred miles, we reached the sacred soil where John Brown and his sons had helped to fight the battles that made Kansas a free State.

Lucy Stone, Mr. Blackwell, and Olympia Brown had preceded us and opened the campaign with large meetings in all the chief cities. Miss Anthony and I did the same. Then it was decided that, as we were to go to the very borders of the State, where there were no railroads, we must take carriages, and economize our forces by taking different routes. I was escorted by ex-Governor Charles Robinson. We had a low, easy carriage, drawn by two mules, in which we stored about a bushel of tracts, two valises, a pail for watering the mules, a basket of apples, crackers, and other such refreshments as we could purchase on the way. Some things were suspended underneath the carriage, some packed on behind, and some under the seat and at our feet. It required great skill to compress the necessary baggage into the allotted space. As we went to the very verge of civilization, wherever two dozen voters could be assembled, we had a taste of pioneer life. We spoke in log cabins, in depots, unfinished schoolhouses, churches, hotels, barns, and in the open air.

I spoke in a large mill one night. A solitary tallow candle shone over my head like a halo of glory; a few lanterns around

the outskirts of the audience made the darkness perceptible; but all I could see of my audience was the whites of their eyes in the dim distance. People came from twenty miles around to these meetings held either in the morning, afternoon, or evening, as was most convenient.

As the regular State election was to take place in the coming November, the interest increased from week to week, until the excitement of the people knew no bounds. There were speakers for and against every proposition before the people. This involved frequent debates on all the general principles of government, and thus a great educational work was accomplished, which is one of the advantages of our frequent elections.

The friends of woman suffrage were doomed to disappointment. Those in the East, on whom they relied for influence through the liberal newspapers, were silent, and we learned, afterward, that they used what influence they had to keep the abolitionists and Republicans of the State silent, as they feared the discussion of the woman question would jeopardize the enfranchisement of the black man. However, we worked untiringly and hopefully, not seeing through the game of the politicians until nearly the end of the canvass, when we saw that our only chance was in getting the Democratic vote. Accordingly, George Francis Train, then a most effective and popular speaker, was invited into the State to see what could be done to win the Democracy. He soon turned the tide, strengthened the weak-kneed Republicans and abolitionists, and secured a large Democratic vote.

For three months we labored diligently, day after day, enduring all manner of discomforts in traveling, eating, and sleeping. As there were no roads or guideposts, we often lost our way. In going through canons and fording streams it was often so dark that the Governor was obliged to walk ahead to find the way, taking off his coat so that I could see his white shirt and slowly drive after him. Though seemingly calm and cool, I had a great dread of these night adventures, as I was in constant fear of being upset on some hill and rolled into the water. The Governor often complimented me on my courage, when I was fully aware of being tempest-tossed with anxiety. I am naturally very timid, but, being silent under strong emotions

of either pleasure or pain, I am credited with being courageous in the hour of danger.

For days, sometimes, we could find nothing at a public table that we could eat. Then passing through a little settlement we could buy dried herring, crackers, gum arabic, and slippery elm; the latter, we were told, was very nutritious. We frequently sat down to a table with bacon floating in grease, coffee without milk, sweetened with sorghum, and bread or hot biscuit, green with soda, while vegetables and fruit were seldom seen. Our nights were miserable, owing to the general opinion among pioneers that a certain species of insect must necessarily perambulate the beds in a young civilization. One night, after traveling over prairies all day, eating nothing but what our larder provided, we saw a light in a cottage in the distance which seemed to beckon to us. Arriving, we asked the usual question,—if we could get a night's lodging,—to which the response was inevitably a hearty, hospitable "Yes." One survey of the premises showed me what to look for in the way of midnight companionship, so I said to the Governor, "I will resign in your favor the comforts provided for me to-night, and sleep in the carriage, as you do so often." I persisted against all the earnest persuasions of our host, and in due time I was ensconced for the night, and all about the house was silent.

I had just fallen into a gentle slumber, when a chorus of pronounced grunts and a spasmodic shaking of the carriage revealed to me the fact that I was surrounded by those long-nosed black pigs, so celebrated for their courage and pertinacity. They had discovered that the iron steps of the carriage made most satisfactory scratching posts, and each one was struggling for his turn. This scratching suggested fleas. Alas! thought I, before morning I shall be devoured. I was mortally tired and sleepy, but I reached for the whip and plied it lazily from side to side; but I soon found nothing but a constant and most vigorous application of the whip could hold them at bay one moment. I had heard that this type of pig was very combative when thwarted in its desire, and they seemed in such sore need of relief that I thought there was danger of their jumping into the carriage and attacking me. This thought was more terrifying than that of fleas, so I decided to go to sleep and let

them alone to scratch at their pleasure. I had a sad night of it, and never tried the carriage again, though I had many equally miserable experiences within four walls.

After one of these border meetings we stopped another night with a family of two bachelor brothers and two spinster sisters. The home consisted of one large room, not yet lathed and plastered. The furniture included a cooking stove, two double beds in remote corners, a table, a bureau, a washstand, and six wooden chairs. As it was late, there was no fire in the stove and no suggestion of supper, so the Governor and I ate apples and chewed slipperly elm before retiring to dream of comfortable beds and well-spread tables in the near future.

The brothers resigned their bed to me just as it was. I had noticed that there was no ceremonious changing of bed linen under such circumstances, so I had learned to nip all fastidious notions of individual cleanliness in the bud, and to accept the inevitable. When the time arrived for retiring, the Governor and the brothers went out to make astronomical observations or smoke, as the case might be, while the sisters and I made our evening toilet, and disposed ourselves in the allotted corners. That done, the stalwart sons of Adam made their beds with skins and blankets on the floor. When all was still and darkness reigned, I reviewed the situation with a heavy heart, seeing that I was bound to remain a prisoner in the corner all night, come what might. I had just congratulated myself on my power of adaptability to circumstances, when I suddenly started with an emphatic "What is that?" A voice from the corner asked, "Is your bed comfortable?" "Oh, yes," I replied, "but I thought I felt a mouse run over my head." "Well," said the voice from the corner, "I should not wonder. I have heard such squeaking from that corner during the past week that I told sister there must be a mouse nest in that bed." A confession she probably would not have made unless half asleep. This announcement was greeted with suppressed laughter from the floor. But it was no laughing matter to me. Alas! what a prospect—to have mice running over one all night. But there was no escape. The sisters did not offer to make any explorations, and, in my fatigue costume, I could not light a candle and make any on my own account. The house did not afford

an armchair in which I could sit up. I could not lie on the
floor, and the other bed was occupied. Fortunately, I was very
tired and soon fell asleep. What the mice did the remainder
of the night I never knew, so deep were my slumbers. But, as
my features were intact, and my facial expressions as benign
as usual next morning, I inferred that their gambols had been
most innocently and decorously conducted. These are samples
of many similar experiences which we encountered during the
three months of those eventful travels.[8]

7. WOMEN OF A HOTEL IN A COLORADO MINING COMMUNITY, 1874

At peep of day the next morning they were startled by four
or five of the crusaders piling through the transom into bed
with them. They began: "Yes you tenderfeet, you tried to
shake us last night, but we have you. Get up and dress; the
boys are at the bar having cocktails made for you."[9]

The Pilgrim and the Pioneer dressed and repaired to the bar
of the hotel and there were twelve or fifteen merchants and
bankers sitting in chairs on the top of the bar, while five or
six were behind the bar assisting the bartender in mixing the
cocktails. After all were served they paid the bill, got a cock-
tail for old Aunt Martha, a three hundred pound colored cook,
and then told her they wanted an early breakfast.

The old woman laughed, slapped the donors on the shoulders,
and told them to run up to the attic and call the waitress and
they should have their breakfast immediately.

Two of the leaders went to the girl's room, called her, and
told her if she would get down in ten minutes and wait on them
there would be a dollar in it for her. In a few moments the
girl was down, her face glowing with smiles. Mr. Allan Cran-
dall, the leader said: "She is a nice girl and ought to have a
solid fellow," and tried to induce one after another to lay claim

[8] From E. C. Stanton, *Eighty Years and More*, 245-250.

[9] The two men whom the miners called "tenderfeet" were Mr. Joshua Wick-
ham, an experienced middle-aged prospector, and his friend, Mr. John Campbell,
who had received a legal education in his home state, Tennessee, and had come
to Colorado for the benefit of his health. The author of this narrative refers
to Mr. Wickham as "the Pioneer," and to Mr. Campbell as "the Pilgrim."
These events took place at Lake City, Colorado.

to her, but each made some plausible excuse. Mr. Crandall was not to be outdone. He went to the bar room, secured a screwdriver, walked across the street to a handsomely painted metallic cigar sign, with a tempting havanna in his mouth, and unscrewing it from the sidewalk, called two assistants and ordered them to carry the metallic Indian to the smiling waitress' room and to tuck him snugly away in her bed, as her "solid fellow."

While Mr. Wickham was the best type of the Pioneer, the leaders got the impression from his slipping the crowd the night before, and from his shy, sedate demeanor, that he was an unsophisticated tenderfoot and needed disciplining. They gave their impressions to a bronzed-faced, semi-rapid maid of about thirty-five and persuaded her to seat herself beside him at breakfast to try his susceptibility to feminine charms. They took the head-waiter into the secret that he might seat them properly at the table.

When Mr. Wickham came in, the head-waiter took him to a corner table near the screen which cut off the view of the kitchen, and as Mr. Campbell was about to be seated, the head-waiter tapped him on the shoulder, saying, "I am sorry but that seat is taken," and ushered in the short-haired woman, introduced her, and seated her with Mr. Wickham; and the leaders of the crusade, the waiters, and Aunt Martha, hung about the screen to see the tenderfoot taken in by the short-haired woman. She guyed him and sneered at the East, and he played the greeny and tenderfoot to perfection. She flattered him, coyly looking askance at him, chucked him under the chin, and talked baby talk to him, and he played the game admirably. The crowd behind the screen were overjoyed, and were ready to bejewel the short-haired damsel for the complete sway she had so soon obtained over the tenderfoot.

After a long sitting Mr. Wickham began to rise to go, but the brazen woman, in a pettish attitude, puckered her mouth, caught him by the sleeve, and said: "Now, Mr. Wickham, you are not going to leave me unprotected here among all of these hateful, rough men, are you?"

"I must, I must!" said he. "This is very pleasant, but the best of friends must part, you know."

The woman turned her parted lips up toward him and in an imploring, babyish tone, said: "Who is going to love me when you are gone?"

Mr. Wickham hesitated a moment, raised himself to his natural grandeur, and gently said: "Jesus is going to love you when I am gone, if you are good."

The spontaneous outburst from behind the screen was too quick for the disappointed woman to reply, if she could have said anything. Old Aunt Martha's voice rang out: "Jesus is gwine to love you. Well if dat ain't the doggonest smartest tenderfoot dat eber come to dis here hotel, den I'll gim you my head for a football. Men ain't what dey used to was nohow."

The leaders of the crusade jumped to Mr. Wickham, took him upon their shoulders to the bar and offered him anything in the house, while the short-haired woman slunk away upstairs.

From that moment the Pioneer was a hero with the "old-timers." In the midst of the hub-hub the old German cigar-maker was seen walking up and down in front of his shop across the street, shaking his fist at the place where the sign used to be saying: "The man vat stoled away mine, Indian, I kill mit him. - - -."

The waitress, for some purpose, went to her room during the excitement, and immediately began to scream for the proprietor to come quick—a man was in her bed. The proprietor grabbed his Winchester, the clerk a baseball bat, and the bartender a revolver, and all burst into the waitress's room and began to pound the ringing metallic Indian with their weapons. They soon saw the joke, picked up the cigar sign, and pushed it through a skylight at the top of the house, saying nothing.

The Pilgrim was extremely shy and nervous. He inquired: "Mr. Wickham, is this the usual life out here? If so, I should think ten years a ripe old age, if anyone could even live that long. Tell me, what has converted these people into a drove of common wild beasts?"

"My dear young friend," replied the Pioneer, "there is a most valuable lesson bound up in this unbroken pandemonium. You will observe that there are fifty men here to every woman. If a modest, neatly dressed woman should walk up Silver Street, five hundred men would come out quietly and silently

admire her as long as she was in view. This chaotic civilization is the standard that men fix for themselves when alone. The superiority of older societies is a tribute to womanhood. When man and woman are associated, man greatly elevates the standard of civility and morality for both. Oh! it is here that man can adequately estimate the magnificent attributes of the Caucasian woman. What superb mothers they make! I can hardly conceive that men of this age and sons of exemplary dames can become even temporarily so degenerate. The result of lack of woman's influence is an ocular demonstration of her great worth. It is only sires that have been deprived of the beneficent influence of refined womanhood in the maternity of their children, who can adequately measure their real worth. Here you can actually observe the reason God gave for creating woman. He said truly that it was not well that man should be alone. . . ." [10]

8. AN INTERVIEW WITH A MORMON MOTHER

During our stay in Salt Lake City we found the Mormons most friendly and genial in their disposition towards us; but they do not like to talk of their religion; to the ladies especially the subject is distasteful; neither do they care to receive into their houses visitors from the Gentile world. They have been so vexed and annoyed by the indiscreet questions of curious tourists that they are disposed to shut their doors upon the whole race. Through the influence of some friends in England I made the acquaintance of a Mormon wife, who admitted me within her family circle, where I received advantages which are accorded to few strangers. She has travelled a great deal in Europe, but is now permanently settled in a beautiful house in the centre of the city; her mind has been enlarged and enlightened during her sojourn abroad, and, though still a good Mormon, she has withdrawn from polygamy and left her husband in the full possession of three other wives; perhaps they suffice to absorb his conjugal affections. At her house I met some pleasant Mormon families. Gentlemen do not escort a battalion of wives to these social gatherings, but each accom-

[10] Bell, *Pilgrim and Pioneer*, 191-195.

panies the particular wife to whom he is for the time devoted.
No favour must be shown; his affections must be weighed to a
fraction, and divided equally between the several claimants
thereto. The ladies were refined and pleasant enough; I can-
not say much for the gentlemen. The Mormon men are genial
and good-natured, but as a rule are coarse and sensual-looking,
full of the physical strength and energies of healthy life; one
cannot imagine a bad digestion or ill-regulated liver among
them.

Everybody asked us "how we liked Salt Lake." That ques-
tion being satisfactorily answered at least fifty times in the
course of an hour, we talked and chatted in much the same
fashion as the rest of the world would have done under similar
circumstances. Knowing that the typical state of society here
was utterly different to that in any other part of the world, we
were in a vague state of expectation and excitement, and
watched for some indication of it to come to the surface; we
watched in vain. It was the same here as elsewhere. In general
society all the world over, there is a frothy bubble of conversa-
tion carried on; little is said that is worth repeating, indeed that
is worth saying. I received a good deal of local information,
and was both amused and interested in the gossip that gradu-
ally grew into circulation. Late in the evening, while chatting
more confidentially to a coterie of ladies, I tried to seize the
helm, and without any actual breach of good breeding to steer
the conversation towards matrimonial matters, but on that
subject they were scrupulously silent. They were delighted to
talk of their children; some, and they were young-looking
matrons too, told me they had "fourteen blessings"; others
who had not had time to produce such a growth of humanity
seemed, however, to be doing their best to increase the popula-
tion as fast as they could.

A woman is appreciated and respected according to the
number of her children; those who have no family are merely
tolerated or set aside as "no account." As a rule the childless
wives live together under one roof, while those "more highly
favoured of the Lord" have separate houses, and are more
honourably regarded.

I visited one lady, the wife of a wealthy merchant, an English

gentleman who had outraged his family connections and nailed his colours to the Mormon mast, though he had at no time indulged in the luxury of more than two wives, and at present has only one. Their residence is extremely beautiful; it is built in the fashion of an old-fashioned country house, with gabled roof and pointed windows, and stands in a large garden, beautifully laid out with rare shrubs and luxuriant flowers, a lovely home; the mistress thereof is a stately, noble-looking woman, with a grave earnest face, and eyes that seemed to be looking far away from this world into the next. There were two or three young children playing with their toys on the hearth-rug; some others were having a game at hide and seek, "whooping" in the garden. It seemed to me that a whole school had been let loose to enjoy a holiday.

"Surely," I exclaimed, "these children cannot *all* be yours?"

"They are, and they are not," she answered, "I have fourteen children; some are still in the nursery, some are out in the world. Those," she added, indicating a pair of toddlers on the hearth-rug, "belong to my sister wife, who died about a year ago; but they are the same as mine; they know no difference. Our children were all born under one roof, and we have mothered them in turn."

"This must be an unusual state of affairs," I ventured to remark, "even in Salt Lake. I should hardly have thought it possible that two ladies could have lived happily together under such circumstances."

"Nevertheless it is true," she answered.

"But do you mean to say," I urged, "that you *never* felt any petty jealousies?"

"I do not say that," she said somewhat sharply. "We are none of us perfect, and are all liable to the evil influence of earthly passions; but when we feel weak and failing we pray to God to help us, and He does."

"You are a strange people," I could not help observing. "In no other place in the world could such a state of things exist."

"Because nowhere else would you have the same faith to support you."

"But would you desire your daughters to enter into a polygamous marriage?" I persisted.

"If I could choose," she answered gravely, "they should each be the one wife to a good husband; but that must be as God pleases. Whatever their destiny may be their religion will help them to bear it."

Evidently desiring to end the conversation, she invited us into the garden, showed us her greenhouse, and gathered us some flowers, and we took our leave, having spent a delightful afternoon.

"I am afraid I have been more inquisitorial than good breeding sanctions," I said apologetically; "but how can I gain any information unless I ask for it?"

"I am very glad to have seen you," she replied, with a cordial hand-shake, "though as a rule I do not care to receive strangers —so many come with no introductions and intrude upon our privacy, and ask us questions, and then circulate false reports about us. They seem-to regard us as zoological curiosities; quite forgetting that our homes are as sacred to us as theirs are to them. We used to be very hospitable," she added, "but now we receive no one unless they are introduced to us as you have been." [11]

[11] Lady Duffus Hardy, *Through Cities and Prairie Lands,* 114-118.

BIBLIOGRAPHY

1. MANUSCRIPTS

Brand Records, Mitchell County, Texas.

Brand Records, Nolan County, Texas.

Diary of James Clyman (photostatic negative). Original in the Henry E. Huntington Library, San Marino, California.

The William J. Donaldson Collection of Manuscripts, Polo, Illinois.

The Lucy Maynard Letters, Illinois State Historical Library, Springfield,

Stories of the Pioneer Mothers of Illinois. Folio of letters written for the Illinois.

Illinois Woman's Exposition Board, 1893, in Illinois State Historical Library.

The William Wilson Papers, Illinois State Historical Library.

The Charles E. Wickliffe Collection of Manuscripts, Chicago, Illinois.

2. GOVERNMENT PUBLICATIONS

(a) Federal

Census Volumes.

The Census for 1820 (Fourth). Washington, D. C., 1821.

The Seventh Census of the United States, 1850. Washington, D. C., 1853.

Manufactures of the United States in 1860, *Compiled from the Original Returns of the Eighth Census.* Washington, D. C., 1865.

Preliminary Report of the Eighth Census, 1860. Washington, D. C., 1862.

The Ninth Census of the United States, 1870. 3 vols. Washington, D. C., 1872.

Compendium of the Eleventh Census of the United States, 1890. Washington, D. C., 1897.

Special Reports, Twelfth Census of the United States, 1900. Washington, D. C., 1906.

The Twelfth Census of the United States, 1900. Vol. I, Part I and Vol. II, Part II. Washington, D. C., 1901.

The Thirteenth Census of the United States, 1910. Vol. IV. Washington, D. C., 1914.

The Fifteenth Census of the United States, 1930. Vols. II and III. Washington, D. C., 1932-1933.

Congressional Globe, 41st Congress, 2nd Session. Washington, D. C., 1870.

Congressional Record, 49th Congress, 2nd Session. Washington, D. C., 1887.

Congressional Record, 59th Congress, 2nd Session. Washington, D. C., 1907.

Cook, K. M., *Public Education in Alaska.* United States Department of Interior, Office of Education Bulletin No. 12. Washington, D. C., 1936.

The Statutes at Large of the United States.
 Vol. XII, Boston (Little Brown & Co.), 1865.
 Vol. XXII, Washington, D. C., 1883.
 Vol. XXVII, Washington, D. C., 1893.
 Vol. XXVIII, Washington, D. C., 1895.
 Vol. XXIX, Washington, D. C., 1897.

Supreme Court Decisions
 Cases Argued and Adjudged in the Supreme Court of the United States.
 Vol. LXXXXVIII, Boston (Little, Brown and Co.), 1879.
 Vol. CXXXV, New York (Banks and Brothers), 1890.

(b) State and Territorial

Laws Passed at the Thirteenth Session of the General Assembly of Colorado. Denver, Colorado (Smith and Brooks), 1901.

The Revised Laws of Illinois, 1833. Vandalia, Illinois (Greiner and Sherman), 1833.

Third Biennial Report of the Superintendent of Public Instruction of the State of Illinois. Springfield, Illinois, 1860.

Journal of the Kentucky General Assembly, 1837-1838. Frankfort, Kentucky, 1838.

The Code of Mississippi: Being an Analytical Compilation. Jackson, Mississippi (Price and Fall), 1848.

Statutes of the State of Nevada, Passed at the Twenty-Sixth Session of the Legislature, 1913. Carson City, Nevada (State Printing Office), 1913.

Laws of the State of New York Passed at the Seventy-Second Session of the Legislature. Troy, New York (A. W. Scriber and A. West), 1849.

Journal of the Assembly of the State of New York at the One Hundred and Twenty-Second Session, 1899. New York and Albany (Wynkoop, Hallenbeck, Crawford Co.), 1899.

Journal of the Legislative Assembly of the Territory of Utah, Nineteenth Annual Session. Salt Lake City, Utah, 1870.

Council Journal of the Legislative Assembly of the Territory of Washington, Eleventh Biennial Session, 1887-8. Olympia, Washington Territory, 1888.

Cases Determined in the Supreme Court of the Territory of Washington. Vol. III. Reprint Edition. San Francisco, California (Bancroft-Whitney Co.), 1906.

Council Journal of the Legislative Assembly of the Territory of Wyoming, Second Session. Cheyenne, Wyoming Territory (N. A. Baker), 1872.

3. NEWSPAPERS

Argus of Western America, Frankfort, Ky., December 5, 1817 to March 2, 1838.

Bureau County Patriot, Princeton, Ill., April 21, 1863 to May 3, 1870.

Bureau County Republican, Princeton, Ill., January 14, 1858 to December 31, 1874.

The Chicago Tribune, Chicago, Ill., November 1, 1916 to November 30, 1916.

The Chicago Times, Chicago, Ill., January 16, 1855 to December 30, 1881.

Cincinnati Commercial, Cincinnati, Ohio, October 2, 1843 to March 30, 1874.

Daily Missouri Republican, St. Louis, Mo., August 1, 1863 to December 28, 1864.

Daily Picayune, New Orleans, La., January 25, 1839 to January 24, 1844.

Daily Sanduskian, Sandusky, Ohio, April 25, 1849 to April 23, 1850.

The Daily Union, Washington, D. C., May 1, 1845 to December 31, 1845.

The Focus, Louisville, Ky., March 28, 1827 to January 30, 1832.

Guardian of Liberty, Cynthiana, Ky., January 18, 1817 to March 13, 1819.

The Home Journal, New York, N. Y., February 6, 1847 to April 2, 1864.

The Illinois Republican, Belleville, Ill., January 31, 1849 to January 1, 1851.

Illinois State Journal, Springfield, Ill., April 21, 1849 to December 29, 1887.

Illinois State Register, Vandalia, Ill., and Springfield, Ill., September 1, 1837 to December 23, 1851.

The Kansas City Star, Kansas City, Mo., November 8, 1881 to November 10, 1893.

The Kentuckian, Frankfort, Ky., April 10, 1828 to May 14, 1830.

The Kentucky Gazette, Lexington, Ky., July 19, 1817 to December 17, 1819.

The Kentucky Whig, Lexington, Ky., September 22, 1825 to July 20, 1826.

Liberty Hall and Cincinnati Gazette, Cincinnati, Ohio, December 10, 1835 to February 6, 1940.

Louisville Public Advertiser, Louisville, Ky., September 28, 1833 to October 31, 1840.

The Maysville Eagle, Maysville, Ky., June 2, 1824 to August 8, 1833.

The Maysville Herald, Maysville, Ky., February 18, 1848 to November 29, 1848.

The Mechanic's Press, Utica, N. Y., November 14, 1829 to August 7, 1830.

The Microscope, Louisville, Ky., and New Albany, Ind., April 17, 1824 to June 11, 1825.

Morris's National Press, New York, N. Y., February 21, 1846 to October 31, 1846.

National Era, Washington, D . C., January 7, 1847 to December 11, 1856.

National Intelligencer, Washington, D. C., September 14, 1824 to December 31, 1831.

New York Advertiser, New York, N. Y., March 2, 1817 to February 19, 1819.
New York Evening Express, New York, N. Y., July 25, 1843 to December 31, 1850.
New York Herald, New York, N. Y., July 1, 1867 to October 2, 1867.
New York Sun, New York, N. Y., March 11, 1834 to December 31, 1834.
New York Times, New York, N. Y., November 1, 1916 to August 31, 1920.
New York Tribune, New York, N. Y., January 1, 1842 to April 29, 1891.
New York World, New York, N. Y., January 4, 1865 to June 30, 1865.
Niles Register, Baltimore, Md., September 7, 1811 to February 29, 1840.
Observer and Reporter, Lexington, Ky., May 6, 1837 to May 1, 1839.
Oregon State Journal, Eugene City, Ore., March 12, 1864 to December 26, 1874.
The Public Ledger and Commercial Bulletin, Louisville, Ky., April 28, 1846 to August 1, 1846.
Quincy Herald, Quincy, Ill., January 12, 1843 to November 30, 1864.
Quincy Whig, Quincy, Ill., October 23, 1845 to December 31, 1877.
Quincy Whig and Republican, Quincy, Ill., March 31; 1860 to March 28, 1863.
The Reporter, Lexington, Ky., November 11, 1809 to March 28, 1832.
The Republic, Washington, D. C., June 13, 1849 to December 31, 1849.
Saturday Evening Chronicle, Cincinnati, Ohio, February 17, 1827 to October 24, 1829.
St. Louis Globe-Democrat, St. Louis, Mo., June 2, 1892 to June 30, 1902.
Washington Union, Washington, D. C., January 1, 1859 to April 10, 1859.
Watchman of the Prairies, Chicago, Ill., August 10, 1847 to February 22, 1853.
Western Citizen, Paris, Ky., November 24, 1810 to September 14, 1832.
Western Monitor, Lexington, Ky., February 27, 1819 to April 9, 1825.

4. OTHER PRINTED SOURCES

(a) Books

Abdy, Edward Strutt, *Journal of a Residence and Tour in the United States of North America from April*, 1833, *to October*, 1834. 3 vols. London, England (John Murray), 1835.
Ashe, Thomas, *Travels in America Performed in* 1806. 3 vols. London, England (Richard Phillips), 1808.
Bates, Mrs. D. B., *Incidents on Land and Water, or Four Years on the Pacific Coast*. Boston, Mass., 1860.
Bay, J. C. (translator), *A Journey to North America by Victor Collot*. 2 vols. Paris, France, 1826 (reprint, 1924).
Beadle, J. H., *The Undeveloped West*. Philadelphia (National Publishing Co.), 1873.
Beecher, C. E., *The Duty of American Women to Their Country*. New York (Harper and Brothers), 1845.

Bell, J. C., *The Pilgrim and the Pioneer*. Lincoln, Neb., (International Publishing Association), 1906.

Benson, A. B. (ed.), *America of the Fifties: Letters of Fredrica Bremer*. New York (American Scandinavian Foundation), 1924.

Bernhard, Duke, *Travels Through America During the Years* 1825 *and* 1826. 2 vols. Philadelphia (Carey, Lea and Carey), 1828.

Beste, J. R., *The Wabash, or Adventures of an Englishman's Family in the Interior of America*. 2 vols. London, England (Hurst and Blackett), 1855.

Birkbeck, M., *Notes on a Journey in America*. Second Edition. London, England (James Ridgeway), 1818.

Bishop, Harriet E., *Floral Home or First Years in Minnesota*. New York (Sheldon and Blakeman), 1857.

Blane, William N., *An Excursion Through the United States and Canada During the Years* 1822-1823. London, England (Baldwin, Craddock and Joy), 1824.

Boddam-Whetham, J. W., *Western Wanderings*. London, England (Richard Bentley and Son), 1874.

Bortwick, J. D., *Three Years in California*. Edinburgh and London (Wm. Blackwood and Sons), 1857.

Brackenridge, H. M., *Recollections of Persons and Places in the West*. Second Edition. Philadelphia (J. R. Lippincott and Co.), 1868.

Brown, William, *America: Four Years' Residence in the United States and Canada*. Leeds, England (Kemplay and Bollard), 1849.

Bowles, Samuel, *Our New West*. Hartford, Conn. (Hartford Publishing Co.), 1869.

Buckingham, J. S., *The Eastern and Western States of America*. 3 vols. London, England (Fisher and Son and Co.), 1842.

Burlend, Mrs. [Rebecca], *A True Picture of Emigration*. London, England (G. Berger), 1848.

Burnett, P. H., *Recollections of an Old Pioneer*. New York (D. Appleton and Co.), 1880.

Campion, J. S., *On the Frontier*. London, England (Chapman and Hall), 1878.

Colton, Calvin, *The Americans*. London, England (Frederic Westley and A. H. Davis), 1833.

Colton, Walter, *Three Years in California*. New York (A. S. Barnes Co.), 1854.

Coxe, Margaret, *Claims of the Country on American Females*. 2 vols. Columbus, Ohio, 1842.

Cuming, F., *Sketches of a Tour to the Western Country*. Pittsburgh, Pa. (Cramer, Spear and Eichbaum), 1810.

Curley, E. A., *Nebraska, Its Advantages, Resources, and Drawbacks*. New York (American and Foreign Publications Co.), 1875.

Custer, Elizabeth B., *Tenting on the Plains*. New York (Charles L. Webster and Co.), 1889.

Darby, William, *View of the United States*. Philadelphia (H. S. Tanner), 1828.

Day, S. P., *Life and Society in America*. London, England (Newman and Co.), 1880.

Dixon, William H., *White Conquest*. 2 vols. London, England (Chatto and Windus), 1876.

Douthit, Mary O. (ed.), *Souvenir of Western Women*. Portland, Ore. (Anderson and Duniway), 1905.

Drake, C. D. (ed.), *A Series of Reminiscential Letters from Daniel Drake, M. D. of Cincinnati, to His Children*. Cincinnati, Ohio (Robert Clarke and Co.), 1870.

Duffus Hardy, Lady, *Through Cities and Prairie Lands*. New York (R. Worthington), 1881.

Duncan, J. M., *Travels Through Part of the United States and Canada in 1818 and 1819*. 2 vols. Glasgow, Scotland (The University Press), 1823.

Duniway, Abigail S., *Path Breaking*. Portland, Ore. (James, Kernes, and Abbot Co.), 1914.

Ebbut, P. C., *Emigrant Life in Kansas*. London, England (Swan, Sonnenschein, and Co.), 1886.

Edwards, W. S., *In To The Yukon*. Cincinnati, Ohio (The Robert Clarke Co.), 1905.

Eyre, John, *Travels Comprising a Journey from England to Ohio*. New York (Riker's and Raynor's), 1852.

Farnham, Eliza W., *Life in Prairie Land*. New York (Harper and Brothers), 1846.
 California Indoors and Out. New York (Dix, Edwards, and Co.), 1856.

Farnham, T. J., *Life, Adventures, and Travels in California*. New York (Cornish, Lamport, and Co.), 1852.

Farrar, Maurice, *Five Years in Minnesota*. London, England (Sampson Low, Marston, Searle, and Rivington), 1880.

Faux, W., *Memorable Days in America*: *Being a Journal of a Tour to the United States*. London, England (W. Simpkin and R. Marshall), 1823.

Fearon, H. B., *Sketches of America*. London, England, 1818.

Ferguson, C. D., *The Experiences of a Forty-Niner*. Cleveland, Ohio (Williams Publishing Co.), 1888.

Fidler, Isaac, *Observations on Professions, Literature, Manners, and Emigration in the United States and Canada*. New York (J. and J. Harper), 1833.

Ford, P. L. (ed.), *The Works of Thomas Jefferson*. 12 vols. New York (G. P. Putnam's Sons), 1905.

Ford, Thomas, *A History of Illinois from Its Commencement as a State in 1818 to 1847*. Chicago (S. C. Griggs and Co.), 1854.

Fordham, E. P., *Personal Narrative of Travels in Virginia, Maryland,*

Pennsylvania, Ohio, Indiana, Kentucky, and of a Residence in Illinois Territory: 1817-1818. Cleveland, Ohio (Arthur H. Clark Co.), 1906.

Gabriel, R. H. (ed.), *Recollections of the Gold Rush and Early California by Mrs. Sarah Eleanor Royce*. New Haven, Conn. (Yale University Press), 1932.

Gammel, H. P. N., *The Laws of Texas*, 1822-1897. 10 vols. Austin, Texas (Gammel Book Co.), 1898.

Gregg, Josiah, *Commerce of the Prairies, or the Journal of a Santa Fe Trader*. Second Edition. New York (J. and H. G. Langley), 1845.
 Scenes and Incidents in the Western Prairies. Philadelphia, Pa. (J. W. Moore), 1857.

Gunnison, J. W., *The Mormons or Latter-Day Saints in the Valley of Great Salt Lake*. New York (J. W. Lovell Co.), 1852.

Hall, B. R., *The New Purchase, or Early Years in the Far West*. Second Edition. Philadelphia, Pa. (J. B. Lippincott and Co.), 1855.

Hall, James, *Letters from the West*. London, England (Henry Colburn), 1828.

Hancock, William, *An Emigrant's Five Years in the Free States of America*. London, England (T. Cautley Newby), 1860.

Hannum, A. P. (ed.), *A Quaker Forty-Niner, The Adventures of Charles Edward Pancoast on the Frontier*. Philadelphia, Pa. (The University of Pennsylvania Press), 1930.

Herbertson, A. J. (translator), *American Life* by Paul De Rousiers. Paris and New York (Fermin-Didot and Co.), 1892.

Hoffman, C. F., *A Winter in the Far West*. London, England (Richard Bentley), 1835.

Hulme, Thomas, *Journal Made During a Tour of the Western Countries of America*. London, England (Sherwood, Neely and Jones), 1819.

James, T. H., *Rambles in the United States and Canada*. London, England (John Ollivier), 1846.

Johnson, J. F. W., *Notes on North America*. 2 vols. Boston (Little and Brown), 1851.

Jones, A. D., *Illinois and the West*. Boston, Mass. (Weeks, Jordan and Co.), 1838.

Latrobe, B. H., *The Journal of Latrobe, Being the Notes and Sketches of an Architect, Naturalist, and Traveler in the United States from 1796 to 1820*. New York (D. Appleton and Co.), 1905.

Latrobe, C. J., *The Rambler in North America*. Second Edition. 2 vols. London, England (R. B. Seeley and W. Burnside), 1836.

Lieber, Francis, *The Stranger in America*. 2 vols. London, England Richard Bentley), 1835.

Lippincott, Sarah J., *New Life in New Lands*. New York (J. B. Ford and Co.), 1873.

McClellan, R. G., *The Golden State: A History of the Region West of the Rocky Mountains, Embracing California*. Philadelphia, Pa. (Wm. Flint and Co.), 1872.

McClure, A. K. (ed.), *Lincoln's Own Yarns and Stories*. Chicago and Philadelphia (John C. Winston Co.), n. d.

McClure, A. K., *Three Thousand Miles Through the Rocky Mountains*. Philadelphia, Pa. (J. B. Lippincott Co.), 1869.

Mackay, Alexander, *The Western World*. 3 vols. London, England (Richard Bentley), 1850.

McConnel, J. L., *Western Characters, or Types of Border Life*. New York (J. S. Redfield), 1853.

Marryat, J., *A Diary in America with Remarks on Its Institutions*. 3 vols. London, England (Longman, Orme, Brown, Green, and Longmans), 1839.

Marshall, W. G., *Through America*. New Edition. London, England (Sampson, Low, Marston, Searle, and Rivington), 1882.

Martineau, Harriet, *Society in America*. Fourth Edition. 2 vols. New York (Sanders and Otley), 1837.

Maxwell, A. M., *A Run Through the United States During the Autumn of 1840*. 2 vols. London, England (Henry Colburn), 1841.

Meline, J. F., *Two Thousand Miles on Horseback*. New York (Hurd and Houghton), 1867.

Melish, John, *Travels in the United States of America in the Years 1806 and 1807, and in 1809, 1810, and 1811*. Philadelphia, Pa. (Thomas and George Palmer), 1812.

Michaux, F. A., *Travels to the Westward of the Alleghany Mountains*. London, England (W. Flint), 1805.

Murat, Achille, *The United States of North America*. London, England (Effingham Wilson), 1833.

Nation, Carry A., *The Use and Need of the Life of Carry A. Nation*. Topeka, Kansas (F. M. Stevens and Sons), 1905.

Nichols, T. L., *Forty Years of American Life*. 2 vols. London, England (John Maxwell and Co.), 1864.

Nuttal, Thomas, *Journal of Travels into the Arkansa Territory During the Year 1819*. Philadelphia, Pa. (Thomas H. Palmer), 1821.

Oliver, William, *Eight Months in Illinois, with Information to Immigrants*. Newcastle on Tyne, 1843. Reprint, Chicago (Walter M. Hill), 1924.

Orpen, Adela Elizabeth, *Memories of the Old Emigrant Days in Kansas, 1862-1865*. London and Edinburgh (William Blackwood and Sons), 1926.

Paltsists, V. H. (ed.), *Across the Plains to California in 1852, Journal of Mrs. Lodisa Frizzell*. New York (New York Public Library), 1915.

Peyton, J. L., *Over the Alleghanies and Across the Prairies*. Second Edition. London, England (Simpkin, Marshall and Co.), 1870.

Pine, G. W., *Beyond the West*. Utica, N. Y. (T. J. Griffiths), 1871.

Power, Tyrone, *Impressions of America During the Years 1833, 1834, and 1835*. 2 vols. London, England (Richard Bentley), 1836.

Quaife, M. M. (ed.), *A Woman's Story of Pioneer Illinois by Christiana Holmes Tilson*. Chicago (R. R. Donnelley and Sons Co.), 1919.

Rae, W. F., *Westward by Rail*. New York (D. Appleton and Co.), 1871.

Reynolds, John, *My Own Times, Embracing Also a Story of My Life*. Chicago (Fergus Printing Co.), 1879.

Richardson, A. D., *Beyond the Mississippi*. Hartford, Conn. (American Publishing Co.), 1867.

Rivington, W. J., and Harris, W. A., *Reminiscences of America in* 1869. London, England (Sampson, Low), 1870.

Robertson, James, *A Few Months in America*. London, England (Longman and Co.), 1855.

Robinson, Sara T. L., *Kansas; Its Interior and Exterior Life*. Boston, Mass. (Crosby Nichols and Co.), 1856.

Ropes, Hannah Anderson, *Six Month in Kansas*. Boston, Mass. (John P. Jewett and Co.), 1856.

Rowbotham, F. J., *A Trip to Prairie-Land*. London, England (Sampson, Low), 1885.

Russell, Charles Lord, *Diary of a Visit to the United States in the Year* 1883. New York (United States Catholic Historical Society), 1910.

Rustling, J. F., *The Great West and the Pacific Coast*. New York (Sheldon and Co.), 1877.

Saunders, William, *Through the Light Continent, or the United States in* 1877-8. London, Paris, and New York (Cassell, Petter, and Galpin), 1879.

Shaw, Anna Howard, *The Story of a Pioneer*. New York (Harper and Brothers), 1915.

Singleton, Arthur, *Letters from the South and West*. Boston, Mass., 1824.

Smithwick, Noah, *The Evolution of a State or Recollections of Old Texas Days*. Austin, Texas (Gammel Book Co.), 1900.

Stanton, Elizabeth Cady, *Eighty Years and More*. New York (European Publishing Co.), 1898.

Steele, Mrs. E. A., *A Summer Journey in the West*. New York (John S. Taylor), 1841.

Stewart, Elinore Pruitt, *Letters of a Woman Homesteader*. Boston and New York (Houghton-Mifflin Co.), 1914.

Reminiscences of Senator William M. Stewart of Nevada. New York and Washington (Neale Publishing Co.), 1908.

Strahorn, Carrie A., *Fifteen Thousand Miles by Stage*. New York (G. P. Putnam's Sons), 1911.

Stuart, James, *Three Years in North America*. 2 vols. Edinburgh (Robt. Cadell), 1833.

Summerhayes, Martha, *Vanished Arizona*. Second Edition. Salem, Mass. (Salem Publishing Co.), 1911.

Swisher, James, *How I Know*. Cincinnati, Ohio (Jones, Brother, and Co.), 1881.

Taylor, Bayard, *Colorado, A Summer Trip*. New York (G. P. Putnam's Sons), 1866.

Taylor, William, *California Life Illustrated*. New York (Carlton and Porter), 1858.

Tenney, E. P., *Colorado and Homes in the New West*. Boston (Lee and Shephard), 1880.

Thayer, W. M., *Marvels of the New West*. Norwich, Conn. (Heney Bill Pub. Co.), 1892.

Thwaite, Leo, *Alberta*. Chicago (Rand-McNally and Co.), 1912.

Thwaites, R. G. (ed.), *Early Western Travels*. 32 vols. Cleveland, Ohio (The Arthur H. Clark Co.), 1904-1907.

Tice, J. H., *Over the Plains, on the Mountains*. St. Louis, Mo. (Industrial Age Printing Co.), 1872.

Trollope, Anthony, *North America*. New York (Harper and Brothers), 1852.

Trollope, Mrs. [Frances], *Domestic Manners of the Americans*. Fourth Edition. 2 vols. London, England (Whittaker, Treacher, and Co.), 1832.

The United States and Canada as Seen by Two Brothers in 1858 *and* 1861. London, England (Edward Stanford), 1862.

Volney, C. F., *View of the Climate and Soil of the United States of America*. London, England (J. J. Johnson), 1804.

Williarns, J. S., *Old Times in West Tennessee*. Memphis, Tenn. (W. G. Cheeney), 1873.

Wissler, Clark, *Indian Cavalcade, or Life on the Old-Time Indian Reservations*. New York (Sheridan House), 1938.

Wright, William, *History of the Big Bonanza*. Hartford, Conn. (American Publishing Co.), 1877.

(b) Articles

Adams, George E., "Cape Nome's Wonderful Placer Mines," *Harper's Weekly*, XLV (June 9, 1900), 529-531.

Adney, Tappan, "The Gold Fields of Cape Nome," *Collier's Weekly*, XXV (August 4, 1900), 18.

Baker, Charles M., "Pioneer History of Walworth County," *Report and Collections of the State Historical Society of Wisconsin*, VI (1869-1872), 436-475.

Balderson, William, "Woman Suffrage in Idaho," M. O. Douthit (ed.), *The Souvenir of Western Women*, 117-118.

Beadle, J. H., "The Mormon Theocracy," *Scribner's Monthly*, XIV (July, 1877), 391-397.

Boyesen, Hjalmar H., "Types of American Women," *The Forum*, VIII (November, 1889), 337-347.

Carey, Mrs. Nancy, "Autobiography," *Michigan Pioneer and Historical Collections*, XXXVIII (1908), 168-171.

"Diary of James Clyman," *California Historical Society Quarterly*, IV (December, 1925), 307-360.

Duniway, Abigail Scott, "A Few Recollections of a Busy Life," Douthit ed.), *Souvenir of Western Women*, 9-12.

"Open Letter of George Flower," Albion, Illinois, August 21, 1821, R. G. Thwaites (ed.), *Early Western Travels*, X, 135-149.

"Open Letter of Richard Flower," Albion, Illinois, June 19, 1820, Thwaites (ed.), *Early Western Travels*, X, 128-133.

Fulcomer, Anna, "The Three R's at Circle City," *The Century Magazine,* LVI (June, 1898), 229.

Gillard, Mrs. George, "Pioneering in the Seventies," *Annals of Wyoming* (Cheyenne, Wyo., State Dept. of History), V (July, 1927), 19-24.

Henderson, Caroline A., "Letters from the Dust Bowl," *The Atlantic Monthly*, CLVII (May, 1936), 540-551.

Hoppin, Ruth, "Personal Recollections of Pioneer Days in Michigan," *Michigan Pioneer and Historical Collections*, XXXVIII (1912), 410-417.

Humphreys, Mary G., "Women Bachelors in New York," *Scribner's Magazine*, XX (November, 1896), 626-636.

Jackson, Sheldon, "Alaska and the Klondike," *The Chautauquan,* XXXVIII (November, 1903), 235-249.

Kirkland, W., "The West, The Paradise of the Poor," *The United States Magazine and Democratic Review*, New Series, XV (August, 1844), 182-190.

Lampton, W. J., "The Cape Nome Gold Fields," *McClure's Magazine*, XV (June, 1900), 134-142.

Minor, Francis, "Woman's Legal Right to the Ballot," *The Forum,* II (December, 1886); 351-360.

"Statement of E. W. Nye," R. C. Morris (ed.), *Collections of the Wyoming Historical Society*, 1897), 264-267.

"Diary Kept by W. A. Richards in the Summer of 1873," *Annals of Wyoming*, VII (April, 1931), 467-482, and VIII (July, 1931), 492-505.

Roosevelt, Theodore, "Frontier Types," *The Century Magazine*, XXXVI (October, 1888), 831-843.

Sigourney, Mrs. Lydia H., "Self Educating Teachers," in *Godey's Lady's Book*, XX (March, 1840), 140-142.

White, Mrs. N. D., "Captivity Among the Sioux, August 18 to September 26, 1862," *Collections of the Minnesota Historical Society*, IX (1912), 395-426.

"Diary of Mrs. Narcissa Prentiss Whitman," Douthit (ed.), *The Souvenir of Western Women*, 19-21.

Wood, John, "Two Years Residence in the Settlement on the English Prairie," Thwaites (ed.), *Early Western Travels*, X, 179-351.

5. SECONDARY WORKS

(a) Books

Anthony, S. B., and Harper, I. H. (eds.), *The History of Woman Suffrage.* 4 vols. Imprint varies. Rochester, N. Y., 1881-1902.

Bancroft, H. H., *History of Nevada, Colorado, and Wyoming.* San Francisco (The History Co.), 1890.

Beard, Frances B. (ed.), *Wyoming from Territorial Days to the Present.* 3 vols. Chicago and New York (American Historical Society), 1933.

Calhoun, Arthur W., *A Social History of the American Family from Colonial Times to the Present.* 3 vols. Cleveland, Ohio (The Arthur H. Clark Co.), 1918-1919.

Cannon, F. J., and O'Higgins, H. J., *Under the Prophet in Utah.* Boston (C. M. Clark Publishing Co.), 1911.

Carpenter, Frank G., *Alaska, Our Northern Wonderland.* Garden City, N. Y. (Doubleday, Page and Co.), 1923.

Catt, C. C., and Shuler, N. R., *Woman Suffrage and Politics.* New York (Charles Scribner's Sons), 1923.

Collins, Lewis, *History of Kentucky.* 2 vols. Covington, Ky. (Collins and Co.), 1882.

Cubberley, E. P., *Public Education in the United States.* Revised Edition. New York (Houghton-Mifflin Co.), 1934.

Dorr, R. C., *Susan B. Anthony.* New York (Frederick A. Stokes Co.), 1828.

Fowler, W. W., *Woman on the American Frontier.* Hartford, Conn. (S. S. Scranton and Co.), 1880.

Gerould, Katherine F., *The Aristocratic West.* New York (Harper and Brothers), 1925.

Glasscock, C. B., *Then Came Oil, The Story of the Last Frontier.* Indianapolis, Ind., and New York (Bobbs-Merrill Co.), 1938.

Harveson, Mae E., *Catharine Esther Beecher, Pioneer Educator.* Philadelphia, Pa. (Science Press Printing Co.), 1932.

Hebard, G. R., *The History and Government of Wyoming.* San Francisco, 1919.

Hibbard, B. H., *A History of the Public Land Policies of the United States.* New York (The Macmillan Co.), 1924.

Hicks, John D., *The Federal Union.* New York (Houghton-Mifflin Co.), 1937.

　　　The Populist Revolt. Minneapolis, Minn. (University of Minnesota Press), 1931.

Hittell, T. H., *History of California.* 4 vols. San Francisco (N. J. Stone and Co.), 1898.

Lyman, G. D., *The Saga of the Comstock Lode.* New York (Charles Scribner's Sons), 1934.

Snowden, C. A., *History of Washington.* 4 vols. New York (Century History Co.), 1909.

Whitney, O. F., *History of Utah*. 4 vols. Salt Lake City (G. Q. Cannon and Sons Co.), 1892-1904.

Wooten, D. G. (ed.), *A Comprehensive History of Texas, 1685 to 1897*. 2 vols. Dallas, Texas (W. G. Scarff), 1898.

(b) Articles

Blackwell, H. B., "Woman Suffrage Problems Considered," *The Forum*, III (April, 1887), 131-141.

Cannon, Poppy, "Pin-Money Slaves," *The Forum*, LXXXIV (August, 1930), 98-102.

Capek, Karel, "Woman and the Professions," *The Atlantic Monthly*, CLVII (May, 1936), 579-580.

Cutler, H. G., "Why Do Women Want the Ballot?" *The Forum*, LIII (June, 1915), 711-727.

Diggs, Annie L., "The Women in the Alliance Movement," *The Arena*, VI (July, 1892), 161-179.

Hebard, Grace R., "The First Woman Jury," *The Journal of American History*, VII (Fourth Quarter, 1913), 1293-1341.

Hogan, W. R., "Pamelia Mann, Texas Frontierswoman," *The Southwest Review*, XX (Summer, 1935), 360-370.

Howe, E. W., "Provincial Peculiarities of Western Life," *The Forum*, XIV (September, 1892), 91-102.

Jacobi, Mary P., "Status and Future of the Woman Suffrage," *The Forum*, XVIII (December, 1894), 406-414.

Lewis, Laurence, "How Woman Suffrage Works in Colorado," *The Outlook*, LXXXII (January 27, 1906), 167-178.

Lindsay, Malvina, "Mrs. Grundy's Vote," *North American Review*, CCXXXIII (June, 1932), 485-491.

Looscan, Mrs. M., "The Women of Pioneer Days in Texas," D. G. Wooten (ed.), *A Comprehensive History of Texas, 1685 to 1897*. 2 vols. Dallas, Texas (Wm. G. Scarff, 1898), I, 649-668.

Millspaugh, Mrs. Charles F., "Women as Factors in Civic Improvement," *The Chautauquan*, XLIII (March, 1906), 312-319.

Murphy, J. M., "Woman Suffrage in Washington Territory," M. O. Douthit (ed.), *The Souvenir of Western Women*, 104-107.

Nock, Albert J., "A Word to Women," *Atlantic Monthly*, CXLVIII November, 1931), 545-554.

Orr, Harriet Knight, "A Pioneer Bride," *Annals of Wyoming*, IX (July, 1932), 666-673.

Palmer, Alice Freeman, "A Review of the Higher Education of Women," *The Forum*, XII (September, 1891), 28-40.

Palmer, Gretta, "There Are Plenty of Bachelors," *Ladies' Home Journal*, LVII (February, 1940), 25.

Pearce, Stella E., "Suffrage in the Pacific Northwest," *Washington Historical Quarterly*, III (1908-1912), 99-114.

Phelps, E. J., "Divorce in the United States," *The Forum,* VIII (December, 1889), 349-364.

Pruette, Lorine, "Women Workers Have Come Through," *The American Scholar,* V (Summer, 1936), 328-33.

Stanton, Elizabeth C., "The Other Side of the Suffrage Question," *North American Review,* CXXIX (November, 1879), 432-439.

Stowe, Harriet B., "Catharine E. Beecher," *Our Famous Women* (published and edited by A. D. Worthington and Co., Hartford, Conn., 1884), 75-93.

INDEX

Abdy, Edward Strutt, 46
Adair, Mrs. Cornelia, 115
Adams, General E. S., 9, 141
Adams, George Edward, 205
Adney, Tappan, 205
Advertisements for wives, 73-74
Age of consent, attempt of western
 women to raise, 192
Alaska, settlement of, 200-207
Albany County, Wyoming Territory,
 151, 155
Albion, Ill., 67-68
Alleghany Mountains, 30
Ames, Iowa, 187
Amherst, Mass., 217
Animals, wild, 40
Anthony, Miss Susan B., 111, 132-136,
 138, 141-142, 147, 153, 171, 177, 179-
 180, 183, 193, 200, 208, 210, 262
Anti-Polygamy Law, 1862, 165
Anti-Polygamy Society, 169
Antioch College, 87
Anti-Saloon League, 194
Apache Indians, 107
Appalachian Mountains, 16
Arizona, state of, 207, 208, 213, 215
Arizona Territory, 193
Ashe, Thomas, 48
Athens, comparison with Wyoming, 175

Bachelors, western, 71-75, 213-215
Backwoodsmen, 16, 36-37
Baker, Charles M., 90
Balderston, William, 189
Balanced diet, frontier lack of, 56
Bang, Theodosia E., 137, 144
Barnard, Henry, 81
"Barring out," 85-86
Bates, Mrs. D. B., 21, 225
Beadle, J. H., 112, 160, 182
Beard, F. B., 151
Beecher, Miss Catharine Esther, 80-83
Beecher, Henry Ward, 80, 138
Beecher, Lyman, 80
Bell County, Texas, 212
Bell, John C., 112, 130, 147, 266-269
Belton, Mo., 194
Bernhard, Duke, 220
Beste, Mr. J. R., 31, 221
Big Miami River, 33

Bingham, Miss S. C., 168
Birkbeck, Morris, 29, 47
Bishop, Miss Harriet E., 69, 230
Blackwell, Miss Elizabeth, 138
Blackwell, Henry B., 172
Blane, W. N., 73
Bloomer, Mrs. Amelia Jenks, 135-136
Bloomer costume, 135-137
Bloomer, Mrs. Nevada S., 137
Blue Mountains, 240
Boddam-Whetham, J. W., 164-165
Boise, Idaho, 189
Book of Mormon, 181
Borah, William E., 187, 189, 207
Boston, Mass., 98
Boulder Canyon Railroad, 114
Boulder County, Colorado, 114
Bowles, Samuel, 162
Boyesen, Hjalmar Hjorth, 231
Brackenridge, H. M., 18
Bramel, Buck, 152
Bremer, Miss Fredrica, 50, 217
Bright, William H., 153
Brinckle, W. D., 69-70
British Columbia, 123
Brown County, Ill., 86
Brown, John, 262
Brown, Mrs. Martha H., 168
Brown, Mrs. Mary Olney, 171
Brown, William, 60
Buckingham, J. S., 52
Buffalo meat, 239
Bull Moose campaign, 208
Burlend, Mrs. Rebecca, 50
Burlington, Ia., 82
Burnett, Peter H., 110
Burr, Aaron, 158
Buttles, Mrs., 114

Cabins, frontier, 37, 45
Cádiz, Spain, 19
Calhoun, Arthur W., 224
California, 20, 102, 119, 122-123, 128-
 130, 148, 152, 178, 193, 208, 217, 225
Campbell, John, 266-269
Campbell, John A., 150-151, 154, 156
Camp meetings, 59-63, 235-239
Camps, half-faced, 228
Canada, 201, 214, 218
Canajoharie Academy, 132

287

Cannon, F. J., 185
Cannon, Poppy, 232
Cañon Creek, California, 121
Capek, Karel, 232-233
Caraway, Hattie W., 212
Caraway, Thaddeus H., 212
Carbon County, Wyoming Territory, 151
Carey, Joseph M., 177, 191
Carey, Mrs. Nancy, 95
Carpenter, Frank G., 203
Carr, Lino, 230
Carson City, Nev., 148
Cather, Willa Sibert, 218
Catt, Mrs. Carrie Chapman, 135, 157, 187, 210
Census, 1820, 66
Census, 1850, 79
Census, 1860, 104, 178, 213
Census, 1870, 139
Census, 1890, 190
Census, 1930, 213, 215
Central Pacific Railroad, 27
Cessions, Indian, 24
Champaign, Ill., 85
Chapman, Leo, 187
Chatanooga, Tenn., 140
Chicago, Ill., 26-27, 98
Child marriages, frontier, 219
Children, Mormon, 270-272
Chilkoot Pass, 203
Cincinnati, Ohio, 42, 80, 216
Cincinnati, Ore., 102
Circle City, Alaska, 206
Cities, western, 89
Civilization, Anglo-American, 111-112
Civilization, Hispanic, 111-112
Civil War, American, 63, 84, 138-139, 149, 171, 186, 194, 221, 227
Clapp, Miss H. K., 148
Cleveland, Grover, 170, 183-184
Co-education, 87
Colby, Bainbridge, 210
Colfax, Schuyler, 166, 182
Collot, V., 37
Colonial frontier, women of, 15-16
Colonial period, 67
Colorado, 107, 113, 119, 122, 131, 148, 152, 178-180, 190, 192-193, 201, 215
Colorado City, Colo., 113
Colorado Springs, Colo., 217
Colton, Calvin, 59
Colton, Walter, 20
Columbia River, 241
Comanche Indians, 107
Communities, plains—mountain, 215
Comstock, H. T. P., 124
Comstock, Mrs. H. T. P., 124

Congress, United States, 167, 169, 176-177, 186
Constitution, Indiana, 98
Constitutional Convention, New York, 142
Consumption, prevalence of among New England women, 225
Conventions, women's rights, 132-135, 138
Cook, Katherine M., 206
Coolidge, Calvin, 211
Cooper, George, 226
Corbet, Mrs. 125-126
Costume, Turkish, 135
Council Bluffs, Ia., 135-136
Courtesy of males in Far West, 111-113
Cowboys, Wyoming Territory, 151
Coxe, Margaret, 80
Crandall, Allan, 266-267
Creek Indians, 24
Cullom, Shelby M., 167
Cumberland Road, 26
Cuming, F., 45, 58, 77
Curley, Edwin A., 117
Custer, Mrs. Elizabeth Bacon, 126-127

Dakota Territory, 104, 112, 114, 119, 150
Dance Halls, Colorado, 131
Darby, William, 107
Daviess, Mrs. Samuel, 47
Dawson City, Yukon Territory, 202, 204
Day, Samuel P., 163
Declaration of Independence, Women's, 132-133, 138
Democratic party, 187, 190, 262-263
Dentists, frontier, 55-56, 138-139
Denver, Colo., 131, 180
Depression, 1929, 232-233
De Rousiers, P., 98
Desert, Great American, 23, 113
Des Moines River, 158
Des Plaines River, 244
Diggs, Annie L., 197
Disease, Alaska, 204
Disease, frontier, 51-57, 88, 104, 261
Dixon, Ill., 261
Dixon, William H., 125-126
Dorr, R. C., 200
Drake, Dr. Charles, 58
Dresser, Paul, 226
Dubuque, Ia., 83
Duffus Hardy, Lady, 168, 184, 269-272
Duncan, J. M., 61
Duniway, Mrs. Abigail Scott, 102-103, 122, 146-147, 187, 193-194
Duniway, Ben, 146
Dunne, Edward F., 208-209

Dust Bowl, 233
Dust storms, 105
Dyson, Mrs. George, 220

Ebbutt, P. G., 220
Edmunds, George F., 169
Edmunds Law, 169
Edmunds-Tucker Act, 170, 173-174, 181, 183-184
Education, leadership of western women in, 192-193
Edwards, W. S., 203
Egan, Howard E., 9
Electoral College, strength of suffrage states in, 190, 209
Elkhorn River, 260
Emerson, Ralph Waldo, 138
Engineering problems, Colorado, 131
English officials, 15
Environment, Great Plains, 105-107, 117
Eugene City, Oregon, 122
Erie Canal, 27, 88
Eyre, John, 96

Farmers' Alliance, 197
Farmers, bonafide western, 37
Farnham, Mrs. Eliza W., 35-36, 39, 44-45, 61, 64, 69, 75, 128-129, 221, 244-258
Farrar, Maurice, 69
Far West, 171
Faux, W., 37-38, 51, 53, 88
Fearon, H. B., 33
Federalist party, 23
Female employment, 134
Female servants, Illinois, 67-68
Female servants, Minnesota, 69
Fencing, 25
Ferber, Edna, 218
Fiddler, Isaac, 216
Fifty-niners, 178
Fisher, Alexander Metcalf, 80
Flathead Indians, 239
Flower, George, 29-30, 45
Foraker, Joseph B., 185
Ford, Thomas, 18
Fort Hall, 239-240
Fort Harker, 126
Fort Hays, 126
Fort Stanwix, 24
Fort Vancouver, 241
Fort Walla Walla, 240
Forty-niners, 102, 123, 161-162
Foster, Stephen C., 226
Fourteenth Amendment, 141, 171
Fowler, W. W., 47, 99
Franklin, "state" of, 158
French, Mrs. Charlotte Olney, 171
French settlements, frontier, 16-21
Frizzell, Mrs. Lodisa, 105

Frolic, frontier, 58
Frontier, Canadian, 17
Frontier, end of, 65
Frontier homes, location of, 52
Frontier, Kansas, 103-104
Frontier meals, 48
Frontier, Michigan, 95
Frontier schools, 79-87, 148, 206-207, 242, 260
Frontiersmen, 38-44
Frontier taxation, 78-79
Frontier, Texas, 106, 226
Frontier, timber-prairie, 22, 146
Frontier, trans-Alleghany, 15, 22-23, 219, 233
Frontier women, 15-21, 30-75, 77-84, 87-132, 137, 146, 148-149, 152-157, 159-177, 179, 201-207, 219-233, 239-242, 244-261, 266-269
Fulconer, Miss Anna, 206
Furguson, Charles D., 161
Furguson, James E., 212
Furguson, Mrs. Miriam, 211-212

Gadsden Purchase, 24
Gains, Ab, 49
Garrison, William Lloyd, 138
Geneva Medical College, 138
"Gentiles," Utah, 159-160, 169, 184
Geographers, early American, 22
Georgia, state of, 37
German immigrants, 28
Gerould, Katharine F., 214
Gillard, Mrs. George, 110
Girls, captured by Indians, 226-227
Glasscock, C. B., 118
Gloyd, Charles, 194
Gold Rush, California, 225
Goldsmith, Oliver, 224
Grand Mound, Washington Territory, 171
Grant, Ulysses S., 150, 157
Grazing, Colorado, 178
Great American Desert, 113
Great Britain, 225
Great Plains, 143, 218, 231
Greeley, Colorado, 113
Greeley, Horace, 107, 129, 140, 142, 156
Greene, Roger S., 172
Gregg, Josiah, 19, 112
Gulf of Alaska, 202
Gunnison, J. W., 163-164

Hall, B. R., 38, 137
Hall, J., 48
Hancock, William, 26
Harland, Jeff J., 172
Harpe Brothers, 47-48
Harris, W. A., 162-163

Harrisburg, Ill., 259
Harrison, Benjamin, 117, 177, **182**
Hartford Female Seminary, 80
Hartsough, Mrs. I. N., 155-156
Heartz, Mrs. E., 192
Hebard, G. R., 154, 157, 176
Henderson, Carolina A., **233**
Hicks, John D., 27, 198
Hittell, T. H., 20
Hoar, George Frisbie, 91
Homes, changes in, 188
Homes, Mormon, 163-164
Homestead Act, 24-25
Homesteading, Nebraska, 116-117
Homesteading, Wyoming, 117-118
Hook, Miss Frances, 140
Hoppin, Ruth, 43
Horsemanship, frontier girls, 57
House of Representatives, Colorado, 200
House of Representatives, Idaho, 187
House of Representatives, United States, 167
Houses, sod, 106, 228
Houston, Sam, 92
Howe, Chief Justice, 155-156
Howe, E. W., 223
Hudson Bay Company, 241
Huggett, Albert J., 9
Hughes, Charles E., 210
Hulme, Thomas, 42-43
Humphreys, Mary G., **214**

Idaho, state of, 148, 192-193, 213, 215
Idaho Territory, 150
Illinois, northern, 258
Illinois, prairies of, 22
Illinois, state of, 25, 27, 36-37, 53, 61, 79, 97, 158-159, 210, 213
Immigration from Europe, 28-29, 66-67, 162, 218
Immigrants, western, 24
Immorality, of a few western **women**, 223-225
Independence, Mo., 101, 158
Indiana, state of, 25, 36-37, 53, 98, 221
Indian policies, United States, 17, 217
Indians, 22, 107-110
Indian Territory, 195
Indies, Spanish, 19
Industrial Revolution, 28, 88
Inns, frontier, 34
Iowa, prairies of, 22
Iowa, public schools, 187
Iowa State College, 187

Jackson, Andrew, 78
Jackson, Mrs. Helen Hunt, **217**
Jackson, Sheldon, 202, 206

James, T. H., 220
Johnson, Hiram W., 207
Johnson, James, F. W., 118
Jefferson, Thomas, 76, 92-93
Jewelry, western, 64-65
Joliet, Ill., **244**
Jones, A. D., 52
Judge, Wyoming woman as, 155
Judges, federal, 186
Jurors, woman as, 155-157, 172-173

Kansas, frontier, 220
Kansas, state of, 138, 143-144, 148, 150, 208, 262-266
Kiowa, Kansas, 196
Kentucky frontier, 132
Kentucky, frontier **women** of, **220**
Kentucky petitioners for presidential pardon, 227
Kentucky, salt wells of, **25**
Kentucky, state of, 36-37, 40, 46-47, 79, 94, 194
Kirkland, Ohio, 158
Kirkland, W., 41
Klondike Creek, 201
Klondike region, 202-203
Kneass, Nelson, **226**
Knight, Mrs. Mary Hezlep, 127
Koshkonong, Wisc., 50

La Crosse, Wisc., 112
Lake City, Colo., 147, 266-**269**
Lake Michigan, **244**
Lampton, William J., 204
Land, desire for, 24
Land Laws, federal, 1796-1821, 24-25
Laramie County, Wyoming Territory, 151
Laramie, Wyoming, 155
Latrobe, B. H., 60
Latrobe, C. J., 15, 53, 55, 229
Latter Day Saints, 158-159, 168
Lease, Mrs. Mary E., 197-198
Leavenworth, Kansas, 141
Legal rights, women's, 138
Legislature, Washington Territory, 172-173
Leisure, frontier women, 57
Lewis, Laurence, 200
Lewis, Samuel, 78
Life insurance, growth of, 95
Lincoln, Abraham, 53, 63, 227
Lincoln, Mrs. Nancy Hanks, 53
Lincoln, Neb., 145
Lincoln, Thomas, 36, 39
Lippencott, Miss Sarah Jane, 113
Log cabins, 228
Loneliness, frontier women, 46-48
Looscan, Mrs. M., 108

Louisiana Purchase, 24
Lyceum Bureau, 145
Lyman, George D., 121

Mackay, A., 222
Mackinaw River, 253-254
Madison, Wisc., 50
Madrid, Spain, 19
Mann, Mrs. Pamelia, 92
Manufacturing, Middle West, 26
Married women, absence of at American social affairs, 222-223
Marryat, J., 52
Marshall, W. G., 162
Martineau, Miss Harriet, 23, 216-217, 221
Maynard, Mrs. Lucy, 30-31
McClure, Alexander K., 130-131, 227
McCormick, Cyrus Hall, 26
McGee, Charles, 219
McKinley, William, 199
McLoughlin, John, 241-242
McLoughlin, Mrs. John, 241-242
McLoughlin, Miss Maria, 242
Medicine Lodge, Kansas, 195
Melish, John, 53
Meridian, ninety-eighth, 22
Methodists, the, 59
Mexico, Republic of, 19
Michaux, F. A., 40, 42, 46-47
Michigan, pioneer women of, 43
Michigan, volunteer infantry, 141
Middle Ages, 228
Miller, Amos, 260
Miller, Mrs. Elizabeth Smith, 135
Millspaugh, Mrs. Charles F., 201
Milwaukee, Wisc., 82-83
Mining camps, California, 119-122
Mining, Colorado, 113, 131
Mining, Wyoming Territory, 150
Minnesota, constitution of, 138
Minnesota, female servants, 69
Minnesota frontier, 217
Minnesota, state of, 127
Minnesota Territory, 230
Minor, Francis, 142
Mississippi, "Ladies Bill" of 1839, 93-94
Mississippi River, 26-27, 88, 111, 158, 258
Mississippi Valley, 26
Missoula, Mont., 211
Missouri River, 101, 103
Missouri, state of, 159
Money, American, 26
Montana, state of, 193, 209, 213, 215
Mormons, 124, 158-167, 182, 185, 269-272
Mormon, children of, 145, 167
Mormon women, 158-170, 269-272

Morrill Land Grant Act, 87
Morris, Mrs. Esther McQuigg, 127, 152-155
Mortality, Civil War, 139
Mortality, frontier, 53-55
Mortality, infant, 162-163
Mortality statistics, 1860, 104
Motion pictures, 232
Mott, Mrs. Lucretia, 132, 134
Mountain bread, 239
Mountains, Sierra Nevada, 121

Nacogdoches, Texas, 92
National wealth, 139
Nation, Mrs. Carry Amelia, 194-196, 198-199
Nation, David, 194
Nauvoo, Ill., 158-159
Nebraska Territory, 104, 116, 119
Negro suffrage, 142
Nevada, state of, 98-99, 193, 213, 215
Nevada Territory, 119, 122
New Albion, Ill., 29, 50-51
New Deal, 212
New England, 80, 83-84, 221, 232
New Mexico, state of, 215
New Mexico Territory, 19, 119, 193
New Orleans, La., 18, 38, 216
New West, 16, 22
New York City, 98, 138, 214, 232
New York, state of, 96, 132, 135, 158, 191
Nez Perces Indians, 239
Niagara Falls, N. Y., 31
Nichols, Thomas L., 137
Nock, Albert J., 29
Nome, Alaska, 204-205
Normal schools, 87
North Carolina, state of, 43, 59, 158
Northern Pacific Coast, 204
Nutting, William, 226
Nye, E. W., 152

Oberlin College, 87
Ogden, Utah, 168
O'Higgins, H. J., 185
Ohio River, 26, 216, 258
Ohio, state of, 37, 53, 96, 98
Oklahoma, opening of, 117, 218
Old West, 22
Oregon county, 100-102
Oregon, frontier school in, 242
Oregon, state of, 122, 138, 146, 193, 208, 210
Orientals, 178
Orpen, Mrs. Adela Elizabeth, 103
Orr, H. K., 127
Ostenso, Miss Martha, 218

Pacific Coast, 100
Pacific Ocean, 22
Palmer, Mrs. Alice Freeman, 232
Palmer, Greta, 215
Palo Alto, Texas, 140
Pancoast, Charles Edward, 125
Panic of 1837, 132
Paris, dressmakers of, 18
Parker, Miss Cynthia Ann, 226
Parker, Theodore, 138
Payne-Aldrich Tariff, 207
Pearce, S. E., 171
Peoples party, 178-180, 187, 197-198, 200
Peyton, John L., 76
Philadelphia, Pa., 98
Phillips, Wendell, 138, 142, 144
Phonographs, 232
Physicians, female, 138-139
Physicians, shortage of in West, 138-139
Piedmont, American, 16
Pike County, Ill., 43
Pine, George W., 157
Pioneers, Alaska, 202-207
Pioneers, Anglo-American, 18
Pioneers, French, 17
Pioneers, Kentucky, 40
Pittsburgh, Pa., 33
Plains-mountain West, 22-23, 27-28, 162, 177, 189-190, 197, 213-215
Plateau region, 106-107
Platform, Democratic, 1916, 210
Platform, Progressive, 1912, 208
Platform, Republican, 1916, 210
Polygamy, Mormon, 158-170, 181-182, 185-186
Postal service, women in, 139
Prairies, western, 22, 25-26, 242-244
Prentiss, Lieut., 160
Presbyterians, the, 59
Presidential campaign, 1916, 210
Princeton, Ind., 64
Private schools, western, 77-78
Progressive party, 208-209
Prohibition, Kansas, 195-196
Prohibition, national, 196
Prohibition party, 194
Pruette, Lorine, 233
Public schools, western, 78-86
Pullen, Mrs. Harriet, 203

Quillin, Mrs. Mary H., 32
Quilting parties, frontier, 58
Quincy, Ill., 55, 82

Radio, 232
Rae, W. F., 162
Railroads, Colorado, 131
Rangers, Texas, 226-227

Rankin, Miss Jeanette, 211-212
Recruiting, confederate, 140
Reed, Thomas B., 176
Reform, female dress, 135-138
Republican party, 186-187, 190, 262-265
Resorts, Colorado, 178
Revolutionary War, 23, 25, 57
Reynolds, John, 42
Richards, Mrs. J. H., 187
Richards, W. A., 151
Richardson, Albert D., 111
Richardson, W R., 143
Riter, Mrs. Levi, 167
Rivington, W. J., 162-163
Roads, plank, 27
Robertson, James, 31
Robinson, Charles, 262-265
Robinson, Mrs. Sarah L., 103
Rochester, N. Y., 132-134
Rockford, Ill., scarcity of women in, 68
Roosevelt, Theodore, 106, 185, 199-201, 207, 231
Roper, Mrs. Hannah Anderson, 103
Ross, Mrs. Nellie T., 211-212
Ross, William B., 211
Rowbotham, F. J., 23
Ruffians, border, 47-48
Russell, C. L., 162
Rutledge, Miss Ann, 54, 227

Sacramento, Calif., 124
Sacramento Valley, 178
Ste. Genevieve, Mo., 18
St. Joseph, Mo., 212
St. Louis, Mo., 27
Saline County, Ill., 259
Salt Lake City, Utah, 145, 166-167, 269-272
Salt, prices of, 25
Salt wells and miles, 25
San Francisco, Calif., 125, 203
Saniford, Mrs., 134
Sanitary systems, demand of Alaskan women for, 204-205
San Jacinto, battle of, 92
Santa Fe trade, 19
Saunders, William, 131
Savanna, Ill., 258
Scandinavian Immigrants, 28, 112, 217
Scarborough, Dorothy, 106, 218
Schools, Alaska, 206-207
Schools, early western, 79, 148, 260
School teachers, salaries in Wyoming, 191-192
Scott, Mr. Harvey W., 146
Seelye, Miss Sarah E. E., 140-141
Seminole Indians, 24
Senate, Idaho, 187
Senate, United States, 167, 185

Seneca Falls, N. Y., 132-135
Señoritas, Californian, 20-21
Sermons, Mormon, 164
Servants, western shortage of, 222
Seward Peninsula, 204
Shaw, Dr. Anna Howard, 39, 127, 147-148
Shawneetown, Ill., 35
Sheeks, Ben, 153-155
Shuler, N. R., 135
Sigourney, Mrs. Lydia H., 80
Silver standard, 26
Singleton, Arthur, 40
Skagway, Alaska, 203
Slade, William, 82
Smith, Mrs. Elizabeth Clemmons, 43
Smith, Joseph, 181
Smoot, Reed, 185
Snake Indians, 239
Society, western, 223
Sod houses, 228
Soil, Old West, 16
South Adams, Mass., 132
South Carolina, state of, 37
South Dakota, state of, 148
South Pass City, Wyoming Territory, 152, 155
Spanish-American War, 199
Spanish settlements, frontier, 16-21
Speculative appeal, in West, 216
Spinsters, 71, 121
Spitting, attitude of Europeans on, 49
Spokane, Wash., 173
Squatters, frontier, 37
Stanislaus River, 119
Stanton, Mrs. Elizabeth Cady, 102, 132-134, 145-146, 175, 262-266
States, Pacific, 161
Steamboats, western, 26, 35-36, 64-65
Steele, Mrs. Eliza A., 65, 242-244
Stegal, Mrs., 48
Sterling, Ill., 261
Stevenson, Robert Louis, 105
Stewart, Mrs. Elinore Pruit, 117-118
Stoddard, John L., 217
Stone, Miss Lucy, 262
Stores, frontier, 63-64, 110-111
Stowe, Mrs. Harriet Beecher, 80
Strahorn, Mrs. Carrie Belle, 125-126
Suffrage Amendment to Constitution, 210
Suffrage Conventions, 183, 193
Suffrage, presidential, 209
Summerhays, John W., 109
Summerhays, Mrs. Martha, 109
Sunday observance, 51
Supreme Court, Illinois, 209
Supreme Court, United States, 186, 195

Sweetwater County, Wyoming Territory, 151

Tabor, Mrs. Elizabeth, 179
Taft, William H., 207
Taylor, William, 130
Tazewell County, Ill., 146
Teachers, frontier, 78-86
Teachers' institutes, 84
Teachers, salaries of women in Wyoming, 154
Temperance organizations, 193
Tennessee, state of, 37, 48-49, 59, 132, 210, 266
Tenney, E. P., 164
Texas, constitution of 1845, 94; frontier,, 106; prairies, 144; Republic of, 92; state of, 194
Thayer, William M., 151
Thompson, Mrs. E., 114
Thwaite, Leo, 214
Tilson, Mrs. Christiana H., 31
Tilton, Theodore, 144
Traditions, Anglo-Saxon, 223
Train, George Francis, 263
Trans-Alleghany frontier, 233
Transportation, early western, 26-28
Trollope, Anthony, 230
Trollope, Mrs. Frances M., 42, 47, 51, 59-60, 62-63, 77, 216, 220, 230, 235-239
Trollope's Bazaar, 216
Trout, Mrs. Grace Wilbur, 209
Tucker, Henry, 226
Turkey Hill, Ill., 85
Tuttletown, Cal., 119

Unassigned Lands, Oklahoma, 24
Union Pacific Railroad, 27
Unitah County, Wyoming Territory, 151
United States Bank, 94
University of Iowa, 87
University of Michigan, 87
Utah, state of, 148, 184, 192-193, 215
Utah Territory, 104, 119, 150, 159-170, 173, 183, 190, 269-272

Verney, Sir Henry, 123
Virginia City, Nevada, 121
Volney, C. F., 17

Walker, Miss Mary, 219
Walworth County, Wisconsin, 90
War of 1812, 25
War service, female, 139-141
Washington, D. C., 227
Washington, state of, 148, 176, 192-193, 203, 208, 213

Washington Territory, 104, 119, 146, 171-174
Weaver, James B., 198
Webb, Walter P., 9, 23
Wellesley College, 232
Wells, Mrs. Emmeline B., 183
Wentworth, John, 125
Western Female Institute, 80
Western girls, 77-78, 231
Western men, chivalry of, 196
Western society, 223
Western Tennessee, 224
Western women, 64-65, 76-87, 100-118, 119-132, 137, 148-149, 192-193, 228-233
West Indies, British, 16
West, plains-mountain, 22-23, 27-28, 162, 177, 189-190, 197, 213-215
West, Trans-Alleghany, 22
White, Mrs. N. D., 108
Whiteside County, Illinois, 258, 260
White slavery, congressional fear of, 167
Whitman, Mrs. Narcissa, **239-242**
Whitney, C. A., 173
Whitney, O. F., 166-167, 182
Wickham, Joshua, 266-269
Wilkesbarre, Pa., 258
Willard, Samuel, 85-86
William I of Prussia, letter of, 156-157
Wilson, Howard E., 9
Wilson Law, 195
Wilson, William, 39
Wilson, Woodrow, 210
Wind mills, 25
Wisconsin frontier, 217
Wisconsin, scarcity of women in, 67

Wissler, Clark, 115
Woman suffrage, 153-155, 166-167, 169, 171-175, 178-180, 184, 187-191
Women, colonial frontier, 15-16; their journeys westward, 30-37; hardships on farms, 37-51; home tasks, 42; facing wild animals, 43; as milkers, 43-44; European, 49-51; their fecundity, 52; death rate, 53-55; at camp meetings, 59-63; bank stock holdings, 94; of Wyoming, 154; as school officials in Colorado, 179; as legislators, 180; decline in number of office holders, 200; aiding Northwest Mounted Police, 203-204; as proponents of welfare legislation, 210-211; as high officials, 211-212; early aging of, 221; western shortage of, 224
Women's Christian Temperance Union, 193-194
Wood, John, 33, 35-36
Woodruff, Wilford, 182
World War, 210-211-212, 214
Worthington, Mrs. Sarah N., 52, 258-261
Wright, William, 126
Wyoming, state of, 213, 215
Wyoming Territory, 117-118, 150-158, 170, 174-176, 190, 191

Yellowstone River, 144
Young, Brigham, 165-166, 181-182
Ypsilanti, Mich., 148
Yukon, gold discoveries, in, 199
Yukon River, 201, 203

American Women: Images and Realities
An Arno Press Collection

[Adams, Charles F., editor]. **Correspondence between John Adams and Mercy Warren Relating to Her "History of the American Revolution," July-August, 1807.** With a new appendix of specimen pages from the "**History.**" 1878.

[Arling], Emanie Sachs. **"The Terrible Siren": Victoria Woodhull, (1838-1927).** 1928.

Beard, Mary Ritter. **Woman's Work in Municipalities.** 1915.

Blanc, Madame [Marie Therese de Solms]. **The Condition of Woman in the United States.** 1895.

Bradford, Gamaliel. **Wives.** 1925.

Branagan, Thomas. **The Excellency of the Female Character Vindicated.** 1808.

Breckinridge, Sophonisba P. **Women in the Twentieth Century.** 1933.

Campbell, Helen. **Women Wage-Earners.** 1893.

Coolidge, Mary Roberts. **Why Women Are So.** 1912.

Dall, Caroline H. **The College, the Market, and the Court.** 1867.

[D'Arusmont], Frances Wright. **Life, Letters and Lectures: 1834, 1844.** 1972.

Davis, Almond H. **The Female Preacher, or Memoir of Salome Lincoln.** 1843.

Ellington, George. **The Women of New York.** 1869.

Farnham, Eliza W[oodson]. **Life in Prairie Land.** 1846.

Gage, Matilda Joslyn. **Woman, Church and State.** [1900].

Gilman, Charlotte Perkins. **The Living of Charlotte Perkins Gilman.** 1935.

Groves, Ernest R. **The American Woman.** 1944.

Hale, [Sarah J.] **Manners; or, Happy Homes and Good Society All the Year Round.** 1868.

Higginson, Thomas Wentworth. **Women and the Alphabet.** 1900.

Howe, Julia Ward, editor. **Sex and Education.** 1874.

La Follette, Suzanne. **Concerning Women.** 1926.

Leslie, Eliza . **Miss Leslie's Behaviour Book: A Guide and Manual for Ladies.** 1859.

Livermore, Mary A. **My Story of the War.** 1889.

Logan, Mrs. John A. (Mary S.) **The Part Taken By Women in American History.** 1912.

McGuire, Judith W. (A Lady of Virginia). **Diary of a Southern Refugee, During the War.** 1867.

Mann, Herman . **The Female Review: Life of Deborah Sampson.** 1866.

Meyer, Annie Nathan, editor. **Woman's Work in America.** 1891.

Myerson, Abraham. **The Nervous Housewife.** 1927.

Parsons, Elsie Clews. **The Old-Fashioned Woman.** 1913.

Porter, Sarah Harvey. **The Life and Times of Anne Royall.** 1909.

Pruette, Lorine. **Women and Leisure: A Study of Social Waste.** 1924.

Salmon, Lucy Maynard. **Domestic Service.** 1897.

Sanger, William W. **The History of Prostitution.** 1859.

Smith, Julia E. **Abby Smith and Her Cows.** 1877.

Spencer, Anna Garlin. **Woman's Share in Social Culture.** 1913.

Sprague, William Forrest. **Women and the West.** 1940.

Stanton, Elizabeth Cady. **The Woman's Bible** Parts I and II. 1895/1898.

Stewart, Mrs. Eliza Daniel . **Memories of the Crusade.** 1889.

Todd, John. **Woman's Rights.** 1867. [Dodge, Mary A .] (Gail Hamilton, pseud.) **Woman's Wrongs.** 1868.

Van Rensselaer, Mrs. John King. **The Goede Vrouw of Mana-ha-ta.** 1898.

Velazquez, Loreta Janeta. **The Woman in Battle.** 1876.

Vietor, Agnes C., editor. **A Woman's Quest: The Life of Marie E. Zakrzew-ska, M.D.** 1924.

Woodbury , Helen L. Sum n er. **Equal Suffrage.** 1909.

Young, Ann Eliza. **Wife No. 19.** 1875.